Everyday Modernism

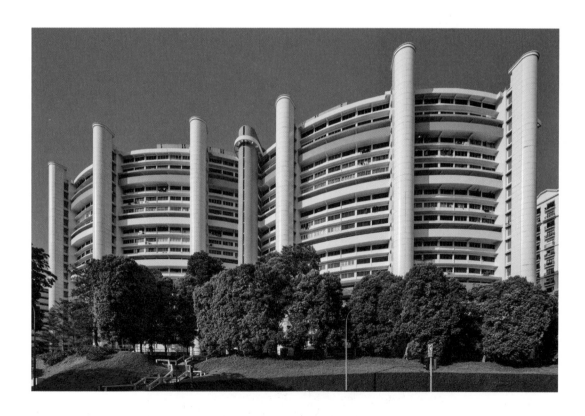

Double-curve block, Blk 168A Queensway (1973), Housing & Development Board.

Supported by

National
Heritage
Board

The views expressed here are solely those of the authors in their private capacities and do not in any way represent the views of the National Heritage Board and/or any government agencies

Published under the Ridge Books imprint by:
NUS Press
National University of Singapore
AS3-01-02, 3 Arts Link
Singapore 117569

Fax: (65) 6774-0652
E-mail: nusbooks@nus.edu.sg
Website: http://nuspress.nus.edu.sg

National Library Board, Singapore Cataloguing in Publication Data
Name(s): Chang, Jiat-Hwee. | Zhuang, Justin, author. | Soh, Darren, photographer.
Title: Everyday modernism : architecture & society in Singapore / by Jiat-Hwee Chang and Justin Zhuang ; with photographs by Darren Soh.
Description: Singapore : NUS Press, [2023]
Identifier(s): ISBN 978-981-325-187-8 (paperback)
Subject(s): LCSH: Architecture--Singapore--History--20th century. | Buildings--Singapore--History--20th century. | Architecture and society--Singapore--History--20th century. | Singapore--Buildings, structures, etc.
Classification: DDC 720.959570904--dc23

Cover image: Peninsula Plaza photographed by Darren Soh
Designed by: Hanson Ho / H55
Printed by: AC Dominie

ISBN 978-981-325-187-8 (paper)

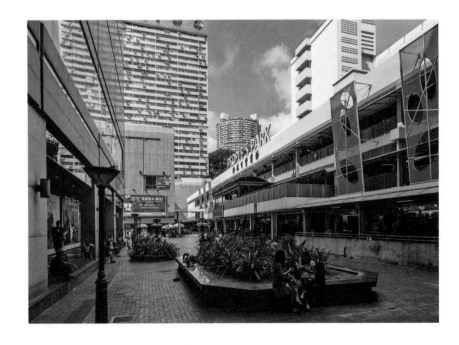

People's Park (1968), Tan Wee Lee and Peter B. K. Soo of the Housing & Development Board.

Everyday Modernism:

Architecture & Society in Singapore

By Jiat-Hwee Chang and Justin Zhuang

With photographs by Darren Soh

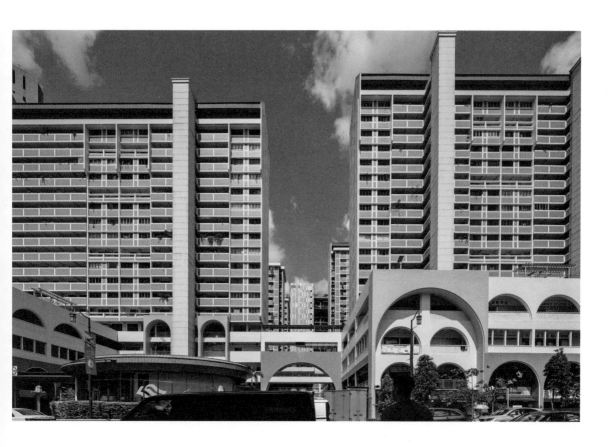

Hong Lim Complex (1980), Housing & Development Board.

RIDGE BOOKS
SINGAPORE

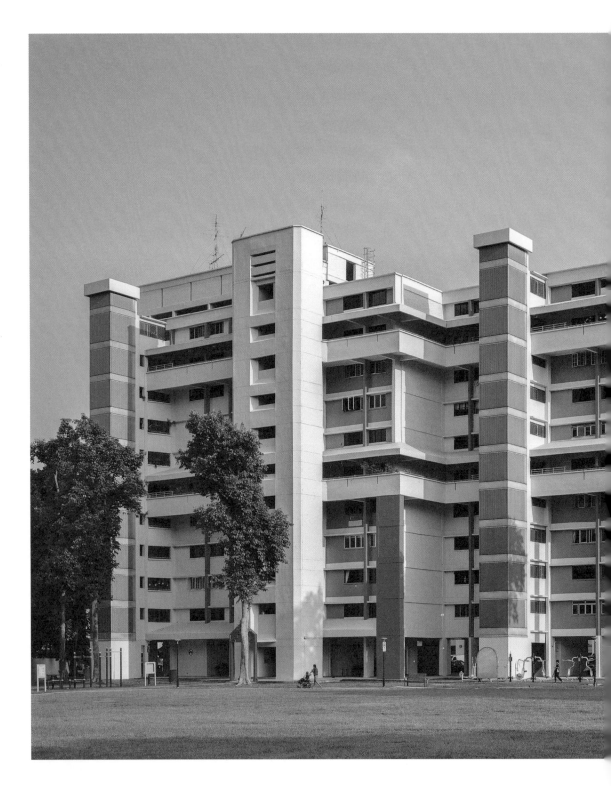

Staggered block, Blk 51 Kent Road (1981), Housing & Development Board.

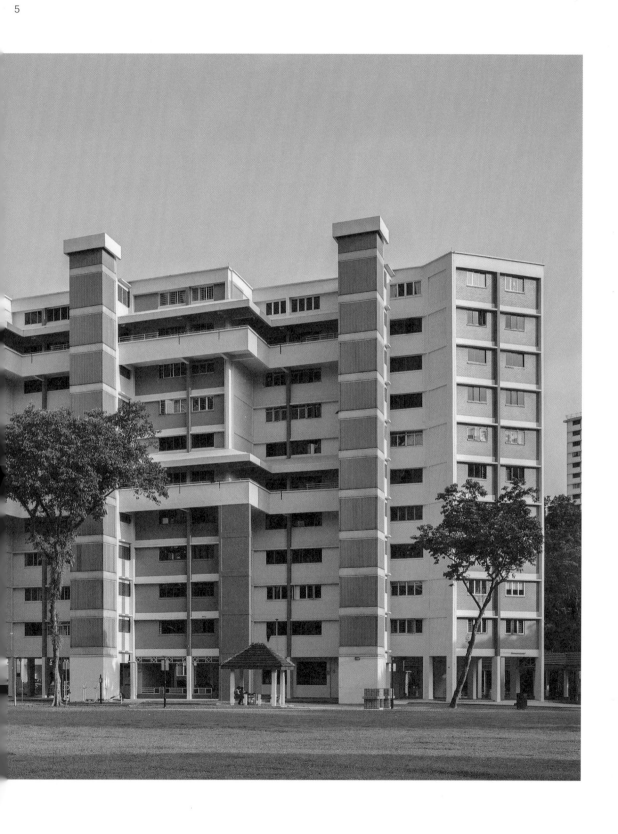

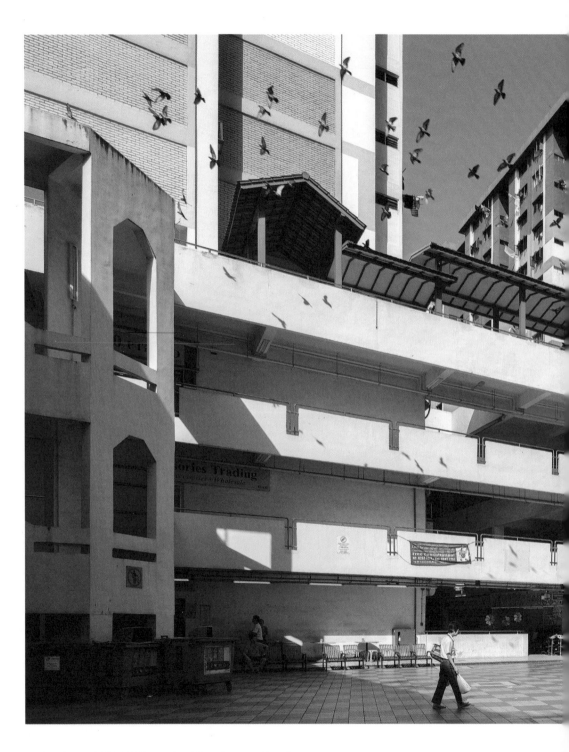

Rochor Centre (1977–2019), Housing & Development Board.

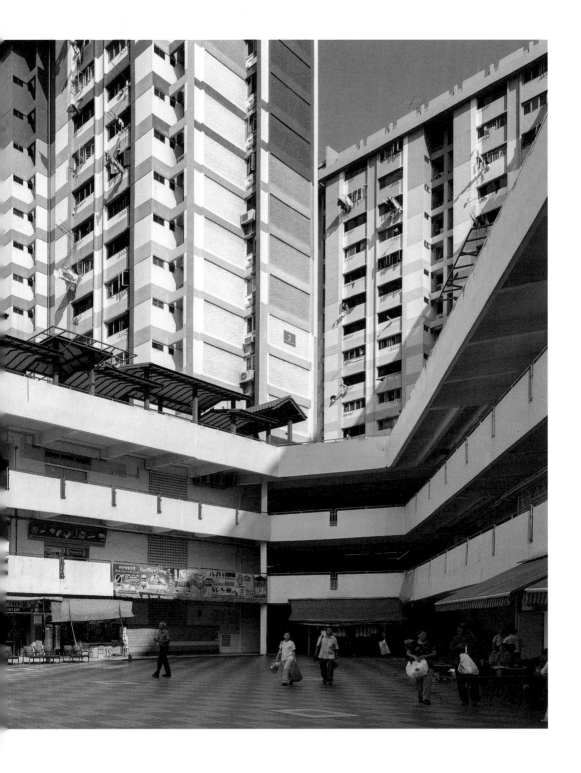

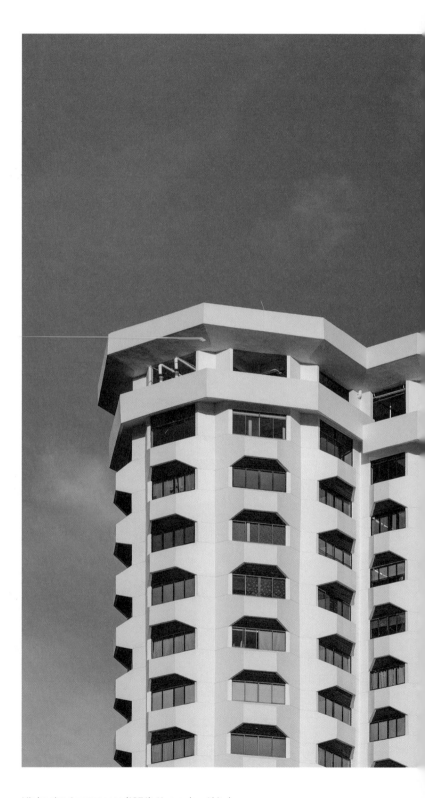

Highpoint Apartments (1974), Kumpulan Akitek.

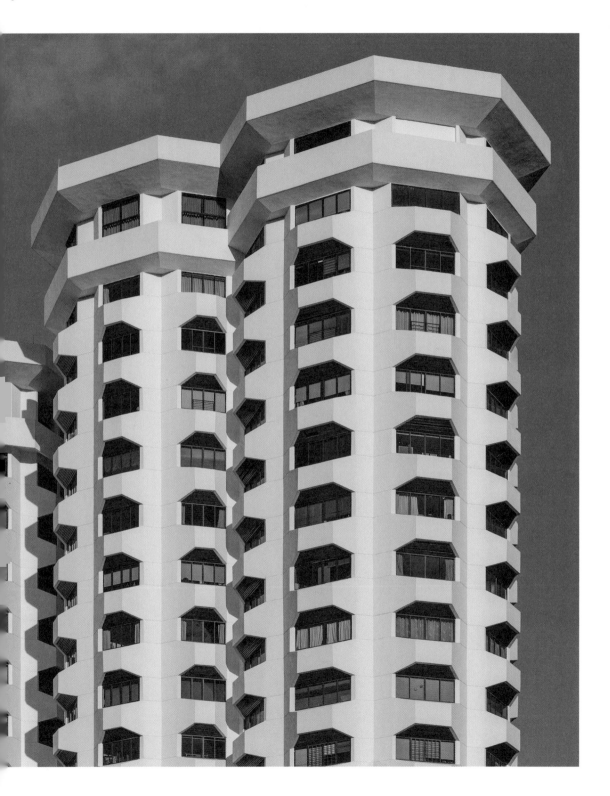

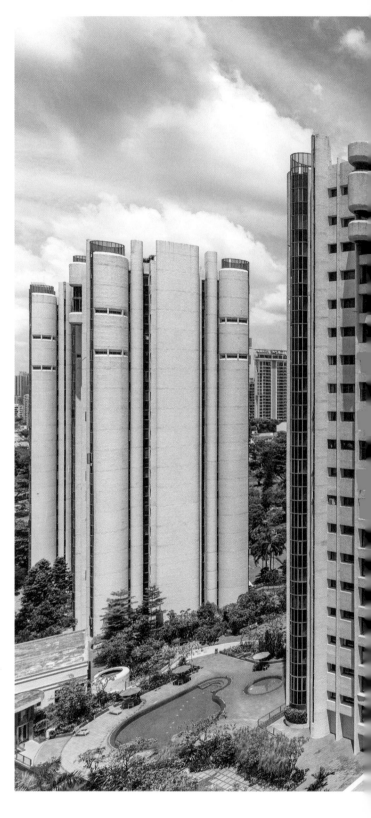

Horizon Towers (1983), Timothy Seow of Timothy Seow & Partners.

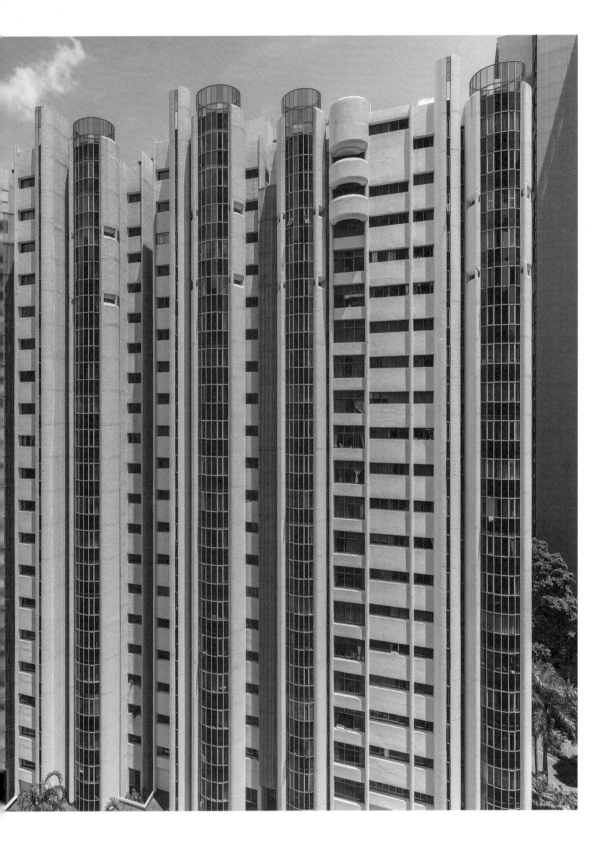

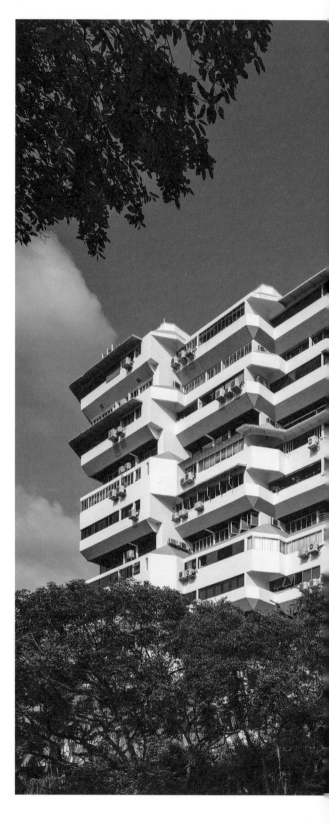

Townhouse Apartments (1976), Kumpulan Akitek.

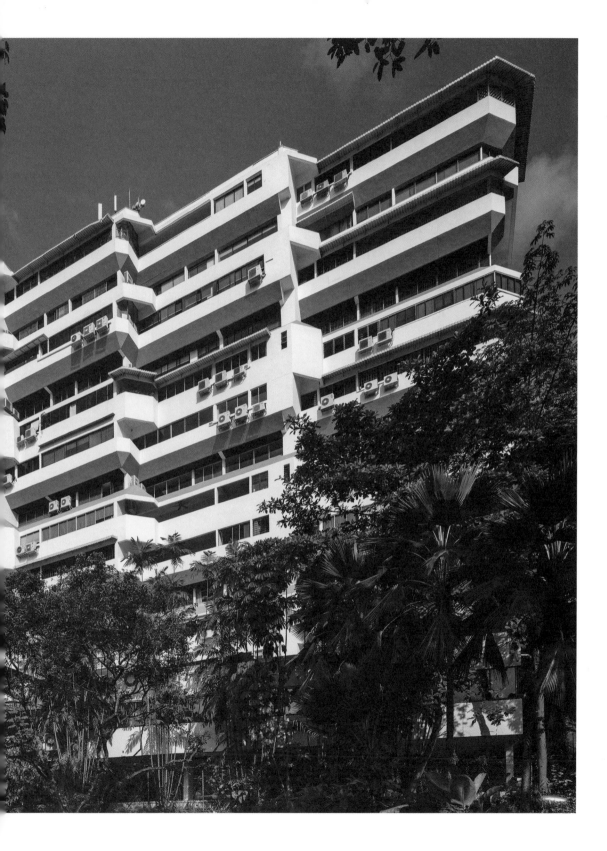

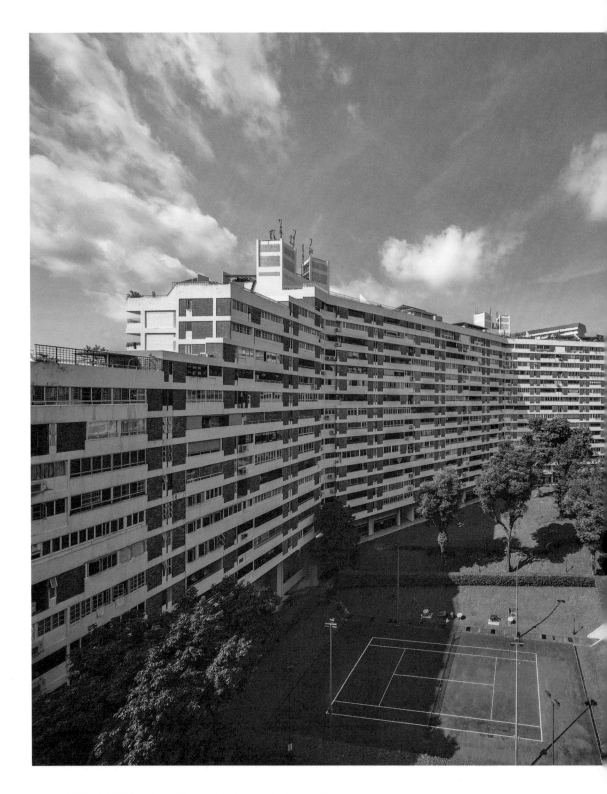

Pandan Valley (1977), Tan Cheng Siong of Archurban Architects Planners.

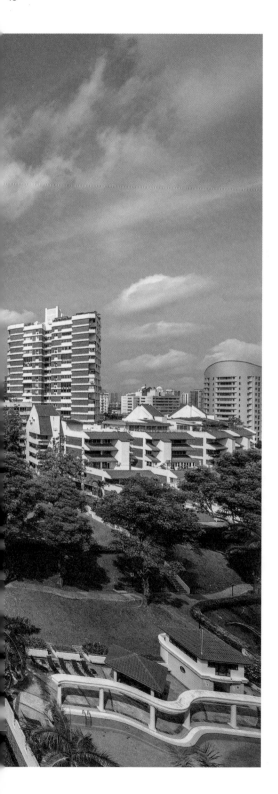

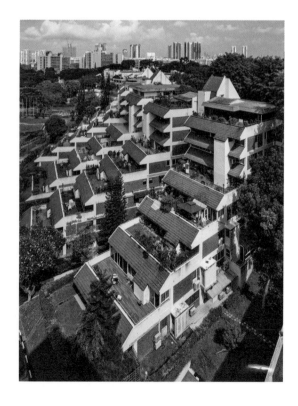

Stepped blocks at Pandan Valley.

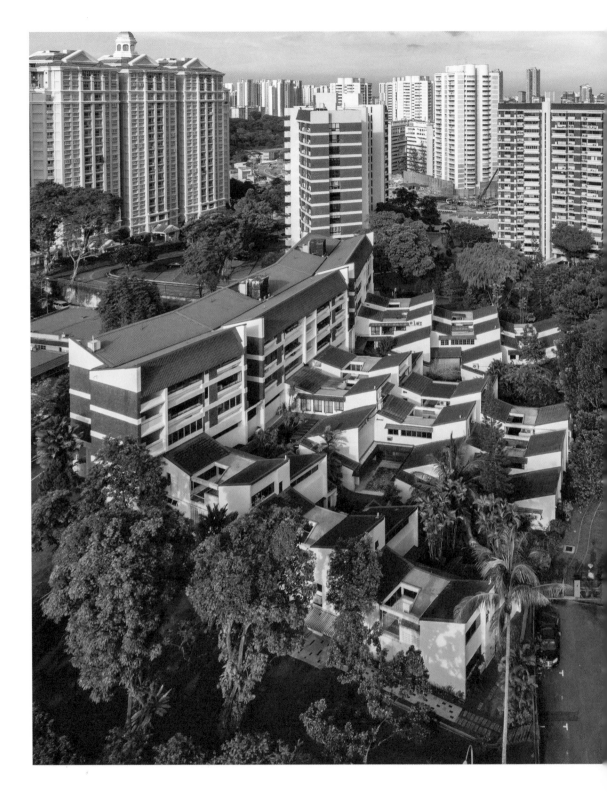

Faber Garden (1984), Chan Fook Pong of Regional Development Consortium.

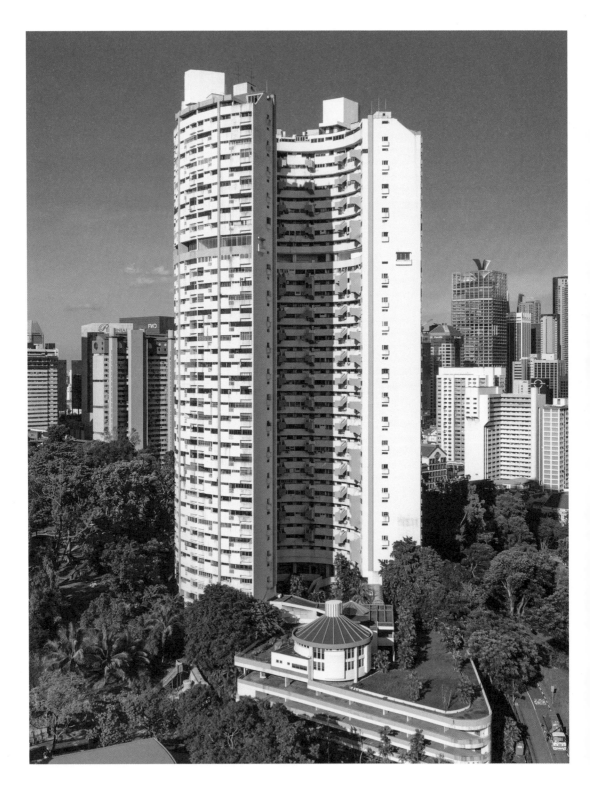

Pearl Bank Apartments (1976–2019), Tan Cheng Siong of Archurban Architects Planners.

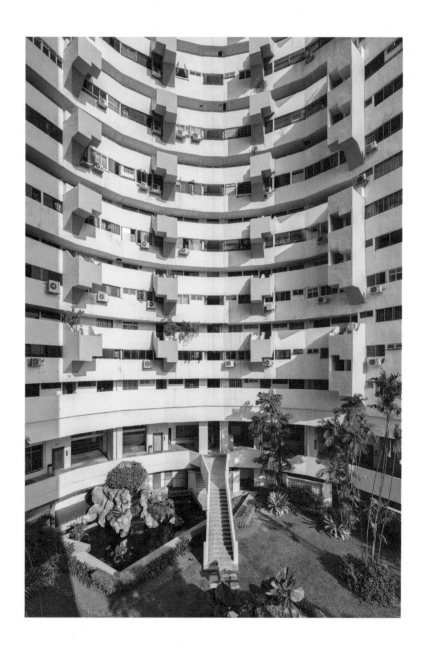

Garden inside Pearl Bank Apartments.

Façade of the former Cathay Building (1939), Frank Wilmin Brewer.

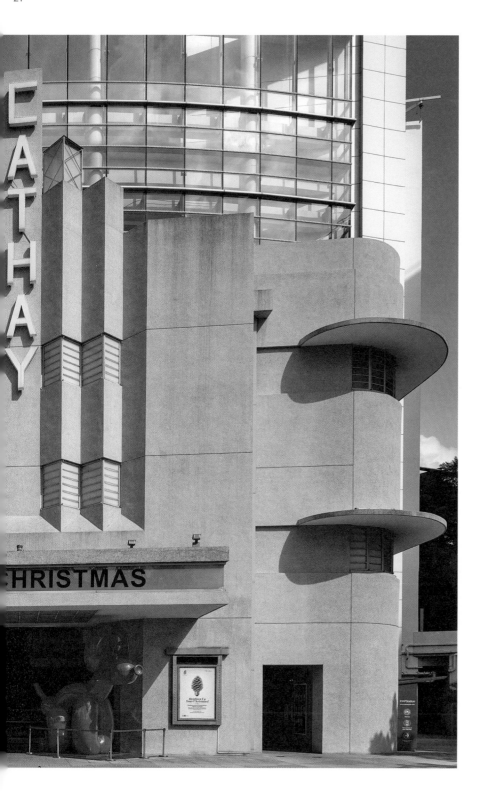

Yishun 10 (1992), Geoff Malone of International Project Consultants.

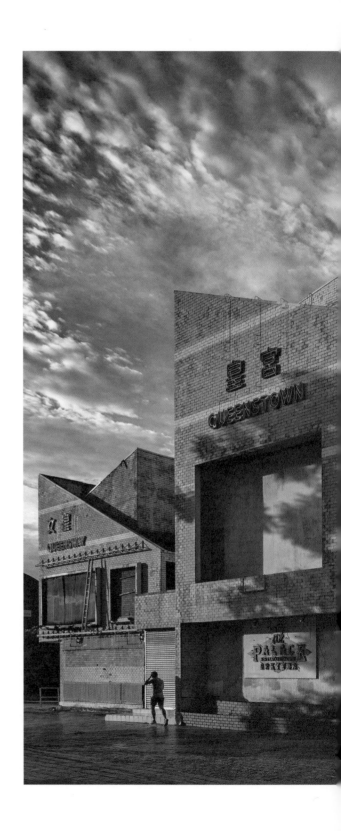

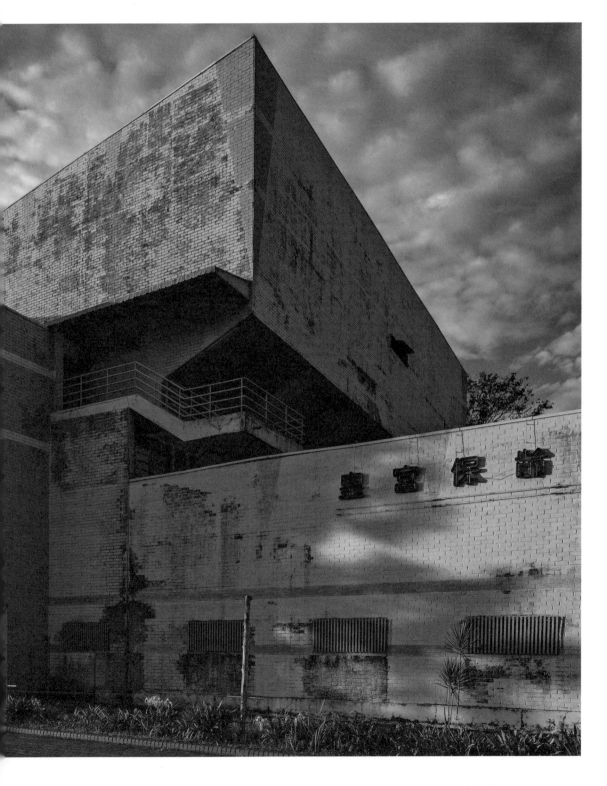

Queenstown Cinema and Bowling Centre (1977–2013), Chee Soon Wah of Chee Soon Wah Chartered Architects.

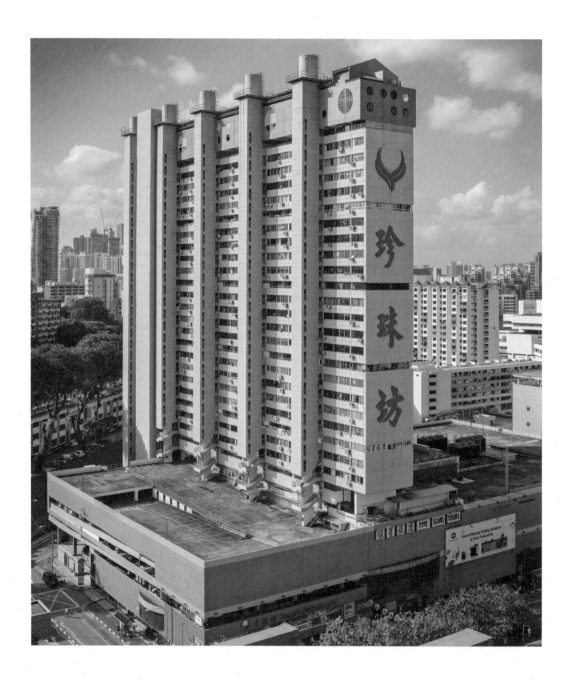

People's Park Complex (1973), Design Partnership.

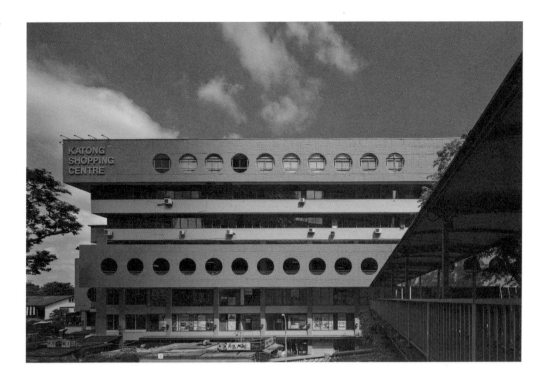

Katong Shopping Centre (1973), Design Partnership.

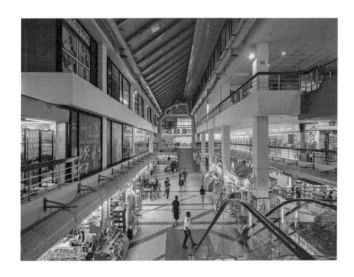

Interior of Golden Mile Complex (1972–3), Design Partnership.

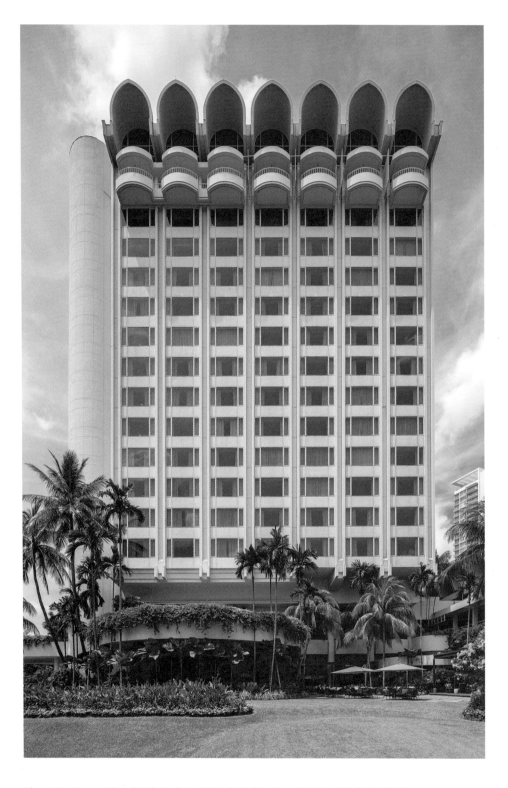

Shangri-La Tower Wing (1971), Seah Lee & Heah Architects with Kanko Kikaku Sekkeisha.

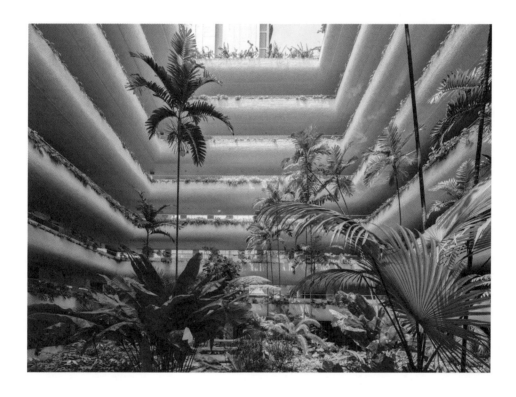

Shangri-La Garden Wing (1978), Wimberly Whisenand Allison Tong & Goo. Landscape design by Belt, Colin and Associates.

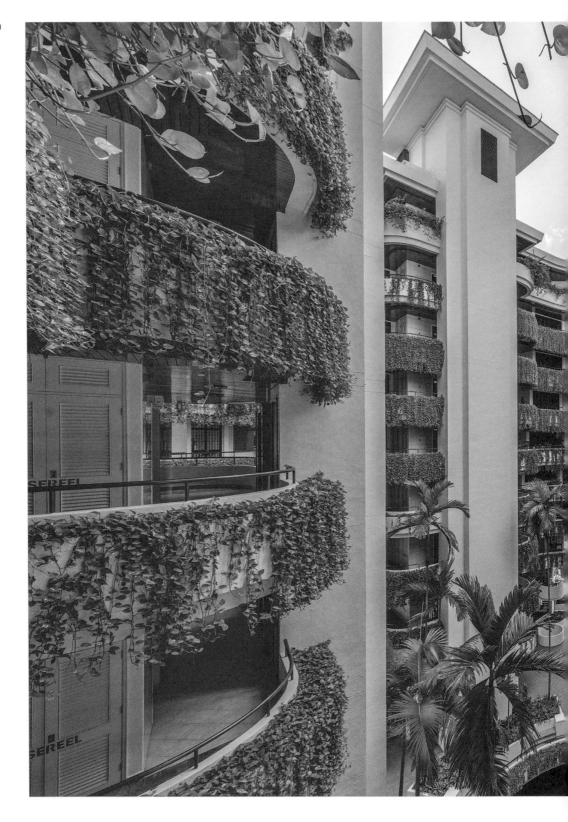

The Arcadia (1983), Wimberly Whisenand Allison Tong & Goo.

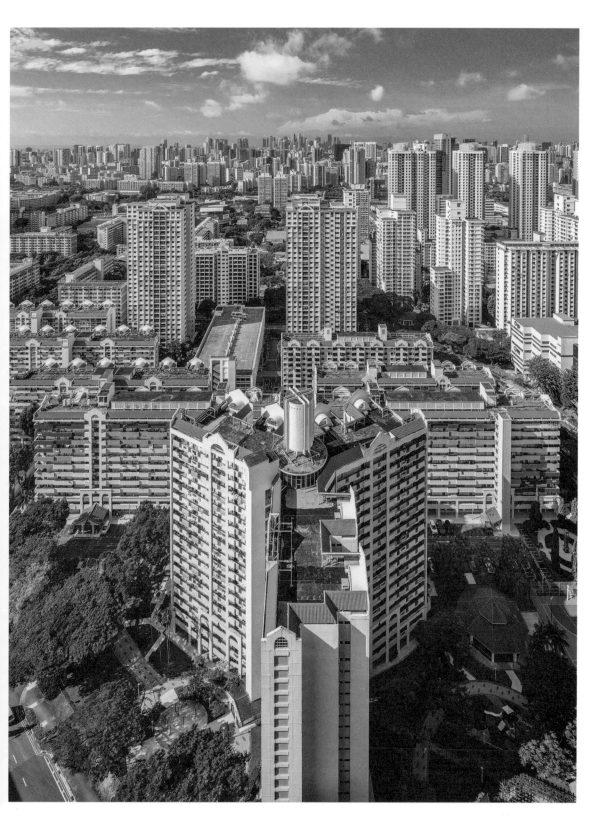

Y-shaped block, Block 53 (foreground) with a rooftop gallery (c. 1970s), Housing & Development Board.

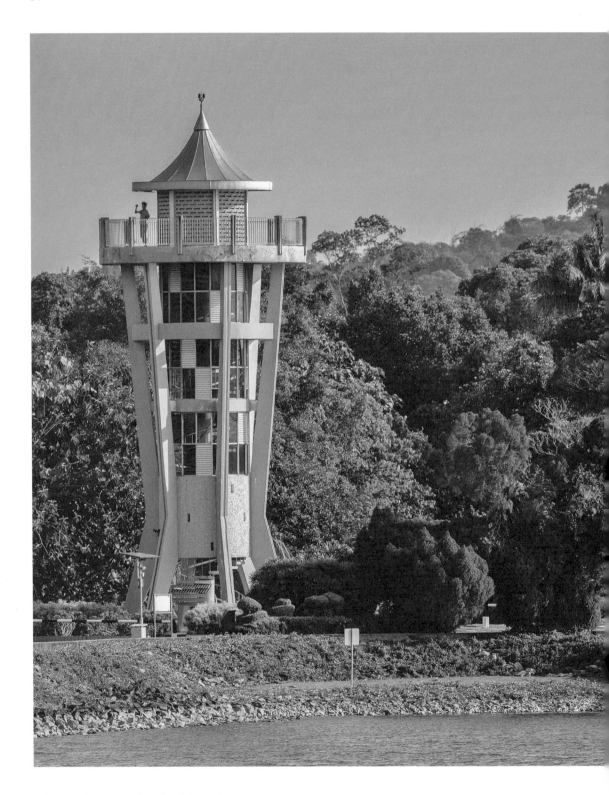

Seletar Lookout Tower (1969), Public Works Department.

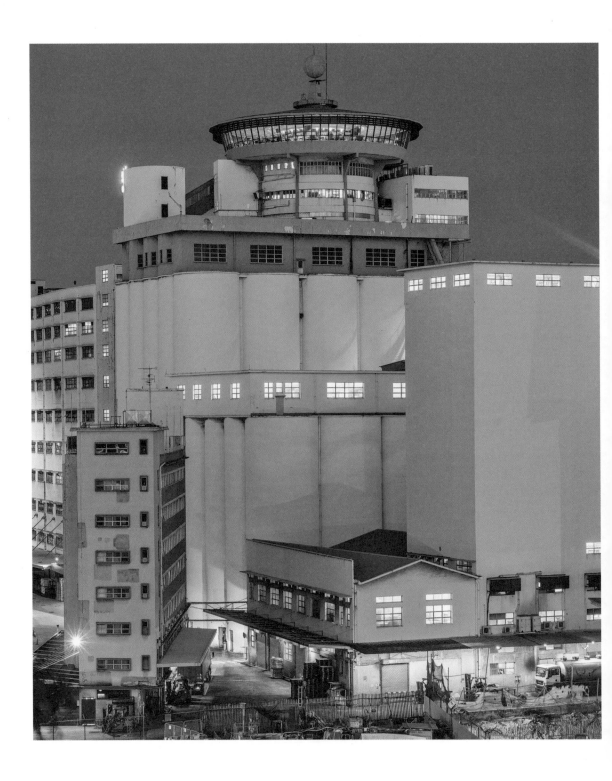

Prima Tower (1971).

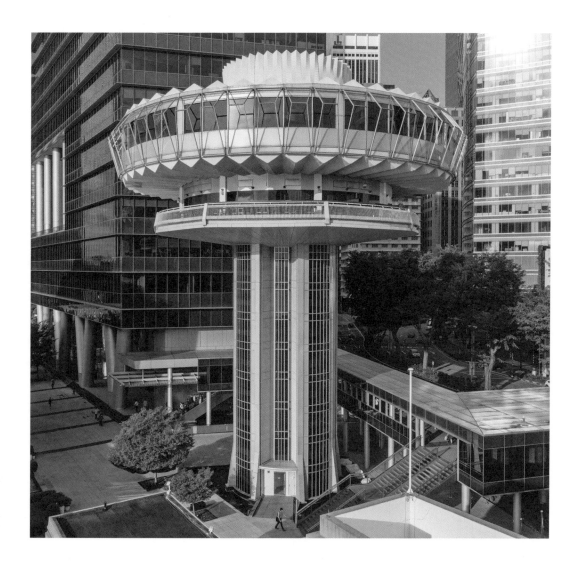

Change Alley Aerial Plaza (1971), KK Tan & Associates.

East Coast Park Lagoon (1976), Public Works Department.

Big Splash (1977–2006), Timothy Seow & Partners.

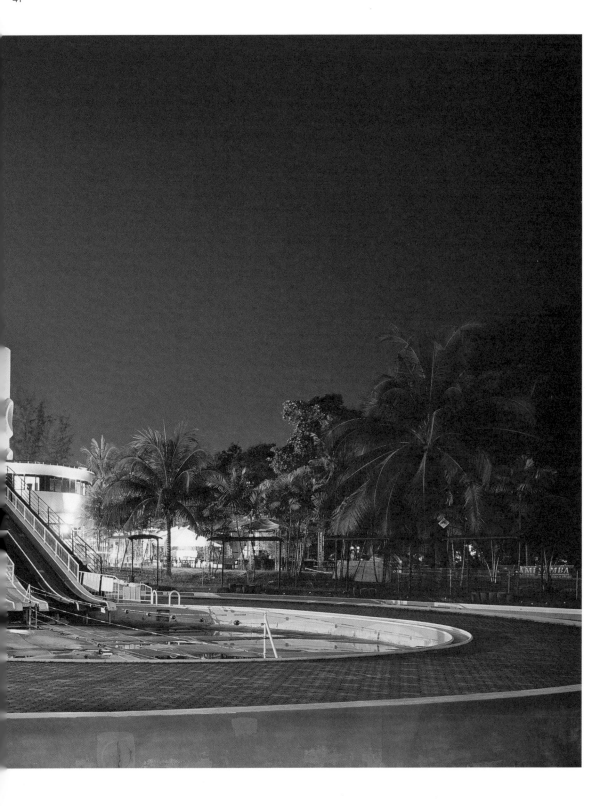

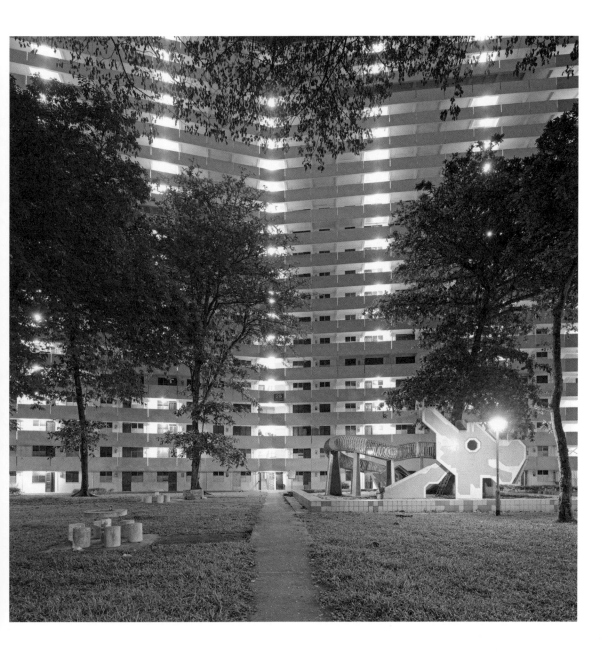

Dragon playground at Toa Payoh Lorong 6 (c. 1979), Khor Ean Ghee of the Housing & Development Board.

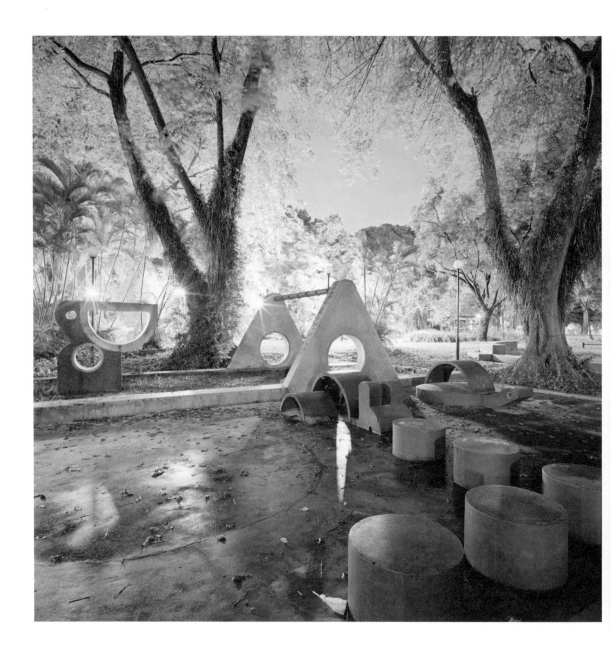

Pelican, rabbit and tortoise playground at Dover Road estate (*c.* 1970s–2011), Khor Ean Ghee of the Housing & Development Board

"Adventureland" playground at Spooner Road Estate (c. 1980s–2010s), Khor Ean Ghee of the Housing & Development Board.

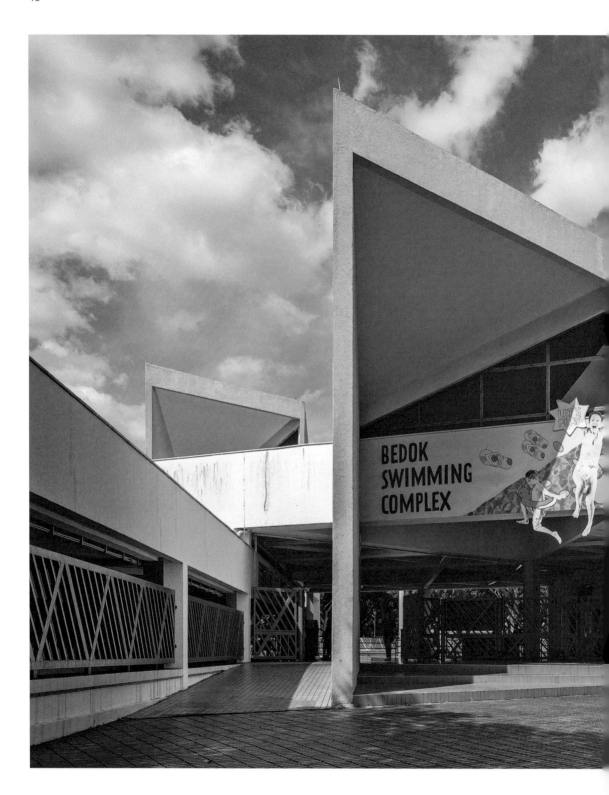

Bedok Swimming Complex (1981–2017), Housing & Development Board.

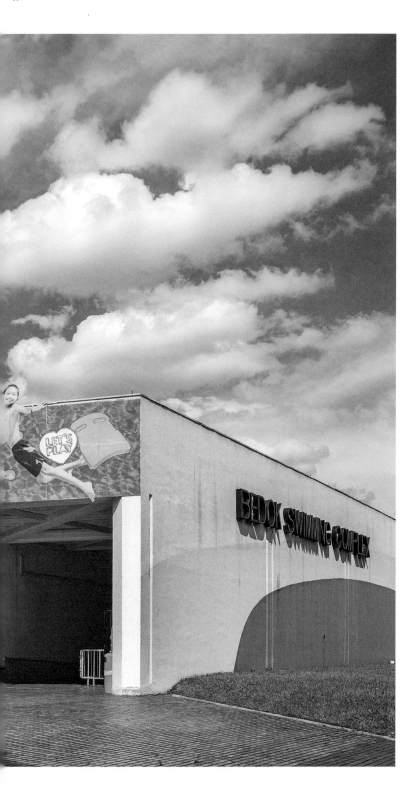

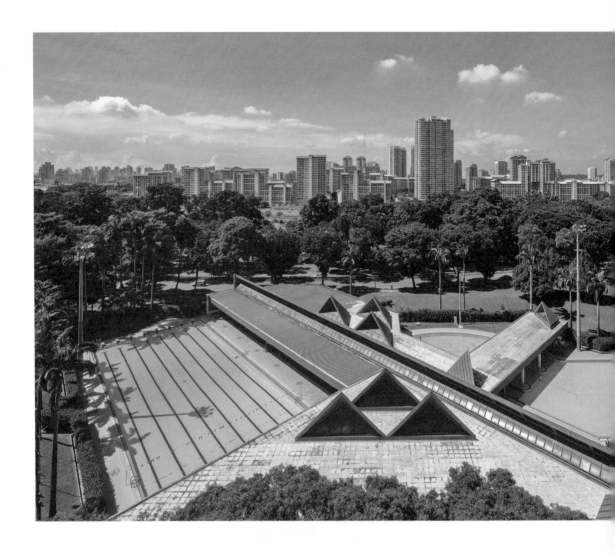

Ang Mo Kio Swimming Complex (1982), Housing & Development Board.

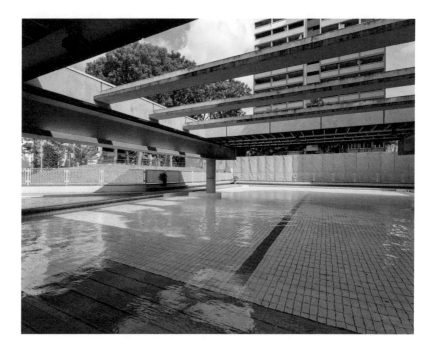

Buona Vista Swimming Complex (1976–2014), Housing & Development Board.

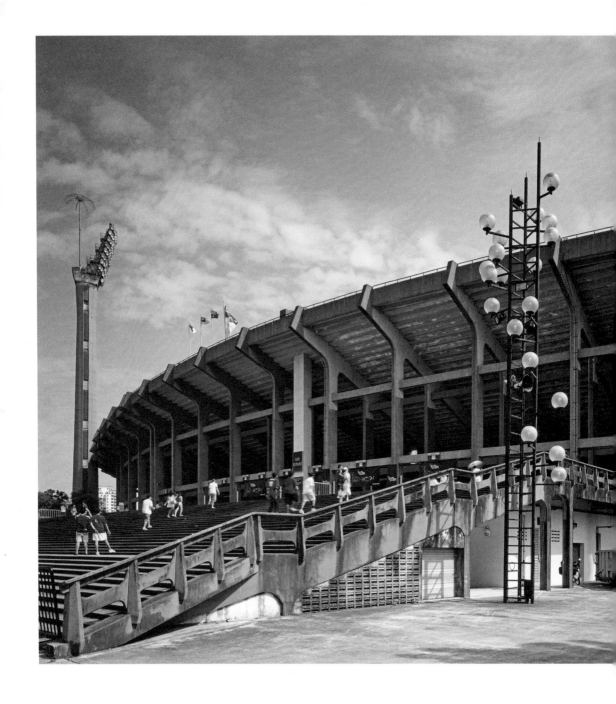

National Stadium (1973–2011), Tan Choo Guan of the Public Works Department.

Interior of Former Singapore Badminton Hall (1952), Ng Keng Siang.

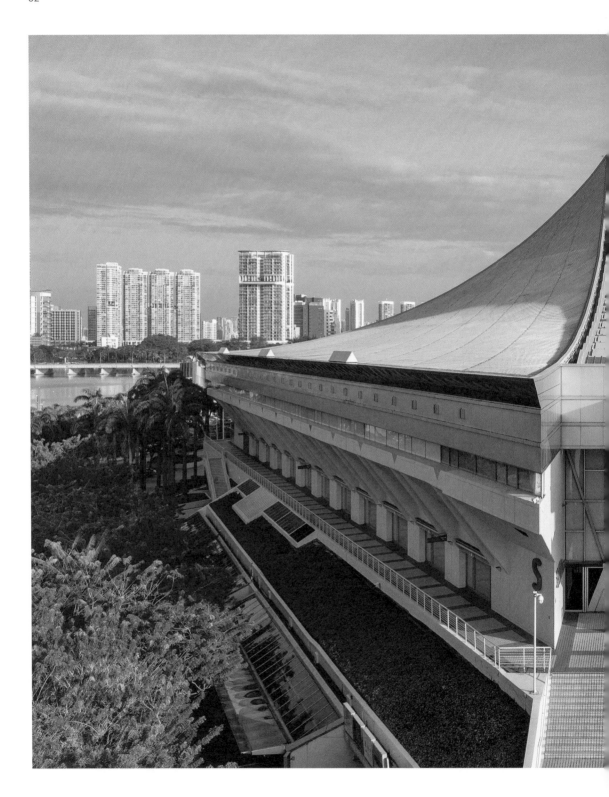

Singapore Indoor Stadium (1989), Kenzo Tange Associates.

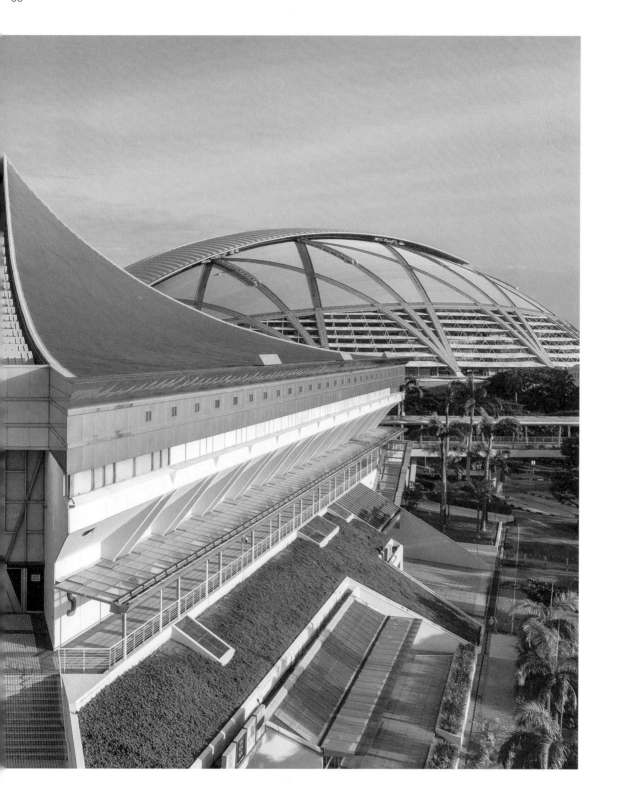

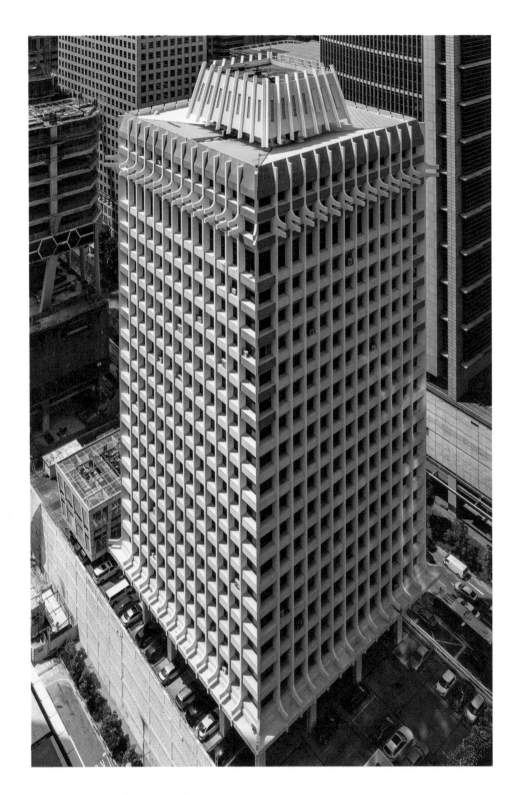

Shenton House (1975), Tay Joo Teck Architect.

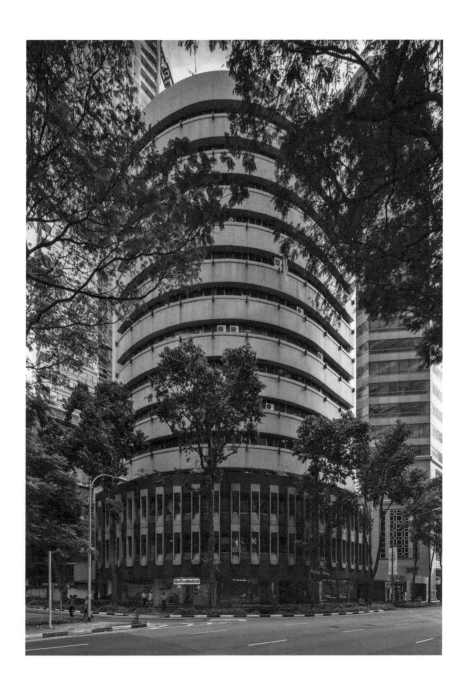

Anson Centre (1973), Yao & Quek Chartered Architects.

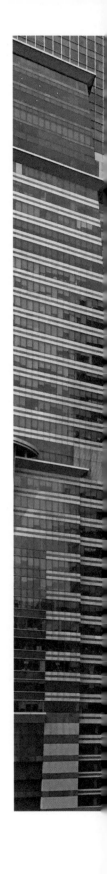

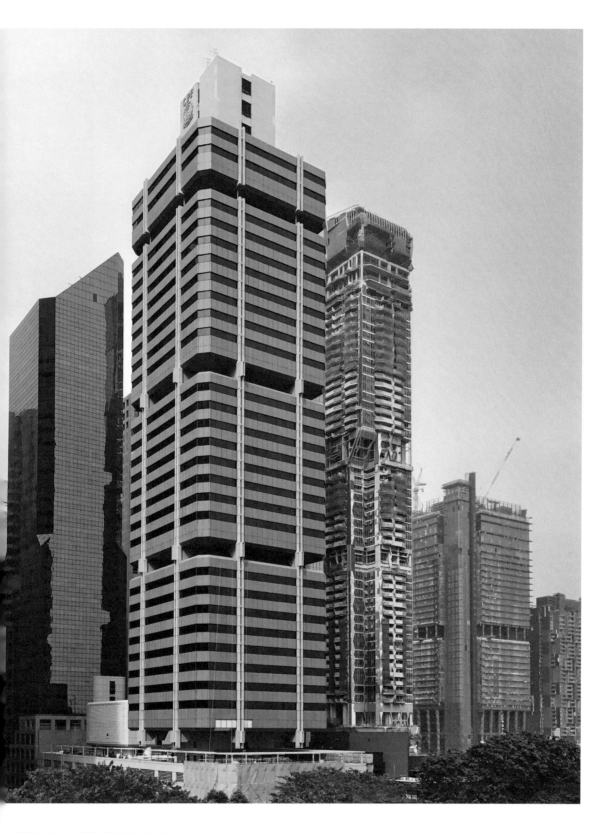

CPF Building (1977–2017), Public Works Department.

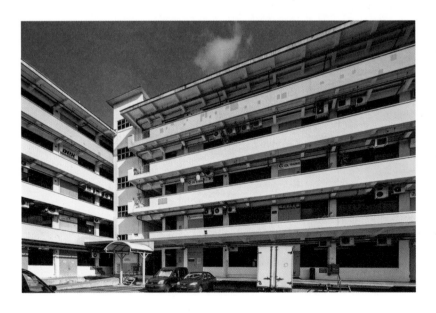

Blk 115 at Tanglin Halt (1965), Economic Development Board.

Cintech I (c. 1987), Jurong Town Corporation.

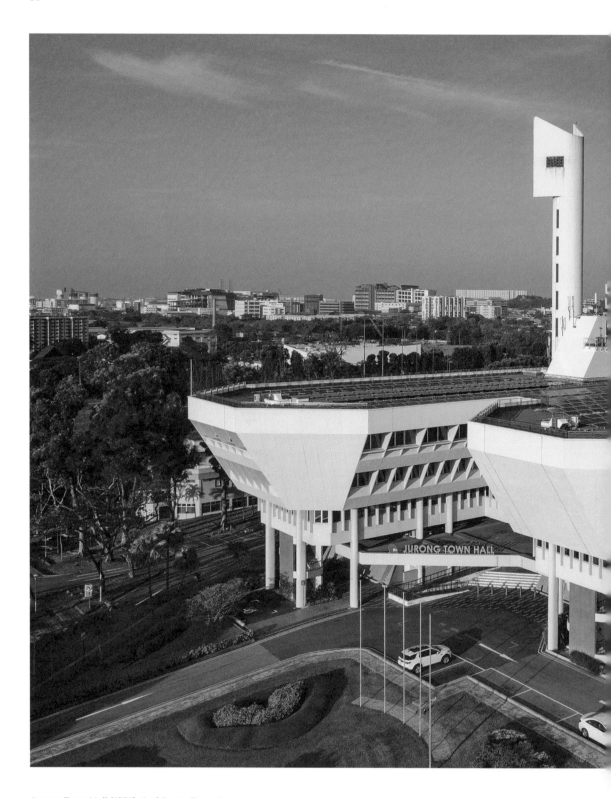

Jurong Town Hall (1974), Architects Team 3.

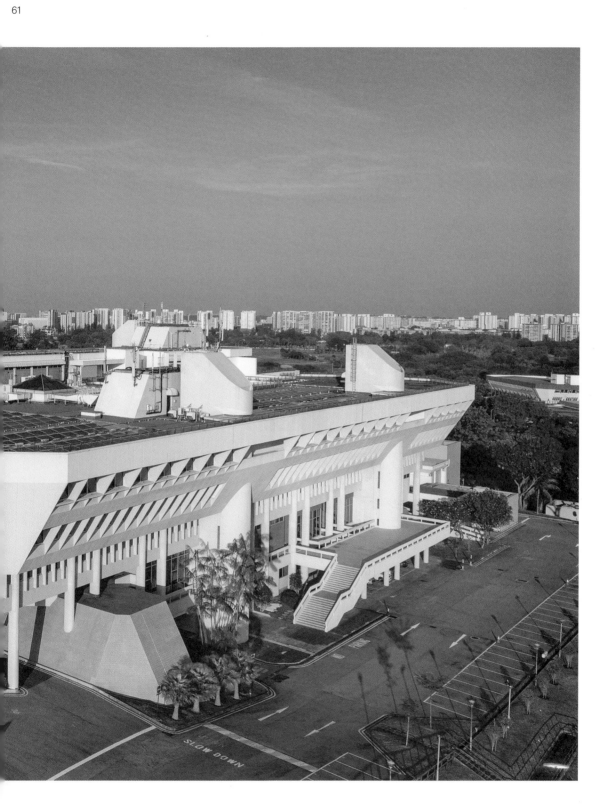

Interior of Jurong Town Hall.

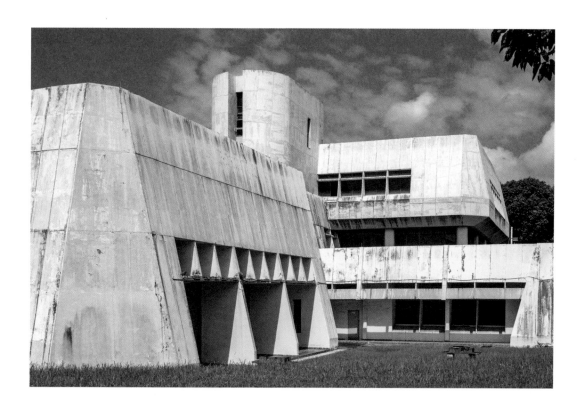

Former French-Singapore Institute (1983), Jurong Town Corporation.

TABLE OF CONTENTS

TRAVEL

CONNECT

PRAY

Introduction

Everyday Modernism:

The Singapore Vernacular

Like over 80 per cent of Singapore's resident population, all three of us—Jiat-Hwee, Justin, and Darren—live in public housing flats. And like everyone who grew up in the city-state since the 1970s, we are surrounded by, and our lives are enacted in, a built environment that is utterly modernist. Besides public housing—all of which are modernist and mostly planned and designed by the state agency, the Housing & Development Board (HDB)—we socialise with others in modern markets, hawker centres, schools, public libraries and community centres. We spend our leisure time in modern shopping malls, swimming pools, playgrounds and parks. We work in modern office towers and high-rise flatted factories, and some of us even pray in modern religious buildings. Getting around Singapore also means travelling via public transport interchanges, expressways and pedestrian overhead bridges—all designed based on modern transportation planning principles. When we die, we, or what remains of us, are just as likely to reside in modern high-density, space-saving columbaria that have displaced cemeteries in the city.

The quotidian and taken-for-granted modernist built environment that surrounds and structures our everyday lives in Singapore—or what we call "everyday modernism"—is the subject of this book. Everyday modernism is not just about the built environment. It is also deeply entangled with our social, political, economic and cultural processes of modernisation and conditions of modernities. As a concept, it is both specific and general. While "everyday modernism" arose from our study of the built environment in Singapore, it is also a broad reworking and reframing of existing architectural and urban theories.

TRANSCENDING THE "EVERYDAY"

The word "everyday" appears straightforward and self-evident, but its use in the field of architecture has always been a part of what architectural historian Dell Upton describes as a "dichotomous and hierarchical thinking about the landscape".[1] Everyday architecture is traditionally seen in opposition to Architecture with a capital "A". While the latter refers to the formal works by professional architects, the former describes non-pedigreed vernacular structures by anonymous builders. Or as another architectural historian Nikolaus Pevsner has characterised as simply the utilitarian structure of the bicycle shed

that is distinct from the aesthetic achievement of the Lincoln Cathedral in England.[2] Even when architects, designers and planners began to appreciate, rather than dismiss, everyday architecture, they simply inverted the hierarchy while leaving the dichotomy intact. The pioneers of postmodern architecture, Robert Venturi and Denise Scott Brown, for example, hailed the pop aesthetics of Main Street and Las Vegas in the United States while criticising high modernism.[3] Other scholars have also followed the trail blazed by urban theorist Margaret Crawford in drawing from French theorists Henri Lefebvre and Michel de Certeau to celebrate the lived spaces and grounded practices of everyday urbanism against the abstract spaces planned and imposed by experts, bureaucrats and capitalists.[4]

Such hierarchical dichotomy exists in the discussions of Singapore's largely modernist built environment too. In the realm of "Architecture", scholars, writers, photographers and the architecture fraternity have singled out exemplary modernist buildings such as the National Theatre (1963–1986) by Alfred Wong Partnership; Singapore Conference Hall and Trade Union House (1965) by Malayan Architects Co-partnership; People's Park Complex (1973) and Golden Mile Complex (1972-3) by Design Partnership; Jurong Town Hall (1974) by Architects Team 3; and Pearl Bank Apartments (1976) by Archurban Architects Planners.[5] They are typically celebrated by acclaiming the creativity of their architects as is the tendency of traditional architectural historiography.[6] The architects involved helmed private practices and they included notable figures such as Lim Chong Keat, Alfred Wong, William S. W. Lim, Tay Kheng Soon and Tan.[7] All who have been recognised for their lifetime achievements by either the city's professional body for architects, the Singapore Institute of Architects, or national agencies in charge of promoting architecture and design such as the DesignSingapore Council.[8] In this book, we call these exemplary post-independence buildings "heroic modernism" for two reasons. First, they were built during what Alfred Wong characterised as the "heroic period" for the local architectural profession, when its members were entrusted with designing the major projects that laid the foundation for the rapid socio-economic developments of the new nation.[9] Second, we use "heroic" to evoke the

formal inventiveness, bold visions and the can-do spirit of the architects that designed them.[10]

Singapore's built environment also consists of ordinary modern designs, such as public housing, markets, hawker centres, swimming pools, public parks, schools, libraries, community centres and factories. These make up much of the city-state's everyday environment and are often taken for granted and seldom acclaimed. It perhaps reflects how architectural discourse privileges the extraordinary over the ordinary, which is so ubiquitous that it seems unworthy of scholarly attention. The neglect may be due to the absence of conventional design authorship too. Unlike heroic modernism, which was by architects in private practice, these everyday modern structures and buildings in Singapore were planned and designed to a great extent by those working in government agencies such as the HDB, Public Works Department (PWD) and Jurong Town Corporation (JTC). These organisations' ethos of subsuming the individual under the collective means that such built works tend not to be attributed to any specific architect.

The dichotomous and hierarchical thinking about modernism in Singapore, however, does not hold up to scrutiny. For instance, the divide between architects working in private practice and those in state agencies is not rigid and impermeable. Not only did many architects go from working in the public sector to running their own private practices,[11] both sides have also collaborated to design various public buildings over the decades under diverse circumstances. Several heroic modernist buildings, such as the National Theatre, Singapore Conference Hall and Trade Union House and Jurong Town Hall, while owned by the state, were commissioned through competitions for architects in private practice to solicit the best designs and help build local capacity simultaneously. Many privately owned modernist buildings were also built on land sold by the government as part of its sale of sites programme, including the People's Park Complex, Golden Mile Complex, and Pearl Bank Apartments. In other words, they were made possible by an urban renewal programme carefully coordinated and implemented by the state. Beyond such collaborations, exemplary examples of heroic modernism have also shaped its ordinary brethren, as seen in the string of brutalist buildings that came up around

Jurong Town Hall after its completion. (see Jurong Town Hall Road) Everyday modernism to us combines the heroic with the ordinary and the iconic with the inconspicuous. Whatever their spatial and formal attributes, provenance and authorship, these modernist buildings affect while being affected by the conduct of our everyday lives. Everyday modernism is both the outcome and the vehicle for socio-economic development, modernisation and nation-building in Singapore.

MODERNISM AND THE DEVELOPMENTAL STATE

Modernism arrived in Singapore during the early 20th century with colonial entrepôt capitalism, and it developed further with colonial social welfare programmes such as the construction of public housing and schools.[12] However, it was only with the decolonisation of Singapore that modernism brought about large-scale territorial and built environmental transformations on the island. Amidst a politically turbulent and socially unstable period characterised by labour strikes and political unrest, Singapore attained self-government from the British in 1959. The newly independent government led by the People's Action Party (PAP) adopted new strategies to address the crises—including turning to export-oriented industrialisation, stabilising industrial relations and disciplining the labour force, among others—to create social stability and economic growth. These strategies became even more crucial after Singapore's 1963 merger with Malaysia fell apart two years later. The resulting loss of its hinterland due to the separation called into question Singapore's prospects as an independent nation.[13]

The PAP government pressed on with rolling out massive socio-economic development programmes that dwarfed prior changes even as there were continuities in the forms and norms of modernisation.[14] The state subsidised the construction of many social and physical infrastructures to attract investors to support an industrialisation programme. While the social infrastructure allowed Singapore to provide low-cost and high-quality labour, the physical developments provided savings in the investors' establishment and operation costs.[15] State agencies known as statutory boards were specifically established to expedite the comprehensive planning and implementation of these projects.

Among the first three statutory boards established after Singapore gained self-government in 1959 were the Economic Development Board (EDB) and HDB to promote industrial development and provide low-cost public housing respectively. Their early establishment showed that mass housing and urban development were closely tied to economic development and industrialisation. One of EDB's earliest projects was to plan and build Singapore's main industrial estate, Jurong Town, for the many factories and plants it was attracting industrialists to open. More than a home for factories, the envisioned "garden industrial town" also had a significant residential component and a variety of social and recreational amenities such as the Jurong Bird Park, Jurong Drive-in Cinema and the Jurong Park Complex comprising of the Chinese and the Japanese Gardens.[16] By 1968, the JTC was established to take over from EDB as "the work associated with the management and the development [of Jurong Town] have [sic] become so large and complex".[17]

While EDB and JTC developed industrial spaces, HDB focused on mass housing and built upon the work of its colonial predecessor, the Singapore Improvement Trust (SIT). The SIT had cumulatively produced 23,000 flats or 10 per cent of the city's housing stock by 1958, a figure that architectural historian Miles Glendinning considered as "virtually unprecedented within any European colonial territory".[18] However, Singapore still faced a dire housing landscape characterised by an inner city of congested shophouses encircled by insanitary kampongs around the urban fringes.[19] The HDB began building public housing at a rate much greater than the SIT, but it did not significantly deviate from previous planning and design norms at first. One of the earliest types of housing that HDB developed for the victims of the 1961 Bukit Ho Swee fire and to resettle kampong "squatters"[20] was "emergency housing", a typology established by the SIT. The HDB also continued developing Queenstown, which was first planned by SIT as Singapore's first self-sufficient "satellite town"[21]. However, HDB doubled the projected capacity of the town to house some 150,000 residents to better meet the needs of Singapore's rapidly growing population. It was achieved by adding two more neighbourhoods to the five originally planned and increasing the population density of each.[22]

NEW TOWNS AND MODERN LIVING

Queenstown was Singapore's earliest experiment in decentralisation and self-sufficiency. It helped move the population out of the congested city centre and into what was envisioned as "a self-contained and balanced community"[23] served by an array of commercial, educational, recreational, religious and even industrial facilities—making Queenstown "quite independent of the City proper".[24] The amenities included many firsts in Singapore: the first full-time branch of the National Library (see *Public Libraries*), the first sports complex in a public housing estate and the first flatted factory. (see *Industrial Spaces*) Queenstown also consisted of a mix of standardised building designs, such as its public housing blocks (see *Public Housing*) and schools (see *Public Schools*), as well as one-offs like the iconic Blessed Sacrament Church, (see *Churches*) Mujahidin Mosque (see *Darul Aman Mosque*) and Queenstown Cinema and Bowling Centre. (see *Cinemas*) The array of buildings were the works of HDB as well as private architectural firms like Iversen Van Sitteren and Partners and Chee Soon Wah Chartered Architects. Another government agency involved in Queenstown was the PWD, a former colonial institution that was instrumental in the early development of Singapore and continued to be so after independence when it became a government agency.[25] It was responsible for the planning and construction of public buildings like schools and libraries, as well as infrastructures such as roads, bus shelters, drains and sewerage systems across the nation, including in public housing estates.

A common denominator of all the buildings developed in Queenstown was their modernist design, which were strikingly different from the shophouses and urban kampong houses that made up Singapore's traditional built environment. This was similar in many developing nations in the mid 20th century, which used modernism as an instrument for rapid social transformations.[26] In his seminal work *The Modernist City*, anthropologist James Holston argued that the use of architectural aesthetics and planning techniques that were radically different from those of the past was key to achieving such accelerated transformations.[27] Compared to past low-rise housing, HDB apartment towers were massive both in terms of height and their sheer number of units. They also stood out with their rectilinear forms and plain surfaces, offering residents flats with new kinds of layouts and spatial configurations. Modernist new towns such as Queenstown inverted the figure-ground relationship of traditional cities too. They had no streets and squares, and the sense of open spaces and enclosures was also unlike shophouse districts and urban kampongs. The distinction was even more pronounced in HDB's next satellite town, Toa Payoh, which was the first to be fully developed by the agency. It accommodated twice the population of Queenstown with what was regarded at that time as an "extremely high density" estate of 500 persons per acre.[28] The residents were spread across four neighbourhoods of housing estates that were organised around the town centre and connected via a circular road system. The town centre was designed as a pedestrianised mall and lined with four-storey developments with ground floor shops and flats above, reminiscent of traditional shophouses.[29] Anchoring the nodes of the L-shaped mall were large squares, key public buildings such as a library, and four towering apartment blocks to guide pedestrians in the town centre and welcome approaching vehicles.[30] Next to Toa Payoh town centre was also a recreational belt consisting of a 4.8-hectare garden, a 2-hectare swimming complex as well as a 3,000-seat sports stadium.

Toa Payoh exemplified HDB's "neighbourhood principle" of planning where the resident population is organised to support the provision of various amenities. The "town centre" is where major facilities that require a larger population size to be viable are located, and it is supported by "neighbourhood centres" and "neighbourhood sub-centres" that cater to smaller groups of residents. The apartment blocks are organised around these three centres of activity, and they ideally should be within walking distance of at least one to create a "neighbourhood of convenience". The comprehensively planned modern environment of Toa Payoh became the model for subsequent HDB new towns developed in the mid to late 1970s, such as Woodlands, Ang Mo Kio, Bedok, Clementi and Jurong West.[31] They utterly restructured everyday lives in Singapore as HDB public housing became the prevailing living environment. New towns contained a significant proportion of the architecture of everyday modernism, which served as a social

infrastructure too. They were made up of public housing and facilities such as hawker centres, markets, polyclinics, schools, community centres, parks, sports complexes and even playgrounds, in which the state subsidised housing, healthcare, education, recreation and other social services. Such developments can be regarded as an integral part of what sociologist Manuel Castells and colleagues called the "*sui generis* welfare state" of Singapore.[32] Indeed, the government spent 40 per cent of its expenditure on social development and welfare in the early 1960s.[33] Low-cost public housing and the various amenities provided in new towns served as what some scholars called wage subsidy, ensuring that many Singaporeans could attain a fairly high standard of living despite the relatively low wages in the 1960s and 1970s. Furthermore, having to pay regular rent and mortgages also encouraged public housing residents to become disciplined wage labourers. Taken together, the building of new towns and public housing served as an important foundation for Singapore's rapid industrialisation and accelerated socio-economic development from the 1960s.

DEVELOPING AN "INTEGRATED URBAN ENTITY"

The rise of new towns across Singapore was aided by the finalisation of the First Concept Plan in 1971. The plan established a "new town" prototype model and shows the inextricable relationship between housing and urbanisation in Singapore.[34] New towns like Queenstown and Toa Payoh allowed the government to resettle the population that previously resided in the overcrowded slums of the inner city and squatters at the urban fringes. The completion of a certain quantity of public housing was thus an "essential ingredient"[35] for launching an urban renewal programme that only began around the completion of HDB's first five-year building programme in 1965.

The Concept Plan embraced a radically different planning approach from an earlier masterplan drawn up by the colonial government for Singapore in 1955. The latter proposed dividing the main island into central, urban and rural planning districts,[36] which was later criticised by United Nations (UN) appointed planner Erik Lorange when he visited Singapore in 1962 to advise on its planning. Lorange argued that the colonial masterplan's proposal for the city centre had "a somewhat passive acceptance of existing conditions" that suggested "a general reluctance to believe at all in the feasibility of accomplishing schemes of any bolder cast".[37] In witnessing the beginning of the post-independence government's robust response to housing shortages, Lorange felt that the masterplan could take on "a more comprehensive and radical approach".[38] This arrived in 1963 when another team of UN experts, Charles Abram, Susumu Kobe and Otto Koenigsberger, visited the city to advise on "the establishment of a comprehensive physical plan for the development of Singapore".[39] The trio also felt that the 1955 masterplan underestimated population growth and criticised its proposed radial growth pattern for being overly conservative, outdated (as "[r]adial growth belongs to the pre-motorcar age"), and "unsuitable for a modern metropolis".[40] They eventually drew up a diagrammatic plan that treated the whole island as a single integrated urban entity and served as a "guiding concept" for Singapore's urban development. Known as "Ring City Singapore", the sketch plan consists "a chain or necklace of [coastal] settlements around a central open area" that includes a nature reserve, two airports at Paya Lebar and Tengah, and other green spaces for recreational, agricultural and infrastructural uses.[41] It became the basis of the First Concept Plan drawn up by the government-appointed State and City Planning (SCP) team established in 1967.[42] In the Concept Plan, the ring became smaller and further away from the coasts. It also intersects with an east–west corridor of development on the south of the island.[43]

Singapore's approach to urban renewal, however, turned out to be even more radical than what the UN team recommended. For instance, the latter explicitly "rejected the idea of the wholesale demolition of large quarters" and articulated the principles of urban renewal in Singapore as a combination of conservation, rehabilitation and rebuilding.[44] However, conservation was largely ignored until the 1980s. A tabula rasa approach of demolition and rebuilding to urban renewal was adopted instead, due to land use constraints and development considerations during Singapore's early nationhood. When the government launched its

sale of sites programme in 1967, for instance, it included many parcels of land that were amalgamated from small plots compulsorily acquired by the state.[45] These were created by the Urban Redevelopment Department (URD), which demolished shophouses previously standing on these plots, provided the necessary urban infrastructure for immediate development, and came up with design and planning guidelines on the type and intensity of development. For the first three sales in 1967, 1969 and 1970, the URD even provided fairly detailed designs for the proposed developments.[46] They were always modernist and often came in the new form of high-rise podium-tower blocks, which signalled the beginning of an industrialised economy and contrasted against the existing low-rise environment. URD's sale of sites programmes ultimately gave birth to modern high-rise typologies for offices, hotels, private residences and mixed-use complexes to serve the different sectors of Singapore's emerging new economy.[47] The first three sales, for instance, led to the earliest office towers on Shenton Way, (see Shenton Way) mixed-use complexes such as the People's Park Complex (see Shopping Centres) and Golden Mile Complex and high-density residential towers like Pearl Bank Apartments.

What is also notable about URD was that it started out as a department within the HDB before it was restructured into a statutory board renamed as the Urban Redevelopment Authority (URA) in 1974. Whether it was urbanisation or constructing public housing, both URA's and HDB's efforts were enabled by the same mechanism of land acquisition that accelerated urban development in the post-independence years. The Land Acquisition Act of 1966 replaced a former colonial-era ordinance to give the government greater powers to acquire land at low cost in order to build affordable public housing and infrastructure projects. Thus, public agencies could acquire land compulsorily at minimal compensation from private landowners and carry out urban development that served the greater public good.[48] Some analysts have argued that this was crucial for the developmental state, whose raison d'être was to intervene to promote industrialisation and social developments that were essential for economic growth.[49] It most certainly empowered state entities such as the HDB, URA, JTC and PWD to

remake Singapore into a comprehensively planned modernist built environment, which we seek to illustrate in our book.

LIVING WITH MODERNISM

As with many modernist planning and architectural schemes, Singapore's housing and urbanisation schemes from the 1960s and 1970s can be seen as a part of what political scientist James Scott famously conceptualised as the "high modernist" ideology of the state.[50] He characterised such schemes as having formal order that was equated with functional order; monofunctional zoning and narrow criteria of efficiency; and a root-and-branch (or tabula rasa) approach to urban planning.[51] Indeed, post-independence Singapore's preoccupation with economic growth and modernisation, while also working with limited resources and capital then, prioritised efficiency, low-cost and functionality in its criteria for design and planning. State agencies also produced designs that were premised on various rationales of optimisation and forms of standardisation. Thus, the modernist built environment that emerged in Singapore simplified and reduced the complex social and natural world in a manner that Scott theorised as prone to fail.

Yet, such top-down, high modernist schemes did not fail in Singapore. There could be many reasons behind the failure of an architectural or urban scheme and it is often too simplistic to attribute any failure solely to the design and ignore the social and economic conditions.[52] In the case of Singapore, its modernist public housing and urban planning have been widely lauded and hailed as a success, including recognition by United Nation's World Habitat Award.[53] The concurrence of the three of us who live in public housing and choose to write a book about it is of course also an indication—albeit a minor one—of its success. Our book, however, is not interested in rehashing these conventional indicators of successes. Rather, we would like to move beyond production-centric accounts of architecture and focus on their mediation, reception and consumption to help us better understand the impact of modernism in Singapore.[54]

One approach is to understand modern architecture from the perspective of the user, who is neither a universal or undifferentiated category but a socio-historically constituted entity.[55] From

that perspective, one can begin to see how the use of a building is a set of situated practices that particularises the universal and localises the global. Likewise, a building can be used beyond what is prescribed and intended by the designers and authorities.[56] It also has affordances, or latent functions and meanings, that might deviate from or even subvert the original intended use. Affordances are often manifold, and they unfold in multidirectional ways.[57] Seen together with the user as not a passive recipient but an active agent of change, one can imagine how they come together to transform a design. As architectural historian and theorist Kenny Cupers points out, focusing on use helps us construct "an alternative history of architecture", one that is more "relational" and "connects the accounts of architects, projects, and ideas with a larger social, spatial, and material history".[58]

In architecture, use is often equated with various modes of inhabitation. The differences and dissonances between architectural production and consumption or intended use and actual use are also attributed to the gaps between these two conceptions of space. On the one hand, there is the abstract space of modernism planned and intended by state, capital and their appointed experts. On the other hand, there are the lived spaces emerging through everyday practices. The distinctions between them, however, are not just down to their dissimilar conceptions. They can also be attributed to how spatial and temporal dimensions of architecture interact, notes writer Stewart Brand,

> [t]he word 'building' contains the double reality. It means both 'the action of the verb BUILD' and 'that which is built'—both verb and noun, both action and result. Whereas 'architecture' may strive to be permanent, a 'building' is always building and rebuilding. The idea is crystalline, the fact fluid.[59]

Architectural historian and theorist Hannah le Roux has showed how modernist buildings are evolving entities, constantly being used and reused, designed and modified through what she calls "occupation".[60] Le Roux further argued that the minimal and abstract forms of modernist buildings are supportive of changes as they have many potentialities for different

kinds of social lives. In other words, modernist buildings are not products of reductive abstraction and thus alienating environments, as observed by many critics, but are polyvalent minimal artefacts pregnant with multiple latent uses and meanings. Le Roux described this understanding of modernism that challenged the abstract-lived spatial bifurcation as "porous modernism". Although her observations and arguments stemmed from African contexts, we also see this "porous modernism" in Singapore. This multivalent porosity is evident in Singapore's public housing, which has received the most scholarly attention. Sociologist Chua Beng Huat, for example, has shown that the void decks of HDB flats accommodated different users and uses, many unexpected by the planners. They include the daily gatherings of residents to the less frequent use for Chinese funeral wakes and Malay wedding receptions. While void decks have designated uses like bicycle parking, there are also misuses like skateboarding and playing football, which are explicitly banned.[61] Other than the public spaces, the private interior spaces of the HDB flats were also built with basic fixtures and finishes so that the residents, most of whom own their flats, could adjust the layouts and renovate the spaces to suit their own needs and tastes.[62] In addition to supporting different uses and their social lives, accommodating physical changes and individual expressions, modernist buildings in Singapore have also been adapted and appropriated in other ways to become the city-state's vernacular. Our notion of "everyday modernism" is an attempt to encapsulate such lived and vernacular dimensions. While covering the movement's more familiar associations with the developmental state in Singapore, we also look at the "afterlives" of its buildings.

THE LIVES AND DEATHS OF BUILDINGS

By the "afterlife" of a building, we are referring to what happens after the presumed "completion" of a building in conventional architectural understanding. This refers to it being constructed, which roughly coincides with when a building is opened for use and begins to develop a social life. One way to explore the temporal dimensions of a building—its various lives from commission to construction, from "completion" to demolition—is through writing a

building biography. This method developed by historian Neil Harris and refined by geographers Donald McNeill and Kim McNamara, goes beyond the limited understanding of a building as a static and autonomous object frozen in time. Instead, it captures the building's various stages of existence and how it is a dynamic entity intimately bound up with wider social, cultural, economic and political processes.[63]

A building biography might reveal that the fate of a building is tied up with the economic reality of it being a real estate asset planned, designed and built based on specific financial calculus; appreciating and depreciating with time, shifting norms and boom-and-bust cycles.[64] Or it might disclose how maintenance and repair are essential in preventing a building's rapid descent into obsolescence or at least slowing its decay from use and weathering over time.[65] Obsolescence is not just down to the physical or material properties of a building. It is perceived as much as it is real, strongly influenced by a "social process of endowment" as architect Jeremy Till has argued using sociologist Michael Thompson's "rubbish theory".[66] The value we attribute to all artefacts, including buildings, is socially malleable. Besides having economic values as real estate assets, buildings also have socio-cultural values. Our judgement of whether a building is beautiful or ugly often depends on the social construction of taste. The way we assign cultural significance to a building also depends on who and what kind of events are associated with it and how the association is made.

As cultural anthropologist Igor Kopytoff noted in his seminal essay "The Cultural Biography of Things", every artefact moves in and out of the two polarities of commoditisation and singularisation. But some are precluded from commoditisation, that is "partak[ing] in a single universe of comparable values" that homogenises value and facilitates exchange, by being marked as uncommon and incomparable, that is singularised and thus without equivalence in value.[67] Kopytoff argued that such a designation or classification of an artefact is based on a cultural response. While uncommon, it is not inevitable that an ageing building with declining real estate value must slip into obsolescence and be demolished or redeveloped. That building could potentially

be socially endowed with certain value and thus be deemed worthy of conservation for posterity. After which its economic value might even appreciate. The maintenance and repair work necessary to prolong the life and maintain the value of a building requires both the commitment of financial resources and a socio-cultural reorientation towards what STS (science, technology and society) scholar Steven J. Jackson calls "broken world thinking", which takes the fragility of our socio-natural world seriously and sees the acts of maintenance and repair as being critical.[68]

Several modernist buildings discussed in our book are under the threat of demolition due to poor maintenance and inadequate repair. This has also affected their social perception. Although the Golden Mile Complex was recently gazetted for conservation, it was once called a "vertical slum" by a nominated member of parliament.[69] Its neglect partly stems from the building owners' unwillingness to spend on what they perceive to be an ageing and depreciating real estate asset, which only exacerbates physical decline and the social stereotype. In most cases, this vicious cycle would lead to such privately owned strata-titled buildings in Singapore being put up for collective sale and redevelopment— often giving its multiple owners each a tidy profit. Such was the case in Pearl Bank Apartments, which was sold, demolished and, at the time of writing, was being redeveloped into another condominium, barely four decades after its completion.[70] (see *Pearl Bank Apartments*)

In contrast, many state-owned modernist buildings are still in use or have been adapted for new uses. One reason is they are overseen by state agencies, such as the HDB, the SLA (Singapore Land Authority), and the Town Councils, which are known for their rigorous maintenance regimes of properties under their charge.[71] HDB in particular is committed to the repair and maintenance of public housing from the outset so as to make high-rise, high-density living acceptable to the Singaporean population.[72] Over the decades, it has retrofitted and improved most of its older public housing in what are known as "upgrading programmes" that are subsidised by the state.[73] As a result, many HDB flats have not encountered similar issues of physical decay and social stigmatisation despite their identical typology and construction with

various privately owned strata-titled modernist buildings, many of which are even younger. Even buildings executed in the same architectural style can elicit very different responses due to their state of upkeep. For instance, the negative public perceptions of Pearl Bank Apartments, Golden Mile Complex and People's Park Complex are frequently attributed to their brutalist aesthetics. It is what purportedly renders these buildings "brutal" and turns them into eyesores,[74] even though brutalism's etymological origins is in *béton brute*, the French words for "raw concrete", rather than the literal association with harshness and crudeness. Yet, well-maintained state-owned buildings with the same brutalist aesthetics, like the Jurong Town Hall and the former Subordinate Courts (see *Institutional Buildings*), do not prompt similar negative associations at all.

The continual maintenance of a building or letting it deteriorate for eventual demolition are just two ends of a spectrum in dealing with temporal changes in a building. Our book explores a whole gradation of other types of changes in physical structure, use and perception in Singapore. For instance, many ageing modernist strata-titled buildings that are not well regarded by the mainstream society have attracted shops and services catering to the various marginalised migrant communities in Singapore due to their low rent. Among the well-known examples are Golden Mile Complex for the Thai community, Peninsula Plaza for the Burmese community, and Lucky Plaza for the Filipino community.(see *Lucky Plaza*) While these building's users, including owners, tenants and visitors might have changed, their function have remained largely the same—as mixed-use complexes with shops in the podium. In other modernist buildings, both the function and users have changed dramatically even if the structures remained mostly unaltered. For instance, a flatted factory has been turned into a furniture showroom in Tan Boon Liat Building (see *Tan Boon Liat Building*) and a cinema converted to a church in The Metropole. (see *Cinema-Churches*) In this book, the different types of building biographies are not just documented in words. They are also recorded in images—both archival images and new photographs by Darren. The book is therefore both a textual and visual biographical record of everyday modernism in Singapore.

EXPANDING MODERNISM INTO THE EVERYDAY

The complex relationship between the form of a building and its use, or its morphology and function, are captured by the word "type" in architectural discourse. Type can be used to refer to either form or use, but it often combines both senses.[75] Such flexibility and complexity define the organising principle of our book. Instead of conventional building types, we use six key verbs—live, play, work, connect, travel and pray—to capture the rich interplay between forms and uses. Each verb heading introduces essays that use a combination of building biographies and biographies of building types to tell socio-cultural histories and reveal more about Singapore society. The essays cover building types that are typical (that is, widely replicated) and those that are exceptional, and also discusses how some of the buildings slipped in and out of types through changes in form and use. Our focus on types also hints at the standardised types that were produced by state agencies for housing, schools and factories, such that a single design could be replicated many times to speed up the process of design and construction. Some of these standardised types exist in the sub- or supra-building scales too and are more infrastructure than buildings. Among those featured are multi-storey car parks (see *Market Street Car Park*), pedestrian overhead bridges (see *Pedestrian Overhead Bridges*), public transport interchanges (see *Interchanges*) and expressways. (see *Pan-Island Expressway*) Type could also be used to refer to the ownership structure or the urban development model of a building, such as the strata-titled property and the condominium. (see *Pandan Valley*)

In all, the book has 32 illustrated essays covering a broad spectrum of buildings and types that cut across Singapore's colonial and post-independence periods. The bulk of it focuses on buildings and landscapes planned and built during the era of rapid socio-economic modernisation and nation-building in the 1960s and 1970s, but we also extend into the earlier period of colonial modernity between the 1930s and 1950s, as well as the era of late capitalism in the 1980s. The expanded timeframe allows us to better understand the dramatic modernisation of Singapore in the 1960s and 1970s from a longer historical perspective and in relation to earlier precedents. In so doing, the essays end up

discussing a wider range of modernist aesthetics beyond modernism and brutalism to include art deco and postmodernism. They also widen the scope to a larger network of architects, firms and agencies that were vital to city-state's modernism, yet largely remain unknown. We seek to uncover both the pioneering examples and the exemplary precursors—many of which are forgotten—and to connect them to today's ubiquitous architectural and planning concepts and typologies. We also try to link to similar buildings and ideas both locally and internationally as modernism was very much a global project too.

Our broad scope and multiple authorship have inevitably resulted in a slightly heterogenous focus and tone. While the essays primarily focus on building biographies and the social aspects of architecture, we also strive to engage in formal and spatial descriptions of buildings, unavoidably entailing the use of some specialist language. Nonetheless, this book is not intended to be *the* comprehensive history of modernism in Singapore. In fact, we intentionally leave out several well-known examples that have been extensively documented elsewhere—most notably the Singapore Conference Hall and Trade Union House, National Stadium and National Theatre—to make room for lesser-known ones. Our book is certainly not the first nor will it be the last on architectural modernism in Singapore. The rapid loss of such built heritage in Singapore in recent years has sparked action to protect it. Civil society groups such as the Singapore Heritage Society and Docomomo (Documentation and Conservation of the Modern Movement) Singapore have mobilised to document these buildings and advocate for their conservation.[76] These groups and individuals have put out publications and organised events, including forums, conferences and exhibitions to raise public awareness and as attempts to further endow these modernist buildings with social meanings and significance.[77] In recent years, the state has begun conserving such buildings, most notably the Singapore Conference Hall and Trade Union House, Jurong Town Hall and the former Subordinate Courts.[78] In October 2021, the Golden Mile Complex was also gazetted for conservation, setting an important precedent for other privately owned heroic modernist buildings.[79] Works by heritage groups such as

My Community have also contributed to saving modernist buildings from the wrecking ball.[80] Active in Queenstown since 2010, the group's advocacy for Singapore's oldest new town has contributed to the conservation of two modernist buildings in the town centre that is undergoing redevelopment, the creation of a heritage plan for the town, and even the setting up of an independent community museum.[81]

We hope *Everyday Modernism* offers a useful reference for this growing conversation. It can also serve as a resource for understanding how Singapore's reputation as a modern global city today was built upon the progressive ideals and ideas of those who came before. Most important-ly, we hope it would stimulate further interest and research into modernism in the city-state and make the modern environment we live in a larger part of our everyday conversations.

Notes

1 Dell Upton, "Architecture in Everyday Life," *New Literary History* 33, no. 4 (2002): 708.
2 Bernard Rudofsky, *Architecture without Architects: A Short Introduction to Non-Pedigreed Architecture* (New York: Doubleday, 1964); Nikolaus Pevsner, *An Outline of European Architecture* (London: Penguin Books, 1972).
3 Robert Venturi, Denise Scott Brown, and Steven Izenour, *Learning from Las Vegas* (Cambridge, MA: MIT Press, 1972).
4 Margaret Crawford, "Introduction," in *Everyday Urbanism*, ed. John Chase, Margaret Crawford, and John Kaliski (New York: Monacelli Press, 1999); Nihal Perera, *People's Spaces: Coping, Familiarising, Creating* (New York: Routledge, 2016). The theorising of the everyday by Lefebvre and de Certeau is not without problem as they tend to embrace the ordinary and the banal only to see it as necessitating an aesthetic transfiguration in order to redeem it. See Rita Felski, "Introduction," *New Literary History* 33, no. 4 (2002): 607–22.
5 See, for example, Ho Weng Hin, Dinesh Naidu, and Tan Kar Lin, *Our Modern Past: A Visual Survey of Singapore Architecture, 1920s–1970s* (Singapore: Singapore Heritage Society and SIA Press, 2015); Wong Yunn Chii, *Singapore 1:1 City: A Gallery of Architecture and Urban Design* (Singapore: Urban Redevelopment Authority, 2007); Lai Chee Kien, Koh Hong Teng, and Yeo Chuan, *Building Memories: People, Architecture, Independence* (Singapore: Achates 360, 2016).
6 This characterisation of the traditional architectural historiography is made in C. Greig Crysler, *Writing Spaces: Discourses of Architecture, Urbanism, and the Built Environment, 1960–2000* (New York: Routledge, 2003), 37.

7 Many of these architects have written about their design considerations and processes behind these buildings, making their design authorship explicit. See, for example, Alfred Hong Kwok Wong, *Recollections of Life in an Accidental Nation* (Singapore: Select Books, 2016); Robert Powell and Tay Kheng Soon, *Line, Edge & Shade: The Search for a Design Language in Tropical Asia* (Singapore: Page One Pub., 1997); Lim Chong Keat, "The International Context for Southeast Asian Architecture," in *Architecture and Identity: Proceedings of the Regional Seminar,* ed. Robert Powell (Singapore: Aga Khan Award for Architecture, Concept Media, 1983).

8 Alfred Wong, Tay Kheng Soon, Lim Chong Keat and William Lim were awarded the Singapore Institute of Architects' Gold Medal in 1998, 2010, 2015 and 2017 respectively. Tan Cheng Siong received the President's Design Award Designer of the Year in 2012 from the DesignSingapore Council.

9 Alfred H. K. Wong, "A Brief Review of Our Recent Architectural History," in *Contemporary Singapore Architecture*, ed. Singapore Institute of Architects (Singapore: Singapore Institute of Architects, 1998), 252.

10 This use of "heroic" draws from a book on the iconic brutalist structures in Boston. See Mark Pasnik, Michael Kubo, and Chris Grimley, eds., *Heroic: Concrete Architecture and the New Boston* (New York: The Monacelli Press, 2015).

11 Prominent examples include Liu Thai Ker, Ng Kheng Lau, Yip Yuen Hong and Yap Mong Lin.

12 For the architecture of late-colonial social welfare programmes, see Dale Cuthbertson, "The Singapore Education Plan," *The Quarterly Journal of the Institute of Architects of Malaya* 1, no. 3 (1951): 31–48; K. A. Brundle, "The Singapore Medical Plan," *The Quarterly Journal of the Institute of Architects of Malaya* 2, no. 2 (1952): 29–47; Stanley Woolmer, "The Work of the Singapore Improvement Trust," *The Quarterly Journal of the Institute of Architects of Malaya* 3, no. 2 (1953): 47–68.

13 Ole Johan Dale, *Urban Planning in Singapore: The Transformation of a City* (Shah Alam: Oxford University Press, 1999).

14 Rodolphe De Koninck, Marc Girard, and Thanh Hai Pham, *Singapore's Permanent Territorial Revolution: 50 Years in 50 Maps* (Singapore: NUS Press, 2017).

15 Manuel Castells, L. Goh, and R. Yin-Wang Kwok, *The Shek Kip Mei Syndrome: Economic Development and Public Housing in Hong Kong and Singapore* (London: Pion, 1990); Garry Rodan, *The Political Economy of Singapore's Industrialization: National State and International Capital.* (New York: St. Martin's Press, 1989).

16 Tang Hsiao Ling, "Industrial Planning in Singapore," in *50 Years of Urban Planning in Singapore,* ed. Heng Chye Kiang (Singapore: World Scientific, 2017), 153–76; *Jurong Town Corporation Annual Report 1968–69* (Singapore: JTC, 1969); *Jurong Town Corporation Annual Report 1970* (Singapore: JTC, 1971).

17 Words of Goh Keng Swee, minister for finance and the "economic architect" of Singapore, cited in *Jurong Town Corporation Annual Report 1968–69,* 1.

18 Miles Glendinning, *Mass Housing: Modern Architecture and State Power – a Global History* (London: Bloomsbury Visual Arts, 2021), 503.

19 For the congested shophouses, see Barrington Kaye, *Upper Nankin Street, Singapore: A Sociological Study of Chinese Households Living in a Densely Populated Area* (Singapore: University of Malaya Press, 1960).For the urban kampongs, see Loh Kah Seng, *Squatters into Citizens: The 1961 Bukit Ho Swee Fire and the Making of Modern Singapore* (Singapore: NUS Press, 2013).

20 Loh, *Squatters into Citizens.*

21 J. M. Fraser, *The Work of the Singapore Improvement Trust 1953* (Singapore: Singapore Improvement Trust, 1953), 45.

22 *Housing and Development Board Annual Report 1960* (Singapore: Housing & Development Board, 1961), 34. In fact, Queenstown was earlier planned to house only a population of 50,000. See Singapore Improvement Trust, *Queenstown, Singapore: Final Report of the New Towns Working Party on the Plan for Queenstown* (Singapore: New Towns Working Party, 1958), 10; *Introducing Queenstown* (Singapore: Singapore Improvement Trust, 1958), n.p.

23 Singapore Improvement Trust, *Queenstown, Singapore,* 9.

24 *Housing & Development Board Annual Report 1967* (Singapore: Housing & Development Board, 1967).

25 In 1920, the Public Works Department, Straits Settlements, was established. Prior to that, it was known as the Public Works and Survey Department (1873–1919) and Public Works and Convict Departments (up to 1872). See Wong Yunn Chii, "Public Works Department Singapore in the Inter-War Years (1919–1941): From Monumental to Instrumental Modernism" (unpublished research report, Singapore, National University of Singapore, 2003), 29. The PWD was a British colonial institution found throughout the British Empire. See Peter Scriver, "Empire-Building and Thinking in the Public Works Department of British India," in *Colonial Modernities: Building, Dwelling and Architecture in British India and Ceylon,* ed. Peter Scriver and Vikramaditya Prakash (New York: Routledge, 2007), 69–92; Ibiyemi Omotayo Salami, "The Architecture of the Public Works Department (PWD) in Nigeria During the Early to Mid Twentieth Century" (PhD thesis, Liverpool, The University of Liverpool, 2016).

26 Jiat-Hwee Chang and William S. W. Lim, "Non West Modernist Past: Rethinking Modernisms and Modernities beyond the West," in *Non West Modernist Past: On Architecture and Modernities,*

ed. William S. W. Lim and Jiat-Hwee Chang (Singapore: World Scientific, 2011), 7–24.

27 For a wide-ranging discussion of how the modernist built environment was different from its traditional counterpart, see James Holston, *The Modernist City: An Anthropological Critique of Brasilia* (Chicago: University of Chicago Press, 1989), chaps. 4 and 5.

28 Choe, Alan Fook Cheong, interview by Soh Eng Khim, 1 August 1997, accession no. 001891 disc 6 of 18, National Archives of Singapore.

29 Chua Beng Huat, *Designed for Living: Public Housing Architecture in Singapore* (Singapore: Housing & Development Board, 1985), 96.

30 *Housing & Development Board Annual Report 1973/74* (Singapore: Housing & Development Board, 1974), 51–57.

31 Aline K. Wong and Stephen H. K. Yeh, eds., *Housing a Nation: 25 Years of Public Housing in Singapore* (Singapore: Maruzen Asia for Housing & Development Board, 1985), 95.

32 Castells, Goh, and Kwok, *The Shek Kip Mei Syndrome*, 187.

33 Dale, *Urban Planning in Singapore*, 35.

34 Castells, Goh, and Kwok, *The Shek Kip Mei Syndrome*, 237.

35 Dale, *Urban Planning in Singapore*, 126.

36 *Colony of Singapore Master Plan: Written Statement* (Singapore: Authority of the Colony of Singapore, 1958).

37 Erik Emil Lorange, "Final Report on Central Redevelopment of Singapore City," 1962, 20, Unversity of Liverpool Library, William Holford papers, D147/V13.

38 Lorange, 20.

39 Charles Abrams, Susumu Kobe, and Otto H. Koenigsberger, "Growth and Urban Renewal in Singapore: Report Prepared for the Government of Singapore" (New York: United Nations Programme of Technical Assistance, Department of Economic and Social Affairs, 1963), 6.

40 Abrams, Kobe, and Koenigsberger, 57–58.

41 Ibid, 63.

42 Dale, *Urban Planning in Singapore*, 132–33. The idea of using a Concept Plan to guide long term development continues to be practised today. A new Concept Plan has been issued once every ten years since 1971.

43 A 1969 progress report of the work of the State and City Planning noted that "K.A.K. [Koenigsberger, Abrams, Kobe] 'Ring' Plan is not at all satisfactory" thus leading to its rather substantial modification. See State and City Planning, "Notes on the United Nations Assistance in Urban Renewal and Development Project, Singapore," January 1969, 40, Renate Koenigsberger's Collection, London.

44 The UN team added that "[i]t has acknowledged the wisdom of Patric [sic] Geddes' advice to Asian cities that 'conservative surgery is better than amputation'." Abrams, Kobe, and Koenigsberger, "Growth and Urban Renewal in Singapore," 18. See also Dale, *Urban Planning in Singapore*, 122–25; Rem Koolhaas, "Singapore Songlines: Portrait of a Potemkin Metropolis … or Thirty Years of Tabula Rasa," in *S, M, L, XL*, ed. OMA, Rem Koolhaas, and Bruce Mau (Rotterdam: 010 Publishers, 1995), 1008–86.

45 The URD was only formed in 1966 but by 1974, its work would be so significant that it become a separate statutory board, the Urban Redevelopment Authority (URA). Dale, *Urban Planning in Singapore*, 126–27.

46 Kah-Wee Lee, "Regulating Design in Singapore: A Survey of the Government Land Sales (GLS) Programme," *Environment and Planning C: Government and Policy* 28 (2010): 145–64.

47 *A Pictorial Chronology of the Sale of Sites Programme for Private Development* (Singapore: Urban Redevelopment Authority, 1983).

48 Castells, Goh, and Kwok, *The Shek Kip Mei Syndrome*, 267–69. It has been argued that this constituted Singapore's mode of land reform and redistribution. See Chua Beng Huat, "Singapore as Model: Planning Innovations, Knowledge Experts," in *Worlding Cities*, ed. Aihwa Ong and Ananya Roy (Malden, MA: Wiley-Blackwell, 2011), 27–54; Anne Haila, *Urban Land Rent: Singapore as a Property State* (Walden, MA: Wiley-Blackwell, 2015).

49 See, for example, Glendinning, *Mass Housing*, chap. 16; W. G. Huff, "The Developmental State, Government, and Singapore's Economic Development since 1960," *World Development* 23, no. 8 (1995): 1421–38.

50 James C. Scott, *Seeing like a State: How Certain Schemes to Improve the Human Condition Have Failed* (New Haven: Yale University Press, 1998).

51 The idea of Singapore's urbanisation was based on the tabula rasa mode was popularised by Koolhaas, "Singapore Songlines".

52 A well-known illustration of this is the case of the Pruitt-Igoe public housing project. Its demolition has been attributed to the failure of modern architecture when in fact it was not architectural design but the embedded social and political problems of the project that led to its deterioration. See Katharine G. Bristol, "The Pruitt-Igoe Myth," *Journal of Architectural Education* 44, no. 3 (1991): 163–71.

53 "HDB Chairman Receives UN Award for Tampines," *The Straits Times*, 6 October 1992.

54 Grace Lees-Maffei, "The Production—Consumption—Mediation Paradigm," *Journal of Design History* 22, no. 4 (2009): 355–59.

55 See Kenny Cupers, "Introduction," in *Use Matters: An Alternative History of Architecture*, ed. Kenny Cupers (New York: Routledge, 2013), 1–12.

56 Jennifer Kaufmann-Buhler, "Diversionary Tactics at Work: Making Meaning through Misuse," in *Design History Beyond the Canon*, ed. Jennifer Kaufmann-Buhler, Victoria Rose Pass, and Christopher S. Wilson (London: Bloomsbury Publishing, 2019), 35–48.

57 Julka Almquist and Julia Lupton, "Affording Meaning: Design-Oriented Research from the Humanities and Social Sciences," *Design Issues* 26, no. 1 (2010): 5–6,.

58 Cupers, "Introduction," 2.

59 Stewart Brand, *How Buildings Learn: What Happens after They're Built* (New York: Viking, 1994), 2.

60 Hannah le Roux, "Lived Modernism: When Architecture Transforms" (PhD thesis, Leuven, Katholieke Universiteit Leuven, 2014).

61 Chua Beng Huat, *Political Legitimacy and Housing: Singapore's Stakeholder Society* (London: Routledge, 1997), 82–84.

62 Jane M. Jacobs and Stephen Cairns, "The Modern Touch: Interior Design and Modernisation in Post-Independence Singapore," *Environment and Planning A* 40 (2008): 572–95; Chua, *Political Legitimacy and Housing*, Chap. 5.

63 Neil Harris, *Building Lives: Constructing Rites and Passages* (New Haven: Yale University Press, 1999); Donald McNeill and Kim McNamara, "The Life and Death of Great Hotels: A Building Biography of Sydney's 'The Australia'," *Transactions of the Institute of British Geographers* 37, no. 1 (2012): 149–63.

64 See, for example, Daniel M. Abramson, *Obsolescence: An Architectural History* (Chicago: University of Chicago Press, 2016), Chap. 1.

65 Stephen Graham and Nigel Thrift, "Out of Order: Understanding Repair and Maintenance," *Theory, Culture & Society* 24, no. 3 (2007): 1–25.

66 Jeremy Till, *Architecture Depends* (Cambridge, MA: MIT Press, 2009), 70–71.

67 Igor Kopytoff, "The Cultural Biography of Things: Commoditization as Process," in *The Social Life of Things: Commodities in Cultural Perspective*, ed. Arjun Appadurai (Cambridge: Cambridge University Press, 1986), 69.

68 Steven J. Jackson, "Rethinking Repair," in *Media Technologies: Essays on Communication, Materiality, and Society*, ed. Tarleton Gillespie, Pablo J. Boczkowski, and Kirsten A. Foot (Cambridge, MA: MIT Press, 2014), 221–40.

69 "'Eyesore' at Beach Rd: No Relief in Sight," *The Straits Times*, 7 March 2006.

70 Interestingly, the real estate group CapitaLand that bought Pearl Bank Apartments in the collective sale for redevelopment has the Singapore government sovereign wealth fund Temasek Holdings as its majority shareholder. Stephanie Luo, "Pearl Bank Apartments in Outram Sold En Bloc to CapitaLand for S$728m," *The Straits Times*, 13 February 2018.

71 SLA is known for its asset enhancement programme. See, for example, Singapore Land Authority, *Land, Our Canvas: Singapore Land Authority Annual Report 2017/18* (Singapore: SLA, 2018).

72 Jane M. Jacobs and Stephen Cairns, "Ecologies of Dwelling: Maintaining High-Rise Housing in Singapore," in *The New Blackwell Companion to the City*, ed. Gary Bridge and Sophie Watson (New York: Wiley-Blackwell, 2010), 79–95.

73 Robbie B. H. Goh, "Ideologies of 'Upgrading' in Singapore Public Housing: Postmodern Style, Globalization, and Class Construction in the Built Environment," *Urban Studies* 38, no. 9 (2001).

74 Mike Ives, "Too Ugly to Be Saved? Singapore Weighs Fate of Its Brutalist Buildings," *The New York Times*, 27 January 2019.

75 Adrian Forty, *Words and Buildings: A Vocabulary of Modern Architecture* (New York: Thames & Hudson, 2000), 304–11.

76 Singapore Heritage Society organised a series of events under "En Bloc, or Buildings Must Die" to discuss the challenges of conserving modernist built environment. See Amanda Chai, "The Substation's next Exhibition Explores the Weird Tug-of-War behind Conservation in Singapore," *SG Magazine*, 20 August 2018, https://sgmagazine.com/arts-things-to-do/news/substations-next-exhibition-explores-weird-tug-war-behind-conserving. Docomomo Singapore, led by Ho Weng Hin and his heritage conservation consultancy firm Studio Lapis, organised a two-day conference "Progressive Once More," 31 October–1 November 2019 to advocate for creative ways to adaptively reuse modernist buildings in Singapore. See 林方伟, "激活亚细安世纪中期现代建筑：叫去留不那么沉重," 联合早报, 24 November 2109. Disclosure: Jiat-Hwee Chang, Justin Zhuang and Darren Soh are founding members of Docomomo Singapore. Chang also sits on its executive committee.

77 See also Darren Soh's photographic exhibition "Before it all goes" held at the Chapel Gallery, Objectifs, 23 August–30 September 2018.

78 John Lui, "S'pore Conference Hall a National Monument," *The Straits Times*, 5 January 2011; Chew Hui Min, "Jurong Town Hall 'a Baby' among National Monuments," *The Straits Times*, 3 June 2015.

79 Ng Keng Gene, "Conservation of Golden Mile Complex Paves Way to Protect S'pore's Modernist Buildings," *The Straits Times*, 26 October 2021.

80 See http://www.mycommunity.org.sg

81 Melody Zaccheus, "Three Queenstown Buildings to Be Conserved after Lobbying by Civic Group," *The Straits Times*, 3 October 2013; Melody Zaccheus, "Queenstown Rolls out Heritage Plan," *The Straits Times*, 14 August 2014; Melody Zaccheus, "Stroll through Queenstown's Past – and Celebrate Its History," *The Straits Times*, 23 February 2019.

0.01 Singapore in 1963, showing the
clear divide between the rural
(white) and urban (black) areas that
arose out of decades of growth and
accepted as is by the 1955 colonial
masterplan.

0.02 The 1963 "Ring City Singapore"
sketch plan by UN experts offered a
more radical approach to urban
development. It treated the whole
island as a single integrated urban
entity and planned a ring of coastal
towns around a central open space.

0.03 The UN plan was the basis of the
State and City Planning team's First
Concept Plan drawn up in 1971. The
ring of satellite towns became
smaller and were further away from
the coasts. It also intersected with
an east-west corridor.

0.01

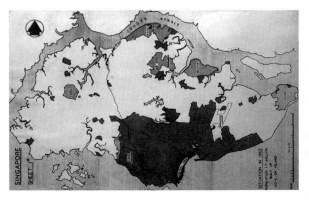

0.02

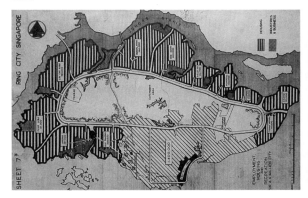

0.03

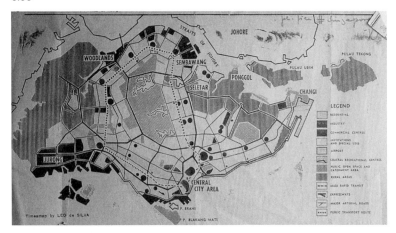

0.04 The masterplan for Queenstown, the first satellite town in Singapore, as envisioned by the SIT in 1958. It was eventually realised by the HDB who increased its density significantly.

0.05 The diagrammatic plan of Toa Payoh New Town by HDB shows how it was connected by a circular road system and organised around a town centre, town garden and sports complex.

0.04

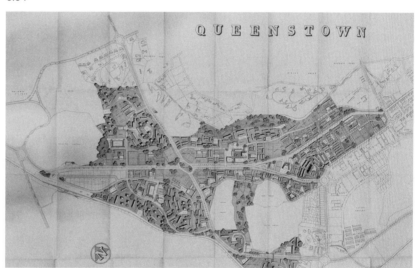

0.05

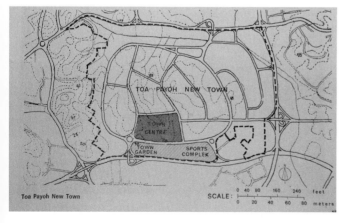

0.06 Aerial view of Toa Payoh New Town
 under construction in 1972.

0.07 Masterplan of Singapore's main
 industrial estate, Jurong Town, by
 JTC. Besides factories, it also had a
 residential component known as
 Taman Jurong, as indicated on the
 top right.

0.08 The residential area of Taman Jurong
 was supported with various social
 and recreational amenities as seen in
 this 1978 aerial view. On the right is
 the Jurong Drive-In Cinema.

0.09 Besides building and designing
 infrastructure such as roads, the PWD
 was also behind many government
 buildings, ranging from schools to
 modern offices such as the CPF
 Building.

0.06

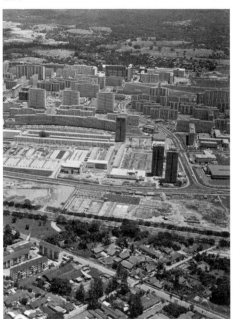

0.07

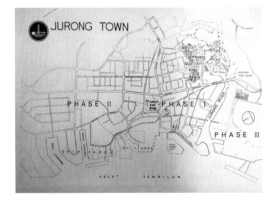

0.08

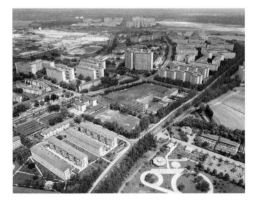

0.10 The reclaimed land at Telok Ayer Basin with the newly completed podium tower blocks along Shenton Way in the background. The urban renewal in the city centre was made possible by the resettlement of the urban population in the newly completed public housing, much of which was in satellite towns like Queenstown and Toa Payoh.

0.11 The void decks of HDB flats accommodated different uses, including as a bird-singing corner, where songbirds chirped while their owners socialised.

0.12 The void decks were also used to host Malay wedding receptions.

0.13 HDB flats were sold with basic fixtures and finishes so that residents could adjust the layouts and renovate the spaces to suit their needs.

0.11
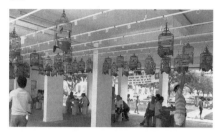

0.12

0.09
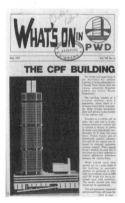

0.10

0.13

Live

1-5

1 Public Housing: The Many Shapes of Home

Public housing in Singapore is often caricatured as simply rectangular blocks of high-rise apartments. But the imagery of non-descript design falls apart upon closer inspection. There are the clover-like point blocks at Ang Mo Kio Avenue 2, the slab blocks that bend and zigzag around one another in Bukit Purmei and towers with semi-circular balconies along Aljunied Road. These were some of the seven "new façades" introduced by the Housing & Development Board (HDB) in August 1979 to transform Singapore's public housing "from that of mass produced stereotypes to recognisable individual housing estates".[1]

Previously, public housing was indeed designed in rectilinear forms: the slab block or the point block. The former was the most prevalent typology and was introduced from Europe via the Singapore Improvement Trust (SIT), the predecessor of the HDB. The SIT was set up by the British in 1927 to carry out town planning and improvement, which later included constructing low-cost public housing. This originally came in the form of artisans' quarters and tenement houses as well as two-, three- and four-storey walk-up flats that are similar to those still found in Tiong Bahru.[2] However, the urgent need to alleviate the housing shortage after the Second World War led to the

introduction of even taller "slab block" apartment buildings. Between 1952 and 1953, SIT completed three such nine-storey blocks at Upper Pickering Street, designed by its chief architect Stanley Woolmer. Every block had 40 apartments, each with two bedrooms, a living room, bathroom, water closet and front balcony. They were laid out from the second storey with five apartments per level, while the ground floor was reserved for shops and offices. The different levels were connected by lifts that stopped on the second, fifth and eighth floors, while a common corridor provided access to the units. This was the typical slab block: essentially horizontal strips of apartments that were connected by a corridor that could easily be stacked one on top of another to new heights.[3]

The Upper Pickering flats introduced high-rise living—and dying—to those in Singapore. Barely a year in, they became popularly known as "suicide flats" as people leapt to their deaths from its balconies, airwells and streamlined spiral staircases. Within three years of its completion, some 19 people plunged to their deaths and SIT finally barricaded potential suicide areas with barbed wire in 1955.[4] Meanwhile, the agency continued building higher slab blocks. In 1956, it

completed a 14-storey public housing with a distinct zigzag façade known as Forfar House. Located in Queenstown, the 39.6-metre-tall building was then Singapore's sixth tallest building, dwarfed only by the Asia Insurance Building, Cathay Building [see Cinemas], Bank of China, MacDonald House and Finlayson House.[5]

After Singapore gained self-governance from the British in 1959, the high-rise slab block became the design of choice for public housing. Its straightforward and economical construction fulfilled the newly formed HDB's goal to build affordable housing quickly. Early HDB blocks typically ranged from 5 to 12 stories because constructing anything higher required a new set of timber formwork for concreting.[6] They consisted entirely of either one-, two- or three-room apartments, with 14 to over 60 per level, each served by a common external corridor. In 1960, such standard flats cost just S$8 per square foot to construct for a multi-storeyed building of up to 12 storeys, which was one of the lowest costs in the world. Even cheaper were the one- and two-room "emergency" flats with units on both sides of a central corridor, which cost just $7 per square foot to construct, excluding cost of land and lifts.[7] But it was later discovered that such "double-loaded corridor" apartments suffered from poor ventilation, a lack of natural lighting and reverberating noises. The layout was subsequently used only for one-room flats to keep their prices low.

Having broken the back of Singapore's housing shortage by constructing "the maximum number of units of public housing in the minimum time and at the most economical cost", the HDB began experimenting with the slab block design from its Second Five-Year Plan launched in 1966 to improve public housing.[8] Such efforts gave birth to a curved slab block and new configurations—pin-wheel, L-shape and U-shape—by joining several of them together. Blk 53 in Toa Payoh, for instance, was completed in 1967 by interlinking the corridors of three slab blocks to create a pin-wheel design, also called a Y-shape. A new building typology arrived when the HDB introduced the "point block" to address "appeals by the public for flats with more privacy".[9] Consisting of a central core made up of lifts and staircase that served only four flats per storey, the point block significantly reduced the slab block's long corridors. Residents had fewer

neighbours on the same level and no longer had to worry about people being able to see into their apartment from the corridor. The towering form of the point block also offered a vertical counterpoint to the horizontal slab block, and the HDB used them to create landmarks in housing estates, such as those that anchor the town centre in Toa Payoh and Bendemeer.

The earliest public housing point blocks were completed in the form of Blocks 160 and 161 along Mei Ling Street in the neighbourhood of Queenstown. These 20-storey towers, consisting of a mix of three- and four-room flats on each floor, were so popular that the applications for sale in 1969 "far exceeded the supply" and the HDB predicted it would become a trend as citizens sought privacy and more spacious accommodation.[10] But as they were more expensive to build than slab blocks, particularly as construction costs rose in the 1970s, subsequent point blocks only came with five-room flats and were sold at a premium.[11] Regardless if a block was a slab or a point, its height and length was ultimately determined by a key housing technology: the lift. To manage its lifespan and residents' waiting time, HDB formulated a desired number of units to be served per lift and this ratio shaped the design of public housing blocks. Wider slab blocks with more units per level tended to have fewer storeys, while narrower point blocks that housed fewer units per storey could go taller—infinite variations of design confined within a box.[12]

Besides construction cost and lift access, public housing blocks were also moulded by the HDB's desire to foster neighbourliness amongst its residents. In 1976, the agency began building more "mixed" blocks with different flat sizes to create more "balanced socio-economic groupings".[13] These were well-integrated to maintain the typically symmetrical and rectilinear block designs that used to contain flats of only one size. The intention to bring residents closer together also led to different common corridor designs. HDB planners and architects saw the corridor as a functional connection between flats, and a "residential street" where children played, neighbours met and even hawkers and tradesmen came to peddle their wares.[14] To encourage more communal use, the corridors were segmented into smaller units in the 1970s which curved, bent, fragmented and eventually

reconfigured the traditional linear slab block. As then HDB chief architect Liu Thai Ker explained:

> How [do] you compose a block? In fact, at some stage we talked about 'the courtyard in the sky'. That means you group four to eight units of an apartment around a corridor. Or we make this corridor a bit wider but it's shorter. You know, you have so called end units so that the corridor, instead of 20, 30 units sharing one corridor, you break it up into groups of four to eight. It's amazing how by having only four to eight families sharing a corridor, the sense of community is very strong.[15]

Another common area that was popularised in public housing during the 1970s was the void deck. By keeping the ground floor of public housing blocks free of apartments, HDB created a space that could be filled with community facilities, including kindergartens, childcare centres and senior citizen clubs. Residents could also book them for temporary social functions such as weddings and funerals.

Through the various developments, HDB developed a kit-of-parts—flats, lifts, corridors and void decks—that culminated in seven new block designs in 1979. The once rectangular point block was now available in tubular form or with semi-circular balconies. Two slab blocks could be connected in a 90- or 120-degree turn. They could also each house a combination of three- and four-room flats. By re-orientating the four apartments on each level in a typical point block, it became a "multi-directional" design. Add two more apartments on each level and you have a "six-unit" point block. The final new design, and arguably the biggest breakthrough, was to combine the point and slab block that were previously "so diverse that the two could not be matched"[16]. A 25-storey point block was married with a nine-storey slab block to allow the HDB to create a single development that had three-, four- and five-room flats on each floor for the first time.

These seven new block designs marked the beginning of a sustained effort to create distinctive public housing in Singapore from the 1980s. The HDB began paying more attention to architectural details on housing blocks so as to strengthen their identity as seen in the maritime-inspired features of the coastal town, Pasir Ris. In 1991, private architects were invited for the first time to design public housing as part of a new Design and Build Scheme to introduce fresh ideas and forms. The inaugural project in Tampines Street 45 saw P&T Consultants design eight tower blocks with 10 slab blocks to contain all 620 units. The 10-storey high blocks were arranged to contain three separate courtyards and share a distinctive brick façade.

These efforts have helped a previously monotonous public housing architecture evolve into a cacophony of designs to suit the diverse tastes of the over 80 per cent of Singapore residents who live in them today. But these different shapes of home continue to share the same fundamental units: the slab block and the point block.

Notes

1 *HDB Annual Report 1978/79* (Singapore: Housing & Development Board, 79 1978).

2 J. M. Fraser, *The Work of the Singapore Improvement Trust 1927–1947* (Singapore: Singapore Improvement Trust, 1953).

3 J. M. Fraser and Stanley Woolmer, "Singapore Improvement Trust: 3 Blocks of 9 Storey Flats at Upper Pickering St, Singapore," *The Quarterly Journal of the Institute Architects of Malaya* 3, no. 1 (1953): 35–42.

4 "Suicide Leaps at SIT Flats Now Over—Tenants," *The Singapore Free Press*, 18 March 1955.

5 "Forfar House Is the Sixth Highest," *The Straits Times,* 4 November 1956.

6 Aline K. Wong and Stephen H. K. Yeh, eds., *Housing a Nation: 25 Years of Public Housing in Singapore* (Singapore: Maruzen Asia for Housing & Development Board, 1985), 56–112.

7 *Housing and Development Annual Report 1960* (Singapore: Housing & Development Board, 1961), 32–33.

8 *Housing & Development Board Annual Report 1966* (Singapore: Housing & Development Board, 1967), 46.

9 *Housing & Development Board Annual Report 1968* (Singapore: Housing & Development Board, 1969), 35.

10 *Housing & Development Board Annual Report 1969* (Singapore: Housing & Development Board, 1970), 77.

11 *Housing & Development Board Annual Report 1968*, 36.

12 Wong and Yeh, eds., *Housing a Nation*, 138.

13 Maureen Chua, "More 'Mixed' Flat Blocks Planned by the HDB," *The Straits Times*, 16 June 1976; Wong and Yeh, "Physical Planning and Design."

14 Wong and Yeh, eds., *Housing a Nation*; Sylvia Leow, "Corridor Traffic," *Our Home*, 1973.

15 Liu Thai Ker, interview by Irene Quah, 22 January 1997, transcript of accession no. 00173 reel 14, p. 121, National Archives of Singapore.

16 Irene Ngoo, "Seven New Designs Planned for Flats," *The Straits Times*, 2 August 1979.

1.1

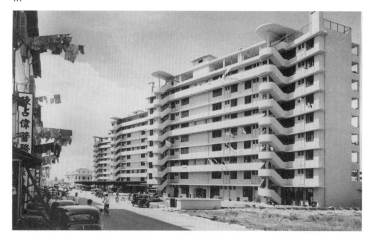

1.1 Three early public housing "slab blocks" at Upper Pickering Street completed in the early 1950s by SIT. Such designs supported taller and denser residential developments, which were key for alleviating Singapore's urgent housing shortage.

1.2 The 14-storey Forfar House in Queenstown by SIT was Singapore's tallest public residential building when it officially opened in 1956.

1.3 Aerial view of Queenstown's various public housing block designs. While rectilinear slab blocks were the most common, they were also L-shape blocks (centre) and clusters of three tower-like point blocks (top).

1.4 Blocks 26 and 28 along Bendemeer Road, were two of the earliest point blocks completed by the HDB in 1970. The 24-storey tower-like forms served as landmarks for the estate.

1.5 A spread in the August 1979 issue of HDB's magazine, *Our Home*, showcasing its seven new public housing facades. They marked a maturing of earlier attempts to create more variation in public housing design.

1.2

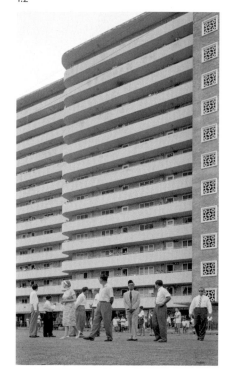

1.3

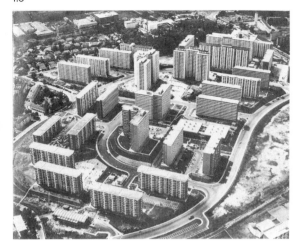

1.4

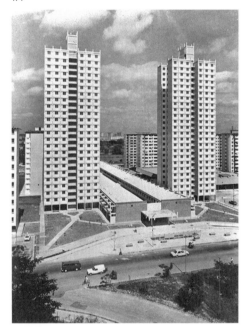

1.5

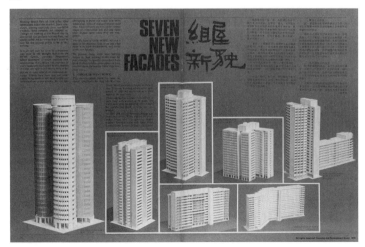

2 **People's Park:** **Pioneering Integrated Living in a Denser City**

It has received accolades from the likes of the President's Design Award 2020, the World Architecture Festival 2018 and has even been hailed as "a model for future public housing".[17] Yet, Kampung Admiralty by WOHA Architects is not an entirely new idea in Singapore. By bringing together public housing for seniors, a medical centre, a childcare centre and commercial spaces into a single "vertical kampong", the 11-storey integrated development completed in 2017 fits the podium tower typology introduced by the Housing & Development Board (HDB) some five decades ago.

In 1968, Singapore's public housing agency completed the eight-storey "Park Road Redevelopment" as a "multi-use" concept "integrated within a single complex".[18] Better known today as People's Park, the building on 32 New Market Road is made up of a three-storey commercial podium that is topped with a five-storey residential slab block. Between the two components is a void deck with various community facilities. While Kampung Admiralty has many elderly friendly amenities as an experimental retirement village, People's Park initially had a kindergarten, landscaped play area and even a wading pool for toddlers. After all, People's Park was built when

Singapore had roughly three times more working adults supporting an elderly person than its rapidly ageing population today.[19] The development was one of the earliest projects in a massive urban renewal programme aimed at clearing valuable slum areas for economic development and arresting the decay of the city centre. The scheme divided the 1,700 acres of the old city into nine precincts north of the Singapore River and eight south of it, and People's Park was part of "Precinct South I", a 180-acre site that was bounded by Outram Road, Havelock Road and New Bridge Road. HDB envisioned replacing the area's "old rickety tin sheds and temporary structures" with modern developments that could house three times as many people, and provide room for new enterprises to create employment and raise living standards.[20] People's Park achieved this with a podium tower that efficiently combined housing with shops. The design by HDB architects Tan Wee Lee and Peter B. K. Soo had 130 flats, of which 90 were two-room units and 40 were three-room apartments. Its multi-level retail podium re-accommodated all the shops and eating stalls from the neighbouring People's Park market that used to occupy the land. Not only did its tenants get to

stay in the neighbourhood, HDB boasted they offered "essentially the same area but in much better and more hygienic surroundings".[21] The mixed-use development also freed up an adjacent 2.5-acre site that the government later sold to private developers to build People's Park Complex. Its architects, Design Partnership, adopted a similar typology for the building completed in 1973, which consists of a six-storey podium—then Singapore's largest shopping complex—and a 25-storey residential block above (see *Shopping Centres*).

Prior to People's Park and the podium tower, the HDB piloted the idea of integrating retail and residential when it completed its first urban renewal development project in Singapore's central area. Selegie House officially opened in May 1963 as a "multi-storey residential-cum-shopping precinct" on a two-acre site bounded by Selegie Road, Short Street and Albert Street.[22] Its 466 two-, three- and four-room flats were spread across two 10-storey blocks and one 20-storey block. The three slab blocks were linked on the ground by four rows of two-storey shops blocks with living quarters above to enclose two open courts.[23] Selegie House's model of lower-level shopping arcade combined with residential blocks above carried on to People's Park in a more compact and well-defined podium tower form.

By the mid 1970s, both the public and privately developed podium towers named after People's Park in Chinatown were joined by similar developments in the vicinity. HDB completed a row of 20-storey housing-cum-retail podium towers perpendicular to its People's Park, which stretched all the way down to Chin Swee Road. Opposite Upper Cross Street, a privately developed People's Park Centre arose as a four-storey retail podium with a pair of towers for offices and residences. The retail podiums of these various new developments were linked by overhead bridges and elevated walkways such that pedestrians could stroll through Chinatown's main shopping centres "without setting foot on the road".[24] Even Park Road, which used to front HDB's People's Park, was turned into a brick-paved pedestrian mall with fountains, a clock tower and street furniture to further the segregation from vehicular traffic.[25] Years later, People's Park Square, the lively, well-connected and comfortable space created from this urban

design exercise was deemed by urban designers as "one of the most successful urban spaces in Singapore".[26]

Following People's Park, HDB built 15 other podium towers across Singapore's central area, including elsewhere in Chinatown, Jalan Besar, Bugis, Tanjong Pagar and Lavender. But unlike the kind of pedestrian connections made in People's Park, these newer podium towers largely stood alone.[27] The typology also gained popularity amongst private developers during this period. While some combined residential towers with commerce too, for instance Queensway Shopping Centre (1974) and Bukit Timah Plaza (1979), a stretch of office-cum-commerce podium towers arose in the financial area of Shenton Way. They were the result of planning requirements set by the state's urban planners, and the similar building types linked up on the ground floor for the benefit of pedestrians too (see *Shenton Way*). A key difference between private podium towers and those built by the HDB was the latter were never air-conditioned because of costs.

In the 1980s, the podium tower typology lost its relevance as the HDB shifted its focus from renewing the city centre to developing new towns in the rest of Singapore. The agency could afford to separate retail and residential in lower density developments as it was constructing in outlying areas that were significantly less costly. While the agency continued mixing the two in key nodes of a town, they came more in the form of three- or four-storey buildings similar to shop-houses such as those in Toa Payoh town centre. The last two podium towers built in the central area were King George's Avenue (1982) and Cheng Yan Court (1983). It was almost three decades later that this typology was revived for a public housing development in the form of the Clementi Town Mixed Development in 2011. An open-air bus interchange and an old shopping mall next to Clementi MRT station were replaced by a podium tower, which brought together two 40-storey public housing towers with 388 units that sat above a five-storey retail podium with two basements that is connected to an air-conditioned bus interchange. The introduction of a transport function into the podium tower is part of a growing number of "integrated developments" that have arisen with Singapore's expanding mass rapid transit network. Land situated next to or above train stations outside the city centre

are prized by private developers seeking to take advantage of the high footfall and convenience with a development offering both retail and residences. Even better if there is a bus interchange nearby. Some examples of such developments built since the 2000s include The Centris, Bedok Residences, Punggol Watertown and North Park Residences.

The renewed interest in podium towers is perhaps an indication of how densification has spread from Singapore's city centre to its heartlands too. Although Kampung Admiralty is also located next to an MRT station, it offers a broader interpretation of how the podium tower can offer new possibilities of living as Singapore becomes denser. Beyond a means for developers to maximise financial yield and for the state to achieve the productive use of land, the ability to mix specialised uses in a single piece of architecture—retirement homes, healthcare facilities and senior-friendly retail—shows how integrated living can benefit select communities too.

Notes

17 Lee Hsien Loong, "National Day Message 2018," Prime Minister's Office Singapore, 8 August 2018, https://www.pmo.gov.sg/Newsroom/national-day-message-2018.

18 "New Buildings in Singapore — 2 'Park Road Redevelopment' Supplement," *Journal of the Singapore Institute of Architects*, no. 28/29 (October 1968): 9–20.

19 Ong Hwee Hwee, "Singaporeans Aged 65 and Older Form 13.1 Per Cent of Citizen Population as Society Continues to Age," *The Straits Times*, 30 September 2015.

20 "New Buildings in Singapore — 2 'Park Road Redevelopment' Supplement"; "Rejuvenating the Old Core of the City," *The Straits Times*, 21 July 1965, sec. Housing & Development Board Exhibition.

21 "New Buildings in Singapore — 2 'Park Road Redevelopment' Supplement."

22 *Housing & Development Board Annual Report 1963* (Singapore: Housing & Development Board, 1964), 29.

23 "20-Storey Flats Ready on June 1," *The Straits Times*, 18 April 1963.

24 Adrian Chiam, "A Stroll… and Not One Foot on the Road," *New Nation*, 17 October 1974.

25 *Housing & Development Board Annual Report 1973/74* (Singapore: Housing & Development Board, 1974), 105.

26 C. K. Heng and V. Chan, "The Making of Successful Public Space: A Case Study of People's Park Square," *Urban Design International* 5 (2000): 50.

27 Valerie Koh, "Podium Memories: A Study of the Evolution of the HDB Podium-Blocks in Singapore" (unpublished M.Arch dissertation, National University of Singapore, 2013).

2.1

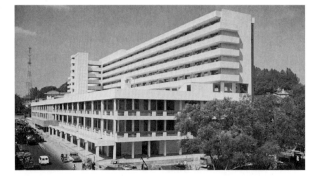

2.1 Completed in 1968, People's Park at Park Road was HDB's first podium tower development. The multi-use building combined retail on its first three levels with a five-storey residential slab block.

2.2 People's Park contained many amenities for residents, including a creche (left) and landscaped internal courts in the shopping podium (right).

2.3 The former Outram Park Residential-cum-Shopping Complex opened in the 1970s comprised of a network of podium towers. The blocks of flats sat above two floors of shops, offices and eateries.

2.4 The newly completed Rochor Centre (centre) at Rochor Road in 1976 showcased how the podium tower supported denser urban development as compared to its surrounding shophouses then.

2.5 Blocks 52 and 54 at Chin Swee Road were designed as podium towers connected by an elevated pedestrian network on the lower floors. It allowed pedestrians to walk from nearby People's Park without meeting any vehicles.

2.3

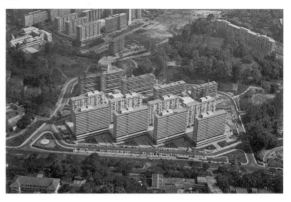

2.4

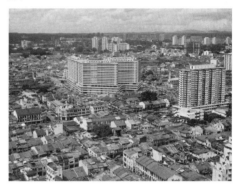

2.5

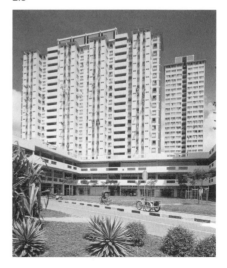

2.2

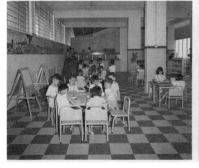

3 Futura:

The Past and Future of
Luxury High-Rise Apartments

With its elliptic concrete balconies, circular cores and bronze-tinted curtain wall, Futura resembled a spaceship set for launch when it was completed in 1976. The flamboyant architectural language of this 25-storey apartment tower designed by Timothy Seow went beyond just its façade. Its plan was made up of a central service core linked to three prongs, and each saw the juxtaposition of circular and angular elements to create a seemingly constantly changing exterior that Seow likened to a "mobile sculpture".[28] Various photographs of Futura's centrally air-conditioned interiors also depicted its apartments furnished with teardrop-shaped bathtubs and the organic Tulip chairs designed by Finnish-American architect Eero Saarinen—completing a space-age look that was all the rage in the 1960s and 1970s.[29]

Futura did not just look like it came from the future, but became the future of luxury high-rise residential development in Singapore. It was one of the pioneering examples of this type. Its 69 split-level apartments shared many characteristics of such early residences, including private lift lobbies, maisonettes, large balconies and the absence of shared party walls between units for maximum privacy. Futura also had three two-storey penthouses equipped with private sauna,

swimming pool and landscaped roof terrace. Such features were central to Seow's concept of "bungalows in the air", which he first began exploring with Maxima in the early 1970s.[30]

Located at the junction of Holland Road and Belmont Road, the 14-storey residential tower completed in 1973 was developed on a piece of land owned by Seow's parents. Its first two storeys were for common use, followed by 10 floors that each had just one apartment, and topped with a two-storey penthouse with a roof garden. Each apartment had its own private lift lobby and residents had access to a shared swimming pool, barbecue terrace and landscaped garden.[31] The unusually luxurious design prefigured the introduction of "condominiums" as a planning policy in 1972 and challenged the notion of high-rise living being associated only with Singapore's then emerging public housing landscape.(see Public Housing) It so impressed developer Henry Kwee, the founder of Pontiac Land that he appointed Seow to design Westwood and Beverly Mai.[32] The latter development completed in 1974 pioneered the incorporation of maisonettes in apartment blocks. Its 48 units, which were organised four to a floor, had split levels to segregate the private bedroom spaces from the

living and dining rooms, as well as a large balcony. Unlike Futura's space-age look, Beverly Mai's slender angular 28-storey block was inspired by the work of English architect Denys Lasdun, whom Seow had admired while studying architecture in England at the Oxford College of Technology (today's Oxford Brookes University) between 1958 and 1962. In particular, the thick horizontal bands on the Beverly Mai's façade resembled those found on Lasdun's Keeling House (1959) apartment tower in London. The bands also function to visually separate the maisonettes on the elevation.[33]

Maxima, Beverly Mai on Tomlinson Road and the Futura at Leonie Hill were part of a short-lived boom of luxury high-rise residences in Singapore during the first half of the 1970s. Built mostly on the city-state's prime land of Districts 9, 10 and 11, the high-rise residences offered floor areas of 3,000 square feet or more to rival the many landed dwellings around it. Such "bungalow-size flats" sold at approximately S$200,000—two to three times the price of the costliest apartments in the pre-1970 era but still cheaper than buying a comparable landed bungalow in the area—and were the first to cater to Singapore's emerging "luxury flat sector".[34] They were spurred by a confluence of factors, including the scarcity of land, rising affluence among Singaporeans and the entry of foreign money. According to newspaper reports, there was an "influx of foreign executives, particularly Americans in the oil business" who were willing to pay high rent for "top quality accommodation".[35] The 1960s to early 1970s was when major oil companies began investing heavily in oil refineries in Singapore, making it the world's third largest refining centre by the mid 1970s.[36] In addition, foreigners were reportedly pumping "'hot' money" into Singapore in the 1970s as the government started the Asia Dollar Market, Asia Bond Market and Asia Gold Market to attract overseas capital and turn the city-state into a regional financial centre.[37] These socio-economic changes might account for how well the units at Beverly Mai and Futura sold despite their astronomical prices.[38]

Besides Seow's creations, two other notable luxury high-rise residences from this period were Highpoint and Townhouse Apartments, completed in 1974 and 1976 respectively. Both were designed by Kumpulan Akitek, a firm that was founded and helmed by Victor Chew, with Wee

Chwee Heng and Chan Sau Yan as partners. Like Futura, the apartments at Highpoint were each expressed as a separate entity on the plan so that they did not share party walls and offered residents privacy. But instead of a space-age architectural language, Kumpulan Akitek used octagonal shapes, in continuation of their earlier geometry-driven works. Each apartment in Highpoint is made up of a cluster of three octagonal shapes fused together to offer panoramic views from its location at Mount Elizabeth. The polygonal motif is further accentuated on the exterior by the canted shapes of the balconies and overhangs.[39] Townhouse Apartments is also similar to Futura in that it was based on the high-rise reinterpretation of a low-rise, landed typology. As its name suggests, the development at Cavenagh Road consists of six 12-storey towers containing six penthouses and 48 "townhouses in the air", each of which is a maisonette with three or four split levels.[40]

After Futura, Seow went on to distinguish himself as an architect known for his sculptural and "futuristic" style. His projects ranged from the distinctive circular elements found in Draycott Towers (1978) and Horizon Towers (1983) to the "sheared pyramid" and "tilted polygonal" forms in a 1983 development of various bungalows at Cluny Hill Park.[41] Many of Seow's early high-rise developments have since been demolished—including Beverly Mai (now Tomlinson Heights) and the Futura (today's New Futura)—but they can be seen as precursors to at least two forms of contemporary residential development in Singapore.[42] Firstly, many of the exclusive features in these luxury high-rise developments have become the norm in contemporary up-market condominiums. Secondly, projects such as Futura, which used a sculptural form to differentiate itself, anticipated the now popular deployment of "iconic design" by famous architects as a selling point in Singapore's real estate market.

Just as the rise of luxury high-rise residences in the 1970s could be attributed to state-initiated economic developments in the oil and financial sectors, the post-2000 proliferation of luxury condominiums with distinctive designs and up-market amenities should be understood in relation to the government's efforts to turn Singapore into a global private banking hub.[43] Together with low personal and corporate tax in Singapore, the latter has attracted a significant

number of high-net-worth individuals to reside in the city-state. As property law places restrictions on non-citizens owning landed property, many have invested in condominiums instead. For example, James Dyson, founder of the eponymous technology company, Alibaba co-founder Sun Tongyu, and Facebook co-founder Eduardo Saverin have broken the records for the most expensive condominiums.[44] They have reportedly bought into some of the most spectacular-looking luxury condominiums built in recent years, including the Sculptura Ardmore (2017) designed by New York-based Carlos Zapata, which is wrapped with cantilevered swimming pools, tilted facades and glass fins, and the Rubik's Cube-inspired Le Nouvel Ardmore (2015) by French architect Jean Nouvel. However, long before the arrival of these "starchitects", Seow and others were already dreaming up new ways of luxury high-rise living.

Notes

28 "Mobile sculpture" is a misnomer as, unlike the kinetic sculptures by the likes of Alexander Calder that were called mobiles, Futura did not move and was thus immobile. Only the viewer was mobile. "A 25-Storey Mobile Sculpture," *Far East Builder*, November 1970.

29 "In the Round…," *Building Materials & Equipment*, March/April (1975).

30 Nellie Har, "'Bungalows in the Air'—A Unique $2m Project with Swim Pool and Roof Garden," *The Straits Times*, 26 June 1970.

31 "Luxurious Maxima Homes a Sell Out," *New Nation*, 21 August 1971.

32 Catherine Ong, "Back Where He Belongs," *The Business Times*, 11 July 1998.

33 Ibid.

34 William Campbell, "Highrise Goes High Class," *The Straits Times*, 19 June 1970.

35 For a history of the petrochemical industry in Singapore, see Tilak Doshi, *Houston of Asia: The Singapore Petroleum Industry* (Singapore: ISEAS–Yusof Ishak Institute, 1989).

36 Ng Weng Hoong, *Singapore, the Energy Economy: From the First Refinery to the End of Cheap Oil, 1960–2010* (New York: Routledge, 2013), 45–46.

37 "Homes for Every Group…," *New Nation*, 30 May 1973. For the transformations in Singapore's financial sector, see Lee Sheng-Yi, *The Monetary and Banking Development of Singapore and Malaysia*, 3rd ed. (Singapore: Singapore University Press, 1990); Tan Chwee Huat, *Financial Markets and Institutions in Singapore*, 3rd ed. (Singapore: NUS Press, 2005).

38 "Luxury Flats," *New Nation*, 19 June 1971.

39 "Circular-Flat Concept in High-Rise Living, Only One Family on Each Floor," *New Nation*, 20 May 1972.

40 Mok Sin Pin, "The Bold Concept in Split-Level Luxury Apartments," *The Straits Times*, 6 March 1972.

41 Catherine Ong, "Avant Garde: Bizarre Designs for Those Who Dare to Be Different and Can Afford to Pay," *Singapore Monitor*, 29 May 1983.

42 Jeremy Au Yong, "Is S'pore's First Condo Worth Preserving?: Some Architects Say 'Yes', and Fear a Whole Era of Iconic Buildings Like Beverly Mai Could Be Wiped Out," *The Straits Times*, 24 September 2006; "'What Are They Doing to My Buildings?'," *The Straits Times*, 14 September 2007; Cecilia Chow, "City & Country: Changing Skylines," *The Edge*, 18 October 2010.

43 Wayne Arnold, "In Singapore, a Local Switzerland for Asia's Wealthy," *International Herald Tribune*, 24 April 2007; John M. Glionna, "Singapore, a New Home for Riches," *Los Angeles Times*, 11 November 2006.

44 Siddarth Shrikanth, "James Dyson Buys Singapore's Most Expensive Flat," *Financial Times* (London) (2019). Dyson sold his penthouse condominium unit about a year after he bought it; Elizabeth Kerr, "Besides Billionaire James Dyson, Which Tycoons Own Luxury Singapore Penthouses and Apartments?" *South China Morning Post*, 22 July 2019.

3.1

3.1 Rising above Leonie Hill, the Futura
 stood out with its space-age
 aesthetics. The design completed
 in 1975 was a forerunner in luxury
 high-rise residential development
 in Singapore.

3.2 Plan of the Futura showing how a
 typical floor housed three
 apartments. Each unit had a private
 lift lobby and was organised around
 a living room with a large balcony,
 creating the impression of
 "bungalows in the air".

3.2

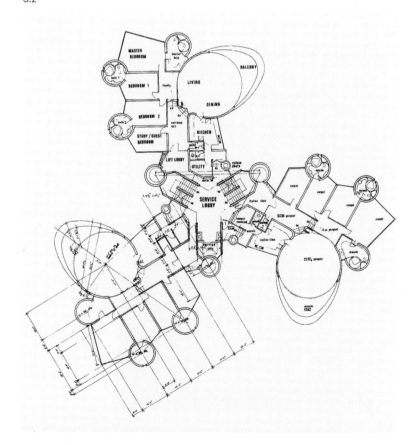

3.3 The space-age look of the Futura, which was all the rage globally in the 1960s and 1970s, extended into its interiors which had seamless "cockpit" windows that offered panoramic views.

3.4 Completed in 1974, Beverly Mai was ground-breaking for incorporating maisonettes in apartment blocks, and providing shared facilities such as the swimming pool. The latter is common in condominium projects today.

3.3

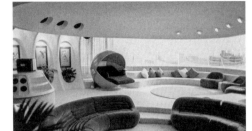

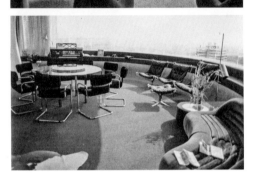

3.4

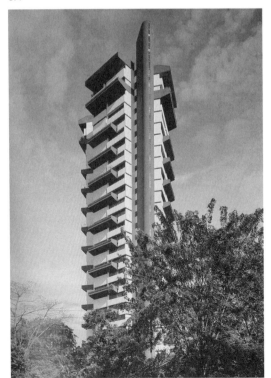

3.5 A typical floor plan of Highpoint
 Apartments by Kumpulan Akitek
 illustrating the separation of its
 three units to offer panoramic
 views.

3.6 A typical floor plan and section
 of Townhouse Apartments by
 Kumpulan Akitek shows how
 each unit is a maisonette with
 three or four split levels.

3.5

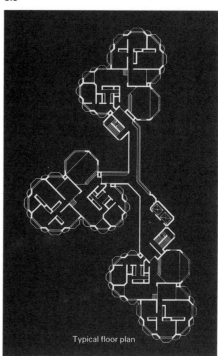

Typical floor plan

3.6

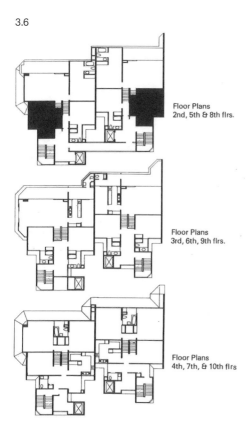

Floor Plans
2nd, 5th & 8th flrs.

Floor Plans
3rd, 6th, 9th flrs.

Floor Plans
4th, 7th, & 10th flrs

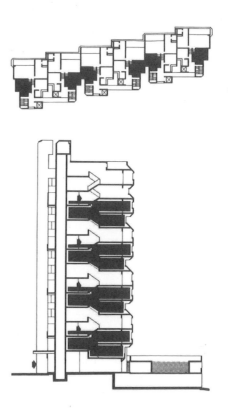

4 Pandan Valley:

The Domestication of "Rural" Singapore

When Pandan Valley was launched for sale in November 1977, it was described by the newspapers as a "test case for the relevance of condominium housing in the Singapore lifestyle."[45] The development designed by Tan Cheng Siong and his Archynamics Architects (which later dissolved and led him to start Archurban Architects Planners in 1974) was one of the earliest to be approved under a new condominium planning policy introduced by the government on 16 May 1972.[46] Singapore's Chief Planner Tan Jake Hooi had released a circular outlining the state's concern with the "'wasteful sprawl' of low-density housing estates in the outer suburbs of the city".[47] These typically consisted of terrace and semi-detached houses built eight to ten kilometres outside the city centre, and had a density of 30 to 50 units an acre compared to the average of 500 units per acre in public housing development. Such developments were not an efficient use of land and often failed to provide residents with sufficient well-maintained green and open spaces.

Instead, Tan identified "condominiums" as a new solution in Singapore that was in line with the government's desire to intensify development across the country. They typically contained multiple units on an undivided plot, and had communal facilities and open spaces for recreation that could "create a better living environment in which community consciousness and cooperation will also be fostered".[48] The Ministry of National Development began offering incentives to encourage private developers to build condominiums. For instance, it allowed increased residential densities of up to twice that stated in the Master Plan if their design adhered to the other planning controls of the policy. The two main controls were setting the minimum plot size of homes at 1 acre or 0.4 hectares to restrict land subdivision and fragmentation, and to limit building coverage to 20 per cent of the site area so as to ensure sufficient open, green space.[49]

The push for condominiums led to the spread of private apartments from Singapore's city centre to its suburbs.[50] Prior to the policy's introduction, some private developers had already started experimenting with similar developments in the central area where land was at a premium, such as Beverly Mai (1974), Futura (1976) and Pearl Bank Apartments (1976). (see Futura and Pearl Bank Apartments) While these largely came as single apartment towers, condominiums in the suburbs had multiple blocks because they were built on larger plots of land. Several early examples even

combined buildings of different typologies to achieve the residential density. For instance, Pandan Valley organised its 605 units in seven blocks across 20 acres of land; it had three block types: step, slab and tower.[51] Its neighbour in Ulu Pandan, Ridgewood, consisted of townhouses, tower blocks and garden apartments.[52]

Such combinations of different building types in a single development surprisingly fulfilled what state planners hoped the condominium guidelines would achieve. They had not stipulated the form of such developments, but instead left it to the "imagination, inventiveness and ingenuity of architects and other professionals involved".[53] The ambiguity, however, also led to the delay of projects such as another Archynamics Architects' development, Faber Garden along Angklong Lane. It was conceived around the same time as Pandan Valley in the early 1970s but was only completed in 1984. The condominium combines mid-rise stepped blocks with tower blocks and went through several rounds of building plan submission before receiving final approval from the authorities.[54] By then, Archynamics Architects, had split up and the project came under one of its other partners, Chan Fook Pong, who founded Regional Development Consortium Architects in 1974.

Besides the form of apartment buildings, another key aspect of the condominium policy was the planning and design of open spaces and common facilities. At Pandan Valley, the buildings were carefully planned around the undulating topography of its site. The natural valley at its centre was retained as a part of the landscape and inspired its name. Residents also had access to a range of facilities, including shops, two swimming pools, six squash courts and two gymnasiums. A similar emphasis on planning the garden and communal facilities was also evident in Hillcrest Arcadia, a condominium designed at the edge of Bukit Timah by Chan Kui Chan Architects & Planners. *Building Materials & Equipment* described in a 1977 report how its collection of two 3-storey walk-up blocks, two 14-storey high-rise blocks, and three 9-storey terraced garden blocks were organised to take full advantage of the views of the nearby MacRitchie Reservoir and Singapore Turf Club.[55] The developers had also set aside a portion of the total project budget specifically for landscaping, and even came up with its name that was "possibly

the first time in Singapore a hill has been honoured in this fashion".[56] Such green features became a defining characteristic for those who lived in condominiums, according to a 1982 survey. "What makes life in a condominium so liveable is the presence of recreational facilities and open space through which the tension that goes with high-rise, high-density living can easily be released," explained the researcher, Dr Teo Siew Eng of the Geography Department at the National University of Singapore.[57] Today, the idea of condominiums as lush, green environments continues to feature prominently in property advertisements and brochures.

Besides drawing up the framework for the design and planning of privately developed apartments in the suburbs, the main aspect of the condominium policy was to define the legal concept of ownership and management in such properties. The word "condominium" can be traced to the Latin root for "co-ownership" and the policy led to a raft of changes to express this. Amendments were made to the Land Titles (Strata) Act to include the common interest in the common spaces of such properties while recognising a separate interest in space within it.[58] The Building and Common Property (Maintenance and Management) Act (1973) was also enacted to spell out that a syndicate of co-owners was responsible for the management of the whole condominium property.[59] These aspects of the policy have very much defined the life and death of such developments in Singapore as its residents have jostled over a range of issues, from how best to maintain the estate as it ages and whether to sell it for redevelopment. Such undesirable social attitudes were predicted by at least one early sceptic of the condominium concept and incidents have exposed the challenges of the state's original hope that such developments would create a sense of community amongst its residents.[60]

Although condominiums have become an aspirational form of living for many Singaporeans—even becoming one of the five Cs desired by its citizens in the 1990s, the others being credit card, cash, car and country club membership—the policy was controversial when it was first introduced. High-rise apartments might have sold well in the denser city centre, but developers were unsure how buyers would respond to such housing in the suburbs.[61] Several even accused

the government of creating a lull in the private housing market as the policy's lack of clarity led to the freezing of at least two dozen developments and the return of three plans for readjustment.[62] As one developer then reportedly asked: "Who wants a common garden in rural areas?"[63]

It turns out that many Singaporeans do today.

Notes

45 "Pandan Condominium Project a Test Case," *The Business Times*, 21 November 1977.
46 "Condominium Flats Go on Sale Today," *The Straits Times*, 19 November 1977.
47 William Campbell, "Condominium: New Housing Style for Gracious, Better Living," *The Straits Times*, 8 January 1973.
48 Ibid.
49 N Khublall, *Strata titles* (Singapore: Butterworths Asia, 1995), 51.
50 Ibid.
51 "Condominium Flats Go on Sale Today."
52 "Ridgewood: Condominium Housing at Ulu Pandan/Ridgewood," *Journal of the Singapore Institute of Architects* 74 (1976).
53 William Campbell, "Designs for Better Living…," *The Straits Times*, 9 January 1973.
54 "Faber Garden Condominium A Return to Nature", *Building Materials & Equipment*, March 1981.
55 "Condominium-Style Living Catches on in Singapore," *Asian Building & Construction*, September (1980).
56 "Hillcrest Arcadia: A S$40 Million Condo Adventure", *Building Materials & Equipment*, December (1977).
57 Monica Gwee, "More Opting for Condominium Life," *The Business Times*, 10 September 1983.
58 William Campbell, "A Complex Legal Concept of Home Ownership," *The Straits Times*, 10 January 1973.
59 Wong Tai-Chee, *A Roof over Every Head: Singapore's Housing Policies in the 21st Century* (Calcutta: Sampark, 2005).
60 "Doubt over New Plan for Homes," *New Nation*, 23 November 1972.
61 Campbell, "Designs for Better Living…."
62 Abby Tan, "The Big Freeze in Housing Projects," *New Nation*, 12 October 1972.
63 S. V. Suppiah, "Condominium Concept Causes Lull in Housing Development," *New Nation*, 29 July 1972.

4.1 Site plan of Pandan Valley showing the arrangement of its three building types—step, slab and tower blocks—and car parks.

4.2 Perspective drawing of Pandan Valley illustrating how common spaces like playgrounds and gardens were carefully designed to encourage interactions among the residents. Such landscaped environments have become key in condominium developments.

4.1

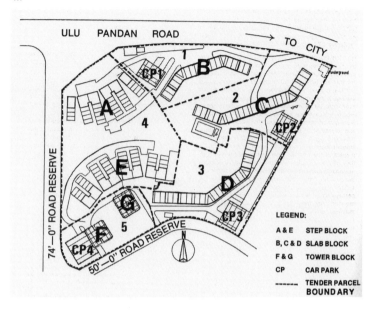

4.2

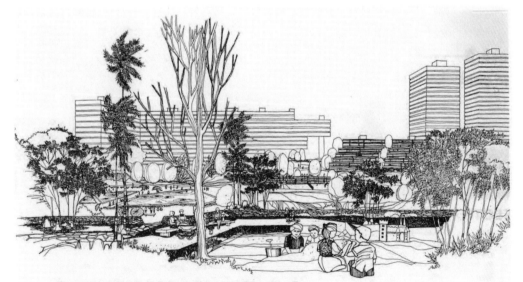

Perspective View From Block A

4.3

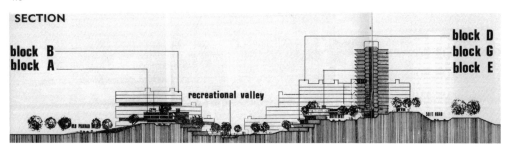

SECTION

block **B**
block **A**

recreational valley

block **D**
block **G**
block **E**

4.3 A section drawing of how Pandan
 Valley's different block types were
 designed in response to the
 topography of the site. The stepped
 blocks were sited on the slope and
 the point blocks on the narrow
 hilltop.

4.4 A 1977 advertisement touting
 Pandan Valley as offering "the best
 of everything". As a new type of
 residential development introduced
 in Singapore in 1972, the
 condominium was seen as a "test
 case" for the nation's lifestyle.

4.5 Ridgewood, located next to Pandan
 Valley, was another condominium
 development consisting of different
 building types in a green
 environment as depicted in this
 1977 advertisement.

4.6 A 1977 advertisement promoting
 Hillcrest Arcadia as offering "the
 healthy life in condominium style"
 due to its lush landscape and
 garden apartments.

4.4

4.5

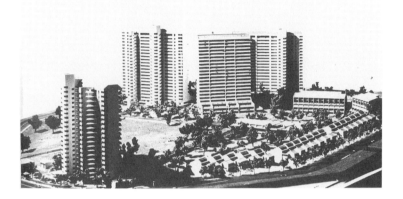

4.6

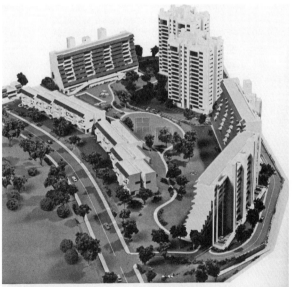

Pearl Bank Apartments:

How Can We Maintain the High Life?

The life and death of Pearl Bank Apartments tells the tale of how high-rise living can be a tall order. Over its four decades of existence, the apartment tower experienced the ups and downs typical of a private communal residence in Singapore; it ultimately met its end in 2019.

Completed in 1976, Pearl Bank was hailed as the tallest apartment block in Southeast Asia.[64] Modern high-rise buildings were just emerging in Singapore, but, even then, the development designed by Tan Cheng Siong, who was then part of Archynamics Architects, stood out on top of Pearl's Hill. Rising to 37 storeys, Pearl Bank towered above the nearby low-rise shophouses in Chinatown and the 16-storey Outram Park public housing estate next door. The single horse-shoe shaped tower was designed to house some 1,500 residents in an over 80,000 square feet site, and it was regarded as the densest private residential development in Singapore at the time.[65]

The "high life"—high-density and high-rise—envisioned by Pearl Bank and a slew of pioneering apartment towers in the 1970s was crucial for land-scarce Singapore with its rapidly growing population. Conventional private housing typically came in the form of terrace and semi-detached houses or bungalows in small fenced-in compounds. Pearl Bank contained 280 units of two-, three- and four-bedroom apartments, including eight penthouses with roof terraces, and eight commercial units. These were stacked up in rows of eight on each floor, rising up to 113.4 metres atop Pearl's Hill—a towering example of the modern concept of owning "airspace" in Singapore.

This was made possible by the Land Titles (Strata) Act of 1967, which allowed for property to be divided in vertical blocks, known as strata, instead of the traditional horizontal division of land. The act, imported from New South Wales, Australia, also outlined the notion of "common property"—lift lobbies, corridors, lawns, car parks, rubbish collection areas—within a housing development that were co-owned by all its residents. The "strata" allowed developers to build private homes within the reach of the middle class in Singapore, except these were located in the air instead of on traditional landed property. Pearl Bank was an early example of such a strata development, and the apartment tower also housed facilities, including a communal level on its 27th storey that was planned with a multipurpose hall, game room, billiard room and library.

While Pearl Bank is recognised as a condominium today, the development actually prefigures the introduction of this planning concept in Singapore. Instead, Pearl Bank came out of the government's third sale of sites programme in 1969, when developer Hock Seng Enterprises bought the first-ever piece of land in the city centre that was earmarked for private high-rise housing. It was only during Pearl Bank's construction that "condominiums" were formally introduced in 1972 by the Ministry of National Development. This spurred the development of private residences made up of apartment blocks with open, green spaces for recreation (see *Pandan Valley*). Although the ministry envisioned condominiums to "create a better living environment in which community consciousness and cooperation will also be fostered", it also raised the question of how owners who had "an undivided interest in common" would maintain the shared spaces.[66] The Building and Common Property (Maintenance and Management) Act was introduced in 1973 to address the issue, but developers and residents continued tussling over how best to achieve this and at what cost.

By 1981, the Singapore Institute of Architects (SIA) highlighted maintenance as a "critical problem" of condominium living in Singapore.[67] Not only was there a lack of manpower and expertise in this area, the organisation of professional architects anticipated that the ever-rising costs as estates aged would "put a strain on the residents".[68] In addition, while condominium facilities were supposed to encourage more intermixing and a gracious living amongst residents, they would also "sometimes bring about greater conflicts". Several months later, the Minister of State (National Development), Lee Yock Suan expressed similar concerns. According to him, it was "not unusual" in condominiums for "first-floor owners refusing to pay more for lift maintenance and non-car owners refusing to pay towards upgrading car-parking facilities".[69] Such myopic views had to be addressed as more condominiums were built in Singapore, or it would result in the "degradation and devaluation" of such properties.

Pearl Bank exemplified these various challenges over its lifetime. A decade after completion, one of its lifts was damaged when the chain linking the lift car to its shaft crashed through the roof. In 1991, plaster started peeling off the tower's exteriors. The building supervisor installed a cargo container at the block's entrance to protect residents from falling debris, a makeshift solution which ended up sitting there for months.[70] Such incidents, including other reports of its lifts breaking down frequently, water leaks and even rats in the apartments, created a public perception of Pearl Bank as "run-down" and "ageing".[71] These problems were compounded by an increasing indifference from owners, some of whom began renting out their apartments and even illegally partitioning them to house more tenants. Many consistently voted down higher maintenance fees, preventing repairs from being carried out.[72] These challenges were not unique to Pearl Bank. Other early strata developments of the era, such as Golden Mile Complex (1972-3) also deteriorated so much that then Nominated Member of Parliament Ivan Png said it had become a "vertical slum".[73] The economist added that such a "terrible eyesore and national disgrace" was the most extreme example of how strata buildings could deteriorate due to individual owners looking out only for their own interests. (see *Lucky Plaza*)

For Pearl Bank, the tipping point came in 2007 when a majority of its owners had enough of what had become an "ugly, concrete monster"[74]. While an attempt two years earlier to list the over three-decades-old apartment for collective sale failed to achieve the required 80 per cent of votes from owners , it was successful this time around. At the right price, the owners would sell their apartments to a buyer who would most likely demolish and build anew. Pearl Bank became one of several condominiums put up for sale that year as an "en bloc fever" raged on in Singapore. They collectively revealed how fragile "communal living" was in condominiums as the decision to en bloc often divided residents into two camps. As at least 80 per cent of the residents must agree for a condominium to be put up for collective sale, the "sellers" harassed and coerced the "stayers". Things got so ugly that it even spurred a group of residents from different estates facing en bloc to come together and to create a website to share information, called "Hope" (Home Owners Protecting Entitlements).[75]

The appetite for en bloc in 2000s was encouraged by various shifts in government policy as Singapore faced an ageing cluster of first-generation modern properties built in the

1970s. In 1999, the strata law was amended to remove the need for unanimous consent in a collective sale. Then in 2005, the Singapore Land Authority streamlined the process of collective sales by establishing a precedent and granting in-principle approval to top up the lease of the site which the mixed-use development Eng Cheong Tower stood on. By removing the previous need for a formal application, it reduced the risk for developers and sped up sales.[76] As a result, en bloc became a profitable alternative to residents spending ever more money to maintain their apartments. To encourage collective sale, some even began encouraging poor maintenance to create a dilapidated property.[77] When Pearl Bank was put up for sale in 2007, the chairman of the en bloc committee and resident Patrick Tan explained why it made sense. "This is a very old building. We've spent a lot of money on maintenance. It's just too expensive to upkeep."

However, Pearl Bank's asking price—S$750 million—was too expensive for the market in 2007, and again in 2008 and 2011. By then, the threat of its extinction had roused architects and heritage groups to call for the apartment's conservation and even spurred a group of residents to rally against the "condo raiders"[78] in 2014. Working with the architect of Pearl Bank, the group submitted the building for voluntary conservation. They proposed that its land lease be extended and for permission to be granted to build a second apartment block on top of its

five-storey car park so as to raise funds to retrofit the existing building. Almost 90 per cent of the residents voted in favour of this plan, but unlike a collective sale, the law required unanimous consent for its conservation.

In 2019, Pearl Bank was finally sold on its fourth collective sale attempt for S$728 million. Despite attempts behind the scenes to convince the developer to conserve it as part of a new development, CapitaLand soon unveiled an entirely new design containing 774 apartments ranging from studios to penthouses. It was a bittersweet vindication of the original architect's vision on how attractive living in a modern city could be.

"At the time when I first conceived it, I sincerely believed that there must be an answer to city living. Because most of us wanted to desert the city at that point of time to go to a landed property with a garden. That was the ideal," Tan says.[79]

Although condominium living offered the benefits of shared facilities at a fraction of the cost of maintaining one's own place, it also raised the question of how a group of residents could maintain them over time.

"When you build super-high, it is super difficult: more people, more quarrels, more differences," says Tan. "Because of that we have to learn how to live together in a very positive and creative way."

Notes

64 "Going up in S'pore S-E Asia's Tallest Flats," *The Straits Times*, 13 July 1970.

65 Ng Huiwen, "Pearl Bank Apartments Sold: What Makes the Development Iconic?" *The Straits Times*, 13 February 2018.

66 "Report on Condominiums," *Journal of the Singapore Institute of Architects*, 55 (1972): 2–19.; William Campbell, "Condominium: New Housing Style for Gracious, Better Living," *The Straits Times*, 8 January 1973.

67 "Editorial," *Journal of the Singapore Institute of Architects*, 107 (1981): 1.

68 Ibid.

69 Irene Ngoo, "Professionals to Help Spruce up Private Housing," *The Straits Times*, 1 November 1981.

70 Lesley Koh, "Containing the Danger," *The Straits Times*, 6 December 1991.

71 "A Hidden Emerald," *The Straits Times*, 29 June 2003; "Man Stuck in Lift for Seven Hours," *The New Paper*, 28 January 2006; Val Chua, "New Lease on Life for Ageing Properties," *Today*, 20 July 2005; Pearl Lee, "Pearl Bank Still Special after All These Years," *The Straits Times*, 2 May 2014.

72 Personal interview with long-time resident Ed Poole over email between 14–16 June 2016.

73 "Parliamentary Debates Singapore Official Report Tenth Parliament Part II of Second Session," Budget (Singapore: Parliament, 6 March 2006), https://sprs.parl.gov.sg/search/report?sittingdate=06-03-2006.

74 Desmond Ng, "Ugly Monster," *The New Paper*, 30 April 2007.

75 Lim Wei Chean and Arshad Arlina, "Hope for Owners Fighting En Bloc," *The Straits Times*, 11 August 2008.

76 Kalpana Rashiwala, "Eng Cheong a Good Collective Sale Model," *The Business Times*, 11 January 2005.

77 "En Bloc Investors or Just Vultures?" *The Straits Times*, 27 May 2007.

78 Retrieved from Ed Poole's Facebook from 15 March 2010.

79 Personal interview with Tan Cheng Siong on 30 March 2016.

5.1 A 1976 advertisement for Pearl Bank
 declaring the 37-storey apartment
 block as the tallest in Southeast Asia.
 It was also one of the earliest modern
 high-rise residences in Singapore.

5.2 A sectional perspective of a typical
 split-level apartment unit in Pearl
 Bank. The innovative design offered
 rich and layered spatial experiences.

5.1

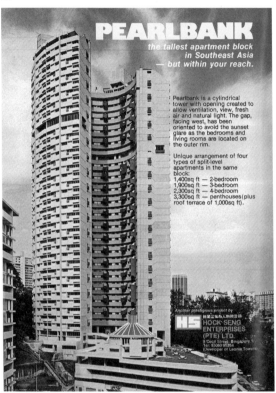

5.2

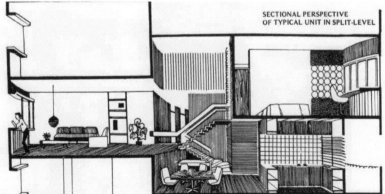

5.3 As Pearl Bank aged and its residents gave way to tenants, it became more challenging to maintain the building. Issues such as leaking were unresolved and turned the building into an eyesore.

5.4 In 2014, Pearl Bank's original architect worked with some residents to create a conservation proposal. The plan to rejuvenate the development with a new residential block failed to get the required approval from all owners.

5.5 Even after Pearl Bank was sold in 2018, various architects created alternative proposals to demolishing the building entirely. One example by Docomomo Singapore sought to rehabilitate the building by injecting a mix of uses including assisted living, co-working spaces and luxury apartments.

5.3

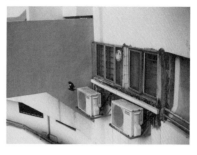

5.4

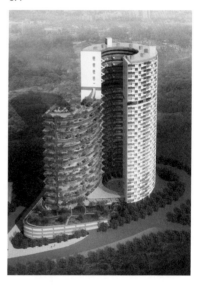

5.5

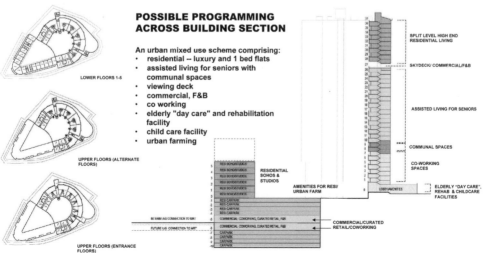

POSSIBLE PROGRAMMING ACROSS BUILDING SECTION

An urban mixed use scheme comprising:
- residential -- luxury and 1 bed flats
- assisted living for seniors with communal spaces
- viewing deck
- commercial, F&B
- co working
- elderly "day care" and rehabilitation facility
- child care facility
- urban farming

LOWER FLOORS 1-5

UPPER FLOORS (ALTERNATE FLOORS)

UPPER FLOORS (ENTRANCE FLOORS)

SPLIT LEVEL HIGH END RESIDENTIAL LIVING

SKYDECK/ COMMERCIAL/F&B

ASSISTED LIVING FOR SENIORS

COMMUNAL SPACES

CO-WORKING SPACES

ELDERLY "DAY CARE", REHAB & CHILDCARE FACILITIES

COMMERCIAL/CURATED RETAIL/COWORKING

RESIDENTIAL SOHOS & STUDIOS

AMENITIES FOR RESI/ URBAN FARM

Play

6-13

6 Cinemas: The Architecture of Advertisement

Touted as the "first little 'skyscraper'" in Singapore, the 87-metre-tall Cathay Building completed in 1941 was well known as the tallest building in the city.[1] It had apartments offering views as far as the Johore Strait, but the building itself offered an equally impressive view on the ground from the foot of Mount Sophia. The front of the building, which housed a cinema, featured a stepped façade that gradually receded into a series of walls with rounded corners, and were complemented by thin horizontal fins. These elements of the art deco style, specifically of the streamline moderne variant, was then the architecture language of choice for fashionable cinemas in the West.[2] The Cathay Building's façade was on trend in another way. It had a tall vertical element that announced the cinema's name, and below it was the main billboard and the marquee that advertised the movie on show. All three elements were illuminated at night—turning the cinema into an example of Lichtarchitektur (light architecture) as first imagined by German architects in the 1920s.[3]

The Cathay Building bore all the hallmarks of modern architecture that its owners, Lim Cheng Kim (or Mrs Loke Yew) and her son Loke Wan Tho, must have encountered on their round-the-world trip during which they conceived of the cinema.[4] Its aesthetic also came to embody the latter's vision for cinema design, which he articulated some years later: "The cinema business more than any other business, sells its goods by means of front-of-the-house advertising. The whole of the façade of a cinema is, in fact, its shop window."[5]

The Cathay Building indeed helped its cinema, which officially opened in October 1939, stand apart from others in Singapore. Unlike the Alhambra and the Capitol, two prominent cinemas of the era that were both built in the eclectic classical style, the Cathay Building was "instantly recognizable as new, as fashionable".[6] Although the Pavilion Cinema, built in the 1920s and located further up on Orchard Road also had an art deco façade that was decorated with chevron patterns, it was a much simpler and humbler building in comparison. As a 1939 advertisement for the Cathay Building suggested, it represented "the final word in Modernity, Artistry and Efficiency".[7]

The building's modern exterior extended into its equally impressive and luxurious interior. The crush hall (entrance hall) had black marble walls and columns, green tiled floors, chrome railings and a gold ceiling.[8] Its 1,321-seat auditorium featured acoustic panels crafted in the shape of

peacock wings set next to decorative columns capped in capitals with floral motifs. The Lokes spared no expense on design: the Shanghai-based British sculptor W. W. Wagstaff, who was behind the famous bronze lions of the 1935 Hong Kong headquarters of the Hong Kong and Shanghai Banking Corporation, was specially brought in to supervise the moulding of the frescoed walls and ceiling; while the Russian artist Vasily A. Zasipkin, who moved from Shanghai to Singapore in 1937, was hired to decorate the interior.[9] Besides modish décor, the Cathay Building's interior also had technologically advanced fittings and provisions for comfort. It was the first cinema in Singapore to be air-conditioned,[10] and had upholstered seats and special lighting, as well as the latest sound system.

While the media by and large lavished praise on the Cathay Building, some members of the public were appalled by such conspicuous architecture that was designed to stimulate consumption. Even before the cinema opened, a reader caustically remarked in *The Straits Times* that the building was the latest example of buildings in Singapore getting "uglier and uglier" in a letter published next to a headline "Modernism Invades Dhoby Ghaut":

> This looks as though the owners had said: 'Design the building for neon lights,' and now we have the Dhoby Ghaut exercise in modernistic architecture, which certainly does not look complete without its neon lights....[11]

Such distaste for modernistic architecture was met with a robust defence by another reader who felt that Singapore had to keep up with world trends, particularly "towards cleanness of line and boldness of style adopted (for very good reason) by the modern architect".[12] This same reader added that there was nothing wrong with the building being lit up, because "is not Neon light one of the gayest forms of decoration?"[13]

The question of decoration goes to the heart of art deco, which was a transitional style between classical buildings and modern buildings. It was essentially a decorative approach that was popularised by, and named after, the 1925 Exposition des Arts Décoratifs et Industriels Modernes held in Paris. While initially applied by industrial designers to a broad range of products

from cigarette lighters to fridges, it was then adopted by architects to decorate their classically planned buildings so they looked modern.[14] Such was the case of the Cathay Building, whose architect Frank Wilmin Brewer was better known for works that appeared inspired by the earlier arts and crafts movement. His buildings—such as the house at No. 1 Dalvey Road (1927), the Anglo-Chinese School at Cairnhill (1928), and St. Andrew's School (1939)—typically featured arched openings, venetian windows, textured walls with buttresses, and pitched roofs with flared eaves.[15] The Cathay Building was the only major art deco building in Brewer's oeuvre besides a 1936 clubhouse for the Singapore Swimming Club.[16]

The 1930s also saw other buildings in colonial Singapore turn to the art deco style to project modernity. Just two years prior to the completion of the cinema in the Cathay Building, the Public Works Department finished the main terminal building at the Singapore Civil Aerodrome complex at Kallang—one of the department's earliest works in the streamline moderne style.[17] Local architect Ho Kwong Yew also designed several grand houses, such as the Chee Guan Chiang House (1938) at Grange Road and Aw Boon Par House (1937), that combined the streamline aesthetics of art deco with other motifs that fitted their owners' tastes to display their wealth and cultural capital.[18] The currency of the style in Singapore continued after the Second World War when it was used on the headquarters of two prominent financial institutions: the Bank of China Building (1953) by Palmer & Turner, and the Asia Insurance Building (1955) by Ng Keng Siang. The latter even replaced the Cathay Building as the tallest skyscraper in the colony by topping out at 18 storeys.[19]

By the 1950s, art deco was making way for the international style, which was truly becoming international.[20] Loke must have been aware of this shift as he chose the latter for his new flagship cinema. Officially opened in 1953, the Odeon Theatre designed by Palmer & Turner was then hailed by Loke as a modern example of "design follow[ing] function". Specifically, the Odeon's façade had "signs and cut-out displays ... plastered all over its face"[21] and a third of it was left for the placement of movie advertisements. Like the Cathay Building, it also had a vertical architectural element that held up the cinema's

name in a neon sign, but this was clad in gold-coloured aluminium and positioned off-centre as part of a modernist composition.[22] In another sign of its modernity, the Odeon was the first cinema in Singapore designed to be integrated with the automobile. It was raised on pilotis to accommodate a car park for more than 100 vehicles at the ground floor, and had a drive-in ticketing office for patrons to purchase tickets without leaving their cars.[23]

The Odeon was followed by a series of other modernist cinemas, including the Globe Cinema (1959-1978) in Great World and the Lido Theatre with its adjoining Shaw House (1958-1990). Both were designed by Gordon Dowsett of Van Sitteren & Partners.[24] The Globe Cinema was a particularly "outstanding work" of the architect, according to Eu-Jin Seow who was a pioneer architect and former professor and head of school at National University of Singapore. He praised the way Dowsett utilised the angle of the balcony seating and the slope of the upper balcony roof to create a wedge-like "dramatic form" that floated above the entrance foyer, which was further exposed by the totally glazed front and sides of the foyer.[25] It created an especially impressive sight at night as what looked like different coloured lights lined the edges of the cinema's unusual volumes, while circular globe lights illuminated the sloping ceiling of the foyer, rendering it visible to the outside.

The Cathay Building, Odeon Theatre and Globe Cinema perhaps represented the glamorous age of cinema design in Singapore between the 1930s and 1950s. While modernist cinemas continued to be built after, particularly in the emerging new towns in the suburbs, they were often plain looking, utilitarian structures. Some exceptions include the Queenstown Cinema and Bowling Centre (1977) designed by Chee Soon Wah. It was a structure clad in exposed bricks and whose massing of interlocking slopping volumes was reminiscent

of the works of Finnish modernist architect Alvar Aalto. That most new cinemas built between the 1960s and 1980s came in mere functional shells perhaps reflected how cinemagoing had become an everyday affair, and attention-grabbing architecture was no longer needed to draw patrons in.

However, the arrival of Yishun 10 in 1992 shook up cinema design again.[26] The first proper multiplex in Singapore was designed by architect Geoff Malone. He was told to conceive "something that looked as though it landed in Yishun from outer space" and would stand out from the surrounding public housing estate.[27] His response was a building with metallic and red cladding, sprinkled with technological motifs drawn from science fiction and red, orange and blue strips of neon that lit up at night. Yishun 10 offered a futuristic beacon for the estate, but the local cinema industry had been battered in the 1980s by the arrival of video-cassette tapes. Many cinemas closed down and several were even converted for other uses. (see Cinema-Churches)

Although some considered the multiplex to be a "monstrosity" that suffered from an "elephant-iasis of neon lights",[28] Yishun 10 proved to be very popular with cinemagoers as its striking exterior was complemented with a more comfortable and convenient cinemagoing experience. Within a short time, it attracted a record turnover and popularised the concept of a multiplex within Singapore and the region.[29] The success was testament to owner Golden Village Entertainment's plan for a flamboyant exterior, which would help the new entrant to Singapore's cinema industry stand out from the competition. In the words of its managing director, John Crawford, Yishun 10 sought to be "more demonstrably high-tech, and demonstrably entertainment-based"[30]. Some four decades after Loke expressed his belief in using architecture as a form of advertisement, it was such a cinema that jolted the industry back to life again in the nineties.

Notes

1 "Singapore's First 'Skyscraper' in the Making,"
 Malaya Tribune, 10 July 1939.
2 For cinemas in the art deco style around the
 world, see Edwin Healthcote, *Cinema Builders*
 (Chichester: Wiley-Academy, 2001), 20–24.
3 Ibid., 38.
4 "Cathay Cinema Opens Door Tonight," *The
 Singapore Free Press*, 3 October 1931.
5 Loke Wan Tho, "Utmost in Beauty & Comfort," *The
 Singapore Free Press*, 8 June 1953.
6 Healthcote, *Cinema Builders*, 21.
7 "Cathay," *The Straits Times Annual*, 1 January 1939.
8 "Cathay Cinema: Artist's Pictures of the Interior,"
 The Straits Times, 9 April 1939.
9 Lim Kay Tong, *Cathay: 55 Years of Cinema*
 (Singapore: Landmark Books, 1991), 97–98;
 "Singapore's First 'Skyscraper' in the Making."
 On Zasipkin, see "New Singapore School of Art,"
 Sunday Tribune (Singapore), 10 October 1937.
10 The Alhambra, housed in an older existing
 building, was fitted with air-conditioning in 1938.
 The Capitol had a cooling system installed when it
 was completed in 1930 but that system was not a
 conventional air-conditioning system as it did not
 involve refrigeration and dehumidification. For the
 former, see "Mountain-Air Climate in Singapore,"
 *The Singapore Free Press and Mercantile
 Advertiser*, 27 July 1938. For the latter, see
 "Cinema and Theatre: Largest and Best Equipped
 in East," *The Singapore Free Press and Mercantile
 Advertiser*, 14 August 1929.
11 W.G.H., "Supreme Court and Cathay Cinema:
 Criticism of New Singapore Architecture," *The
 Straits Times*, 12 June 1939.
12 "Singapore in Transition: The Cathay Design
 Defended," *The Straits Times*, 16 June 1939.
13 Ibid.
14 Patricia Bayer, *Art Deco Architecture: Design,
 Decoration and Detail from the Twenties and
 Thirties* (London: Thames & Hudson, 1992).
15 Eu-jin Seow, "Architectural Development in
 Singapore" (unpublished PhD thesis, University of
 Melbourne, 1973), 331–35; Julian Davison, *Swan
 & Maclaren: A Story of Singapore Architecture*
 (Singapore: ORO Editions and National Archives
 of Singapore, 2020), 319-21; May Seah, "Former St
 Andrews School was Carefully Restored with the
 Help of Photographic Records," *The Straits Times*,
 4 November 2017; Lea Wee, "A Glimpse of Good
 Class Bungalows, the Biggest and Rarest Houses
 Here," *The Straits Times*, 17 September 2016.
16 "Malayan Architectural Personalities: Frank Wilmin
 Brewer, F.R.I.B.A.," *The Malayan Architect* 7, no. 8
 (1935): 185.
17 Wong Yunn Chii, "Public Works Department
 Singapore in the Inter-War Years (1919–1941):
 From Monumental to Instrumental Modernism"
 (unpublished research report, National University
 of Singapore, 2003), 83–89.

18 Jiat-Hwee Chang, "The Visual Culture of
 Sinophone Modernism: Aw Boon Haw's Cultural
 Entrepreneurialism and Early Twentieth-Century's
 Architectural Eclecticism," *Southeast of Now* 5,
 no. 1-2 (2021); Ho Weng Hin and Tan Kar Lin, "Ho
 Kwong Yew," in *Southeast Asian Personalities of
 Chinese Descent: A Biographical Dictionary*, ed.
 Leo Suryadinata (Singapore: Institute of Southeast
 Asian Studies, 2012); "New Residence Grange
 Road - Singapore - for Chee Guan Chiang," *The
 Malayan Architect* 10, no. 2 (1938); "Mansion on a
 Hill: Work Nearing Completion," *Morning Tribune*,
 12 March 1936.
19 "Skyscraper Is a 'Sign of Faith'," *The Straits Times*,
 20 June 1953; "Colony 'Skyscraper' Ready This
 Month," *The Straits Times*, 6 November 1955.
20 When Henry-Russell Hitchcock and Philip Johnson
 called architecture of the modern movement
 "international style" in an exhibition of the same
 name at the Museum of Modern Art in New
 York City in 1932, only about 16 countries were
 represented in the catalogue. At that time, most
 territories of the world were colonies and not
 sovereign nations. Even among the around 60
 nation states in existence then, only a small
 portion was represented. See Anthony D. King,
 "Internationalism, Imperialism, Postcolonialism,
 Globalization: Frameworks for Vernacular
 Architecture," *Perspectives in Vernacular
 Architecture* 13, no. 2 (2006).
21 Loke, "Utmost in Beauty".
22 Geoffrey Boland, "This New Cinema Will Have 'Cry
 Room,' Five Bars—and 3D," *The Straits Times*, 29
 March 1953.
23 "City's Best Car Park, Deaf Aids and a Cry Room,"
 The Singapore Free Press, 8 June 1953.
24 "New Cinemas Built under Huge Progress Plan,"
 The Singapore Free Press, 29 April 1958.
25 Seow, "Architectural Development" 367.
26 The first multiplex was created in 1988, when
 Shaw Brothers split the Jade and Prince cinemas
 at the podium of Shaw Towers into smaller
 cinemas. However, Yishun 10 was the first new
 building to be conceived, built and operated as a
 multiplex. Ravi Veloo, "They Came, They Saw, They
 Conquered," *The Straits Times*, 15 March 1994.
27 Ibid.
28 Quoted in Ida Bachtiar, "Yishun's Perfect 10," *The
 Straits Times*, 29 October 1992.
29 Rebecca Lim and Ravi Veloo, "Golden Village
 Enters KL with Two Multiplexes," *The Straits Times*,
 15 July 1994.
30 Veloo, "They Came, They Saw, They Conquered."

6.1 A 1939 advertisement for the Cathay
 Building highlights its art deco façade
 that lights up at night. It illustrated the
 owner's vision of the cinema façade
 as a shop window.

6.2 Exterior view of the Cathay Building
 during the day, c. 1950s. The design
 was an example of how buildings in
 colonial Singapore turned to the art
 deco style to project modernity.

6.3 The Cathay's auditorium featured
 acoustic panels in the shape of
 peacock wings next to decorative
 columns capped in capitals with
 floral motifs.

6.1

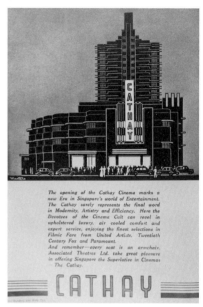

6.2

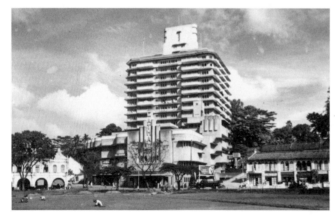

6.3

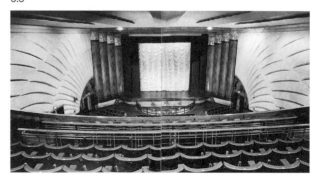

6.4 The Odeon Theatre, completed by Palmer and Turner in 1953, was another example of Loke's vision of cinemas designed as an advertisement.

6.5 The Globe Cinema at Great World Amusement Park was another example of the glamorous age of cinema design in Singapore.

6.6 Completed in 1992, Yishun 10 echoed earlier ideas of cinema design with its high-tech exterior that came alive with the glow of neon lights.

6.4

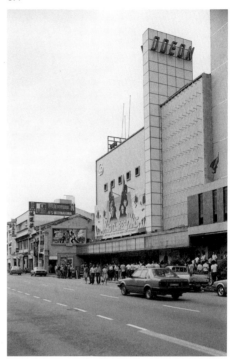

6.5

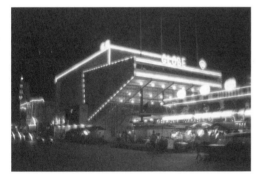

6.6

7 **Shopping Centres:**

Moving Retail from the Streets to the Interior

When Prime Minister Goh Chok Tong declared during his 1996 National Day Rally that "Life for Singaporeans is not complete without shopping!"[31] he may very well have added that Singapore is incomplete without its shopping centres. Today, the city-state has over 100 of them, a staggering number that has become unsustainable, and even obsolete, with the rise in e-commerce.[32] But in the 1970s, the arrival of "shopping-under-one-roof" in Singapore was regarded as a realisation of a futuristic concept according to this news report:

> Shopping, the instant way and in cool comfort was something of the future... [t]hose multi-storeyed complexes, air-conditioned, beautifully decorated and stocked with everything that anyone could almost wish to buy under one roof was a shopper's dream.[33]

Shopping centres in Singapore indeed offered a new way of retail that was spatially, temporally and programmatically distinct from before.[34] Once conducted in shophouses lining vehicular streets, shopping now happened within multi-storey interiorised, pedestrianised and air-conditioned environments that protected shoppers from the city's heat and humidity, as well as from the noise and pollution of its streets. Many early shopping centres literally displaced old shophouses as they were built on land purchased from the government as part of its urban renewal programme that began in 1967. The state acquired small plots of land in the central area, upon which shophouses sat, and consolidated them into larger parcels for sale to private developers in a tender system.[35] What often emerged were mixed-use developments built in the form of a single podium tower that had retail and commercial units in the lower-level podium forming a "shopping centre" and a residential or office tower above.(see People's Park and Shenton Way) Early examples include Specialists' Shopping Centre (1972), People's Park Complex (1973, with the shopping podium opening earlier in 1970),[36] Woh Hup Complex (1972-3, later renamed as Golden Mile Complex), Plaza Singapura (1974), and Queensway Shopping Centre (1974).

Shopping centres were a mid-century North American invention, and those in Singapore exhibited similar features to what architectural historian Margaret Crawford has characterised as "an inverted space whose forbidding exteriors hid paradisiacal interiors."[37] Not only were they

introverted entities organised around "internal concourses" and "interior courtyards," or what we call atriums today, they also catered to automobiles by providing ample parking spaces with an integrated multi-storey car park.[38] However, while North American shopping centres enclosed themselves and severed all connections to the surroundings,[39] a number in Singapore strategically opened themselves up to integrate surrounding pedestrian movements.

At the People's Park Complex, architects Tay Kheng Soon and William Lim of Design Partnership sought to capture "the atmosphere of informal bustling activity" of traditional street shopping by creating what they called a "City Room", essentially a large internal concourse around which circulation elements such as escalators, stairs and walkways were organised.[40] All sides of the complex were also designed with pedestrian entrances, including one connecting to an overhead bridge. To integrate the building with a pedestrianised plaza on its northeast side, the architects even created a double-volume front porch that blurred the boundaries between the two. Another example was Plaza Singapura by BEP Akitek. The firm created a landscaped forecourt between the building and the major thoroughfare of Orchard Road to draw in pedestrians, and even provided an underpass that linked to a garden across the road. The strong connections with greenery were part of efforts by the owner, the Development Bank of Singapore, to create a property that contributed to "the image of a cleaner and greener Singapore". The theme continued inside the mall, where shops were planned around landscaped interior courtyards to create a "park-like environment bringing the outdoors, indoors".[41]

Early shopping centres in Singapore also did not adhere to the "classic dumbbell format" of having two anchor tenants, typically department stores offering a large variety of goods, placed at the two ends of a building with smaller stores arranged along a corridor linking them.[42] Both People's Park Complex and Plaza Singapura had only one anchor tenant. Located in the former was Overseas Emporium, a local company that sold goods imported from China. The latter was home to Yaohan, a Japanese department store. According to a news report, the dumbbell format was not popular in Singapore because the mostly local developers favoured "the concept of the

'standard shop unit'" instead.[43] Such smaller units were probably easier to sell and rent given how many buyers or tenants would have been those moving in from shophouses.

There were also relatively few large department stores locally. Even as more shopping centres were built throughout the 1970s, established local department stores did not aggressively take on the role of anchor tenants. Two of Singapore's oldest department stores, Robinsons and John Little, were owned by the OCBC Group from the mid 20th century and stayed within the company's Specialists' Shopping Centre during this period.[44] Emporium Holdings Group then owned the largest number of department stores in Singapore, including the Oriental Emporium, but most of them were located in the town centres of public housing estates instead.[45] The only exception was Metro which, during its peak in the 1980s, had department stores in several shopping centres, including Bukit Timah Plaza, Far East Plaza, Holiday Inn Building, Lucky Plaza, Marine Parade Centre, Merlin Plaza and Supreme House.

Instead, foreign players filled the gap in department stores. One of the most significant was the Japanese department store Yaohan. After becoming an anchor tenant at Plaza Singapura in 1974, it rapidly expanded to five branches over the decade.[46] Yaohan introduced a number of novel ideas, including a delicatessen serving "take-away" local, Japanese and Western food, "open-view bakery and snack shops", play areas for children and a "carnival atmosphere" in its stores to stimulate consumption.[47] Its success paved the way for other Japanese competitors, including Isetan, Daimaru and Sogo to establish stores in Singapore.[48]

Beyond offering retail, shopping centres also became popular with the government to host public education exhibitions, particularly in their atriums.[49] They were ideal venues found across the island and had long opening hours, typically from 10 am to 10 pm.[50] Besides the city centre—particularly along Orchard Road, New Bridge Road and Golden Mile—many new shopping centres popped up in the suburbs during the 1970s, especially in the more densely populated, higher-income private residential areas of Katong, Bukit Timah and Thomson.[51] The likes of Katong Shopping Centre (1973), Bukit Timah Plaza (1979) and Thomson Plaza (1979), can be seen as precursors to the "heartland malls" built from the 1990s. The

latter, however, are typically built next to Mass Rapid Transit (MRT) stations or within the town centres of public housing estates that were originally built with more traditional pedestrianised malls.

Unlike most shopping centres today, which are owned by a single developer or part of a real estate investment trust (REIT), many of Singapore's early shopping centres were strata-titled developments where the shop units were sold to individual owners. Without top-down control over tenant mixes and a tendency to invest less in maintenance and refurbishment works—which can be carried out only if the majority agree—many older shopping centres have not aged well and often declined to a shadow of their former glory, particularly in light of competition from newer shopping malls.[52] (see *Lucky Plaza*) Some exceptions are Queensway Shopping Centre and Sim Lim Square (1987), which are known as meccas for sportswear and electronic products respectively.

Barely into their forties, many of Singapore's early shopping centres started to be put up for collective sale in the new millennium, hoping to attract a willing buyer to inject a new lease of life, typically through their demolition. It was a fate predicted by a retail consultant in the 1970s, who noted that shopping centres have a "tendency toward rapid obsolescence where its life expectancy is relatively short as compared to other forms of real estate".[53] Like the consumption culture they enable, shopping centres are ultimately buildings that thrive on novelty too.

Notes

31 Quoted in Chua Beng Huat, *Life Is Not Complete without Shopping: Consumption Culture in Singapore* (Singapore: Singapore University Press, 2003).

32 Nikki Diane De Guzman, "Too Many Malls in Singapore?," *PropertyGuru*, 19 February 2016, https://www.propertyguru.com.sg/property-management-news/2016/2/117722/too-many-malls-in-singapore.

33 "Instant Shopping in Air-Cool Comfort: New Multi-Storey Centres Change the S'pore Skyline," *The Straits Times*, 15 October 1972.

34 "Rows of Shops Make Way for Luxurious Complexes," *The Straits Times*, 5 September 1971.

35 *A Pictorial Chronology of the Sale of Sites Programme for Private Development* (Singapore: Urban Redevelopment Authority, 1983).

36 For a detailed historical account of People's Park Complex, see Eunice Seng, "People's Park Complex: The State, the Developer, the Architect and the Conditioned Public, c. 1967 to the Present," in *Southeast Asia's Modern Architecture: Questions in Translation, Epistemology and Power*, ed. Jiat-Hwee Chang and Imran bin Tajudeen (Singapore NUS Press, 2019).

37 Margaret Crawford, "The World in a Shopping Mall," in *Variations on a Theme Park: The New American City and the End of Public Space*, ed. Michael Sorkin (New York: Hill and Wang, 1992), 22.

38 Interestingly, the word "atrium" was not used in Singapore in the 1970s for shopping centres. In

the cases of People's Park Complex and Plaza Singapura, "internal concourses" or "covered courts" were used respectively. See Pauline Khng, "Outspoken 'Third-Fourth' Generation Architect," *Asian Building & Construction* October (1975); "Plaza Singapura – Strong Horizontal Expression," *Building Materials & Equipment*, January (1975). The word "atrium" was only used in newspaper articles referring to hotels designed by John Portman in Singapore.

39 This was based on Crawford's reading of Southdale Mall in Edina, Minneapolis, built in 1956 and designed by Victor Gruen. Crawford, "The World".

40 "People's Park Complex," *Process: Architecture* 20 (1980).

41 "Plaza Singapura – Strong Horizontal Expression," *Building Materials & Equipment,* January (1975), 6-35.

42 For dumbbell format, see Crawford, "The World". 20.

43 Teo Teck Weng, "Planners' Paradise or Nightmare?," *The Business Times*, 1 August 1978.

44 Ng Kok Beng, "A Tale of Three Shopping Centres," *The Business Times*, 30 October 1980.

45 "Group's Spectacular Growth in 14 Years," *The Straits Times*, 28 March 1980.

46 Andrea Ng, "Ex-Yaohan Supermart Staff Reunite to Mark SG50," *The Straits Times*, 31 May 2015.

47 Lee Yew Meng, "Will Yaohan Stop at 3?," *New Nation*, 25 May 1979; "The One-Stop Centre for the Family Shopping…", *New Nation*, 2 November 1974.

48 "Japan Firms Eyeing the S'pore Market," *New Nation*, 10 June 1978.

49 For example, at the People's Park Complex, a whole series of exhibitions on topics such as road safety, dental health, and clean water were held in 1973 alone. See Seng, "People's Park Complex", 248–49.

50 Sim Loo Lee, *Study of Planned Shopping Centres in Singapore* (Singapore: Singapore University Press, 1984), 6–10.

51 Mok Sin Pin, "Moving in Date for Shopping Paradise Nears," *The Straits Times*, 8 January 1973; Emily Ng, "$15mil. Centre on the Way up in Katong," *New Nation*, 25 May 1971; "Factors That Prompted the Setting up of Modern Centres," *New Nation*, 27 June 1978; Edward Prentice, "Shopping Centres in Singapore as Long Term Investment," *Building Materials & Equipment*, October (1981).

52 Melissa Lin and Kash Cheong, "Ageing Malls Face Hurdles to Upgrading: Many Poorly Patronised, in Disrepair as Unit Owners Disagree on Plans," *The Straits Times*, 2 July 2013; Cheryl Ong, "Pitfalls Plague Strata Titled Malls: Multiple Owners Spell Woes in Terms of Collective Sales and Maintenance," *The Straits Times*, 27 December 2014.

53 Teo, "Planners' Paradise or Nightmare?"

7.1 People's Park Complex (top left) under construction, 1973. It was one of Singapore's first shopping centres and formed a striking contrast with the surrounding shophouses in Chinatown.

7.2 The "City Room" inside the People's Park Complex, c. 1980s, which all circulation elements were designed around, brought the bustling atmosphere of traditional street shopping into the building.

7.3 Night market at Pagoda Street, c. 1980s. The pedestrian overhead bridge (right) linked the street to People's Park Complex. An example of how the building was designed to integrate pedestrian movements from the surroundings.

7.1

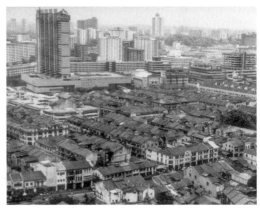

7.2

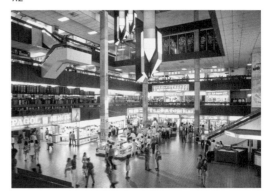

7.3

7.4 In 1975, Minister for Health Dr Toh Chin Chye opened a two-week Infant and Child Care exhibition at People's Park Complex. Shopping centres became popular for hosting public outreach events as they were centrally located and had long opening hours.

7.5 A view of Hock Lam Street from Hill Street, looking towards North Bridge Road, 1977. Peninsula Shopping Centre towers above the shophouses which used to house retail until such modern developments.

7.6 Completed in 1973, Katong Shopping Centre was one of the first such malls to open outside the city centre. Others include Bukit Timah Plaza and Thomson Plaza, both completed in 1979.

7.4

7.5

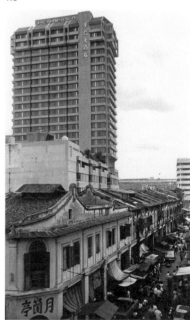

7.6

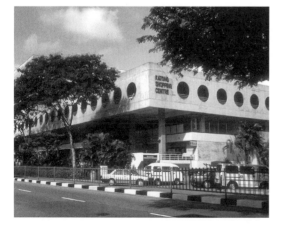

8 Hotels:

Singapore as a
Tropical Asian Paradise

Beginning in the late 1960s, Singapore experi-
enced a hotel building boom as developers
rushed to meet the rising tourist arrivals and take
advantage of government tax incentives.[54] While
there were only 16 hotels offering just over 1,100
rooms in 1963, the numbers surged dramatically
in just under a decade to meet the "noticeable
shortage".[55] By 1972, Singapore had 70 hotels
offering some 7,551 rooms—and almost all were
designed by local architects. The trend led a
writer to boast in the *Journal of the Singapore
Institute of Architects* that hotel design and
building in the young nation had "reached
maturity within an extremely short period of
time", and that the standards of "sophistication in
finish and décor is at least equal to, if not
exceeding that of, the American Continent".[56]

The American hotel model was then leading
the way around the world. It was commonly
expressed, at least in the late 1940s, in the form
of modernist slab blocks that rested on podi-
ums.[57] This was the typology adopted by new
hotels emerging in Singapore in the 1960s and
1970s, from an external point of view.[58] Among
the more prominent large establishments
completed during this period were Hotel Malaysia
(1968) by Alfred Wong Partnership; Singapore

Hilton (1970) by BEP Akitek; Ming Court Hotel
(1970) by Kumpulan Akitek; and Shangri-La Hotel
(1971) by Seow, Lee, Heah & Partners with Kanko
Kikaku Sekkeisha. By and large, these hotels
housed their rooms inside slab blocks, which
were placed along double-loaded corridors. Their
common facilities—including banquet halls,
conference and meeting rooms, restaurants,
cocktail bars, coffee houses and shopping
arcades—were typically housed in the podium.
The only exception was Hotel Malaysia, which
was formed by two overlapping slab blocks to
create a sweeping façade.

While hotels in Singapore had a common
modernist idiom, they tried to incorporate region-
al aesthetics to distinguish themselves. For
instance, the rooftop restaurant of the Singapore
Hilton had "a series of peaked, sloping roofs" on
its perimeter that supposedly evoked a Malay
kampong.[59] Stretching across its façade was also
a 82-metre-long by 6-metre-tall relief mural by
Malaysia-born artist Gerald D. A. Henderson,
which depicted semi-abstract symbols of wayang
topeng masks, a lion face and mythical Asian
motifs across 19 different panels.[60] Inside the
Hilton's lobby was a 7.6-metre cast aluminium
mural by artist Seah Kim Joo, whose works also

featured in Singapore's other modern hotels. His batik murals, for example, were extensively used in Hotel Malaysia alongside precast stone panels of Ibanese design, teak carvings and light fittings made of woven cane with aluminium cylinders to offer guests "a strong sense of being in this part of Asia, rather than just any international hotel which could be located elsewhere".[61]

Such an approach of incorporating various traditional or tradition-inspired designs in Singapore's modern hotels can be traced to the interior design firm Dale Keller and Associates. The Hong Kong-based firm that worked on Hotel Malaysia, Singapore Hilton and the Ming Court Hotel was led by Dale Keller and his wife, Patricia, who were Japanese-trained designers from the United States. They were known for their interior work on some of the earliest modern hotels in East Asia, including Marunouchi Hotel (1961), Hotel Okura Tokyo (1962), Hilton Hotel Tokyo (1963) and Hong Kong Hilton (1963).[62]

A 1977 essay by Dale offers a glimpse of the firm's hotel design philosophy. He critiqued the first generation of hotels, those built from the 1950s to the 1970s, as having a "monotonous uniformity" because they were "[d]esigned to almost identical standards and to satisfy almost identical requirements".[63] For him, these "American hotels that no one wants to find abroad, but all too often does" were "a form of cultural colonialism". Instead, he envisioned the "hotels of tomorrow"[64] to have distinctive qualities

in such intangibles as environmental appropriateness, respect for national and geographical location, and regard for variations in the lifestyle of the traveler. Each hotel of tomorrow will be designed as a unique and individual environment, one with a sense of place.[65]

Dale Keller and Associates achieved this by undertaking extensive research for every project to familiarise themselves with the indigenous cultures for which they were designing. Before starting work on the Singapore Hilton, the Kellers embarked on a 5,632-kilometre drive through Malaysia and Singapore to visit museums and villages, as well as to collect antiques and artefacts.[66] Besides referencing local cultures, Dale also identified the landscape as a key aspect of hotel design:

Not only is it true that in many climates landscaping alone may be the most important decorative element in a hotel concept, but it is now seen that planting, paving, water, and the other elements of landscape architecture can be used as an integral part of functional design.[67]

In the Singapore Hilton, for instance, the Kellers designed the lobby with an indoor fountain and lush tropical plants. However, this idea was best exemplified by another hotel that was not designed by the Kellers. The Shangri-La Hotel may have had no explicit cultural referent but it was set in what the Singapore Tourist Promotion Board advertised as "12½ acres of tropical garden with over ½ a mile of garden walkway, a picturesque waterfall, luscious fruit trees, exotic tropical birds and vividly coloured flowering shrubs".[68] This Edenic landscape was the work of Hawaiian landscape architecture firm Belt, Collins and Associates, whom hotel owner Robert Kuok had hired after experiencing their work in Hawaii. The firm's landscape architect Raymond Cain surrounded Shangri-La with a lush green environment that he described as "shaped and arranged to be seen in plain view from above, on the various floor levels of the hotel as well as from within the building at ground level".[69] This was enabled by extensive glass enclosures that visually connected this resort-like exterior with the hotel interiors.[70]

Completed in 1971, the Shangri-La became the "premier businessmen's resort hotel of Southeast Asia" and was so successful that it expanded just a few years later.[71] While other hotels converted some of their rooms to offices because of a glut in hotel rooms in Singapore,[72] the Shangri-La opened a new Garden Wing in 1978. The nine-storey 170-room structure with an open atrium was designed by Hawaiian architectural firm Wimberly Whisenand Allison Tong & Goo (WWATG) with Belt, Collins and Associates returning to work on the landscape.[73] The Garden Wing was described as having "a spectacular two-story waterfall [that] cascades into a rock-lined koi pond below, amid lush tropical foliage".[74] Surrounding its open-air atrium were corridors that led to large rooms with huge curved balconies, which were lined with bougainvillea-filled planter boxes.

The Garden Wing clearly complemented the

original Shangri-La, but project architect Gregory M. B. Tong revealed that the design was to augment Singapore's then vision of becoming a Garden City too.[75] It also shares many features of WWATG's earlier works, including its best-known hotel in Hawaii, the Sheraton Maui (1963). Shangri-La's Garden Wing also has a terrace of broad curvilinear balconies with planting on the edges to give the impression of a "hanging garden"[76], which was a modern interpretation of the lānai, a traditional Hawaiian porch or veranda. It can be traced to the pioneering designs of Vladimir Ossipoff, a preeminent architect of Hawaii's modern architecture who made the lānai and its casual way of living the organising principles of his architecture.[77]

The expanded Shangri-La cemented the hotel as the standard for hotel landscape design in Singapore, which was bolstered by a 1985 award from the Hawaii chapter of the American Society of Landscape Architects. It was hailed as the first of its kind to deviate from the traditional English garden style in Singapore, offering a "controlled jungle" style that was "characterized by large groupings of plants into masses of the same species".[78] The style was popularised around the Asia Pacific as Belt, Collins and Associates worked on many more hotels and resorts for the Shangri-La chain over the decades.[79] As one of the best-known landscape architecture firms in the region, it also attracted many apprentices to work in Asia, most notably Bill Bensley and Karl Princic, who later set up their own successful practices designing for some of the most luxurious hotels and resorts in Southeast Asia.[80]

In Singapore, WWATG subsequently brought the concept of garden living into the residential typology when its co-founder George Wimberly and local architect Chua Ka Seng completed The Arcadia in 1983.[81] With its stepped façade filled with planter boxes on every level, the condominium is reminiscent of Shangri-La's Garden Wing and the Hawaiian lānai. Both buildings' incorporation of landscaping as part of the building were forerunners in introducing a new vertical dimension to Singapore's greening efforts. It was only after 2009 that this truly took off when the government introduced incentives to encourage private building owners and developers to include skyrise greenery in their projects. From garden walls to sky terraces and roof gardens, Singapore is no longer just green on the ground but all around and above the city too.

Notes

54 "'More Hotels' Forecast for Singapore," *The Straits Times*, 1 June 1967.

55 "Shortage of Good Hotel Rooms, They Say," *The Straits Times*, 27 May 1967.

56 "Hotels in Singapore," *Journal of the Singapore Institute of Architects* 50 (1972): 3.

57 Among the better-known early examples of hotels in slab blocks are the Terrace Plaza, Cincinnati (1949), and Istanbul Hilton (1955), both designed by Skidmore, Owings & Merrill. See Annabel Jane Wharton, *Building the Cold War: Hilton International Hotels and Modern Architecture* (Chicago: University of Chicago, 2001).

58 "The Trend in Singapore Hotels... Reaching for the Sky," *The Construction Review* 2 (1972).

59 "Hotel's Decor Reflects Colour and Charm of S'pore," *The Straits Times*, 30 January 1971.

60 "10 years in Singapore Hilton Plays Lead Role in Hospitality Industry," *The Straits Times*, 1 November 1980.

61 "Hotel Malaysia," *Journal of the Singapore Institute of Architects* 26/27 (1968): 18.

62 "The Keller Touch in Hotel Rooms Worldwide," *The Straits Times*, 11 October 1984; "Marco Polo Opens Doors," *The Straits Times*, 23 January 1970. See also Eunice Seng, "Temporary Domesticities: The Southeast Asian Hotel as (Re)Presentation of Modernity, 1968–1973," *The Journal of Architecture* 22, no. 6 (2017): 1102–04.

63 Dale Keller, "The Hotel of Tomorrow," *Cornell Hotel and Restaurant Administration Quarterly* 17, no. 4 (1977): 49.

64 Ibid., 52.

65 Ibid.

66 "Hotel's Decor Reflects Colour and Charm of S'pore." Their preparatory research might have also helped them with their interior design for Kuala Lumpur Hilton, which opened four years after the Singapore one in 1972. It incorporated even more Malaysian motifs, crafts and materials in its décor. See "A 'Showcase' of Malaysian Motifs," *The Straits Times*, 6 July 1973.

67 Keller, "The Hotel of Tomorrow", 53.

68 Singapore Tourist Promotion Board, *The Hotels of Singapore* (Singapore: Singapore Tourist Promotion Board, 1971), u.p.

69 Cited in "Region's Plants for Landscaping," *The Straits Times*, 31 July 1970.

70 "Shangri-La Hotel, Singapore," *Journal of the Singapore Institute of Architects* 50 (1972).

71 "Only Hotel with all the Resort Facilities," *The Straits Times*, 19 August 1978.

72 Peter Ong, "Heat Is On," *New Nation*, 7 October 1971; Gregory Tong, "Hotel Architecture," *Building Materials & Equipment*, November (1977).

73 "Shangri-La Hotel to Be Extended," *Asian Building & Construction* September (1975); Rangit Gill, "Hotel Extension Embraces Resort, Garden Concept," *Asian Building & Construction* November (1978).

74 Fiona Gruber, *Belt Collins* (Mulgrave: Images Publishing Group, 2003), 83.

75 "Face to Face with Gregory Tong," *Building Materials & Equipment*, November (1978).

76 For a description of Sheraton Maui, see Don Hibbard, *Designing Paradise: The Allure of the Hawaiian Resort* (New York: Princeton Architectural Press, 2006), 90–93.

77 Dean Sakamoto, ed. *Hawaiian Modern: The Architecture of Vladimir Ossipoff* (Honolulu and New Haven: Honolulu Academy of Arts and Yale University Press, 2007).

78 "Shangri-La Wins US Landscaping Award," *The Business Times*, 13 September 1985.

79 Gruber, *Belt Collins*; "Kuok Group Banks on Shangri-La's International Fame," *The Straits Times*, 14 June 1983.

80 Made Widjaya, *Modern Tropical Garden Design* (Singapore: Editions Didier Millet, 2007), 36.

81 "Arcadia: Rustic Retreat," *Building Materials & Equipment*, July (1983).

8.1 Aerial view of Hotel Malaysia,
 designed by Alfred Wong Partnership,
 with the fountain of Tanglin Circus in
 the foreground.

8.2 View of the Hotel Malaysia lobby,
 which incorporated a batik mural
 (right) by Seah Kim Joo along with
 other luxurious finishes in an interior
 designed by Hong Kong-based firm
 Dale Keller and Associates.

8.3 Hotel Malaysia's coffee shop had light
 fittings made of woven cane with
 aluminium cylinders to create a sense
 of being in Asia.

8.1

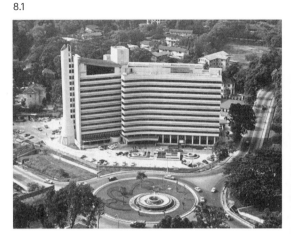

8.2

8.3

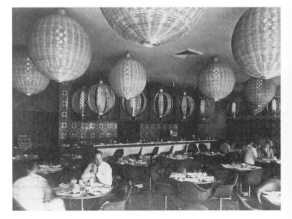

8.4 Singapore Hilton under construction, 1969. The design by BEP Akitek had a slab block of hotel rooms over a podium of facilities, which was typical of hotels then.

8.5 Ming Court Hotel, completed in 1970 by Kumpulan Akitek, distinguished itself with an ochre roof form to give an "Oriental" character as suggested by its name too.

8.6 Shangri-la Hotel with the Garden Wing (right) pioneered the extensive use of lush tropical greenery to define itself as the "resort hotel" of Southeast Asia.

8.4

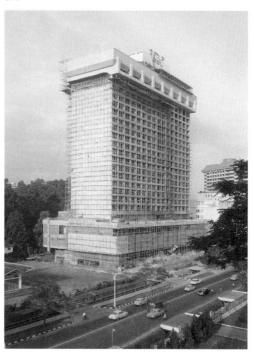

8.5

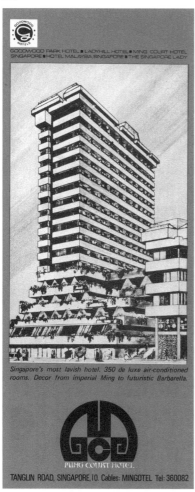

8.6

Lookout Towers:

Views of Singapore's Modern Development

Foreign dignitaries and industrialists visiting Singapore in the 1960s and 1970s would have witnessed an impressive prospect of a young nation. On their carefully orchestrated itinerary, these very important persons (VIPs) were typically accompanied by ministers to inspect assembly lines, grace opening ceremonies of factories, and, to top it off, witness panoramic views of Singapore's on-going development. From the growth of industrial spaces at Jurong to the engineering feat at the country's largest open reservoir in Seletar, such key aspects of Singapore's rapidly modernising landscape were strategically on view through various specially constructed lookout towers and galleries across the island.

A popular choice was the Jurong Hill Lookout Tower, which received the likes of the Prime Minister of Canada Pierre Trudeau, the Vice-Premier of China Deng Xiaoping and Britain's Queen Elizabeth II. Officially opened in 1970, the 18-metre-tall circular viewing tower by the Jurong Town Corporation stood on what was formerly known as Bukit Peropok, a 61-metre-high hilltop in the middle of the emerging Jurong Town.(see *Jurong Town Hall)* Instead of stairs, the tower had a gentle spiral ramp which allowed guests to take a

leisurely stroll as they took in panoramic views of new factories and chimney stacks overtaking the once swampy land. At the top of the tower was an air-conditioned reception hall, while at its foot on the mezzanine floor was the first restaurant in Jurong Town.[82] VIP guests were also invited to commemorate their visits by planting a tree in a garden on the hill. What became known as the "Garden of Fame" and "VIP Hill" were key for the emerging nation that had become independent in 1965.[83] Previously dependent on entrepôt trade, the Singapore government saw industrialisation as a way to build up its economy, curb the detrimental effects of stagnating trade and also mitigate the impact of the withdrawal of British forces in 1971.[84] Such a vision would have been impressed upon visitors to Jurong Hill Lookout Tower.

While the industrialisation of Singapore was on display at Jurong Town, its efforts to house its citizens could be viewed via a purpose-built rooftop gallery on a 19-storey public housing block in Toa Payoh New Town. Completed in the early 1970s by the Housing & Development Board, the distinctive Y-shaped Block 53 played host to various foreign and local dignitaries, including Queen Elizabeth II, and was even

dubbed a "VIP block". Another view on offer was from the lookout tower designed by the Public Works Department next to Seletar Reservoir. The 18-metre tower opened in 1969 to demonstrate the young nation's efforts in creating Singapore's then largest open reservoir, ensuring clean water for the growing population and its rapidly expanding industries.[85]

Besides playing host to VIPs, both the towers in Jurong and Seletar offered views to those living in Singapore too. They were within public parks and envisioned as part of a suite of recreation facilities for suburban families living in the west and north regions respectively.[86] Similar lookout towers were also built inside the Toa Payoh Town Garden and the Chinese Garden in Jurong. These parks developed in the 1970s were created in tandem with residential, industrial and infrastructure developments as part of the nation's plans to encourage stronger social cohesion and balanced community life amongst its citizens.[87]

While the pagoda towers in the 32-acre Chinese Garden were reminiscent of ancient Chinese architecture in keeping with its theme prepared by Professor Yu Yuen-Chen and a certain R. H. Han from Taiwan, the other three lookout towers had designs representative of a modern epoch.[88] Leaving behind the traumatic experiences of a short but tumultuous merger with Malaya in 1963, Singapore found itself thrusted onto the international stage. The nation's sovereignty was quickly established on global and regional platforms, such as gaining membership into the United Nations in September 1965, and, shortly after, becoming one of the five founding members of the Association of Southeast Asian Nations (ASEAN) in 1967. Buildings of this period, mostly designed by local architects in public agencies or private practices, were influenced by international trends as Singapore become increasingly global.[89]

The spiral tower at Jurong Hill was described as a "futuristic" and "imaginative design without stairs".[90] Seletar Lookout Tower with its rocket-like look was fondly nicknamed the "Space Rocket". The 25-metre tower at Toa Payoh Town Garden was topped with an octagon-like "eye". These towers were completed in or soon after 1969 when space exploration fervour reached its zenith globally, as astronauts from the Apollo 11 mission successfully landed and walked on the moon for the first time. The desire for designs

that pointed upwards and beyond was also fuelled by the likes of the Space Needle in Seattle, a flying saucer-like design created in 1962 for the city's space age-themed World Fair. In Singapore, this trend was captured in the design of three towers. The the Urban Renewal Department had even planned to build Singapore's own "Space Needle" on Mount Faber, which would reach a height of 237 metres above sea level.[91] Even private developments such as the pioneering high-rise residential tower, Futura, adopted such space-age aesthetics in its architecture and interiors (see *Futura*).

A 1970 *Straits Times* editorial noted how Singapore was shaping up to become a "futuristic city in the sky" as developers announced in quick succession their plans to build observation lifts, skywalks, aerial cable-cars and revolving restaurants on their new high-rise buildings in commercial and tourist areas such as Shenton Way and Orchard Road.[92] One example was the Mandarin Hotel built on Orchard Road, the brainchild of the Overseas Union Bank founder Lien Ying Chow. The hotel employed overseas hotel management experts and even a Hollywood set designer, Don Ashton, to differentiate itself from others in Singapore's emerging tourism and shopping belt.[93] At the time of completion in 1973, the 40-storey hotel was the tallest building in Singapore and was also topped with Southeast Asia's first revolving restaurant, Top of the M. Housed in a rooftop structure that sat an impressive 173 metres from the ground, it offered an unobstructed view of the skyline stretching from the Singapore River in the south to Johore up north.[94] Top of the M consisted of two decks, a stationary lower deck with an observation lounge, and a restaurant housed in the dome-shaped upper deck. Both offered views through a special glass panel façade that cut out reflection and prevented fogging.[95] Patrons enjoyed special set meals comprising of a mix of international cuisine and local dishes while the restaurant rotated slowly at a rate of one revolution per hour, allowing guests ample time to identify familiar landmarks from above while they ate.[96]

While Top of the M was located inland and offered views of Singapore's cityscape, two other revolving restaurants built in the 1970s provided vantage points to admire the nation's ports and coastlines instead. The revolving structures at Prima Tower and the Change Alley Aerial Plaza

were completed in 1971 and 1974 respectively, but the restaurants they housed only opened in the late 1970s. The delays were attributed to an oversupply of restaurant space in prime commercial areas, exorbitant rental prices for the novelty structures, and a lack of trained chefs and managers as Singapore fast-tracked the growth of its tourism sector in the mid 1970s.[97] When they finally opened, the towers provided two contrasting perspectives of Singapore's urban renewal efforts. The Prima Tower at Keppel Road boasted spectacular views over the fast-developing container terminals at Keppel Harbour, while the revolving tower next to Clifford Pier overlooked Telok Ayer Basin and the Singapore River, which was transforming from a working river into a recreational waterfront.

Both the Prima Tower Revolving Restaurant and the Change Alley Aerial Plaza Tower adopted a similar flying-saucer structure with tapering glass windows surrounding the entire observation deck. The former was perched 70 metres above massive grain silos while the latter was held up just 27 metres above ground. Despite their waterfront views, a newspaper commentary on the waning novelty of revolving restaurants highlighted an obvious disadvantage as the Top of the M, had already "stolen the limelight" by being the first of its kind.[98] Adding insult to injury, the article noted that these later entrants were nowhere close to the hotel in terms of height.

Such sentiments were perhaps also indicative of how elevated views had become commonplace in Singapore as citizens began moving into high-rise apartment blocks and working out of offices towers. (see *Public Housing and Shenton Way*) Fast forward to today, lookout points and observation decks have become ever more ambitious in the form of "sky bridges", "sky gardens" and "sky parks" incorporated into the architecture of buildings that promise not just views but also outdoor activities. As the city becomes increasingly built up, the drive to be better and more innovative than what came before continues to redefine Singapore's skyline.

This essay was co-authored with Ian Tan.

Notes

82 "Soon—a Super Tower on VIP Hill," *The Straits Times*, 5 January 1969; "Wok to Open Hill-Top Restaurant," *The Straits Times*, 22 June 1970.

83 "Soon—a Super Tower on VIP Hill"; "Garden of Fame on This Hilltop," *The Straits Times*, 28 August 1987.

84 Stephen Dobbs, *The Singapore River: A Social History 1819–2002* (Singapore: NUS Press, 2003), 103.

85 "Big Step Forward in the Republic's Search for Water," *The Straits Times*, 10 August 1969.

86 Chia Poteik, "Scenic Sight Reservoir," *The Straits Times*, 10 July 1969.

87 "Parks Galore at Jurong," *New Nation*, 2 June 1975; "Princess Alex Opens Seletar Reservoir," *The Straits Times*, 11 August 1969.

88 "Chinese Garden Taking Shape on Four Islands in Jurong River," *The Straits Times*, 23 October 1971; *Jurong Town Corporation Annual Report 1970* (Singapore: JTC, 1971), 29.

89 E. J. Seow, "The Physical and Architectural Development of Modern Singapore," in *Rumah: Contemporary Architecture of Singapore* (Singapore: Singapore Institute of Architects, 1981), 22–23.

90 "Soon—a Super Tower on VIP Hill."

91 "'Space Needle,'" *The Straits Times*, 17 March 1970.

92 William Campbell, "Going UP!," *The Straits Times*, 2 April 1970.

93 "Top Team to Run Asia's Best Hotel," *The Straits Times*, 21 June 1969.

94 Lee Su San, "Shaping up: A Stately Pleasure Dome 39 Storeys Up," *The Straits Times*, 14 June 1972.

95 Ibid.

96 "Making a Slow Orbit over a Meal," *The Straits Times*, 22 September 1973.

97 Ting Hi Keng, "Revolving Restaurant All Set to Open at Last," *New Nation*, 25 March 1977; "Third Revolving Restaurant Will Open Soon," *The Straits Times*, 29 June 1978.

98 "Still No Takers for Revolving Restaurant Site," *Business Times*, 8 February 1977.

9.1 The Jurong Hill Lookout Tower was designed to showcase Singapore's modern development to foreign dignitaries such as Britain's Queen Elizabeth when she visited in 1972.

9.2 As the Queen ascended the 18-metre Jurong Hill Lookout Tower, she could see the transformation of Jurong into an industrial estate.

9.1

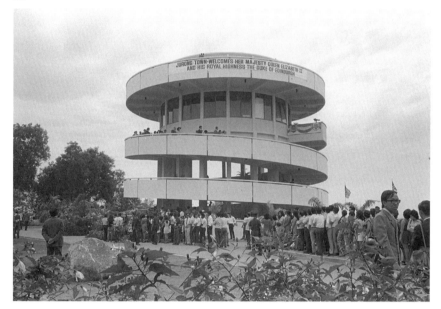

9.2

9.3 On the ground floor of the Jurong Hill
 Lookout Tower was the restaurant,
 The Hilltop, as depicted in this
 advertising matchbook.

9.4 Another observation deck Queen
 Elizabeth was brought to during her
 1972 visit to Singapore was on the
 rooftop of Blk 53, a public apartment
 block in Toa Payoh. There she saw the
 nation's efforts to house its citizens.

9.3

9.4

9.5 Revolving restaurants offering views
 while dining became a fad in
 Singapore during the 1970s. This
 advertising matchbox for Prima Tower
 Revolving Restaurant illustrated how it
 was perched on the top of a 15-storey
 high flour silo at Keppel Road.

9.6 The 40-storey Mandarin Hotel topped 9.5
 with Southeast Asia's first revolving
 restaurant soared above Orchard Road
 when it was completed in 1973.

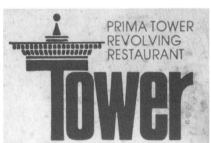

9.6

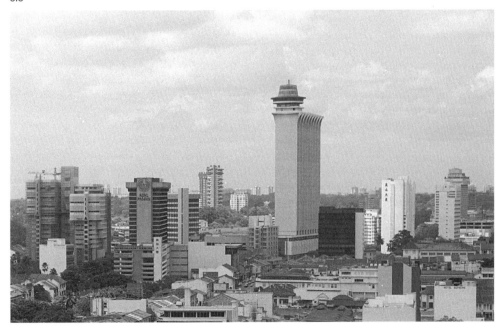

10 **East Coast Park:** **"The Singapore Way"**
 of Recreation

Despite being touted as "an explosive book", *Socialism That Works… The Singapore Way* features a surprisingly idyllic cover. Its aerial photograph of a tree-lined lagoon and greenery that stretches into the horizon could very well have graced a tourism brochure. Instead, the picture of East Coast Park fronts a 268-page publication that refutes "the many half-truths perpetrated by hostile parties" about Singapore.[99] As the newest and largest public recreational centre in Singapore when *Socialism That Works* was released in 1976, it showcased how the People's Action Party (PAP) had literally reshaped the island for modern play.

The entire East Coast Park was developed on land reclaimed from the sea. In the 1960s, the government began extending Singapore's eastern coast to overcome its territorial limitations. Coconut plantations, farms and *kelong* along the coast were displaced, and the line of bungalows along East Coast Road as well as the Singapore Swimming Club lost their impressive seafront views. On the linear strip of reclaimed land, which stretched over 14 kilometres from Bedok to Tanjong Rhu, arose the Marine Parade public housing estate, a belt of private condominiums and several commercial centres. These high-rise developments were fronted by East Coast Park, which its planners declared to be "the biggest green lung of Singapore".[100]

In the 1950s, the British government had introduced modern recreational facilities—such as playgrounds, parks and swimming pools [(see *City Council Pools*)]—in Singapore to provide relief for its rapidly urbanising colony. The succeeding PAP government embarked on this with greater fervour. Two years after the country gained independence in 1965, its first prime minister, Lee Kuan Yew, declared Singapore would become a "garden city" to make it pleasant for citizens and demonstrate how well organised it was to foreign investors.[101] A Trees and Parks Unit was formed in the Public Works Department to oversee a tree planting campaign. By 1976, the unit grew into a separate Parks and Recreation Department with an expanded mandate to create open spaces and parks.

East Coast Park was one of the department's early designs. But unlike those in Fort Canning, Mount Faber and Labrador, the park's location along the coast was significant, said Singapore's head of statutory planning, Tan Tsu Haung:

Without the additional quantum of reclaimed land, the ability to provide more open space and other uses is limited. On the other hand, with the availability of such land for development, the decision to use such expensive land for non-economic purpose speaks eloquently for the Government's conscious and successful effort to provide more and better open space.[102]

The task of turning a flat and featureless plot into a coastal park was initially led by a Colombo Plan landscape architect from Japan. It was finalised in 1974 by government landscape architect Fung Wai Chan. The master plan divided the vast park into six areas, each separated by drainage canals.[103] The first to be developed was the area in front of the Marine Parade public housing estate, which was introduced with landscaped ponds, picnic benches and beach shelters. A S$3.8 million lagoon next to the area was completed in May 1976. It was Singapore's largest man-made swimming pool and the oval-shaped feature lined with colourful umbrella-shaped beach shelters became the focal point of a surrounding holiday and seaside resort designed by the Housing and Urban Development Company (HUDC).[104] Completed in 1977, the public could rent from 110 single-storey red-brick chalets that came in a terrace formation with each block made up of either four or eight units. Every chalet offered a family of four a terrace facing the sea, a bed/sitting area and a bathroom. A bigger chalet could also be formed by unlocking an internal connecting door between adjoining units. In the 1980s, 59 two-storey chalets with kitchenettes were added to meet the growing demand. The resort was also supported by a hawker centre that opened in 1978 and a seafood centre that was added in 1985. In addition, barbecue pits were introduced along the park, which helped popularise this activity amongst Singaporeans. By the 1980s, the Parks and Recreation Department noted that barbecues had "become the most popular past-time in Singapore, with the young revellers staying on the beach throughout the night" in East Coast Park.[105]

The government-led developments were accompanied by private sector projects, including a tennis centre, a crocodile aquarium and Singapore's first two-tier golf driving range.[106] In 1982, the East Coast Recreation Centre was also built to offer squash courts, a racing track for radio-controlled cars, a billiard room, a video room, a gymnasium and the fast-food restaurant McDonalds. The most memorable amongst them, however, was arguably the Big Splash Sports Complex. The S$6 million water theme park designed by Timothy Seow & Partners featured four different pools, including one wave pool, and the highlight was its rainbow-coloured slides offering visitors the thrill of sliding into a pool from a height of 10 or 13 metres. Big Splash's developers were so bullish about their development that they embarked on a similar complex even before its official opening in July 1977. Located in the west of Singapore, the smaller Mitsukoshi Garden in Jurong Town, however, was sold four years later and renamed as C N West Leisure Park.[107]

By introducing new types of modern play, East Coast Park turned the coastline into a relief valve for a rapidly urbanising Singapore. The park also had other facilities to help Singaporeans cope with modern life. While the green landscape offered psychological respite from the concrete jungle, various private and public sports facilities helped citizens stay healthy. The Singapore Sports Council even set up a public "fitness park" that was to have 12 exercise stations for building strength, flexibility, balance and agility along a 2.4-kilometre jogging trail.[108] It was one of two such facilities, the other in MacRitchie Reservoir, built by the council by 1978 to encourage the public to take up recreational sports and keep fit. There was a fear that modern living —sitting while working, travelling and watching television at home—made Singaporeans inactive and unproductive. Outlining the sports council's mission in 1974, the Minister for Social Affairs Othman Wok said: "As Singapore modernises and prospers, changing values and attitudes toward recreation for leisure post a real threat to health ... [t]here is a real danger of our (sic) becoming TV athletes."[109]

The Road Safety Park at East Coast addressed another danger of city life altogether. It replaced what was originally to be an orchard to house 800 tropical fruit trees—until the soil was discovered to be unsuitable.[110] With the help of oil company Shell, the Ministry of Home Affairs instead opened a S$1.3 million park in 1981 to teach school children how to safely use the roads. The facility addressed the high number of pedestrian

casualties in Singapore, a third of which were made up of children below the age of 15.[111] In this miniaturised urban setting, which was similar to an earlier facility in Kallang Park organised since 1958, children took on different roles—including driving go-karts, riding bicycles or walking along the park—to simulate everyday traffic situations. The park was initially opened only to schools, but was eventually made accessible to the public on the weekends from 1985.

With its line-up of facilities for leisure, sports and even education, East Coast Park demonstrated to Singaporeans in a big way what outdoor recreation was like in a modern city. This idea was brought home by the development of green spaces across the island in the 1980s. The Parks and Recreation Department built similar coastal parks on the West Coast and in Pasir Ris, and the latter also offered chalets and barbecue pits. Resort living even entered the heartlands as the Housing & Development Board built parks within public housing estates, and later introduced barbecue pits as part of its upgrading programme in the 1990s.[112]

Some four decades after appearing on the cover of Socialism That Works, East Coast Park continues to play a vital role in the imagination of Singapore as a "City in a Garden"—an evolution of the original vision to become a "garden city". The park runs parallel to the East Coast Parkway (ECP) (see Pan-Island Expressway), which connects Changi Airport to the city centre. Welcomed by the terraced forests with a stunning waterfall inside the airport's latest retail development, Jewel Changi Airport, visitors to Singapore then embark on a ride alongside greenery through its landscaped eastern coast and arrive at downtown anchored by the futuristic-looking Gardens by the Bay. It is a fitting introduction to "The Singapore Way" of utilising greenery and nature to provide recreation in a modern city.

Notes

99 "Socialism That Works... the Singapore Way," The Business Times, 1 February 1977.

100 "Facilities at the East Coast Park," The Mirror, 15 August 1977.

101 Lee Kuan Yew, "Greening Singapore," in From Third World to First: Singapore and the Asian Economic Boom (New York: Harper Business, 2011), 173–84.

102 Tan Tsu Haung, "The Reasons behind Those Lungs," MND News, June 1979.

103 "East Coast Park: Expansive Recreational Development," Building Materials & Equipment, July 1976.

104 When the chalets first opened, it cost S$16 and S$20 a day to rent non-airconditioned units on weekdays and weekends respectively. Air-conditioned units went for S$25 and S$30 a day.

105 Wong Yew Kwan, "The Greening of Singapore – An Introduction to Parks & Recreation Work," in Recreation and the Community: Papers of the 1st Regional Congress on Parks and Recreation (Singapore: Institute of Parks and Recreation, 1981), 17–19.

106 "Facilities at the East Coast Park."

107 Khng Eu Meng, "Mitsukoshi Garden Sold for $4.5 m," The Straits Times, 2 June 1983.

108 Ang Terry, "Fitness Park for Jogging and Exercise," New Nation, 9 September 1976; "Fitness Centre to Open Next Week," New Nation, 12 January 1978.

109 Godfrey Robert, "SSC Launch Campaign to Popularise Sports," The Straits Times, 10 January 1974.

110 Christina Rodrigues, "Plan for $1m Traffic Games Park," The Straits Times, 18 February 1980.

111 "Road Safety Park Will Help Prevent Loss of Lives," The Straits Times, 11 January 1981, sec. Official opening of Road Safety Park.

112 Lim Hng Kiang, "Speech by Mr Lim Hng Kiang, Minister for National Development, at the Annual Dinner of the Singapore Institute of Architects on Friday, 19 April 1996, at 7.30pm at the Shangri-La Hotel, Island Ballroom" (Ministry of Information and the Arts, 19 April 1996), http://www.nas.gov.sg/archivesonline/speeches/record-details/7291db15-115d-11e3-83d5-0050568939ad.

10.1 The idyllic view of East Coast Park on the cover of *Socialism That Works... The Singapore Way* (1976) was a contrast with its content that refuted "the many half-truths perpetrated by hostile parties" about Singapore.

10.2 East Coast Park in construction and the Marine Parade public housing estate in the background, c. 1974. Both developments were constructed entirely on land reclaimed from the sea.

10.3 Holiday chalets at East Coast Park, which were completed in 1977. Such facilities including barbecue pits introduced Singaporeans to resort living.

10.4 Minister for Home Affairs Chua Sian Chin touring East Coast Park's Road Safety Park when it opened in 1981. The facility taught children how to safely use the many roads being developed as part of Singapore's modernisation.

10.5 The Parkland Golf Driving Range, c. 1977-1985, was one of several privately-developed recreational facilities along East Coast Park that introduced modern play activities to Singaporeans.

10.1

10.2

10.3

10.4

10.5

11 ## HDB Playgrounds:

Sandboxes for Moulding Model Citizens

It is sold as pins, pillows and tote bags. It even appeared on a 2011 general election pamphlet. The dragon playground has become one of Singapore's most recognisable icons today. Designed by the Housing & Development Board (HDB) and constructed in various public housing estates between the 1970s and 1990s, the playground has grown from just a safe play space for children to a site—and symbol—for moulding citizenry too.

The idea that children needed designated spaces for play rose with the industrialised city. In the late 19th century, playgrounds emerged in the West to keep children off the streets by offering them a safe space for play. The playground movement spread to Singapore in 1928 when the colonial government worked with various private companies to build its first playground in Dhoby Ghaut. Modern play equipment from the United States, including slides, a roundabout, swings, see-saws and climbing ropes, were installed on a small triangle at the junction of Selegie and Bras Basah roads. The development was much welcomed and *The Straits Times* even called it a "strikingly economical and effective method of alleviating the conditions of life" in Singapore's overcrowded shophouse districts and keeping young children off the streets.[113]

More playgrounds were built across the city over the decades, but they really took off after Singapore gained independence and embarked on a massive public housing programme led by the HDB. Recreational space was regarded as essential for high-rise urban living and play-grounds were built as part of the many public housing estates in development. HDB's early play-ground designs were similar to those imported from the West, consisting mainly utilitarian see-saws, slides, swings and merry-go-rounds made of steel and timber that were installed in an open outdoor space. It was in the 1970s that the agency began experimenting with its own designs as part of efforts to improve the quality of public housing in Singapore. The task fell to interior designer Khor Ean Ghee, who joined the HDB in 1969 and became part of its new Design and Research Unit led by architect Liu Thai Ker.[114]

As Khor had no experience designing playgrounds, he referenced books on this topic from overseas.[115] The 1960s and 1970s coincided with a period in which the playground was "the focus of many new ideas and experiments in art,

architecture and pedagogy" in the West.[116] After the Second World War, playgrounds were increasingly seen not just as safe spaces for children to play, but also to simulate their learning and creativity. This gave rise to abstract play equipment and the "adventure playground", both of which sought to allow children the freedom to express their own ideas about play. Khor's playgrounds exhibit influences from such trends. In his early designs for Toa Payoh Town Garden, the playgrounds reimagined the utilitarian play equipment in sculptural forms. A tower was combined with three slides, while a S-shaped climbing structure topped with a dragon head became the mythical creature. There was even an abstract design inspired by the playful sculptures of British artist Henry Moore. The organic form of this playground design was so complex to construct that Khor had to enlist the help of local sculptor Lim Nang Seng, who was working on Singapore's Merlion statue around the same time.[117]

These experimental playground designs ultimately had to be rationalised as they were to be mass produced across HDB's public housing estates. Instead of each having a unique playground, Khor was to create a series of designs for his architect colleagues to select from for their estates. According to him, the Moore-inspired playground and the hand-cut dragon head also posed challenges for Singapore's then unskilled construction industry.[118] Thus, Khor created a new set of designs that were announced in 1974. Starting with prefabricated concrete drainage pipes, he drew out a variety of animal-shaped playgrounds—rabbit, tortoise, penguin, duck —on a grid. The geometric designs were easy to construct and also economical because they were made out of terrazzo and concrete pipes, the latter of which were manufactured in Bukit Timah by the Hume company. The choice of materials also ensured the playgrounds could withstand the tropical climate while offering smooth and safe surfaces for children to play on.

Khor improved on these designs with five new playgrounds in 1979 that signalled a shift from "static animal sculptures to miniature adventurelands for the young and active".[119] They came with elements for climbing, swinging and running and bore similarities to a series of new fitness corners rolled out in HDB estates the same year. These too were designed by Khor as

part of the Ministry of Defence's efforts to make regular physical exercise a "national habit".[120] Just as fitness corners with their stations for push-ups, pull-ups, sit-ups and leg-raises conditioned adult bodies for National Service, the playground could also be read as a way of disciplining young bodies. In fact, they were often installed side by side to "provide family togetherness for while the children are at play, their parents can have a go at exercising".[121]

Two "adventureland" designs released in 1979 also came to define how Singaporeans remember HDB playgrounds today. Both the dove and a new dragon playground were overlaid with colourful mosaic tiles, which replaced the need for periodic painting required by Khor's earlier designs.[122] This practical solution to a maintenance issue unexpectedly gave subsequent HDB playgrounds their distinct mosaic look when the agency continued the practice of tiling newer designs. By the time Khor left the HDB in 1984, the agency had changed its design approach to create "story-telling" playgrounds that were inspired by children's books such as Humpty Dumpty, the Old Woman who Lived in a Shoe and even Alice in Wonderland.[123] These playgrounds were meant to "fire the imagination of children and enrich their playtime", but they also addressed the HDB's goal of creating estates that were more distinctive and localised. As public housing blocks in the 1980s adopted pitched roofs and traditional building forms to promote a regional identity in new towns and estates (see *Public Housing*), playgrounds were also created in the form of local iconography, such as bumboats and traditional Malay kites. Some designs even reflected histories of places, such as the fruit-shaped playgrounds in Tampines that paid homage to its rural beginnings. Many of these subsequent playgrounds were brought to life by graphic designer Chew Chek Peng who worked with the then head of HDB's Landscape Studio, Maria Boey.

The 1990s marked HDB's gradual withdrawal from designing playgrounds as the agency increasingly turned to proprietary designs imported from overseas. These typically conformed to new national playground safety standards that were introduced in the 2000s.[124] Many old designs were also replaced as part of estate upgrading programmes led by town councils that were newly formed in the late 1980s

to take over the maintenance of public housing estates from HDB. From the perspective of these estate managers, the old mosaic playgrounds had to go because they were "monotonous" and unsafe as concrete was prone to chip off. Sandpits were also unhygienic and needed regular maintenance.[125] By 2003, *The Straits Times* reported that most of the over 1,000 HDB-designed playgrounds in Singapore had been replaced by cookie-cutter fibre-glass playgrounds that came with soft floors.[126]

But mosaic playgrounds refused to die. A decade later, HDB playgrounds re-entered the national consciousness when they became immortalised in souvenirs designed by a genera-tion nostalgic for their childhood and in search of a Singapore identity. The easily recognisable and replicated playgrounds—particularly the dragon and dove designs—proved easy to translate into products ranging from pins and plates to children's toys. The revival was complete in 2015 when the government identified the dragon playground as one of its 50 national icons to mark Singapore's golden jubilee.[127] The HDB has since redoubled its efforts in creating play spaces that shape a "stronger town identity" when it unveiled a new generation of "thematic playgrounds" in 2018. These are inspired by a neighbourhood's heritage and also involve residents more in designing and building their spaces of play.[128] Today, new buyers of a HDB flat also receive a welcome kit with a keychain: On one side is the distinctive dragon playground while the other declares: "Welcome Home!"

Notes

113 "City Playgrounds for Singapore," *The Straits Times*, 21 June 1928.

114 Khor Ean Ghee, interview by He Sujin, 4 September 2008, accession no. 003343 disc 8 of 12, National Archives of Singapore.

115 Khor Ean Ghee, interview by He Sujin, 4 September 2008, accession no. 003343 disc 9 of 12, National Archives of Singapore.

116 Quoted in Gabriel Burkhalter, *The Playground Project* (Zurich: JRP | Ringier, 2016: 31.

117 Personal interview with Khor Ean Ghee on 13 April 2011.

118 Ibid.

119 "New Design Playgrounds," *Our Home*, 1979.

120 George Joseph, "Twice-a-Year Fitness Test for Reservists," *The Straits Times*, 9 October 1979.

121 "Keep Fit Centres at New HDB Estates," *The Straits Times*, 4 October 1979.

122 Khor, interview by He, 4 September 2008, accession no. 003343 disc 9 of 12.

123 "Humpty Dumpty Comes to Pasir Ris," *Our Home*, 1988.

124 Sara Vincent. "Staff Trained to Ensure Child's Play is Safe," *The Straits Times*, 17 November 2000.

125 *Design for Maintainability: The Town Councils' Experience* (Singapore: 14 PAP-run Town Councils, 2004).

126 Michelle Ho, "Exit the Dragon," *The Straits Times*, 20 January 2003.

127 SG50 Steering Committee, "Dragon Playground," *Icons of SG*, accessed 23 January 2019, https:// www.sg/en/ICON/Icons/dragonplayground.aspx.

128 "New Generation HDB Playgrounds to Inspire Imagination and Exploration," Housing & Development Board, 13 April 2018, https:// www.nas.gov.sg/archivesonline/data/ pdfdoc/20180413004/New%20HDB%20 Thematic%20Playgrounds.pdf.

11.1 Three early HDB playgrounds at Toa
 Payoh Town Garden in the early
 1970s. One was a concrete tower
 connected with slides, another had
 a dragon head affixed to a metal
 climbing sculpture, while the third
 was an abstract sculpture inspired
 by Henry Moore.

11.2 Models of animal-inspired
 playgrounds introduced in 1974.
 Many were based on using a
 prefabricated Hume concrete
 drainage pipe for quick and easy
 mass construction.

11.3 Model of the first public housing
 fitness corner. They were released
 in 1979, the same year as new
 "Adventureland" playgrounds that
 shared similar elements for
 climbing and swinging.

11.1

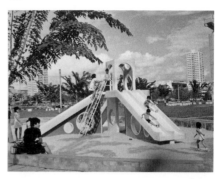

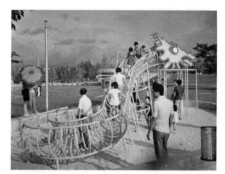

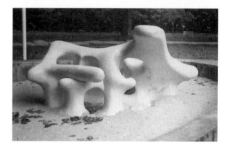

11.2

11.3

12 City Council Pools:

Swimming for Health,
Leisure and Survival

"Singapore is fast becoming a city of swimming pools although it takes less than 30 minutes to get to the beach," noted *The Straits Times* in 1972.[129] By then, the island reportedly had 20 swimming pools—including those owned by private clubs—and there were more on the way. Two years prior, the Housing & Development Board (HDB) revealed that swimming pools would become a standard amenity in all its new towns.[130]

While the popularity of swimming in a tropical island may seem natural, Singapore actually had few suitable beaches for such an activity. The construction of pools across the city-state was necessary for swimming to become a popular form of recreation for the public and a competitive sport. Prior to this, the activity was largely confined to the elite of the British colony. The Europeans were the earliest to have access to it in 1894 when the first swimming club was built in Singapore. The Singapore Swimming Club (SSC) offered a "pool" in the open sea off Tanjong Rhu that was later enclosed by simple wooden structures to create a *pagar* (Malay for "fence"). In 1905, a group of middle-class Peranakans began informally gathering further down the eastern coast in Tanjong Katong and eventually set up the Singapore Chinese Swimming Club as a response to their exclusive European-only counterpart.

The modern swimming pool as it is known today emerged in Singapore only during the 1930s when the SSC opened a 64 by 30 metre open-air seawater pool with swimming lanes. Designed and constructed by United Engineers Limited, the rectangular pool with radius curves at the corners was tiled throughout and even had a diving platform in the form of a Gothic arch with five boards.[131] Several years after its official opening in 1931, its Chinese counterpart also built a concrete pool in its *pagar*. Both developments allowed members to continue swimming even at low tide. This period also saw the public gain greater access to swimming when the Singapore municipal commissioners converted a former reservoir in Mount Emily into a public pool and built a *pagar* at Katong Park. In 1931, a privately run pool opened up for the public when businessman Aw Boon Haw set up the Tiger Swimming Pool at Pasir Panjang in the west. It was expanded in 1940 with a modern new pool

that departed from the typical layout with a deep section in the centre and shallow bottoms at each end to cater to beginners.[132]

Swimming pools became a vital recreational facility for the congested city of Singapore after the Second World War. It was seen as a solution to the "shocking lack of open spaces" in the colony, which doctors argued were vital in getting children to exercise and even fight diseases like tuberculosis.[133] After the colonial government announced in June 1950 that it was considering constructing a new swimming pool in Tanjong Pagar, the editors of The Straits Times expressed enthusiasm, stating, "Nothing will do more to give healthy enjoyment and exercise in the congested areas of the tropical city than swimming pools; and modern techniques for purifying and re-purifying water makes it possible to give this pleasure where it would have been a menace to public health in the past."[134]

But it was only after the Playing Fields Committee was established in October 1950 that the City Council finally agreed to build more recreational facilities.[135] The committee con-firmed Singapore's need for more recreational areas such as parks and playgrounds, and prioritised the provision of swimming pools.[136] The first to be built was the Yan Kit Swimming Pool completed at the end of 1952. The facility designed by City Council architect W. Irving Watson had four separate open-air pools that catered to different types of swimming, which were arranged in a linear fashion on its Tanjong Pagar site. At one end was a main 50-metre pool with racing lines painted at the bottom, followed by a practice pool and a beginner's pool with a maximum depth of 30 centimetres for non-swim-mers. There was also a children's paddling pool housed in a little garden at the entrance.[137] The swimming centre also had a diving tower with springboards placed 1, 3 and 5 metres above the main pool, a single-storey clubhouse and three separate structures for changing rooms and showers—all decked in a streamline moderne style. According to a former pool supervisor, Yan Kit was so popular that a two-hour limit was imposed on users.[138] In an effort to allow more to use the pool, floodlights were installed in 1954 to allow Yan Kit's opening hours to be extended until 9 pm—a feature once reserved only for private club pools.[139] The City Council also began allowing for more "mixed bathing" sessions to maximise use of the facility, which was designed with changing rooms for both sexes unlike the Mount Emily pool.

In its 1955 Administration Report, the City Council noted the growing popularity of its swimming pools, a trend attributed to its policy of "locating new pools in populous areas".[140] Pools were also the Council's most popular amenity, and it added that, "They have an invaluable advantage over anything else in that they provide at any given time, accommodation to so many active participants of all age groups."[141] It was probably why the City Council agreed to Watson's 1954 proposal to build a new pool every two years.[142] The first to be completed in 1957 was a set of two pools in the Farrer Park Athletic Centre, which elevated the recreational activity into a competitive sport. Farrer Park had the first Olympic-length pool amongst the City Council facilities, and it was here where a young Ang Peng Siong was groomed to become Singapore's swimming legend. He later even took over the facility to run a swimming school.

Farrer Park was also the first City Council pool to allow "mixed bathing"[143] at all times. According to former Straits Times editor George L. Peet, it was a radical initiative and marked the "final abandonment of segregation of the sexes at the Farrer Park pool [that] would have been unthink-able in the Singapore pre-war days."[144] However, it would take another two decades before all public swimming pools were open to both sexes in the mid 1970s. The only exception was at Mount Emily which had "women only" days even in 1979.

At the official opening of Farrer Park Swim-ming Pool, Singapore's Chief Minister Lim Yew Hock noted how important recreational facilities such as swimming pools had become to modern living. "One of the big changes in Singapore is that the weekend has become everybody's right, and it is our duty to see that the worker as well as the employer has his opportunities for recrea-tion," he said.[145]

In 1959, the City Council opened yet another public pool in the former King George V Park at River Valley. It was the final such facility built by the British before Singapore gained self-govern-ance, and later, independence. Over the next decade, these four City Council pools were the main places for public swimming and consist-ently attracted long queues, so much so that

people were sometimes turned away.[146] Relief finally came in 1970 as part of Singapore's extensive public housing programme. That year, the HDB completed a public swimming pool as part of the Queenstown estate, the first of such amenities in all subsequent new towns and large housing estates. Like the City Council pools, those designed by the HDB were also built near residences and came in open-air designs with separate pools to cater to a variety of swimmers.

Although swimming pools were first introduced by the British as a form of healthy recreation in a modern city, it became increasingly seen as necessary for the well-being and even survival of citizens post-independence. When Prime Minister Lee Kuan Yew officially opened a swimming pool at the Police Academy in 1977, he said it was "absurd" and "ridiculous" if Singaporeans could not swim because the city-state was surrounded by water, and the number of public-access swimming pools was increasing. He added: "For the next generation, every boy and every girl who is physically fit should be able to swim before he or she leaves primary school."[147]

Notes

129 "Singapore Fast Becoming a City of Swimming Pools," *The Straits Times*, 29 January 1972.

130 *HDB Annual Report 1970* (Singapore: Housing & Development Board, 1971), 19.

131 "Finest Sport for the Tropics," *The Straits Times*, 10 December 1931.

132 "New Swimming Pool for Singapore Costing $45,000," *The Straits Times*, 19 March 1939.

133 "Shocking Lack of Open Spaces," *The Straits Times*, 17 February 1949; "Where Are Singapore's Playfields?," *The Straits Times*, 5 July 1953.

134 "Civic Pointers," *The Straits Times*, 24 July 1950.

135 "S'pore Playfields Survey: Govt. sets up Committee," *The Singapore Free Press*, 2 October 1950.

136 "S'pore Must Have More Recreational Areas," *The Singapore Free Press*, 13 February 1951.

137 "New Pool Opens on January 1," *The Singapore Free Press*, 22 December 1952.

138 Alicia Yeo, "Yan Kit Pool to Reopen – but Not for Swimming," *The Straits Times*, 2 April 2002, sec. Home.

139 P. L. Koh, "Floodlight Swimming in S'pore Public Pool," *The Singapore Free Press*, 1 October 1954; "Singapore to Have Floodlit Bathing," *The Straits Times*, 12 June 1954.

140 *Administration Report* (Singapore: Singapore City Council, 1955).

141 "S'pore Must Have More Recreational Areas."

142 "He Gives Us Parks and Pools," *The Straits Times*, 4 July 1954.

143 Bathing was the common term for swimming at that time.

144 George L. Peet, "This was Singapore at Its Best," *The Straits Times*, 26 February 1957.

145 "Lim: Take Pride in Our Achievements," *The Straits Times*, 23 February 1957.

146 Juliet David, "Getting All Heated up in the Long Futile Wait to Cool Off," *The Straits Times*, 26 June 1972.

147 "Lee: Swimming a 'Must' for Every Child," *New Nation*, 27 February 1977.

12.1

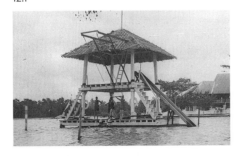

12.2

12.1 Early swimming "pools" in Singapore were in the open sea, such this Singapore Swimming Club facility off Tanjong Rhu with a diving stage.

12.2 The modern swimming facility emerged in Singapore during the 1930s when the Singapore Swimming Club opened a rectangular pool with lanes and an iconic diving platform with a Gothic arch.

12.3 The Britannia Club's Nuffield Swimming Pool at Beach Road was open only to members of the British forces in Singapore.

12.4 In 1940, businessman Aw Boon Haw opened Tiger Swimming Pool at Pasir Panjang. It was one of the first privately-run swimming pools opened to the public.

12.5 Yan Kit Swimming Pool was the first purpose-built public pool completed by the colonial government in 1952. The facility in Tanjong Pagar had sweeping curvilinear diving towers and four separate open-air pools.

12.6 Yan Kit was very popular with the public when it opened because it was one of the few public swimming pools built by the colonial government in the early 1950s. Another was at Mount Emily.

12.4

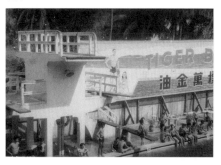

12.5

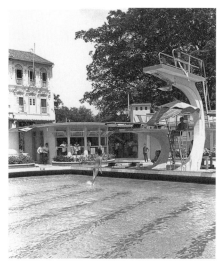

12.3

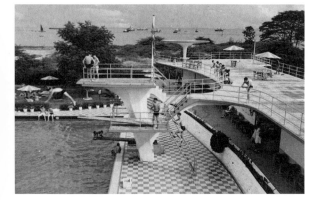

12.6

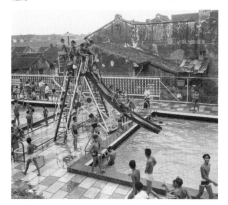

13 **Former Singapore Badminton Hall:**

Financial Gymnastics and Sporting Venues

The Rolling Stones held a rock-and-roll performance in it. So did Malaysia's "Queen of Striptease" Rose Chan and the globally acclaimed San Francisco Ballet Company. It was also the venue of choice for trade fairs, corporate dinners and political events—even serving as the vote counting station for the 1962 referendum on the merger of Singapore and Malaya.

Yet, the Former Singapore Badminton Hall, as its name suggests, was conceived first and foremost as a sporting facility. Completed in 1952, the venue at Guillemard Road should have symbolised how badminton was "finally and firmly established as Malaya's national game".[148] But years of financial struggles, both prior to its construction and even after, turned the badminton hall into an "all-purpose" venue[149] and a tale of the challenges in amassing the vast resources required to build and maintain modern venues for mass spectatorship.

Prior to the purpose-built badminton hall, competitive games were played either in a badminton court inside the Clerical Union Hall on Rangoon Road or the Singapore Volunteer Corps Drill Hall on Beach Road. However, the former had poor lighting and ventilation, while the latter was challenging to book, even leading to tournaments

being postponed. As the sport became increasing popular in the 1930s, the public began calling on the Singapore Badminton Association (SBA) or the municipality to construct a purpose-built venue instead.[150] The association went as far as selecting a site in 1939, but abandoned the project to build a hall near the Post Office Club in Serangoon Road, reportedly because of "nothing else but finance".[151]

Plans for a badminton hall was revived a decade later when Lim Chuan Geok led the Malayan badminton team to England for the inaugural Thomas Cup tournament in 1949. The manager-cum-captain proposed building a modern, first-class venue in Singapore to spur the growth of the sport.[152] His idea was boosted when the eight "little men" of Malaya beat the Americans, and then the Danes in the finals.[153] As cup-holders, Malaya now needed a modern facility to fulfil its privilege of hosting the next championships in 1952. The SBA officially launched a fundraising drive in May 1949 for the estimated $300,000 required for a covered stadium that would house three badminton courts, seats for 5,000 to 7,000 spectators, changing rooms, showers and other facilities for badminton tournaments.[154] However, public

donations were not forthcoming. After a year and a half, only a tenth of the amount was collected. There were even rumours that the project was dead after the government announced plans to build a S$2 million sports stadium off Anson Road that would also accommodate badminton and other indoor games.[155] The SBA insisted it needed its own hall and was vindicated when the government's plans were stalled. Even though it only raised half the money required in October 1951, Lim, who by then was the association's president, went ahead to construct the badminton hall as the Thomas Cup was only eight months away.

The controversial decision led to the high-profile resignation of the head of the badminton hall's fundraising committee, John Laycock. Amongst various issues, he questioned if it was wise to proceed without enough funds and wondered why a badminton hall should have two canteens and a banquet hall.[156] Lim explained that they were necessary for a sporting venue and served as "additional means of raising revenue to make the badminton hall self-supporting".[157] The association had also requested that the government relax its restriction that the hall only be used for badminton so it could be rented out for other events to generate revenue. Lim only went ahead with construction because he knew that the hall was a "paying proposition" and was assured it would be completed in time by the contractor C. H. Tong and architect Ng Keng Siang.[158]

Laycock's worries proved prescient as the construction costs of the hall almost tripled from what was initially estimated to S$850,000.[159] The SBA tried seeking a government loan, but the legislative council declined because it had already agreed to rent out the land for the hall at just S$1 annually for the first five years. Colonial Secretary W. L. Blythe added that "[i]f the project is such that neither the enthusiasm of the public can provide money for it, nor bankers nor financiers are prepared to support it, then I don't think it proper to be tossed into the lap of Government to make the best of it".[160] The hall was eventually completed with a loan from SBA patron, Aw Boon Haw, and because the contractor agreed to collect his payment via the proceeds from events instead.[161]

The Thomas Cup was eventually held in the Happy World Stadium in 1952. Besides being offered attractive financial terms, the Badminton Association of Malaya decided in February that year that it was too risky to wait for the Singapore Badminton Hall's completion with the event just four months away—even though it was eventually completed on time. The next two editions in 1955 and 1958 were eventually held in the hall. However, it became so plagued by financial woes that the government had to step in as a caretaker in 1958.[162] After two decades of leasing the hall for various events to help the SBA clear its debts, the state officially took over the venue in 1978 when it was transferred to the Singapore Sports Council.

The hall's financial struggles must have been instructive to the colonial government. While the Legislative Council passed a bill in 1950 to build a sports stadium in Singapore, the government later questioned if it was financially prudent because of the "more urgent priority" to provide housing, and fears of the stadium becoming a "white elephant".[163] The stadium project was only revived after Singapore became a self-governing state under the People's Action Party in 1959. Instead of a single sporting facility, the National Stadium was envisioned to be part of "a recreational hub" for locals and tourists that consisted of a cinema, an ice skating rink, floating restaurants and even a hotel.[164] Like the Singapore Badminton Hall, sports and entertainment came together again to make the stadium project viable.

Kallang was chosen for this hub because it was easily accessible and close to the existing Singapore Badminton Hall and the Gay World Stadium. It also had large swathes of state land that were sold to private developers to build the entertainment facilities and to raise funds for the new stadium designed by the Public Works Department. Costing some S$50 million, the over 50,000-seat stadium with a running track and football field was also made possible by proceeds from a national lottery set up in 1968.[165] The National Stadium officially opened in 1973, in time for Singapore to host the 7th South East Asian Peninsular Games for the first time. Its design came in a sweeping concrete structural frame with a gravity-defying 20-metre cantilevered grandstand roof that required no columns. The brutalist form by architect Tan Choo Guan was informed by several visits to overseas stadiums including in Kuala Lumpur, Phnom Penh and Tokyo.[166]

The completion of the stadium was followed closely by surrounding developments that made up Kallang Park. On its waterfront were three floating restaurants known as the Oasis Theatre

Restaurant Niteclub & Cabaret, and nearby was Singapore's own "miniature Disneyland", the Wonderland Amusement Park. Both were subsequently joined by the Ice Palace (1974), Singapore's second ice skating rink; Kallang Theatre (1978), which originally opened as Southeast Asia's largest cinema with 2,400 seats; and the Singapore Indoor Stadium (1989) that has a majestic roof designed by Japanese architect Kenzo Tange.

The National Stadium is perhaps best remembered for hosting the national football team's Malaysia Cup exploits, three editions of the Southeast Asian Games and 18 National Day Parades. Besides sporting events, it was also where thousands got to see Pope John Paul II when he visited in 1986, and concerts by Stevie Wonder and Michael Jackson. Despite its growing significance in the national imagination, the government announced in 2001—barely 30 years since it opened—that the "outdated" stadium would be redeveloped for a new multi-purpose integrated sports hub that could attract crowds even on non-event days.[167] However, the demolition of the stadium and its surrounding developments—save for the indoor stadium and theatre—only happened at the end of the decade. It has since been replaced by the Singapore Sports Hub, an integrated sports, entertainment and lifestyle complex made up of a 55,000-seat stadium, a 6,000-seat aquatic centre, a 3,000-seat arena and a 41,000-square metre shopping mall. Similar to the Former Singapore Badminton Hall and Old National Stadium, the $1.3 billion development also required some financial gymnastics to be viable. It was created under a public-private partnership so that the government would not have to bear all the risk and cost.

Instead, a private consortium was granted a 25-year lease to design, construct and operate the facility that was state-owned.

The eventual fate of the Singapore Badminton Hall is perhaps another sign of how interlinked modern sports and property have become. In 2008, the SBA vacated the hall when its 30-year lease with the government expired and the state raised its annual lease from under S$100,000 to S$1.164 million.[168] A private developer then took over the hall and adapted it into an entertainment centre. The former badminton hall housed a prawn fishing restaurant until 2011 when it was rented to a rock climbing school instead. The adjacent three-storey building, which the SBA had constructed in 1986 to house additional badminton courts and offices, was taken over by a spa and a pre-school. Its ground-floor restaurant, formerly the Cantonese eatery Fatty Weng, was replaced by a Korean barbecue chain.

Despite no longer catering to the sport, the building remains popularly known as the Former Singapore Badminton Hall and is recognised as a historic site by the National Heritage Board. The emphasis on "former" is important because a mere 10-minute walk away is another Singapore Badminton Hall built by the SBA some three years after it vacated. Solely dedicated to badminton, the 2,500-square metre facility boasts 14 Olympic-standard courts, permanent seating for 400 spectators, viewing galleries, a gymnasium and 14 dormitory rooms for centralised training camps. There is also space to erect another 1,400 spectator seats for competitions.[169] The S$1.5 million facility was paid for entirely by a group of badminton enthusiasts—just as the original Singapore Badminton Hall was envisioned to be.

Notes

148 "Victory with Honour," *Malaya Tribune,* 28 February 1949.

149 "It's All-Purpose Hall, Says Lim," *The Straits Times,* 30 October 1953.

150 "A Badminton Hall for Singapore?," *The Straits Times,* 15 July 1934; "Badminton Hall for Singapore," *The Straits Times,* 21 April 1935.

151 "Is Singapore Badminton Hall Project Abandoned?," *The Straits Times,* 11 March 1939.

152 Lee Siew Yee, "Lim Chuan Geok's Plan for Halls," *The Straits Times,* 30 January 1949.

153 "Now for the Future," *Malaya Tribune,* 30 May 1949.

154 "$300,000 Hall is Singapore's Aim," *The Straits Times,* 31 May 1949.

155 Sharpshooter, "Shuttlers Anxious about the Badminton Hall," *The Straits Times,* 19 November 1950.

156 "Laycock Resigns," *The Singapore Free Press,* 6 September 1951.

157 "Don't Be Alarmed Over Hall, Says Lim," *The Straits Times,* 18 September 1951.

158 "Work Starts on Thomas Cup Hall," *The Straits Times,* 2 October 1951.

159 "Save the Hall Appeal," *The Straits Times,* 11 March 1954.

160 "Singapore Refuses Badminton Hall Loan by 18 Votes to Three," *The Straits Times,* 21 February 1952.

161 "Badminton Hall 'Hero' Is Contractor," *The Straits Times,* 11 May 1952.

162 Lim Kee Chan, "Hall Is 'Transferred' without Any Fuss," *The Straits Times,* 11 February 1958.

163 "Stadium Should Be Public Project, Says Govt," *The Straits Times,* 22 September 1954; "Hart: Stadium Would Be a White Elephant, Full Every 4 Years," *The Straits Times,* 19 December 1958.

164 William Campbell, "The Re-Shaping of Kallang Park," *The Straits Times,* 20 April 1971.

165 See Kah-Wee Lee, *Las Vegas in Singapore: Violence, Progress and the Crisis of Nationalist Modernity* (Singapore: NUS Press, 2019), 118–147 for more.

166 Lai Chee Kien, Koh Hong Teng, and Yeo Chuan *Building Memories: People · Architecture · Independence* (Singapore: Achates 360, 2016).

167 Ng Boon Yian, "State-of-the-Arts Sports Hub in the Offing, Says Mr Abdullah," *Today,* 15 March 2001.

168 Jeanette Wang, "Singapore Badminton Hall Likely to Close in Jan," *The Straits Times,* 28 July 2007.

169 Chia Han Keong, "After 3 Years, S'pore Gets New Badminton Hall," *My Paper,* 2 November 2011.

13.1 Completed in 1952, the Singapore
 Badminton Hall was more than a
 sporting facility. It became a
 multi-purpose venue to support
 itself financially, including serving as
 a vote counting station for the 1962
 referendum on the merger of
 Singapore and Malaysia.

13.1

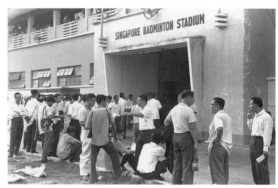

13.2 The large roof of the Singapore
 Badminton Hall as seen in this 1965
 photograph of an arts, crafts and
 hobbies exhibition organised by the
 government's vocational guidance
 steering committee.

13.2

13.3

13.4

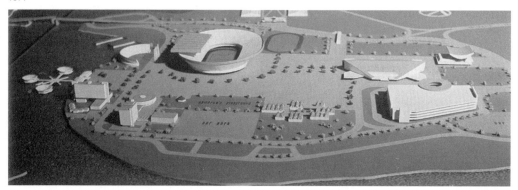

13.3　A 1980 badminton match between China and Indonesia played inside the Singapore Badminton Hall. By then, the venue which struggled to pay off its costs was taken over by the state.

13.4　A 1976 model envisioning how Kallang was to be developed into a sports and entertainment centre. On the top was the National Stadium.

13.5　Advertising matchbox for Oasis, an entertainment complex built in 1969 at Kallang Park. The design by Pan-Malaysian Group Architects had three floating structures connected to a main building on land.

13.5

Work

14-17

14 Shenton Way: Singapore's Commercial
 Centre Grows Up!

Even before construction started on the Develop-
ment Bank of Singapore (DBS) Building, the
50-storey skyscraper was hailed in *The Straits
Times* as "the very symbol of Singapore's pro-
gress through 152 years".[1] Rising to 187 metres,
which made it the city-state's tallest structure
when completed in 1975, the DBS Building was
said to have "opened a new chapter in Singapore's
history in much the same way the construction of
pyramids or the Taj Mahal or the Great Wall of
China had for that of Egypt, India and China".[2]

Such tall claims may have been hyperbolic—
especially in light of the fact that the building has
since been sold and redeveloped—but it reflected
the optimism of the early 1970s when Singapore
experienced an urban renewal fever. As another
journalist then observed:

> From any spot in Singapore, one cannot miss
> seeing an anonymous tall elegant building
> rising up abruptly against the clear blue sky in
> the distance. High-rise buildings are sprouting
> up at a pulsating pace ... Everyone has joined
> the race to the sky.[3]

Besides DBS Building, Singapore also witnessed
the rise of its tallest hotel, Mandarin Hotel (1973),

and residential block, Pearl Bank Apartments
(1976) (see *Pearl Bank Apartments*).[4] But the focal point of the
"race" was along Shenton Way, where the DBS
Building was joined in quick succession by Shing
Kwan House (1974–1998), Robina House (1975–
2008), UIC Building (1975–2012/3), and Shenton
House (1975). All these office towers were erected
on land sold during the second sale of sites
programme organised in 1968 by the then Urban
Redevelopment Department (URD became the
Urban Redevelopment Authority in 1974). While
the first such sales in 1967 provided land for
hotel, recreational and residential developments,
the second focused on modern office buildings
that were largely absent in Singapore. Of the 14
parcels of land put up for sale, five were located
along Shenton Way, a single road at the heart of
Singapore's traditional commercial and financial
district known as the "Golden Shoe". The plan
was to redevelop this area named after its
resemblance to an upturned shoe into the
financial and banking hub of the post-independ-
ence nation. New buildings were to be introduced
to house the expansion of financial institutions
from the nearby Raffles Place and Collyer Quay.
Across from the DBS Building, the First National
City Bank (today known as Citibank) bought and

occupied the UIC Building's entire upper podium and two floors of its tower; Chase Manhattan Bank moved into Shing Kwan House a few buildings down; and next door to it in the Industrial and Commercial Bank Building (1969–1999) were the Banque Nationale de Paris, the Moscow Narodny Bank, the Swiss Bank Corporation and the American Pennsylvania Trust.[5]

Shenton Way not only offered these banks a change in address but a significant leap in the scale of office space in Singapore. At Raffles Place and Collyer Quay, the tallest buildings were the 16-storey Bank of China Building (1953), the 18-storey Asia Insurance Building (1955), and the 15-storey Shell House (1960–1989/90).[6] The buildings in Shenton Way easily exceeded these heights and occupied more sizeable plots of land. One reason so many of these developments were built along this road was the availability of vacant land created from reclaiming Telok Ayer Basin in the early 1930s. Compared to elsewhere in the city centre, these plots were the "least encumbered"— by the need to acquire buildings sitting on typically small plots of land, as well as to compensate and resettle existing owners and tenants— and were "ready for immediate development".[7]

The government put forth a number of incentives to attract private developers to participate in the urban renewal of Singapore's city centre. It required only a down payment of 20 per cent for land premiums and the remainder paid as instalments over ten years. On the advice of United Nations urban planning experts, Charles Abrams, Susumu Kobe and Otto Koenigsberger, the government also offered special concessionary rates on property tax, cutting it by a third to 12 per cent per annum for the first 20 years after a building was completed.[8] Rent control from specific gazetted areas in central Singapore was also gradually phased out—the first being in the Golden Shoe—removing a key obstacle preventing landlords from redeveloping their premises.[9] These initiatives spurred a phenomenal rate of urban development that led a journalist to claim that, "Nowhere else in Southeast Asia can the sheer size and pace of construction work compare with the hubbub currently being created along busy Shenton Way in Singapore's downtown coastal district."[10]

Although the buildings along Shenton Way were not the first to be built in the podium tower typology, the road arguably became defined by it.

The building form was already prescribed for the 1967 sale of sites programme, which led to the construction of retail complexes (see *Shopping Centres*) such as People's Park Complex and Golden Mile Complex. It was also employed by the Housing & Development Board for its public housing in the city centre (see *People's Park*). However, prior to these, the podium tower was envisioned as the future for the Golden Shoe by the Planning Department, the predecessor of the URD. In its 1964 annual report, the department envisioned that from Telok Ayer Market to Maxwell Road will be a scheme:

> ... that takes the form of a podium to a height of 3 storeys which will extend throughout the development. Super-structures will be erected on the podium in the form of towers or slab blocks. The objectives of the scheme are the creation of a harmonious street scape which will give an impressive sky line when seen from the sea or from other parts of the City.[11]

In 1965, a planning control stated that new buildings in the Golden Shoe should consist of a two-storey (later modified to three-storey) podium block, with superstructures of tower or slab blocks based on a plot ratio of 5:1. Beyond creating a "harmonious street scape", the design "could also provide a continuous covered pedestrian walkway around the block."[12] Together with the planned development of pedestrian overhead bridges (see *Pedestrian Overhead Bridges*), the two policies would create a continuous pedestrian network linking all the buildings in the Golden Shoe.[13]

The Malaysia-Singapore Airlines (MSA) Building (1968–1994) was the first to be developed as part of this vision.[14] Located on a plot of land next to DBS Building, MSA Building was probably also the first in Singapore to have an aluminium and glass curtain wall, albeit one shaded with an array of U-shaped aluminium sun-breakers.[15] Designed by Lim Chong Keat of Malayan Architects Co-partnership (MAC) (which was dissolved in 1967 to form Architects Team 3), the MSA Building had a 15-storey tower sitting on top of a three-storey podium that helped "set a pattern for the future development of Robinson Road/Shenton Way as a premier business area".[16]

The neighbouring DBS Building shared similar features as it was also designed by Lim. Both podium towers had a roof garden and an auditorium, and their towers had "waists ... cut in

intervals to give a tiered effect".[17] A significant difference was in scale. The MSA Building rose to only 18-storeys and had a 91-metre-long podium while the DBS Building was 50-storey tall with a podium that stretched 262 metres long. Similarly, the MSA Building's auditorium was a theatrette with a seating capacity for only 124 people whereas the one in DBS could hold 560 people. The contrast in scale also shaped their respective architecture. For instance, the "waists" around the towers were first developed for the MSA Building to fit tenancy requirements, such as creating "executive suites with an open terrace all round".[18] However, the floors at the waist of the DBS Building were allocated for machine rooms instead. To break down the scale of the DBS Building, Lim created a central arcade in the middle of the extremely long podium block in order "to avoid monotony of the straight conventional 'five-foot way'".[19] The podium block was also differentiated with three superstructures: the Auditorium and Conference Exhibition Centre at the Maxwell Road end; a 50-storey tower block in the middle; and a low-rise seven-storey block at the McCallum Street end.

As podium towers offering modern offices and shops lined up along Shenton Way and the city centre, a few developers also tried introducing apartments in them. It was a response to the government's concern that the city centre became "dark and dead after sunset, when the office workers go home".[20] One early example is Anson Centre developed by Hong Leong Holdings in 1973. Originally designed by Yao & Quek Chartered Architects as an office tower, the developer successfully resubmitted its plans for

the 14-storey building to change one floor into three apartments to meet the government's directive and various enquiries from prospective buyers.[21] Another development is the 50-storey International Plaza, which was completed in 1976 as a seven-storey podium topped with a 43-storey tower block. The tower housed offices until the 33rd floor and above it were flats including penthouses on the topmost floor.[22] Such developments were the exception, however, as most buildings in Shenton Way and the Golden Shoe remained purely for offices and commercial use.

It was only in the 21st century that Singapore began realising a city centre that stayed alive even at night. By reclaiming land in front of Shenton Way, the government yet again expanded the city-state's business and financial centre with a "new downtown" known as Marina Bay. The 360 hectares of land allowed the emergence of mega-developments, such as the Marina Bay Financial Centre (MBFC) and Marina One, which offer significantly larger floor plates for contemporary offices and space for residences. Marina Bay also has various recreational facilities, including the Marina Bay Sands integrated resort; the 101-hectare Gardens by the Bay; and a waterfront promenade where events and celebrations are held year round.

Just as the DBS Building and Shenton Way opened a new chapter for Singapore's CBD in the 1970s, Marina Bay has taken on a similar role some three decades later. In 2010, the DBS Building in Shenton Way was sold, and the bank moved into MBFC two years later to become a part of Singapore's latest downtown expansion.

Notes

1 Leslie Fong, "Signing of $36 M Contract Marks a New Era," *The Straits Times*, 29 May 1971.
2 Ibid.
3 Gene Teo, "The Concrete Jungle... " *New Nation*, 20 January 1973.
4 Ibid.
5 "Business Centre Springs up on Shenton Way, Singapore," *Asian Building & Construction* May (1972); Chua Beng Huat, *The Golden Shoe: Building Singapore's Financial District* (Singapore: Urban Redevelopment Authority, 1989), 76.
6 "Xmas Opening of New Bank," *Straits Budget*, 12 November 1953; Tan Hui Yee, "Saved... But It's a Number Game," *The Straits Times*, 7 June 2008; "Shell House, Singapore," *Rumah, Journal of Society of Malayan Architects* 3 (1960). Shell House was sold to the Rubber Association of Singapore in 1974 and renamed the Singapore Rubber House. In 1986, it was again sold and later redeveloped into Savu Tower 1 (1993). Since then it has been renamed several times and was known in 2019 as 16 Collyer Quay.
7 Chua, *The Golden Shoe*, 26.
8 Ibid., 19. See Charles Abrams, Susumu Kobe, and Otto H Koenigsberger, "Growth and Urban Renewal in Singapore: Report Prepared for the Government of Singapore," (New York: United Nations Programme of Technical Assistance, Department of Economic and Social Affairs, 1963); State and City Planning, "Notes on the United Nations Assistance in Urban Renewal and Development Project, Singapore, unpublished file SCP 1.0.5.1.," (Renate Koenigsberger Private Collection January 1969), 60.
9 Chua, *The Golden Shoe*.
10 "Business Centre Springs up on Shenton Way, Singapore," 15.
11 Planning Department, *Annual Report of the Planning Department for the Year 1964* (Singapore: Planning Department, 1966), 4.
12 "DBS Building: Expansive... Quiet but Assertive... Simple but Strong," *Building Materials & Equipment,* December (1977).
13 "Business Centre Springs up on Shenton Way, Singapore."
14 MSA was originally named Malaysian Airlines Ltd. In 1966, it changed its name to Malaysia-Singapore Airlines after Singapore separated from Malaysia. "MAL Is Now MSA," *The Straits Times*, 31 December 1966. It is not clear when MSA Building was demolished and redeveloped but a newspaper article in 1992 indicated that the redevelopment of the old building would begin in 1994. See "SIA Plans to Re-Develop Robinson Rd Building," *The Straits Times*, 1 July 1992.
15 "MSA's New Building: $500,000 Contract for a Local Firm," *The Straits Times*, 15 March 1967.
16 "Malaysia Singapore Airlines," *Journal of the Singapore Institute of Architects* 33 (1969): 9.
17 "DBS Building," 44.
18 In a booklet commemorating the completion of the MSA Building, the two recessed floors were shown to be leased to Qantas and BOAC (British Overseas Airways Corporation). "Malaysia Singapore Airlines," 12.
19 "DBS Building," 34.
20 "Bringing Life to the City Centre at Night...," *The Straits Times*, 17 January 1971.
21 Abby Tan, "Today's Answer for Yesterday's Problem," *New Nation*, 24 April 1971.
22 Tan Cher Soon, "Designed for Diversity," *New Nation*, 22 January 1972.

14.1 A 1964 illustration by the Planning
 Department envisioning Singapore's
 Golden Shoe area to be developed
 into a line of towers sitting on a
 uniform three-storey podium.

14.2 The Malaysia-Singapore Airlines
 (MSA) Building was the first of the
 podium tower typology to be
 developed in Golden Shoe.

14.3 A ground-level view of Shenton
 Way, with Shenton House and
 Robina House (far left). Both podium
 towers were completed in 1975 by
 Tay Joo Teck Architect and Ho Yut
 Choon Architect respectively.

14.4 (R-L) Chinese premier Deng
 Xiaoping, Chinese foreign minister
 Huang Hua and Chairman of
 Singapore's HDB, Michael Fam,
 viewing Shenton Way from the
 rooftop of the MND Building, 1978.
 In the background are the three
 towers of (L-R) MSA, DBS and the
 Central Provident Fund.

14.5 Aerial views of Shenton Way and
 Telok Ayer Basin illustrating the rise
 of podium towers between 1968
 (above) and 1977 (below).

14.6 Advertisement featuring the DBS
 Building completed in 1975.

14.1

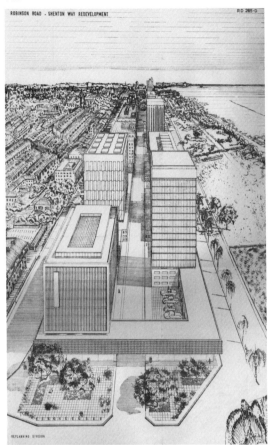

14.2

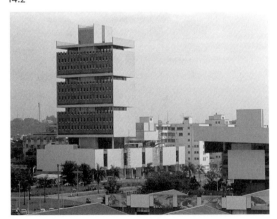

14.3

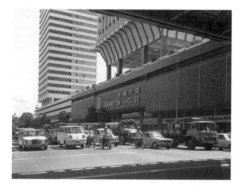

14.4

14.5

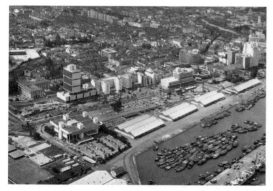

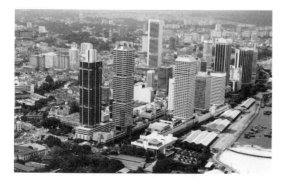

14.6

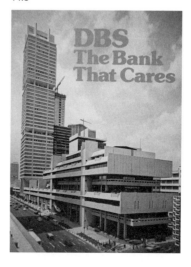

15 Industrial Spaces:

Housing Industrialisation, then a Tech Revolution

After laying the foundation stone for Singapore's first flatted factory on 30 May 1965, the then Minister for National Development Lim Kim San proclaimed it as "yet another step in adapting our small island with limited space to an industrial economy".[23] The five-storey building in Tanglin Halt indeed became much replicated across the city-state as it rapidly industrialised over the decades. Inspired by a similar typology created in Hong Kong during the late 1950s to resettle small industrial units, Singapore began building them via the Jurong Town Corporation (JTC) and the Housing & Development Board (HDB). According to Lim, the goal was to relocate small firms involved in light industries from "hastily adapted and cramped working sites to the spatial [sic.] well ventilated and suitably sited flatted facto-ries"—in the same way that the population was being moved into multi-storey flats (see Public Housing).[24] A tenant could originally lease up to 10,000 square feet of floor area in a flatted factory, while those requiring larger spaces had the option of landed factories, built by either the two agencies or private enterprises.[25] Some 200 firms applied for space in Singapore's first flatted factory, of which 80 per cent were characterised as "cottage

industries" that were affected by the urban renewal around Tiong Bahru.[26]

Better known today as Block 115, Singapore's first flatted factory is a simple, utilitarian building that was economical in both its construction and use of land. It was known for its U-shaped plan, and subsequent flatted factories were also identified in trade literature by the alphabets their plans resembled, the most common being I, L, Z, T and H.[27] It reflected their essentially open plan designs that were organised around service cores and wrapped with balconies and access corri-dors. Such functional designs lacked distinctive architectural qualities unlike those lower-rise buildings owned by a single owner, like, say, the National Iron and Steel Mills (1964) factory with its hyperbolic-paraboloid umbrella roof and the Cooling Systems and Flexibles factory (1971) with its colonnade of elegantly sculpted columns. However, flatted factories were key in supporting Singapore's industrialisation drive post-inde-pendence. Between 1960 and 1972, manufactur-ing grew to become an important part of the economy and its contribution to the gross domestic product (GDP) close to tripled from 9.2 to 25.5 per cent. In 1972, the manufacturing

sector also employed some 173,000 workers or almost a quarter of the country's labour force.[28] Thus, the government prioritised the building of flatted factories to accommodate this growing number, a large proportion who worked in small firms that employed less than 10 people.[29] Even before the development in Tanglin Halt was completed in 1967, it embarked on the planning and construction of four other flatted factory blocks at Redhill and Kallang Basin.[30]

By 1975, some 24 blocks of flatted factories were completed, and another 13 blocks were under construction by JTC alone.[31] They were typically built in industrial estates across the city-state—including Tanglin Halt, Redhill, Kallang Basin, Toa Payoh, Ayer Rajah, Telok Blangah and Tiong Bahru—and located near public housing estates. In fact, several industrial estates were planned as an integral component of New Towns developed by the HDB. The close proximity to residences allowed the labour-intensive manufacturers to tap into an available pool of workers, including housewives. In 1975, it was estimated that females made up 79.2 per cent of the workers in flatted factories, most of which housed manufacturing firms. The women were attracted by the convenient location and also the types of work available. Some 67 per cent of the total leasable floor area in flatted factories was made up of manufacturers from the electronics and garment industry. They typically involved "nimble handiwork" that required female workers rather than the "muscular work" needed by heavier industries such as printing and jewellery manufacturing.[32]

Even as more flatted factories were constructed, the attractiveness of Singapore as the place for multi-national companies (MNCs) to set up factories came under threat. While labour costs used to be low due to years of mass unemployment, wages had increased quite significantly over the decade. For instance, textile firms experienced a 40 per cent hike in their wage bills based on the recommendations of the National Wage Council, an amount that was significantly more than in Hong Kong, Taiwan and South Korea. When electronics manufacturers experienced a similar level of wage increase in 1974, it led to retrenchments and an exodus of firms. The Singapore government began wooing specialist manufacturers to shift the sector towards production that was higher up the value chain

instead.[33] By 1979, the JTC reported "a conspicuous shift in demand for space in flatted factory buildings from labour-intensive, low-skill industries prevalent a decade ago to more sophisticated, high technology industries".[34] That year, Singapore continued restructuring the industry by embarking on a "Second Industrial Revolution".[35]

A national research and development programme was kickstarted to upgrade the economy towards research-based, skill- and capital-intensive high-technology industries.[36] A new type of industrial space in the Singapore Science Park also emerged to support businesses in advanced electronics, biotechnology, computer software, product testing and analysis services, among others.[37] Launched in 1980 as a part of JTC's 10-year masterplan to support Singapore's industrial transformation, the Park moved away from the locational logic and planning rationale of previous industrial spaces and typologies.[38] Unlike flatted factories that were located next to public housing to tap into low-cost labour, the Park was sited next to the National University of Singapore at Kent Ridge to "foster interaction among researchers in industries and the University resulting in a transfer and exchange of knowledge and ideas".[39] It reflected the origins of such "science parks" from the United States of America—specifically Silicon Valley in Palo Alto, and Route 128 in Boston—where the close proximity between major research universities and centres of high-technology industries resulted in synergies. Such a model spread to the rest of the world from the 1970s, and similar parks were established in the United Kingdom, Canada, South Korea, Japan and Taiwan.[40] These countries were part of the 10 examples that a team from JTC and the Singapore Institute of Standards and Industrial Research (SISIR) visited to plan the Singapore Science Park.

Besides its location, the Singapore Science Park was also planned and designed differently from older industrial estates and flatted factories to accommodate new types of labour. Instead of physical work and manufacturing facilities, workers in science parks were expected to use their brains to create new knowledge to stimulate innovation in the manufacturing sector. According to British geographer Doreen Massey and colleagues:

The theme of place and the symbolism of environmental context is central to science parks. Their cultural meaning, and the way that is tied to location, is fundamental. It is not for nothing that they are called 'parks.'[41]

Located in rural or suburban locations, the major North American and European science parks were characterised by their parkland settings that set them apart from the drabness of earlier industrial environments. The Singapore Science Park was planned in a similar manner, according to JTC's annual report:

> In the overall design of the Park, emphasis will be laid on well designed buildings with wide open rolling grounds, aesthetically land-scaped. The Park will not be fenced in so as to enhance the visual impact of wide open space.[42]

Unlike flatted factories, intensive land use did not seem to be an important consideration. The first few buildings in the Singapore Science Park were only two- to three-storeys tall and were surrounded by car parks and landscaped grounds. While previous industrial estates were created out of the typical post-independence tabula rasa approach, which entailed the filling of swampy lands and the flattening of hilly terrains, the Park had "[e]arthworks ... kept to the barest minimum to retain the existing greenery and rolling landscape"[43] of the former British military grounds.[44]

To attract the right tenants to the Singapore Science Park, the JTC and Economic Development Board (EDB) aggressively promoted it both locally and overseas. Although this proved challenging initially because of the 1985 economic recession, the Park subsequently reached a "critical mass" of tenants made up of overseas, local and joint-venture companies with an emphasis on research and development in technology.[45] It also successfully served as a nursery for local technology firms, helping them start up, grow and eventually move out of the Park.[46] By 1988, when Singapore's economy was back on track, the development was doing so well that a journalist claimed that "[h]igh-technology companies are now flocking into the Science Park at such a speed that space is running out".[47]

It led to plans to build upon the Park's first phase of 29 hectares of land with another 79 hectares built across three new phases.[48] Plans were also drawn up to transform the Park into a technology corridor by replacing the manufacturing plants at the neighbouring Ayer Rajah Industrial Estate with spaces of higher economic value.[49] Although the area was re-zoned as a "science habitat" and "business park" in 1991, it was only in the wake of the 1997 Asian Financial Crisis that JTC drew up a masterplan to realise this vision.[50] In 2001, the one-north district, designed with the assistance of world-renowned architectural firm, Zaha Hadid Architects, was unveiled as Singapore's new home for research and development and high-technology industries. Besides offering workspaces in a lush landscape like science parks, the district also had space for living, playing and learning—a new urban configuration to spark innovation in Singapore's on-going transformation from an industrial economy towards a knowledge-based one.

Notes

23 "Text of Speech by the Minister of National Development, Dato Lim Kim San, at the Laying Foundation Stone of the First Block of Flatted Factory at the Tanglin Halt Industrial Estate on Sunday, May 20 (1965), at 11 a.m," National Archives of Singapore, accessed 11 May 2019, http://www.nas.gov.sg/archivesonline/data/pdfdoc/PressR19650530b.pdf.

24 Ibid. For early flatted factories in Hong Kong, see D. J. Dwyer and Lai Chuen-Yan, *The Small Industrial Unit in Hong Kong: Patterns and Policies* (Hull: University of Hull Publications, 1967).

25 Applied Research Corporation, *A Study of JTC Flatted Factories, Prepared for Jurong Town Council* (Singapore: Applied Research Corporation, 1977), 7.

26 Ong Mui Eng, "The Role of Flatted Factories in Singapore's Industrialisation Programme" (B.A. (Hons.), Singapore, University of Singapore, 1975), 16–17.

27 Applied Research Corporation, *A Study of JTC*, 6-13.

28 Ong, "The Role of Flatted Factories", 7–8.

29 A 1962 survey estimated that 70 per cent of the 2,300 firms in manufacturing employed less than 10 workers. Ibid., 16.

30 Ibid., 18.

31 Applied Research Corporation, *A Study of JTC*, 12.

32 Ong, "The Role of Flatted Factories", 64–69.

33 Ibid., 69–72.

34 *Jurong Town Corporation Annual Report 1978-79*, (Singapore: JTC, 1979), 20.

35 Jonathan Rigg, "Singapore and the Recession of 1985," *Asian Survey* 28, no. 3 (1988): 342–3; Pow Ang Yong, "Changing Emphasis of JTC," *Singapore Monitor*, 13 September 1983.

36 Su-Ann Mae Phillips and Henry Wai-chung Yeung, "A Place for R&D? The Singapore Science Park," *Urban Studies* 40, no. 4 (2003): 714.

37 Lilian Chew and Ronnie Wai, "Park Hit by Recession," *The Straits Times*, 5 February 1983.

38 The first sketch masterplan of the Science Park was exhibited at the JTC booth at TechEx 80, a technology exchange fair at World Trade Centre. Paul Jansen, "Science Park Next to Campus," *The Straits Times*, 10 March 1980.

39 *Jurong Town Corporation Annual Report 1980–81*, (Singapore: JTC, 1981), 14.

40 Doreen Massey, Paul Quintas, and David Wield, *High-Tech Fantasies: Science Parks in Society, Science, and Space* (London: Routledge, 1992), 1.

41 Ibid., 87.

42 *Jurong Town Corporation Annual Report 1980–81*, 14.

43 *Jurong Town Corporation Annual Report 1982–83*, (Singapore: JTC, 1983), 21.

44 For the planning of British military landscape in Singapore, see Jiat-Hwee Chang, *A Genealogy of Tropical Architecture: Colonial Networks, Nature and Technoscience* (London: Routledge, 2016), 51–93.

45 Martin Soong, "Science Park Tenants Emphasise R&D," *Business Times*, 29 September 1987.

46 Grace Chng, "Science Park 'Important but Is Not a Magic Pill,'" *The Straits Times*, 5 October 1988.

47 Jeffrey Tsang, "Science Park Filling up Fast, Two More Blocks Being Built," *The Business Times*, 28 December 1988.

48 Soong, "Science Park Tenants".

49 Chng, "Science Park".

50 Kai Wen Wong and Tim Bunnell, "'New Economy' Discourse and Spaces in Singapore: A Case Study of One-North," *Environment and Planning A* 38 (2006).

15.1 The first flatted factory at Tanglin
 Halt Industrial Estate, 1967. The
 five-storey building was introduced
 in Singapore to relocate small firms
 in light industries into safer and
 more compact developments.

15.2 The simple and utilitarian flatted
 factory came in various plans, such
 as a C-shaped design located at
 Tanglin Halt industrial estate.

15.3 Another example of the functional
 plans of flatted factory are these
 two Z-shaped examples at Redhill
 Industrial Estate.

15.1

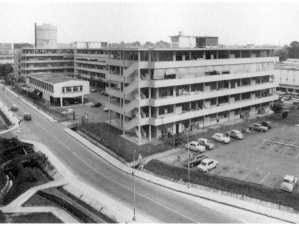

15.2

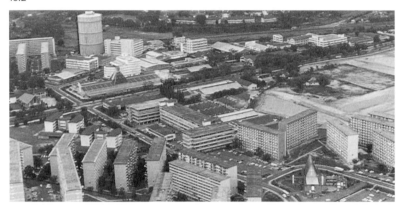

15.3

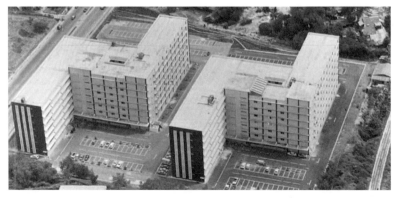

15.4 A female worker of a manufacturer
 of electronic calculators inside a
 flatted factory in Kallang Bahru,
 1979. By building such workspaces
 near public housing estates,
 companies could tap an available
 pool of workers, including
 housewives.

15.5 A delegation from China led by
 state councillor Gu Mu viewing a
 model of the Singapore Science
 Park, 1986. The development was
 part of a new plan to upgrade
 Singapore's economy towards
 research-based, high-technology
 industries.

15.6 A 1981 illustration of the first phase
 of the Singapore Science Park.
 The sprawling development
 located amidst a lush green
 environment was modelled after
 similar ones in the United States of
 America.

15.7 An aerial view of the Singapore
 Science Park in 1988. The park was
 sited next to NUS to foster
 interaction among researchers in
 industries and the institute of
 higher learning.

15.4

15.5

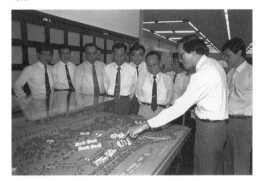

15.6

15.7

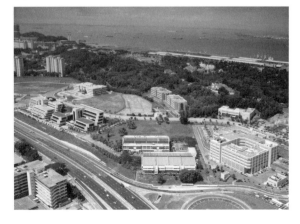

16 Jurong Town Hall Road: The Industrial Future
 as Brutalist

Ugly, hideous and monstrous are just some of
the pejorative terms that have been used to
describe brutalist architecture around the world.
But these concrete buildings—typically defined
by their raw exteriors and blockish forms—once
symbolised Singapore's industrial future. One of
the earliest examples is Jurong Town Hall, which
was completed in 1974. It marked the first in a
line of brutalist structures along Jurong Town
Hall Road, including the Singapore Science
Centre (1977), Unity House (1982–2008),
German-Singapore Institute (1982) and French-
Singapore Institute (1983).

Jurong Town Hall was conceived as the
headquarters of the Jurong Town Corporation
(JTC), a state agency set up to develop and
manage industrial land and infrastructure in
Singapore, and to support its export-oriented
industrialisation programme. Formed in 1968
out of the Economic Development Board (EDB),
JTC was also in charge of developing industrial
estates in Singapore, including Jurong Town, the
"garden industrial town" that had large industrial
zones as well as residential and recreational
amenities.[51] Jurong Town Hall was planned to sit
at the heart of the town and an architecture
competition was called for "a substantial and

impressive building which will serve as a land-
mark symbolising the Jurong Town and will be
remembered by posterity".[52] The building
bounded by Jalan Ahmad Ibrahim and Jalan
Bahru Selatan would also sit "at the centre of the
choice site of 14 acres consisting of an elongated
conical hill, which is centrally located in the
proposed Jurong Town Centre".[53] Jalan Bahru
Selatan was later renamed after the building as
Jurong Town Hall Road.

The winning entry by Architects Team 3,
which was led by Lim Chong Keat, beat 33 other
submissions. The design consisted of two parallel
five-storey elongated blocks of unequal length
with the conference hall placed in between them.
The competition assessors were impressed by
the low-rise building with large floor plates that
could accommodate the whole division of JTC
within a single storey. They also appreciated how
"its unique character combine[d] with dignity
[would] serve as a monumental landmark to
Jurong Town"[54]. Its heavy massing emphasises its
sculptural quality, and the building's walls are
angled both inwards and outwards. Externally,
the top two stories slope outwards and the floor
and roof slabs are cantilevered from the columns.
The top-heavy massing is counter-balanced by

walls that slope inwards in its lower two stories. Overall, the building is a striking piece of brutalist architecture.

Of uncertain provenance, brutalism is an oft-misunderstood label that was first coined by the British architects Alison and Peter Smithson and subsequently adopted in different ways around the world. *Heroic: Concrete Architecture and the New Boston* makes a case for how brutalism in America was disassociated from its original ethos and became linked with a group of architects in their search for a new expression of monumentality.[55] It led to an aesthetic shift away from the international style, such as departing from thinness to thickness, from plane to volume, and from light to heavy construction.[56] The use of bare concrete in a heavy, volumetric and sculptural massing was seen as "reflecting the democratic attributes of a powerful civic expression—authenticity, honesty, directness and strength".[57] When used in government complexes and educational institutions, which was the case in many North American cities from the 1960s to the 1970s, the aesthetic also connoted their longevity and permanence.[58]

Jurong Town Hall's architect, Lim, studied at the Massachusetts Institute of Technology between 1955 and 1957 and may have been influenced by the North American use of brutalist expression for government buildings. In fact, the Hall was just one of several government buildings that his firm Architects Team 3 designed in this style. In neighbouring Malaysia under its Malay name, "Jurubena Bertiga", the firm also designed a number of key brutalist buildings, such as the Bank Negara Malaysia's Penang Branch (1969), Petaling Jaya Town Hall (1970), and Selangor State Assembly Hall, Shah Alam (1978).

Although one of brutalism's main features was the use of exposed concrete—after all, an etymological origin of brutalism was *béton brut*, the French phrase for raw concrete—this was not the case for those built in Singapore. Their concrete surfaces were often plastered over and painted; and even finished with Shanghai plaster. According to Singapore architect Tay Kheng Soon, who designed brutalist-like buildings such as People's Park Complex and Golden Mile Complex (see *Shopping Centres*), "Brutalism, apparently, was too brutal for the bureaucrats."[59] When the Buildings and Common Property (Maintenance and Management) Act was established in 1973 to ensure owners and developers maintained structures they have built and leased to the public, the Building Management Unit required that a building's "more bluntly exposed concrete areas to be painted over".[60] After all, exposed concrete does not weather well in the equatorial climate of Singapore, and if not well detailed and sealed, algae and mould would grow on its porous surface.

Once painted over, brutalist buildings in Singapore were seen in another light. This could explain why the S$9 million Jurong Town Hall, painted in white colour, was regarded as futuristic, a reading supported by its tower with a digital clock. The forward-looking association was also reinforced by the erection of yet another brutalist building along Jurong Town Hall Road: the Singapore Science Centre. With its angled walls and heavy, sculptural massing, it had a similar design to Jurong Town Hall. In fact, it was designed by Raymond Woo, who had worked with Lim on the latter. The scheme beat 22 other entries at a 1971 design competition[61] where impressed assessors praised the building's exterior as "imaginative and stimulating, most expressive of its purpose of arousing interest in, and understanding of, the continually developing wonders of modern science and technology".[62] When completed in 1977, a journalist described the building as a reflection of science, adding: "From afar, the upper floors look like a spaceship hovering over the building, and the promise created by this impression is fulfilled by the interior."[63]

The Singapore Science Centre was the brainchild of Dr Toh Chin Chye, then the Minister for Science and Technology. He wanted a centre to promote science and technology among the general public and to stimulate an interest in the country's youth to become scientists, technologists and perhaps technocrats, who would go on to support Singapore's industrialisation effort. It was built with donations from various industrialised nations—such as West Germany, Japan and the United States—and its programme was based on the study of various science centres and museums in Europe, North America and Japan. However, the Singapore Science Centre "contains some of the better features found in all of them, with a lot of local additions" and was "very much its own".[64]

The idea of selectively borrowing from the best examples around the world was also echoed by

the centre's inaugural director Dr R. S. Bhathal. In an article, he explained that countries like Singapore did not have to "go through the painful and teething problems of discovering science and technology. They are in a position to go shopping in the ... world supermarket of science"—and the Singapore Science Centre represented the booty from this "shopping spree".[65] The idea of growing without growing pains was undoubtedly very appealing to a Singapore seeking to modernise and industrialise rapidly, leapfrogging the usual stages of development. The futuristic architecture of the Science Centre and the Jurong Town Hall arguably embodied the visual culture of such aspirational developmentalism.

The choice of brutalism to represent Singapore's industrialisation programme was further cemented with the completion of two industrial training institutes along Jurong Town Hall Road in 1982. The German-Singapore Institute and the French-Singapore Institute were part of a network of industry-government training centres established by the EDB to boost the technological capacity of Singapore's industries, and both came in brutalist forms too.[66] The aesthetic was also extended to institutional buildings in other parts of the city-state, but only in Jurong was it concentrated along a single stretch. (see *Institutional Buildings*)

The last brutalist building to be built along Jurong Town Hall Road—and the only one that has been demolished at the time of this writing—was one designed for the Pioneer Industries Employees' Union (PIEU). Originally named Unity House, this building was meant as a "symbol of the solidarity of the union members' aspirations and contributions towards Singapore".[67] Designed to "blend" architecturally with the Science Centre

and Jurong Town Hall, it had around 9,500 square metres of floor area and was to be the biggest trade union building in Singapore.[68] The vision never came to fruition. In 1979, the general secretary of the union, Phey Yew Kok, who conceived the project in the late 1970s, absconded after he was charged with the misappropriation of union funds—and only turned himself in after 35 years, in 2015.[69] In the aftermath, the PIEU was split into smaller unions and the completed building was sold in 1981 to the National Iron and Steel Mills, and renamed McDermott House.[70] The building was leased out, including as the headquarters of a large accounting firm, until 1996 when it was sold to JTC. In 2008, it was demolished. Despite being the tallest brutalist building along Jurong Town Hall Road, it had the least to do with industrial development.

Today, the four remaining brutalist buildings in Jurong Town Hall Road stand rather isolated and surrounded by large open spaces. While the Jurong Town Hall was conceived as a beachhead of development in the area, the surrounding town centre and public housing were built much further away as compared to plans and models for the town from the early 1970s. In 2005, Jurong Town Hall was conserved and, a decade later, gazetted a National Monument as "an iconic testimony to Singapore's drive towards modernisation and development in its early years of independence".[71] Today, its brutalist aesthetic may yet be read again as a harbinger of the future: the industrial town is being transformed into Jurong Lake District, a new central business district outside Singapore's city centre.

Notes

51 Tang Hsiao Ling, "Industrial Planning in Singapore," in *50 Years of Urban Planning in Singapore*, ed. Heng Chye Kiang (Singapore: World Scientific, 2017).

52 "Jurong Town Hall Architectural Design Competition," *Journal of the Singapore Institute of Architects* 39 (1970): 5.

53 "Singapore's Jurong Town Hall," *Asian Building & Construction* March (1974): 13.

54 "Jurong Town Hall Architectural Design Competition," 5.

55 Mark Pasnik, Michael Kubo, and Chris Grimley, "Becoming Heroic," in *Heroic: Concrete Architecture and the New Boston*, ed. Mark Pasnik, Michael Kubo, and Chris Grimley (New York: The Monacelli Press, 2015), 18.

56 Joan Ockman, "The School of Brutalism: From Great Britain to Boston (and Beyond)," in *Heroic*, ed. Pasnik, Kubo, and Grimley, 34.

57 Pasnik, Kubo, and Grimley, "Becoming Heroic," 18.

58 Ockman, "The School of Brutalism."

59 Tay Kheng Soon, "Architects, Be Your Own Critics," *The Business Times*, 6 September 1978.

60 "Building Management Unit," *Journal of Singapore Institute of Architects* 64 (1974).

61 "The Science Centre, Singapore," *Journal of Singapore Institute of Architects* 49 (1971).

62 "The Science Centre Architectural Competition," *Journal of Singapore Institute of Architects' Journal* 49 (1971): 4.

63 Salma Khalik, "Centre Will Be More Than Just a Science Museum," *The Business Times*, 10 December 1977.

64 Ibid.

65 Quoted in Ibid.

66 "Government Contributes $9.8m to Training Centre," *The Business Times*, 29 September 1982; Paul Jansen, "More Training Centres Are Being Set up in Jurong," *The Straits Times*, 22 February 1980; "Institutes Hold Open House," *The Straits Times.*, 2 August 1984.

67 Paul Jansen, "Unity House to Be Completed in Middle of 1980," *The Straits Times*, 7 August 1979.

68 "S'pore's Biggest Union Building," *New Nation*, 7 August 1976.

69 Ronnie Wai, "Shadow That Hangs over Unity House," *The Straits Times*, 11 December 1980.

70 "National Iron Ventures into Property," *The Business Times*, 28 February 1981.

71 "Media Release: National Heritage Board Gazettes Jurong Town Hall as Singapore's 69th National Monument," 1 June 2015, National Heritage Board, accessed 24 January 2019, https://www.nhb.gov.sg/~/media/nhb/files/media/releases/new%20releases/2015-2.pdf.

16.1 A model of Jurong town centre
 with Jurong Town Hall on the
 bottom right. The centre was built
 only much later and further away
 from the hall.

16.2 Competition submissions showing
 sections of the Jurong Town Hall by
 Architects Team 3. The brutalist
 building became the headquarters
 of the Jurong Town Corporation
 which oversaw Singapore's
 industrial land.

16.3 Map of the completed Jurong Town
 Hall (bottom left) and the proposed
 location of the Singapore Science
 Centre and Jurong town centre.

16.1

16.2

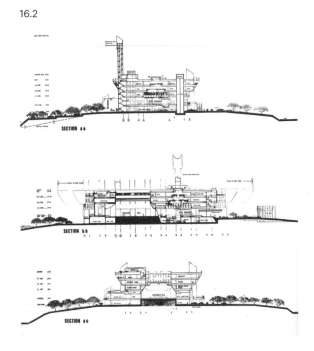

16.3

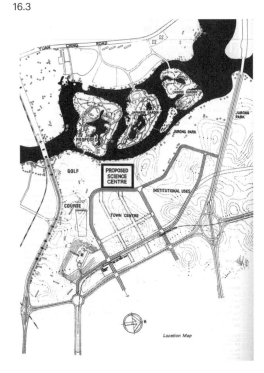

16.4 Unity House was the last brutalist building built along Jurong Town Hall Road during the 1980s. Also known as McDermott House, and later, The Enterprise, it was demolished in 2008.

16.5 The Singapore Science Centre right after its completion in 1977. The building's unusual design was described by some as resembling a spaceship.

16.6 The cluster of brutalist buildings in Jurong, c. 1984. They included the French-Singapore Institute and the German-Singapore Institute (foreground), Unity House (middle) and Jurong Town Hall (background).

16.4

16.5

16.6

17 Tan Boon Liat Building: A Modern Godown for
the Creative Economy

Sitting between the glamorous hotels along Havelock Road to its northeast and the elegant art deco Tiong Bahru public housing estate on the southeast, the Tan Boon Liat Building is an awkward presence. The 15-storey rectilinear slab block sticks out in the hip and tourist-friendly neighbourhood, coming in a form of the generic flatted factories that are typically found in industrial estates located outside the city centre (see *Factories*). Indeed, Tan Boon Liat Building is one of the last physical reminders that the Singapore River was once a place of work rather than the leisure it is known for today. During the 20th century, industrial spaces lined the waterfront to support the former British colony's entrepôt trade. They came in the form of storage warehouses known as godowns and factories such as the Ho Hong Oil Mills at Havelock Road and the Fraser & Neave Factory along River Valley Road. Tan Boon Liat Building arose from the redevelopment of a collection of godowns owned by its namesake, a well-known rattan merchant who lived on Outram Road in the early 20th century. Completed around 1976, this has become the area's last functioning industrial building—albeit updated for Singapore's latest creative economy.

As its architecture by Chok & Associates suggests, the Tan Boon Liat Building was designed in the spirit of industry and no-nonsense functionalism. Its bracket-like floor plan is divided into ten units on each floor, all of which are accessed through a semi-sheltered parapet that connects to the lifts. Two vertical external lift shafts break the monotony of an otherwise homogenous block, bisecting it into three segments: a longer middle section and shorter wings on both ends. The two wings are oriented inwards to form a shallow plaza on the ground floor, which efficiently funnels visitors towards the lifts and carries them to the upper floors. Near the entrance of the site is also a separate two-storey hexagonal building that serves as a canteen.

The building's industrial character echoes what was previously part of the Tan Boon Liat & Co (Singapore) Ltd, an entrepôt company with 32 godowns occupying a sizeable stretch of Outram Road. These were built around 1911 for storing valuable commodities such as rubber, jute, pepper and flour. In November 1961, the 50-year-old two-storey wooden structure containing the godowns went up in flames during a huge fire, causing losses worth an estimated $500,000. The

fire shot over 30 metres into the sky and also spread to surrounding attap houses in Kampong Bukit Ho Swee, causing thousands to flee from the scene.[72] A decade later in 1971, Tan Boon Liat & Co successfully obtained planning approval to build a flatted factory to replace the godowns.[73] The completed 150 units were then sold to individual strata owners as factories, offices and warehouses.

During its first two decades, most mentions of the Tan Boon Liat Building in the newspapers suggest life typical of a flatted factory. Besides run-of-the-mill recruitment advertisements for factory operators and office managers, there were regular sales for a wide collection of products, ranging from early Atari home computers to specially imported fabrics from Europe for making cheongsam—signs of Singaporeans' growing affluence in the post-independence years.[74] There were also amusing articles of life in the many small-scale cottage factories that propelled Singapore's early industrialisation. In 1981, the garment factory OG implemented a "three-minute toilet break" for its workers in an attempt to raise productivity after it found them using the breaks to "visit friends in factories on other floors", go to "the canteen in groups", and, on occasions, they "even went home".[75] Such behaviour also prompted the management to make punch cards mandatory not only for reporting and leaving work, but whenever a worker visited the toilet. Another article from 1990 described Singaporeans' *kiasu* behaviour when taking lifts. Crowds squeezed into an elevator before those in it could exit, forcing the colliding parties to "jostle and elbow their way". The problem was severe enough for a member of parliament, Chng Hee Kok to suggest taking "an institutionalised approach to the problem" before this manifestation of *kiasuism* "takes root and dictates local thinking".[76] Apart from public education, Chng applauded Tan Boon Liat Building's measures to curb undesired elevator behaviour by using lane markers, steel barriers and signage to implore users to "Please Queue Up". These features are still found around the building.

It is probably lost to history why Tan Boon Liat & Co kept the building's industrial function during its redevelopment, bucking the trend of hospitality projects emerging around it. In the late 1960s, the government began acquiring former godowns and fragmented lots around Havelock Road and Outram Road, and assembling them into bigger plots for sale through the government's sale of sites programme. They were planned specifically for hotels, resulting in the development of the King's Hotel (now Copthorne King's Hotel) (1970), Apollo Hotel (now Furama Riverfront Singapore) (1971), Hotel Miramar (1971) and Glass Hotel (now Holiday Inn Singapore Atrium) (1985).[77] Even private landowners in the area seized the opportunity to redevelop their derelict godowns into hotels, such as Keck Seng Group's Riverview Hotel (now Four Points by Sheraton Singapore, Riverview) (1985) along Robertson Quay.

As these hotels arose, the state also launched a campaign in 1977 to clean up the nearby Singapore River and turn it into a waterfront for recreation. As a result, industrial buildings such as godowns and Tan Boon Liat Building gradually lost their relevance. Many were acquired by the state for demolition, while others were re-adapted for new lifestyle uses. For instance, three warehouses along Jiak Kim Street were leased out in 1990 to Lincoln Cheng who turned them into the discotheque and nightclub known as Zouk. In 1992, Singapore's first artist colony, The Artists Village, took over the abandoned Hong Bee Warehouse (formerly known as the Sime Darby Godown) for the Singapore Festival of Arts and turned it into an exhibition space.[78] It was the forerunner of a contemporary trend to turn no-frills industrial buildings into art galleries and artist studios, particularly in such spaces outside the city centre.[79]

Over the years, Tan Boon Liat Building has also evolved with the times. As a strata property, this has been more organic as there is no master developer. What has helped is also its flexible definition as a "flatted factory". Soon after the building was completed, Tan Boon Liat & Co. got into a court case with the government for selling its units not only for factories but also offices and warehouses. The chief planner argued that the written permission for a building to be sold "as factories or offices or stores" should be interpreted as allowing only offices and stores associated with a factory rather than as separate units. However, this was overruled by the High Court in what was believed to be the first case of its kind under the Planning Act.[80]

Around 2009, Tan Boon Liat Building began evolving into an "unofficial Furniture Mall" and a "hot spot for local furniture hunters".[81] Among the earliest furniture stores to move in were five from

Dempsey Hill, who brought along their clientele of mostly expatriates and well-heeled locals.[82] Over a decade on, the building now boasts more than 30 stores offering the "Tan Boon Liat Lifestyle",[83] ranging from the showrooms of modern European luxury brands such as Vitra to those selling antiques sourced from around the world. Many stores are attracted by its central location, affordable rent and spacious units ranging from 2,000 to 6,000 square feet.[84]

This transformation is in step with the neighbourhood and the times. Just a 10-minute walk away, three godowns that once belonged to the Ho Hong Oil Mills were restored and retrofitted in 2016 to create The Warehouse Hotel. The neighbouring Tiong Bahru housing estate has also become home to cafes and lifestyle shops that are the clearest indicators of the neighbourhood's gentrification. The modernists may proclaim that functionalist architecture such as Tan Boon Liat Building are designed with the ethos of form follows function, but its subsequent adaptation by the creative class suggests they are surprisingly much more flexible.

This essay was co-authored with Ian Tan.

Notes

72 "Fire Guts $500,000 Stores," *The Straits Times*, 5 November 1961.

73 Elena Chong, "Owners Win Case under Planning Act," *The Straits Times*, 5 April 1989.

74 "协源源兴布荘有限公司 应付农曆年市场需求由欧洲办进上等布料,"《南洋商报》, 11 January 1980.

75 L. E. Prema, "It's Toilet Time at Outram Factory," *New Nation*, 17 September 1981.

76 "Kiasu S'poreans Jostle and Elbow Their Way into Crowded Lifts," *The Straits Times*, 25 January 1990.

77 *A Pictorial Chronology of the Sale of Sites Programme for Private Development* (Singapore: Urban Redevelopment Authority, 1984).

78 "Archive," The Artists Village, 2018, https://www.tav.org.sg/archive.html.

79 Ong Sor Fern, "Finding Space for Art: A Look at the Studios of Five Artists," *The Straits Times*, 13 May 2019; Martin Mayo, "Factory Art? Singapore's Artist Head for Industrial Buildings in the East," *ChannelNews Asia*, 23 December 2016.

80 Chong, "Owners Win Case".

81 Natasha Ann Zachariah and Hui Shan Rebecca Tan, "Tan Boon Liat Building Is a Hit with Fancy Furniture Hunters," *The Straits Times*, 18 April 2015.

82 Cheah Ui-Hoon, "Departures at Dempsey," *Business Times*, 21 February 2009.

83 Natasha Ann Zachariah, "Tenants at Tan Boon Liat Building Organise Block Party," *The Straits Times*, 26 November 2016; "Tan Boon Liat Lifestyle," n.d., https://www.facebook.com/Tanboonliatlifestyle.

84 Zachariah and Tan, "Tan Boon Liat Building".

17.1

17.2

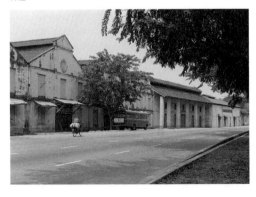

17.1 Godowns along Havelock Road, facing the Singapore River. Such warehouses were developed along the waterfront from the 19th century to support Singapore's entrepot trade.

17.2 A row of godowns showcasing its evolution since they were first developed in the 1840s. The building with a colonnaded verandah (right) was designed prior to the late 19th century, while the one with a decorative gabled roof (left) came after.

17.3 The Sime Darby Godown (later renamed Hong Bee Warehouse) along Robertson Quay was designed by Swan & Maclaren's partner C.J. Stephen in 1939. It's curved end elevation and austere façade was in the modernist tradition.

17.4 An early example of artists transforming industrial buildings happened during the 1992 Singapore Festival of Arts when The Artists Village took over the abandoned Hong Bee Warehouse for an exhibition.

17.5 The former Lim Teck Lim Godowns after their restoration and adaption as part of Clarke Quay's transformation into an entertainment village.

17.3

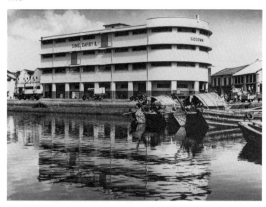

17.4

17.5

Travel

18-21

18 **Market Street Car Park:** **Up, Up … and Who Pays?**

Today, drivers in Singapore may complain about the inconvenience of multi-storey car parks. But this transport infrastructure was much celebrated when the first such facility was completed in the city centre in 1964. A driver even penned a ballad for the car park at Market Street that was published in the Automobile Association of Singapore's (AAS) magazine, *The Highway*[1]:

> … The parking problem rose each day
> And made the drivers mad;
> To drive a mile to find a place
> Was indeed very sad.
> Up stepp'd the gallant government
> To stop the consternation;
> They built a multi-storey'd park
> That earnd' a great ovation.

Such adulation for a non-descript concrete storeroom—a feat few buildings in Singapore can lay claim to—reflected how severe a problem parking in the city centre had become. As early as 1951, a newspaper declared "[i]t's war when you park in Singapore," as drivers jostling for the few parking lots resorted to scratching cars and even puncturing their tyres.[2] The building of a "sky-scraper garage" in the city centre quickly gained traction amongst various solutions proposed by the growing community of drivers. But it took over a decade to realise because of the high construction cost—estimated to be over a million dollars—and the prickly issue of where to build what many viewed as a facility for the privileged few who owned cars.[3]

At first, the government introduced a car parking meter scheme in 1959 for Singapore's commercial centre. Motorists had to pay 40 cents per hour for up to two hours in a restricted parking spot such as Raffles Place, while at other places, it cost 20 cents per hour and this was capped at $1.60 for a whole day.[4] This spurred the AAS to call on the government to use the revenue earned from the scheme to provide drivers with "off the street parking facilities".[5] It separately argued that a multi-storey car park was essential "if the city is to remain healthy" and that any "delay may damage city trade".[6]

In 1961, the government finally announced plans to build a S$2.5 million multi-storey car park at the junction of Cecil, Market and Cross streets. The seven-storey car park designed by the Public Works Department could accommodate about 900 cars and 130 motorcycles and scooters.[7] Although not the first to be built in

Southeast Asia—Ipoh was the first in Malaya to have one in 1963—the Market Street Car Park was touted as the largest in the region when it officially opened in June 1964.[8] It adopted a form similar to several car parks built in Britain during the 1960s, including the Rupert Street Car Park (1960) in Bristol and the Lee Circle Car Park (1961) in Leicester—both of which government representatives would have likely encountered when they visited Britain and Hong Kong in 1961 to inspect such facilities.[9] The Market Street Car Park had ramps connecting each of its decks for cars to enter and exit, while parking was around its perimeter. The seven-storey helical structure with sweeping curved corners around its triangular plot was effectively "one continuous inclined surface" that offered a different driving sensation from the usual linear roads and ramps.[10] With no walls, the open-air structure with its elevation pattern of horizontal cream-coloured banding created a "pictorial surface of light (the barriers) and dark bands (the open storeys)" like its British predecessors, and stood out in a neighbourhood of shophouses.[11] The play of light was also evident in the central well of Market Street Car Park where a staircase was covered with a lattice of interlocking hexagonal concrete blocks that cast shadows across the mosaic floor tiles at different times of the day.

While motorists welcomed a solution to the parking situation, they did not rush to use Market Street Car Park at first. Compared to street parking, many were put off by the inconvenience of parking in a facility that was some distance away from their destination and having to go so far above ground. More importantly, the parking fee was too high. As the previously mentioned ballad goes on to say:

… 'Fifty Cents Per Hour!' they cried
Oh lord, can we afford it?
By far, it will the cheaper be
To sell our car and walk it.

The government, however, did not budge on its parking fees. Then Minister for National Development Lim Kim San even confidently suggested that Singapore would eventually ban street parking in favour of multi-storey car parks or underground facilities—the first of which opened soon after at Raffles Place in 1965.[12] He was proven right when drivers succumbed to the fees

by the end of 1966, and both car parks were reportedly full on Wednesdays and Saturdays and 90 per cent full on the other days.[13] The government subsequently built new multi-storey car parks around the city, including at Clifford Pier, Colombo Court, Philip Street and the junction of Penang Lane and Penang Road.

Besides housing cars, the Market Street Car Park also took advantage of its central location with a shopping arcade and an air-conditioned restaurant on the ground floor. When it was discovered that motorists avoided the car park's uncovered top deck, the space was converted into a restaurant-cum-nightclub instead.[14] Car Park Nite-Spot was not only named after its unusual location, but it proudly advertised that it had "No Parking Problem".[15] Rooftop restaurants became a feature in several multi-storey car parks that were subsequently built. As part of the government's first sale of sites programme in 1967, Singapore's second multi-storey car park was built at Collyer Quay by a private developer and designed by SLH-Timothy Seow & Partners. Overseas Union House (later renamed Overseas Union Shopping Centre) offered 725 parking lots over four floors, shopping at the lower levels and was topped with the 1,600-seat Neptune Theatre Restaurant that offered views of the waterfront.[16] (see *Lookout Towers*) Two other multi-storey car parks built by the government in the 1970s, located in Chin Swee Road and Marine Parade Central, also had rooftop restaurants that became popular establishments connected to the "Four Heavenly Kings" of Singapore's Chinese culinary scene.[17]

By the 1970s, the government's efforts to build more car parks hit a road block as the number of private cars on Singapore's road had more than doubled over a decade from 70,000 in 1961 to 171,090 in 1973.[18] Various initiatives were introduced to dissuade driving into the city centre, including encouraging carpooling, building car parks at the city fringes as part of Park and Ride Scheme, and taxing motorists entering the Central Business District as part of the Area Licensing Scheme. Realising that there was not enough land in the city centre to continue constructing purpose-built multi-storey car parks, the Urban Redevelopment Department (it became the Urban Redevelopment Authority [URA] in 1974) began regulating private developers of new high-rise towers to provide car park lots instead. It led to the integration of parking

facilities within the modern buildings of Singapore's city centre, originally in the podiums and increasingly underground. (see *Shenton Way*) In 1983, when the URA announced that it was building another 3,388 parking lots in and around the city centre, many of these were integrated with retail and office developments such as Funan Centre, South Bridge Centre and Havelock Plaza.[19] One of the last purpose-built car parks built by the government in the city centre was the former Golden Shoe Car Park. Completed in 1984, the 10-storey "shoe-shaped" building offered 1,074 parking lots, three floors for hawker stalls and a restaurant, 17 shops and a petrol kiosk on the ground floor.[20]

While the government ramped up the construction of multi-storey car parks in the city centre to tackle congestion, it resisted building similar facilities outside of it at first. Despite calls by residents of public housing estates for multi-storey car parks because of the lack of open-air parking lots on the ground, the Housing & Development Board (HDB) said they were too expensive and it could not provide a parking lot for each car-owning resident.[21] But, as what happened in the city centre, the HDB eventually succumbed. As Singapore's motor vehicle population continued to grow into the 1980s, supported by the rise of an extensive expressway network across the island (see *Pan-Island Expressway*), the agency realised that multi-storey car parks were "the only answer to the parking problem in housing estates".[22] With high-rise facilities also came significantly higher parking fees. In 1984, season parking fees for HDB car parks were raised from $15 to $20 a month for a surface parking lot and $30 to $40 for a covered car park.[23] By 1989, this increased to $50 and $75 respectively.[24] As motor vehicles in modern Singapore began travelling from one high-rise building to another, their owners paid the high price that came with such convenience.

In the 2010s, both the Market Street and Golden Shoe car parks were demolished to make way for CapitaGreen and CapitaSpring respectively—essentially office towers with multi-storey parking facilities within. The "disappearance" of stand-alone car parks has been driven by the scarcity of land in Singapore, but also a growing understanding of their negative impact on modern life in the form of pollution and accidents. While modern Singapore was once planned and shaped around the convenience of cars, this has become increasingly less so as the city-state heads towards becoming a "car-lite" society.

Notes

1 AAS 3974, "Ballad to the Multi-Storey Car Park," *The Highway*, December 1964.
2 "It's War When You Park in Singapore," *The Straits Times*, 17 May 1951.
3 "Multi-Storey Car Parks Envisaged for S'pore," *Singapore Standard*, 31 August 1951; "'Build a Skyscraper Garage with Parking Fees' — AA," *The Singapore Free Press*, 20 June 1961; "Multi-Storey Car Park Proposed," *The Straits Times*, 15 March 1956; "Multi-Storey Car Park: New Plea," *The Straits Times*, 18 December 1959; "'Skyscraper' Car Park Plan Put Off," *The Straits Times*, 5 August 1959.
4 "Pay-as-You-Park Scheme Extended to More Areas," *The Straits Times*, 30 March 1960.
5 "'Build a Skyscraper Garage with Parking Fees' — AA."
6 "Multi-Storey Car Parks: 'Delay May Damage City Trade'," *The Singapore Free Press*, 18 September 1961.
7 "Minister Opens $2.5 Mil. Car Park," *The Straits Times*, 7 June 1964.
8 "Multi-Storey Car-Park a Big Hit in Ipoh," *The Straits Times*, 12 April 1963; "Minister Opens $2.5 Mil. Car Park."
9 "S$2 Million Car Park: A.A. Thanks Dr. Toh," *The Singapore Free Press*, 26 December 1961.
10 Simon Henley, *The Architecture of Parking* (London: Thames & Hudson, 2007), 203.
11 Ibid., 98–99.
12 "Singapore May Ban Parking in the City Streets," *The Straits Times*, 30 September 1964.
13 "Two Big Car Parks Are Nearly Always Full," *The Straits Times*, 23 December 1966.
14 "Car Park: New Idea for Hot Top," *The Straits Times*, 7 November 1965.
15 "Car Park Nite-Spot," *The Straits Times*, 10 August 1968.
16 *A Pictorial Chronology of the Sale of Sites Programme for Private Development* (Singapore: Urban Redevelopment Authority, 1984).
17 Chefs Sin Leong, Hooi Kok Wai, Tham Yui Kai and Lau Yoke Pui opened Chinese restaurants in the 1960s and 1970s that became very popular with Singaporeans.
18 Percy Senevirantne, "Unsnarling the Traffic Jams We'll Get in the Nineties," *The Straits Times*, 5 May 1973.
19 Rebecca Chua, "CBD to Get More Car Parks," *The Straits Times*, 1 November 1983.
20 "Golden Shoe Car Park Will Fit Motorists," *The Straits Times*, 21 January 1984.
21 "High-Rise HDB Car Parks Call," *The Straits Times*, 18 July 1975; "A Parking Lot for Each Resident? Sorry Says HDB," *The Straits Times*, 31 May 1975.
22 Vincent Fong, "HDB Multi-Storey Car Park Lot Could Cost $160 a Month," *Singapore Monitor*, 21 October 1983.
23 Paul Jansen and Teo Lian Huay, "Parking Fees up from Jan 1," *The Straits Times*, 27 October 1983.
24 "Season parking fees up from June," *The Straits Times*, 16 May 1989.

18.1 The completion of Singapore's first multi-storey car park at Market Street in 1964 was so momentous that it inspired a driver to pen a ballad published in *The Highway,* a magazine of the Automobile Association of Singapore.

18.2 The open-air design of Market Street Car Park created a structure with light and dark bands as seen on the 1965 cover of *The Highway.*

18.3 Singapore's first multi-storey car park was designed by the Public Works Department. The eight-storey helical structure resembled similar overseas developments such as the Rupert Street Car Park in Bristol.

18.1

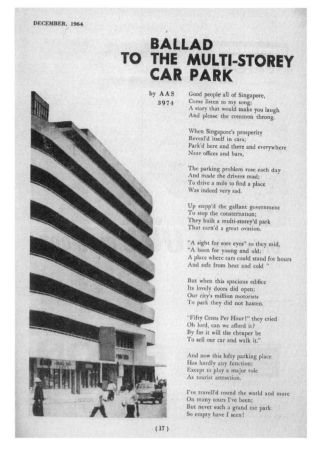

18.2

18.3

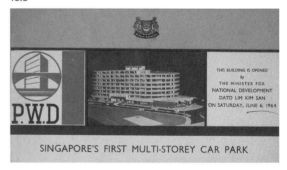

18.4　Matchbox advertising the restaurant-cum-nightclub located on the top floor of Market Street Car Park. It was added later to tackle the problem of drivers' disdain for parking on the uncovered top deck.

18.5　Illustration of an office-cum-shopping-and-car park development designed by SLH-Timothy Seow & Partners. The Overseas Union House at Collyer Quay was completed in 1972 and the first privately-built multi-storey car park.

18.6　On the cover of *The Highway* is the entrance of Singapore's first underground car park which opened in 1965 in Raffles Place. The facility topped with a roof garden eventually made way for today's Raffles Place MRT train station.

18.4

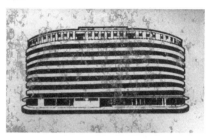

18.5

18.6

19 Pan-Island Expressway:

Speeding Up and Spreading Out Modern Life

That it takes only 50 minutes to drive across Singapore is not only proof of its small size, but a testament to the Pan-Island Expressway (PIE). The city-state's oldest and longest highway connects the island's east and west—from Changi Airport to Tuas Road—like a 42.8-kilometre spine supporting the modernisation of the entire island into a bustling metropolis.

The idea for a road where one could speed across Singapore without encountering a single traffic light can be traced back to the autobahns constructed in Germany during the 1930s. They were the world's first limited-access, high-speed road network and the concept spread to other parts of the world. In 1966, the Public Works Department (PWD) proposed to build similar roads for Singapore in anticipation of a "phenomenal increase of motor traffic in the next 20 years".[25] They would provide for the "fast-moving and relatively uninterrupted circulation of traffic" and link the emerging Jurong industrial estate in the west (see *Jurong Town Hall Road*) with new towns then in construction across the island, including in Toa Payoh and Kallang Industrial Basin.[26] The PIE was envisioned as a three-lane dual carriageway with limited controlled access points so that cars could travel on it at 80 kilometres per hour. It was

significantly faster than the maximum 45 kilometres per hour allowed in Singapore's built-up areas.[27]

Work on this multi-million dollar "super road for S'pore" began with a stretch between Jalan Eunos and Thomson Road.[28] Over the next 15 years, construction was then carried out across four phases that first extended eastwards and then westwards. During the journey towards a speedier city, rocks were blasted away, graves were exhumed and families were vacated from decades-old kampongs to make way for the PIE.[29] In their place, the PWD cobbled together an expressway by widening existing roads and constructing new ones such as between Jalan Eunos and the East Coast Parkway. The construction even involved introducing a series of "roads in the skies"—such as interchanges and flyovers—for motorists to travel above existing traffic. These roads were elevated over existing ones to provide non-stop travel, and sometimes came with a series of loop slip roads for motorists to enter and exit the expressway safely. Flyovers actually pre-dated the arrival of expressways in Singapore as the government had earlier planned to build them to relieve congested intersections such as in Bukit Timah Road, Dunearn Road,

Farrer Road and Adam Road, as well as in Orchard Road and Clemenceau Avenue.[30] One of the earliest flyovers to be completed in 1970 was a three-lane one-way bridge over Clemenceau Avenue allowing traffic to smoothly get from Fort Canning into Oxley Road, and this was followed by two others that year.[31]

The sight of cars literally going up and over the ground-level roads must have been a fascinating one for motorists. A 1970 advertisement marked the completion of the Oxley Rise Flyover by depicting cars floating above traffic with the tagline "To speed progress Hume makes cars fly".[32] It was put out by the cement company, Hume, which supplied the flyover's locally made prefabricated and prestressed concrete beams. Over 200 of them, measuring up to 20.4 metres long were transported from its Bukit Timah factory and successfully installed on-site during a 16-hour operation.[33] But not all construction of such large-scale modern structures went so smoothly. In 1970, a man was crushed to death when four concrete beams weighing a total of 272 tonnes fell from the six-lane flyover that was under construction over Thomson Road.[34] In 1979, a six-lane 4.8-metre high dual carriageway being constructed as part of the Jalan Eunos PIE carriageway collapsed. Fortunately, no one was hurt as workers immediately evacuated after they spotted cracking.[35]

While the PIE was under construction, the government embarked on a second expressway along the south-eastern coastline of Singapore. The East Coast Parkway (ECP), constructed between 1971 and 1981, linked Changi Airport to the central business district and served emerging new towns such as Bedok and Marine Parade. Unlike the PIE that cut through urban developments, the ECP ran alongside the East Coast Park and was designed as a scenic route that presented Singapore as a Garden City to visitors (see East Coast Park). In fact, both the PIE and ECP were designed to be lined with flowering shrubs and greenery on the insistence of Prime Minister Lee Kuan Yew. He wanted to cover up the unsightly expressways' crash barriers and to landscape spaces under the flyovers too. As a result, both expressways were designed as dual carriageways with a 1.5-metre gap between them so that sunlight and rain could come through allowing plants to grow.[36] The ECP was also notable for being connected to the Benjamin Sheares Bridge,

which served as a gateway into the city centre. It was the longest and highest elevated structure completed by the PWD in 1981.[37] Part of the 19-kilometre-long eight-lane dual carriageway was held some 29 metres over the Kallang River Basin by tapering H-shaped trestles so that larger ships could continue to pass underneath. Its vertical lines and the majestic arc of the reinforced concrete bridge across the Marina Centre complemented the then emerging skyline too. While intended to offer a smooth and scenic drive into the city, the "construction spectacular" initially encouraged its first users to opt for the "scenic" option. Many motorists slowed down to admire the sweeping view of the city centre and harbour that the bridge provided. Many wedding couples also stopped and took photographs on the bridge before dashing into waiting cars to avoid being caught by the traffic police.[38]

In 1981, the ECP, Benjamin Sheares Bridge and the entire stretch of the then 36-kilometre PIE were officially completed. The PIE reduced the drive across Singapore from east to west by almost half the time—but only if motorists used the expressway correctly.[39] Throughout the 1980s, the lack of familiarity with "expressway etiquette" slowed traffic and even caused several accidents. The government launched campaigns to educate motorists on the right ways to use the expressways, ensured new drivers knew expressway rules before they were given a license, and enacted laws to ban certain slow vehicles. Nothing was to stand in the way of the PIE achieving the optimum traffic flow of between 1,500 to 2,000 vehicles per lane an hour.[40] Or as a colourful account of the expressway experience in 1983 summed it up: "[I]f you want to drive leisurely, get off the expressways."[41]

Besides speeding up life in the city-state, the PIE also supported the government's plan to redistribute its fast-growing population across the island. Soon after construction of the expressway began, the State and City Planning project was commissioned in 1967 to draft a new land use and transport plan. A team of planners, with the assistance of the United Nations and a firm of Australian consultants, drew up seven plans for Singapore's physical development based on the assumption that it would eventually have a population of 4 million. In 1971, the "Ring Plan" was adopted as Singapore's first Concept Plan. It envisioned a spread of high-density

residential areas around the central catchment area with a southern development belt spanning from Changi in the east to Jurong in the west. These different land uses were to be connected by a network of interconnected expressways that would grow out from the PIE. In the 1980s and 1990s, six new expressways—including the Bukit Timah Expressway (BKE), Ayer Rajah Expressway (AYE), Central Expressway (CTE), Kranji Expressway (KJE), Tampines Expressway (TPE) and the Seletar Expressway (SLE)—were constructed in what has been dubbed the "Era of Expressways".[42] As of 2021, Singapore has 10 expressways with a new addition in construction to connect the north and south of the city-state.

The emerging expressway network and its promise of seamless movement anywhere in the city allowed citizens to envision travelling as a part of everyday modern life. Even before the PIE was completed, many 1970s advertisements for properties—both commercial and residential—began marketing the fact that they were "only minutes away" from an upcoming expressway that offered a convenient connection to the city and the airport. By the mid 1990s, even Tampines Junction, a shopping mall in the east of Singapore, touted its "island wide accessibility" thanks to the expressways.[43]

Spreading out across the entire island today, the expressway network has undoubtedly played a vital role in Singapore's modernisation drive. It made once rural areas accessible for urban development, enabling the rise of the compact city-state. Expressways also offered new, and at times "green" views. Perhaps most significantly, they accelerated everyday life in Singapore and it has not slowed down ever since.

Notes

25 *Public Works Department Annual Report 1966* (Singapore: Public Works Department, 1966), 1.

26 William Campbell, "An express road link for the Singapore satellites," *The Straits Times,* 10 June 1969.

27 Wee Beng Huat, "Motorists Baffled by New Road Signs," *New Nation,* 2 April 1973.

28 "Super Road for S'pore," *The Straits Times,* 30 October 1967.

29 "What All That Blasting Is About," *The Straits Times,* 24 June 1972; Ivan Lim, "Village Makes Way for Super Highway," *New Nation,* 12 October 1971.

30 As early as December 1953, a member of the public suggested Singapore adopt "flyover" traffic in a letter to *The Straits Times.* (See "'Flyover' Traffic," *The Straits Times,* 15 December 1953.) But it was only in November 1964 that Minister for Finance Dr Goh Keng Swee announced the government would construct Singapore's first two flyovers along Bukit Timah Road and Dunearn Road as well as Farrer Road and Adam Road. ("Singapore Is Riding Confrontation," *The Straits Times,* 3 November 1964.) They were eventually built later as part of the PIE.

31 *PWD Annual Report 1970* (Singapore: Public Works Department, 1971), 9.

32 "To Speed Progress Hume Makes Cars Fly," *The Straits Times Annual,* 1 January 1970.

33 "16-Hour Operation to Span Flyover," *The Straits Times,* 9 June 1969.

34 David Gan, "Flyover Crash Kills a Man," *The Straits Times,* 11 March 1970.

35 Leong Siew Hon, "Flyover Crashes after Crack," *The Straits Times,* 13 February 1979.

36 Timothy Auger, *Living in a Garden: The Greening of Singapore* (Singapore: National Parks Board; Editions Didier Millet, 2013), 40.

37 "New Expressway Will Serve Long-Term Needs," *The Straits Times,* 18 April 1981.

38 "Shoot and Scoot at the Bridge," *The Straits Times,* 14 December 1981.

39 "From Changi Airport to Jurong by Car in Just 50 Minutes," *The Straits Times,* 1 February 1981.

40 Brendan Pereira, "Road-Hogs—the Bane of Motorists on Expressways," *The Straits Times,* 15 October 1989.

41 Khng Eu Meng, "Driving Away Bad Habits on the Expressway," *The Straits Times,* 1 May 1983.

42 Lim Tin Seng, "The A(YE), B(KE) and C(TE) of Expressways," *Biblioasia* 14, no. 2 (September 2018): 45–51.

43 "There Is One Move That Promises To Give You The Best Returns in the Long Run: Tampines Junction," *The Business Times,* 19 November 1996.

19.1 A 1970 map of Singapore's future main road network. The bold lines represented the expressway network to be built.

19.1

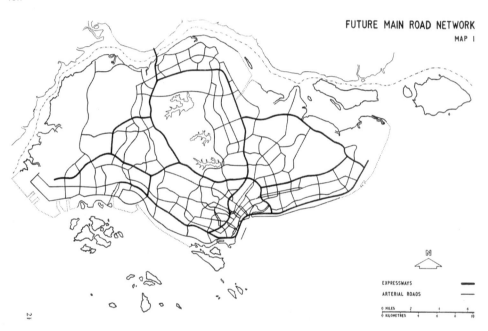

FUTURE MAIN ROAD NETWORK

MAP I

EXPRESSWAYS

ARTERIAL ROADS

19.2 The PIE was developed over 15 years
 by the Public Works Department
 (PWD) to provide "quick and
 uninterrupted flow of traffic" across
 the island. On the cover of PWD's 1971
 annual report was a section seen from
 Thomson Road towards Toa Payoh.

19.3 A newly opened flyover or interchange
 at Jalan Eunos along the eastern
 section of the PIE, 1981. Such "roads in
 the skies" allowed motorists to easily
 travel over existing traffic below.

19.2

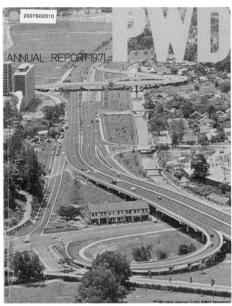

19.3

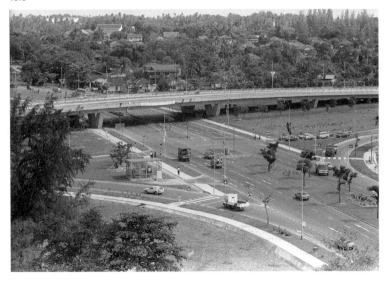

19.4 A 1970 advertisement commemorating the completion of one of Singapore's first flyover at Oxley Rise which allowed cars to "float" above traffic. Hume supplied its locally-made prefabricated and prestressed concrete beams.

19.5 The Benjamin Sheares Bridge was held up by H-shaped trestles some 29 metres over the Kallang Basin to allow ships to pass under. It connected the East Coast Park to the city centre.

19.6 Completed in 1981, the Benjamin Sheares Bridge served as a gateway into Singapore's city centre. Its spectacular views even attracted wedding couples to take photographs there.

19.5

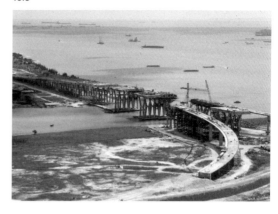

19.6

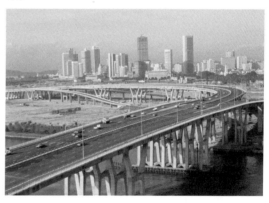

19.4

20 Pedestrian Overhead Bridges: Staying Safe Amidst Accelerated Development

How do you cross a busy street? This seemingly simple question was the subject of a 1970 court case in Singapore. A pedestrian sued a driver for knocking him down while he was standing on the centre line of Upper Serangoon Road, and the court was presented with two different views on the right way to cross a two-way street.[44]

According to the pedestrian's lawyer, the safe way was to momentarily stop in the middle of the road to wait for a chance to complete the rest. But the driver's lawyer contended that a pedestrian should instead wait until the coast is clear in both directions before crossing a two-way street in a single attempt. The verdict? Both parties were to blame, with the pedestrian bearing 20 per cent of the responsibility because he was standing on double white lines.

That a judge had to decide on such a matter summed up the state of Singapore's streets in the 1960s and 1970s. Unlike today, jaywalking had yet to be outlawed and pedestrians were free to cross the road anywhere they wanted. But this lack of segregation between pedestrians and motor vehicles became a problem as motor car numbers grew in the city-state. Traffic flow was being disrupted and motorists were getting into road accidents similar to the 1970 case above. To keep pedestrians off the road, the government began building safer alternatives for crossing.

In May 1964, Singapore's first pedestrian overhead bridge was unveiled at Collyer Quay. Costing S$20,000, the pre-fabricated steel bridge by the Public Works Department (PWD) measured 34.4 metres long by 2.4 metres wide and stood about 5 metres above the road.[45] At its official opening, Parliamentary Secretary to the Ministry of Culture Fong Sip Chee said that while the bridge's design "may not entirely please aesthetic sentiments, let alone satisfy architectural ideals", it met the "real and urgent requirements" of the people. Together with another S$85,000 pedestrian underpass at the nearby Connaught Drive, which he had launched two months prior, these transport infrastructures would help in "relieving traffic congestion in the busy heart of the city".[46] Fong added that the bridge would also help reduce fatalities and other serious road accidents, of which 80 per cent involved pedestrians crossing the street. Beyond their function, such infrastructure had symbolic value too. "As with the underpass, this pedestrian bridge is unique in Singapore and is another mark of the increasing modernisation of our city," he said. "The wheel of progress is irresistibly turning

in Singapore and in various ways Singapore is leading the way in this part of the world, thus winning for itself a definite status and reputation and certainly full justification for the appellation of 'New York of Malaysia'."

Despite these grandiose promises, the bridge turned out to hardly meet any real need.[47] Most still preferred the more straightforward approach: simply crossing the road. Thus, as the PWD began building more overhead bridges, it also added railings across the centre road dividers to "compel them [pedestrians] to make full use" of such a facility.[48] But the physical coercion was not enough. In 1969, the PWD reported that it was reconsidering the building of overhead bridges because of pedestrians' reluctance to use them.[49]

Around the same period, a ground-up public education drive emerged to get pedestrians off the streets. It was initiated by the National Safety First Council (NSFC), a voluntary body established in 1966 to arrest the "Toll of Progress" brought about by an "acceleration" of transportation and industrial development in Singapore.[50] Led by Chairman Milton Tan, the council sought to instil "safety" in all areas of modern life, particularly on the road. Besides encouraging motorists to drive better, it even set up a patrol at Collyer Quay to ensure pedestrians used the overhead bridge instead of jaywalking.[51]

It is worth noting that Tan was also the chair of the Automobile Association of Singapore (AAS), an organisation established in the early 1900s for motoring enthusiasts. Upon assuming chairmanship of AAS in 1960, he began publicly championing the interest of motorists who were facing increasing traffic congestion in the city. Besides lobbying the government to construct multistorey car parks and highways (see *Market Street Car Park and Pan-Island Expressway*), Tan also wanted pedestrians classified as "traffic" and for jaywalking to be banned. Such behaviour was slowing traffic flow and was the main cause of pedestrians dying in fatal traffic accidents.[52] He shared similar views in his role as chair of the NSFC from 1966. In the council's annual reports on road safety, Tan often highlighted how pedestrians statistically represented the largest percentage killed in Singapore. In 1971, the council even attributed the rising number of adult pedestrians being killed to their "dangerous walking habits" and a reflection of "childish impulses [they] have never shed".[53] Two years later, Tan—this time as chairman of the

NSFC—again lobbied for legislation against jaywalking and for pedestrians who did not use overhead bridges to be fined.[54]

Under Tan's leadership, the AAS and the NSFC successfully reframed "road safety" as not just a responsibility of motorists but also pedestrians. By the 1970s, the PWD also began expressing similar views. Describing the pedestrian as a "traffic unit" that was "the most unco-operative and unfortunately the most vulnerable", the agency noted that its 52 overhead bridges had a "low degree of acceptability from the public".[55] This was backed by a NSFC survey at one such bridge, which found that only six per cent of pedestrians used it.[56] Rather than pursue enforcement and education as advocated by Tan, the PWD began exploring alternatives to separating pedestrians from vehicles. Underpasses were favoured by pedestrians and motorists but costly and were challenging to build in Singapore because of service lines along the road. Pushbutton signal crossings were much better accepted by pedestrians but treated with suspicion by "a great number of the motoring public who believe that pedestrians have no rights on the road".[57]

In 1971, a significant step was taken in favour of pedestrians when PWD built the first pedestrian mall at Raffles Place. Despite protests from shopkeepers and the AAS, all vehicles were banned from entering or remaining in the area between 8 am to 7 pm from Monday to Saturday.[58] The mall became a more pleasant environment and the lack of vehicular traffic did not affect sales as feared. The PWD followed up with the Orchard Road Pedestrian Mall in 1974, an attractively tiled pathway that stretched from Ming Court to Mandarin Hotel. Pedestrians were separated from vehicles by a line of shrubs, trees and flowers as well as a parapet or wall to sit on. The mall was hailed by the agency as a "happy reversal of priorities" as streets in Singapore were previously "designed more for the ubiquitous automobile than the hapless long-ignored pedestrian".[59] Following this development, the PWD formed a Walkway Unit in 1977 to plan and build similar infrastructure along New Bridge Road, South Bridge Road and Stamford Road.

Another agency that began developing pedestrian-friendly infrastructure was the Urban Renewal Department. It worked with developers to incorporate elevated linkways and under-

ground connections in their buildings to create pedestrian networks in Shenton Way, Orchard Road and Chinatown.[60] One interesting outcome was for an overhead pedestrian crossing-cum-shopping bridge at Shenton Way. The privately developed Golden Bridge won a 1973 government tender to link the UIC Building, Shenton House, DBS Building and Shing Kwan Building with an air-conditioned connection lined by shops on both sides.[61] In the same year, PWD also replaced Singapore's first overhead pedestrian bridge at Collyer Quay with a glass-walled, air-conditioned connection incorporating 56 shops that connected Change Alley to Clifford Pier.[62]

Even as the city became friendlier to pedestrians, the segregation between them and cars was also reinforced. New laws were introduced in 1977 to make jaywalking illegal. Pedestrians who failed to use a designated crossing—overhead bridge, underpass, zebra crossing and push-button signal crossings—within 50 metres from either side were liable to be fined. The law gave PWD the impetus to embark on a programme in 1980 to construct about 100 overhead bridges within two

and a half years. While steel designs were initially preferred because they were cheaper and caused minimum disruption to traffic during installation, new bridges later came in pre-stressed concrete that was more durable and required less maintenance. Amongst the seven designs introduced, one had a continuous planting trough along each side of the deck.[63] The idea of incorporating greenery into transport infrastructure was the brainchild of Prime Minister Lee Kuan Yew, who envisioned Singapore to be a Garden City.[64] In 1996, PWD even completed a "Garden Bridge" in Chinatown to replace an existing steel one linking Pagoda Street with the People's Park Complex. Its S$6 million design by architect Wong Hooe Wai was inspired by traditional Chinese architecture and the 40-metre-long linkway featured pavilions and rock gardens on its bridge deck.[65]

Today, Singapore has set its sights on going car-lite, which may one day render overhead bridges obsolete. But until then, they continue to stand as reminders of how pedestrians' right of way in the city gradually gave way for the smooth travel of the modern automobile.

Notes

44 T. F. Hwang, "Court Hears Two Views on How to Cross Busy Street," *The Straits Times*, 22 April 1970.

45 "Opened at Collyer Quay — a $20,000 Flyover," *The Straits Times*, 3 May 1964.

46 Fong Sip Chee, "Text of Speech by the Parliamentary Secretary to the Minister of Culture, Mr. Fong Sip Chee, at the Official Opening of the Overhead Pedestrian Bridge at Collyer Quay on May 2nd at 1 P.M." (Ministry of Culture, 2 May 1964), http://www.nas.gov.sg/archivesonline/data/pdfdoc/PressR19640502a.pdf; "Underpass opened—to save time and money," *The Straits Times*, 24 February 1964.

47 "Pedestrians' Boon," *The Straits Times*, 3 May 1964.

48 *Public Works Department Annual Report 1967* (Singapore: Public Works Department, 1967), 16.

49 *Public Works Department Annual Report 1969* (Singapore: Public Works Department, 1969), 15.

50 "Singapore Arrests the Toll of Progress," *The Highway*, 1966.

51 "'Watch Your Step and Live' Safety Drive," *The Straits Times*, 2 November 1966.

52 Milton Tan, "Editorial," *The Highway*, 1960.

53 "Editorial," *National Safety First Council Bulletin*, 1971.

54 Evelyn Ng, "A Call to Enforce Use of Overhead Bridges," *The Straits Times*, 10 February 1973.

55 "Towards Greater Pedestrian Safety," *What's On in PWD*, January 1972.

56 Milton Tan, "The National Safety First Council of Singapore Chairman's Report on Road Safety," 6th Annual Report 1971/72 (Singapore: National Safety First Council, 1972).

57 "Towards Greater Pedestrian Safety."

58 "On-off Mall Plan Gets the Go-Ahead," *The Straits Times*, 22 December 1970.

59 "Orchard Road Pedestrian Mall," *What's On in PWD*, January 1974.

60 "New Shopping Complexes to Get Walkways," *New Nation*, 1 December 1971.

61 "Shops over Shenton Way," *The Straits Times*, 21 March 1973.

62 "New Look for Collyer Quay Bridge," *New Nation*, 7 December 1973.

63 Colin Cheong, *Framework and Foundation: A History of the Public Works Department* (Singapore: Times Edition for Public Works Department, 1992).

64 Timothy Auger, *Living in a Garden: The Greening of Singapore* (Singapore: National Parks Board; Editions Didier Millet, 2013), 40.

65 "$6m Hanging Garden in the Heart of Chinatown," *The Straits Times*, 28 July 1996.

20.1 Singapore's first pedestrian overhead
 bridge at Collyer Quay was officially
 opened by Parliamentary Secretary to
 the Ministry of Culture Fong Sip Chee
 on 2 May 1964. He declared it "another
 mark of the increasing modernisation
 of our city".

20.2 Early overhead bridges were made of
 steel and were erected on-site such as
 this one at Serangoon Road/Lowland
 Road in 1967. Despite the crowds who
 watched their construction, they were
 not popular with pedestrians.

20.1

20.2

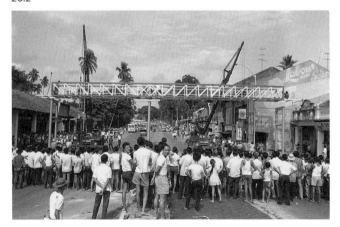

20.3 A 1970s bulletin by the National Safety
 First Council encouraging pedestrians
 to use the pedestrian bridge and
 traffic light when crossing the road.

20.4 A typical 1990s bridge design was
 open-air and had troughs on the side
 for plants, such as flowering
 bougainvillea. Dividers were also
 installed at the centre of the road to
 dissuade jaywalking.

20.5 Golden Bridge designed by KK Tan &
 Associates was one of two pedestrian
 linkways along Shenton Way—the
 other being Change Alley (now known
 as OUE Link)—that also housed shops.
 It linked Shenton House with DBS
 Tower Two.

20.3

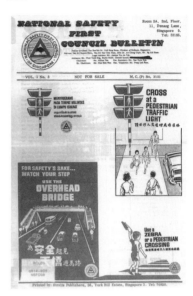

20.4

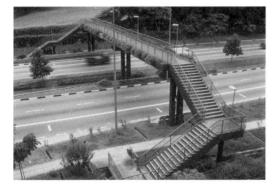

20.5

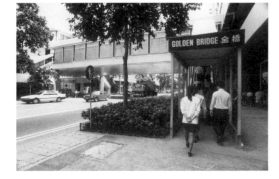

21 Interchanges:

The "Nerve Centre" of an Efficient Public Transport

If the residents had their way in 1976, Toa Payoh may not have had a bus interchange. Beginning in December 1975, the Singapore Bus Services (SBS) polled them about introducing a new bus system in their new town. "Feeder buses" would travel within Toa Payoh and terminate at a proposed interchange in Lorong 6 where residents could then transfer to "trunk services" to get to other parts of Singapore. The proposal was roundly rejected as residents preferred the existing 26 direct bus services that offered "door-to-door" connections between Toa Payoh and the rest of the city.[66] But this was unsustainable as overlapping bus services cost the company in terms of buses, manpower and other operating expenses, explained SBS. Elaborating on its proposal in a *Straits Times* forum letter, a company spokesperson said: "While having the interest of the commuters uppermost in our minds at all times, we cannot continue to provide an unusually high level of service in certain selected areas like Toa Payoh, as this can only be done at the expense of other commuters because of our limited resources."[67]

The need to distribute bus services more efficiently was part of a larger transformation in Singapore's public transport system in the 1970s.

Prior to this, the heavily fragmented sector was made up of 11 private bus companies, and notorious for its duplication of services, inconsistent fares and even labour unrest. The government finally intervened in 1971 by streamlining the companies into four entities—Singapore Traction Company, Amalgamated Bus Company, Associated Bus Services and United Bus Company—that served the different regions of Singapore. When bus services failed to improve, and the Singapore Traction Company even shut down because of staggering losses partly due to operational inefficiency, the remaining three companies were merged into a single entity known as the SBS and placed under the management of a crack team of civil servants.

Along with the reorganisation, a committee was appointed to rationalise bus services across Singapore. In January 1975, SBS announced the introduction of feeder services in all housing estates starting with Toa Payoh. The need for passengers to break up their travels was inevitable because of the lack of resources and the constraints in Singapore's road development, SBS General Manager Wong Hung Kim later explained. "Point-to-point service is simply impossible in view of limited road space, man-

power and other resources ... [c]ommuters must accept transfers as this is the only way for an efficient bus service."[68]

After residents in Toa Payoh rejected the scheme, SBS went ahead with it in the industrial estate of Jurong Town instead. The feeder bus system required the construction of a S$1.8 million bus interchange, which was completed in 1978 at the junction of Jalan Ahmad Ibrahim and Jurong Port Road. Touted as the largest bus terminal of its kind in the region, it served as the "nerve centre" where external bus services ended and internal services that plied the town's industrial and residential estates began.[69] The 2.5-hectare interchange had bay spaces for 90 buses and a pair of linear buildings with industrial-looking jagged roofs.[70] One served as a small office, fuel station and repair bay, while the other was a spacious double-volume passenger concourse with an information counter, canteen and kiosks. Passengers were expected to alight and board the buses at one of 12 berths, arranged six on either side of the concourse, and were guided by signage bearing the bus service numbers that hung from the roofs.

Jurong Interchange had a disastrous opening day as many commuters were confused about which buses to transfer to.[71] A jam within the interchange compounded the problem, and many workers ended up reporting late for work that Thursday. Although the situation improved a week later, some commuters reportedly still walked over 1.6 kilometres to their homes as the buses were always "packed with people like sardines" when they left the interchange.[72] When SBS opened a second interchange some nine months later in Bedok New Town, it put in more effort to educate commuters in addition to the usual press publicity and advertisements. Besides distributing leaflets to the town's residents, the opening occurred on a weekend to allow commuters to use the service for the first time on a non-work day. The interchange designed by the Housing & Development Board (HDB) and rented to SBS sat next to a hawker centre and consisted of various covered concourses around the edges of the bus park. Each was installed with a coloured queueing system and route information kiosk—the first signs of a modern public transport signage system.[73] The launch proved to be a much smoother affair.

With its launch of two bus interchanges and a transformation into a thriving publicly listed company, SBS entered the 1980s by emphatically announcing that "the feeder service is here to stay!"[74] More bus interchanges were built by the HDB as part of a suite of new towns the public housing agency was developing across Singapore. These included Telok Blangah, Ang Mo Kio and Clementi, which had interchanges with similar features as the one in Bedok, but wider passenger concourses to better accommodate the growing number of passengers.[75] The existing interchanges in Jurong and Bedok were also expanded in the early 1980s with more bus berths.[76] By 1984, Toa Payoh finally had a bus interchange and feeder scheme too. Although some commuters complained about longer waiting times and fare increases, the Acting Minister for Communications Dr Yeo Ning Hong said these did not represent the view of the majority.[77] Early bus interchanges designed by HDB took on utilitarian open-plan designs to shelter passengers waiting for buses and allow for easy navigation, but later iterations came injected with distinctive designs to serve as identity markers in public housing towns (see *Public Housing*). For instance, the former Choa Chu Kang bus interchange had a floral scheme, made up of a flower motif and green and yellow colours, to reflect the area's farming past.[78] Pasir Ris and Eunos bus interchanges had a "cultural look".[79] The former was a mix of Chinese, Indian and Malay-Moorish architectural motifs to reflect Singapore's multiracial population, while the latter had a Minangkabau roof reflecting its history as an area for Malays.

In the mid 1980s, the impending arrival of a new Mass Rapid Transit (MRT) system in Singapore transformed bus interchanges into multimodal public transport interchanges too. The new train stations were often built next to bus interchanges, such as in Ang Mo Kio, Bedok and Toa Payoh, and they were connected by underground links. In 1987, Bukit Batok, Serangoon and Bishan bus interchanges also became the first to be incorporated with a multi-storey car park (see *Market Street Car Park*) to maximise the use of land. Indeed, while interchanges made the public transport system more efficient, they occupied large areas of town centres, which was inefficient from the perspective of land use. As early as 1980, SBS's request to expand Ang Mo Kio interchange onto a neighbouring plot of land was reportedly met with resistance from HDB because of its reluctance to

give up land of "prime value" for development.[80]
The expansion was eventually acceded too.

In 2002, this issue was resolved with the
introduction of an "integrated transport hub" in
Toa Payoh. Such a development brought together
a fully air-conditioned bus interchange with
commercial units, and was linked to a MRT
station. Over the last two decades, 10 other such
hubs have been built, often replacing what was
originally a stand-alone open-air bus inter-
change.[81] Although commuters continue to
encounter the hassle of a making transfers in a
public transport journey, they can now do so in
air-conditioned comfort and even enjoy some
shopping along the way.

Notes

66 S. M. Muthu. "Toa Payoh 'no' to SBS feeder service
 plan," *The Straits Times*, 18 February 1976.
67 Benjamin Chua, "Why Feeder Services Are Needed
 in HDB Estates," *The Straits Times*, 27 January 1978.
68 S. M. Muthu, "SBS Plans to Put Super-Buses in City
 Area," *The Straits Times*, 26 January 1978.
69 "SBS's $1.2m Jurong Terminal," *The Straits Times*, 5
 April 1978.
70 "Singapore Bus Service (1978) Ltd. Rationalization
 of Jurong Town Bus Services," *The Straits Times*, 24
 May 1978.
71 S. M. Muthu, "Hundreds Caught Off Guard by the
 New Feeder Services System," *The Straits Times*, 2
 June 1978.
72 S. M. Muthu, "It's Walk to Work for Many in Jurong,"
 The Straits Times, 10 June 1978.
73 Paul Wee, "Colour Code for Bus Queues at
 Interchange," *The Straits Times*, 20 February 1979.
74 "The Feeder Service Is Here to Stay!" *Our Home*,
 August 1979.
75 "Plan for 3 More Bus Interchanges," *The Straits
 Times*, 14 March 1979; "Wider Passenger
 Concourses for SBS Interchanges," *The Straits
 Times*, 23 April 1979.
76 Edmund Teo, "$2.5m for Bigger Bus Centre in
 Bedok," *The Straits Times*, 9 December 1980;
 "New Bus Berths at Jurong Interchange," *The
 Straits Times*, 6 December 1986.
77 "Interchange Works Well in 10 Areas," *The Straits
 Times*, 20 March 1984.
78 Trudy Lim, "A Welcome Sight, This Interchange,"
 The New Paper, 23 April 1990.
79 "Pasir Ris and Eunos Bus Interchanges Get Cultural
 Look," *The Straits Times*, 20 February 1990.
80 Paul Wee, "Risks, so They Can't Use Passenger
 Concourse," *The Straits Times*, 1 February 1980.
81 "Woodlands Integrated Transport Hub to Open on
 13 June 2021," Land Transport Authority, 17 May
 2021, https://www.lta.gov.sg/content/ltagov/en/
 newsroom/2021/5/news-releases/Woodlands_ITH_
 to_open.html.

21.1

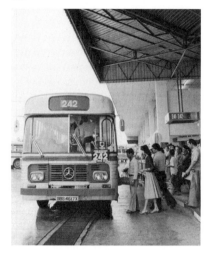

21.2

21.1 Jurong Interchange, at the junction of
 Jalan Ahmad Ibrahim and Jurong Port
 Road, was the first such public
 transport infrastructure built in
 Singapore in 1978.

21.2 After residents initially rejected the
 idea, Toa Payoh Bus Interchange was
 finally built in 1984 for the feeder bus
 system in the new town.

21.3 The success of bus interchanges in
 Jurong and Bedok led to their inclusion
 as part of the development of new
 towns in the 1980s. For instance, this
 bus interchange was developed as part
 of Clementi New Town.

21.4 Early bus interchanges, such as this one
 developed in Ang Mo Kio in the 1980s,
 had utilitarian open plan designs to
 shelter passengers waiting for buses.

21.5 The coloured queueing system and
 route information kiosk were important
 innovations in bus interchange designs
 as seen in this bus interchange in
 Hougang in 1984.

21.4

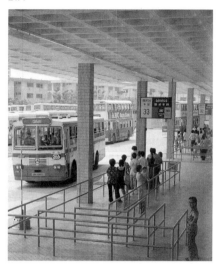

21.3

21.5

Connect

22–28

22 Public Schools: In Search of a Flexible and Identifiable "Instructional Equipment"

In 1975, the Ministry of Education (MOE) and the Public Works Department (PWD) co-organised a competition for school building designs. Opened only to government architects, the call for "fresh and stimulating" designs attracted a total of 50 entries—26 for secondary schools and 24 for primary schools. While previous schools were rendered as "box-like structures with no beauty or character", the 10 winning designs proved otherwise and were "much better than expect-ed", according to a PWD officer.[1] The sentiment was shared by the Journal of the Singapore Institute of Architects which reviewed the designs showcased in an exhibition at the Ministry of National Development (MND) Building:

> The exhibition certainly revealed that, given the freedom and opportunity, architectural product from the public sector need not be stereotyped and dull. A school building should be more than just a conglomeration of classrooms plus a canteen and an assembly hall. Going by the new designs, one looks forward to an improved and much more pleasant and conducive environment for learning to be experienced by school children of the future.[2]

At the exhibition's opening, the Senior Minister of State for Education Chai Chong Yii explained that school designs could be refined because "the 'frantic' rush to 'mass-produce' schools was over".[3] This began in 1949 when the then colonial government initiated a ten-year education supplementary plan to provide mass education for Singapore's growing population after decades of neglect in which very few schools were built. At least 18 new primary schools were built, equipped and staffed every year to ameliorate what then Director of Education A. W. Frisby called a "distressing situation".[4] The need for speed and budgetary constraints led to an "austerity type" design consisting of single-storey classroom buildings that were "capable of arrangement in almost infinite combinations" to fit any site configuration, and could be erected within five months.[5] A small number of secondary schools were also built, and these two- or three-storey buildings were of a more permanent construction in comparison. Between 1949 and 1959, the government built a total of 99 primary schools and 19 secondary schools based on five standard designs.[6]

A second phase of mass-produced schools was launched after Singapore attained self-gov-

ernance in 1959. In line with the newly elected People's Action Party's aim to "develop" its people through education, particularly to support the industrialisation programme, the standard school design was expanded with facilities for science and technical education.[7] Technical and vocational secondary schools were also introduced in 1964, beginning with Balestier Hill Secondary Technical School and Serangoon Gardens Integrated Secondary Technical School.[8] The standard secondary school of the 1960s consisted of an assembly hall, a canteen block, a classroom block and a science block—all typically laid out in a quadrangle. A workshop block was also separated from the other buildings by a car park-cum-parade ground as it housed the noisiest activities.[9] Most of these buildings were single- or two-storied, except for the classroom block that rose to four-stories in order to accommodate more students.[10]

The schools of the 1960s were underpinned by three planning and design considerations. Functionality was about the optimal placement of facilities to ensure a balance between proximity and separation. Flexibility entailed designing buildings to accommodate a variety of teaching and learning methods. Finally, adaptability was "the quality of a building which enables subsequent alteration to be made to its physical fabric".[11] As the school building was considered to be the "largest single item of instructional equipment", flexibility and adaptability were key to "avoid costly obsolescence".[12] However, many schools of this generation have been demolished and rebuilt, particularly when educational policies and pedagogical emphasis changed in the 1990s. The few surviving examples, including those from the 1950s, are no longer used as public schools but are leased out as private education institutes, students' dormitories, tuition and enrichment centres, and art venues.

With the emergence of more public housing new towns in the 1970s, the PWD accelerated school construction and sought to obtain "greater variety in design so that the large number of schools required would not look alike".[13] In this phase (confusingly named the "First School Building Programme"), school designs were "improved" primarily by making classrooms larger and adding facilities such as a sick bay and rooms for extra-curricular activities. PWD even made provisions for the installation of

15-by-3 metre murals on one outer wall of the assembly hall.[14] They were intended for "students to express their creative talent", but local artists were later commissioned. One surviving example is art teacher Ho Cheok Tin's 1979 mural on the development of Singapore for the former Braddell-Westlake Secondary School. Although the school has been demolished to make way for the new Raffles Girls' School campus, Ho's mural was kept.[15]

It was during the "First School Building Programme" carried out between 1973 and 1983 that the competition for new school designs was organised. Of the ten winners, which were evenly split between primary and secondary schools, one of the most striking was a primary school with hexagon-shaped classrooms designed by Puangthong Intarajit, a Thai architect working in the PWD. She was also the competition's only female winner.[16] Her design was first built in Alexandra Road for the former Keng Seng Primary School; it was also realised in Ang Mo Kio and Henry Park.[17] Besides creating a distinctive school, it was claimed that hexagonal classrooms enabled "less formal seating arrangement" as students may be seated around the classroom "unlike present standardised and somewhat regimentalised rows".[18] Such a tenuous connection between school design and education pedagogy was unlike at the Singapore American School in Ulu Pandan, which also had hexagon classrooms. Built earlier in 1974, it was designed by Sim & Associates Chartered Architects with The Shaver Partnership to serve the international school's model of team teaching and the flexible grouping of students to best fit a particular learning situation. Not only did the hexagon shape provide the "essential flexibility" required by the curriculum, it was also knitted together with other hexagons to form a honeycomb pattern that defined the shape of the school.[19]

By the time the PWD launched its "Second School Building Programme" between 1979 and 1988, hexagonal classrooms had fallen out of favour and more conventional classrooms were once again preferred. It perhaps reflected what a group of experts observed in another context about education in Singapore:

As teaching methods of the conventional or traditional style (i.e. teacher-centric approach) are prevalent in Singapore schools,

and as the progressive or non-formal styles of teaching have yet to prove their superiority, the design of classrooms closely follows the traditional model.[20]

Nonetheless, the programme saw the PWD continue to create more variations in school designs. A total of 12 standard designs were developed, of which at least four had the assistance of architects in private practice.[21] Alfred Wong Partnership designed three types—P101, S101, S100—that were eventually realised for 44 schools.[22] The trio shared common features, including a mono-pitched sloping roof that unified a few blocks, and a large-volume concourse covered by a light-weight space-frame roof.[23] Compared to previous schools, the designs from the Second School Building Programme were bigger, more spacious and offered a wider range of facilities. They also had better finishes, enhanced equipment and increased landscaping.[24] But the most significant change was in their construction. In 1983, PWD introduced the "core-contract concept" to encourage Singapore's builders to embrace the less labour-intensive precast construction method when building schools. It led to the modularisation of school building designs, including those by Wong, to facilitate prefabrication.[25] A total of 21 schools were almost entirely prefabricated using different systems under this scheme.

Despite the various attempts to improve designs over the decades, a 1988 survey found schools in Singapore still lacked "identity" in the eyes of school users.[26] Perhaps the crux of the issue was already identified in the 1950s by government architect Dale Cuthbertson:

Standardized building designs, like all ready-made articles have their special uses but can never compete with the individually designed production. Where speed is the essence of the programme standardization is unavoidable, but with a little ingenuity, the aesthetic and practical results of such a programme need not be monotonous.[27]

While the PWD schools built from the 1950s to the 1970s were designed to be flexible and adaptable to resist obsolescence, they were ultimately perceived as outdated by a population expecting school buildings to be individually designed so that they have clear "identities". It also reflected Singapore's constant adjustments in educational policy to "remain nimble enough to seize opportunities that come with changing circumstances".[28] In 1999, the rise in information technology (IT) led to another change in school design as part of a new educational policy towards creating "Thinking Schools, Learning Nation".[29] The Programme for Rebuilding and Improvement to Existing Schools was introduced to upgrade older schools for IT, and it was found that "[t]he main design criteria for schools of the future will be maximum flexibility, adaptability, multi-usage ability".[30] It was a strikingly similar conclusion to the considerations of 1960s school designs, although one perhaps less constrained by economic uncertainty, and more focussed on how future needs will evolve. The new direction probably also reflected how the decades of concern over "uniform and monotonous" school designs seem to have had little impact on their students' having a distinct school identity.[31] Despite school buildings being the largest "equipment" in education, it was the smaller factors—school crests, uniform, teachers and activities—that helped many students form strong memories of their schools, even long after their buildings had been renovated and even demolished.[32]

Notes

1 Teresa Ooi, "Look at Our Schools of the Future," *New Nation,* 21 August 1975.
2 "New Designs for School Building Programme," *Journal of the Singapore Institute of Architects* 72 (1975): 35.
3 Quoted in "Future Schools to Have Own Identity," *The Straits Times,* 21 August 1975.
4 A. W. Frisby, "The Singapore Education Plan," *The Quarterly Journal of the Institute of Architects of Malaya* 1, no. 3 (1951).
5 Dale Cuthbertson, "The Singapore Education Plan," *The Quarterly Journal of the Institute of Architects of Malaya* 1, no. 3 (1951): 37.
6 Public Works Department, *25 Years of School Building* (Singapore: PWD, 1984), 10.
7 Fang Yea Saen, "Story of PWD's Involvement in School Building" (paper presented at the New Direction in School Building, 1989), u.p.
8 Public Works Department, *25 Years of School Building,* 17; "Kuan Yew to Open New Technical School," *The Straits Times,* 14 July 1964.
9 Michael Kok-Pun Liew, Pang Kia Seng, and Harbans Singh, *The Design of Secondary Schools: A Case Study, Singapore* (Bangkok: UNESCO Regional Office for Education in Asia and the Pacific, 1981), 20–21.
10 Public Works Department, *25 Years of School Building,* 18.
11 OECD Programme on Education Building cited in Liew, Pang, and Singh, *The Design of Secondary Schools,* 20.
12 Ibid.
13 Public Works Department, *25 Years of School Building,* 29–30.
14 "Plans for schools with better classes, facilities," *The Straits Times,* 20 April 1975, 5.
15 Melody Zaccheus, "RGS Plans to Showcase Iconic 1979 Mosaic Mural," *The Straits Times,* 13 February 2017.
16 Teresa Ooi, "She Puts Her Heart In It...," *New Nation,* 21 August 1975, 12-13.

17 "News Review: Singapore," *Asian Building & Construction* April (1978), 7.
18 Ibid.
19 "The Singapore American School, Ulu Pandan Campus," *Journal of the Singapore Institute of Architects* 65 (1974): 18.
20 Liew, Pang, and Singh, *The Design of Secondary Schools,* 28.
21 Robert Powell, *Architecture of Learning: New Singapore Schools* (Singapore: Akimedia, 2001).
22 Personal correspondence with Alfred Wong, 17 January–1 February 2019.
23 "New School in Toa Payoh Zone," *The Straits Times,* 21 July 1984.
24 Public Works Department, *25 Years of School Building.*
25 "Getting the Locals Ahead: PWD's Core Contracting Scheme for Schools," *Southeast Asia Building* December (1984).
26 Yip Kim Seng "New School Design Concepts" (paper presented at the New Direction in School Building, The RELC Auditorium, 1989), u.p.
27 Cuthbertson, "The Singapore Education Plan", 48.
28 This founding ethos of Singapore was reiterated many times by Singapore's founding Prime Minister Lee Kuan Yew. In this instance, we are citing from his S. Rajaratnam Lecture delivered at Shangri-La Hotel, 9 April 2009, available at https://www.pmo.gov.sg/newsroom/speech-mr-lee-kuan-yew-minister-mentor-s-rajaratnam-lecture-09-april-2009-530-pm-shangri , accessed 17 January 2019.
29 Powell, *Architecture of Learning,* 19.
30 Ibid., 24.
31 Ooi, "Look at Our Schools of the Future."
32 Note the publication of books such as *My School Uniform: An A–Z Collection of Secondary School Uniforms in Singapore* (2016), *Singapore School Crests: The Stories Behind the Symbols* (2013) and the "HISTORY: Closed and Merged Schools in Singapore" series on http://fionaseah.com.

22.1 Gan Eng Seng School under
 construction, 1951. It was an example
 of one of the standard designs built
 under the colonial government 10-year
 education plan to provide mass
 education for Singapore.

22.2 Kim Seng Technical School under
 construction, 1965. It is an example of
 several technical and vocational
 secondary schools introduced in 1964
 to support Singapore's post-
 independence industrialisation
 programme.

22.3 Layout of a standard secondary school
 based on a 1965 design. It consisted
 of an assembly hall and blocks for a
 canteen, science laboratories and
 classrooms. There were also workshop
 blocks for technical classes, which
 were separated because of the noise.

22.1

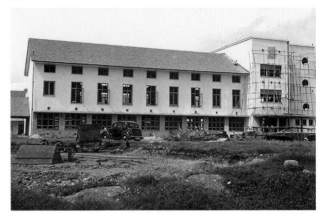

22.2

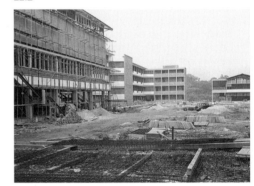

22.3

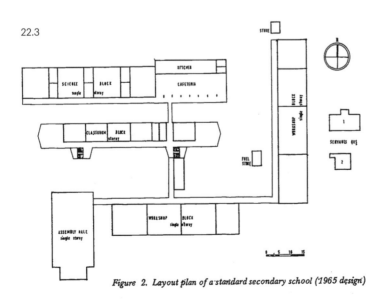

Figure 2. Layout plan of a standard secondary school (1965 design)

22.4 The official opening of the Upper Serangoon Technical School, 1966. On the left are its four-storey classroom block, while the right is a single-storey workshop block.

22.5 Aerial view of the S100-type of school designed by Alfred Wong Partnership. It was one of 12 standard designs created during the "Second School Building Programme" (1979-1988).

22.6 Axonometric drawing of the precast construction system for the P100, P101, S100 and S101 types of schools. It was introduced to embrace less labour-intensive construction methods when building schools.

22.4

22.5

22.6

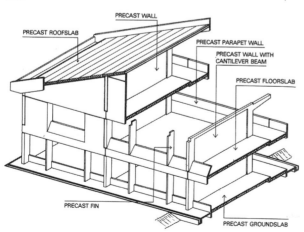

VARIAX SYSTEM

23 Institutes of Systems Planning to
Higher Education: Support a Technocratic State

While the Ministry of Education sought to transform generic but flexible primary and secondary school buildings into spaces with individual identity during the mid 1970s, the design of institutes of higher education in Singapore were heading in the opposite direction.(see *Public Schools*) Two campuses built then, the Singapore Polytechnic (SP) at Dover Road and the University of Singapore (UoS) at Kent Ridge, came in grid-like layouts with standardised building designs such that they could be used interchangeably by different departments. They departed from previous designs, which the architect for SP, Alfred Wong, described as "rigid, long-lived buildings, tailor-made to particular requirements" that were "ill-fitting" for a "mutating organism" such as the campus.[33] He added that such traditional models inherited from neoclassical designs of the 19th century "must now finally be laid to rest".

Wong probably had in his mind the original UoS campus at Bukit Timah, which officially opened in 1929 as one of Singapore's earliest institutions of higher education. Then known as Raffles College, it was designed by London-based architects Cyril A. Farey (1888–1954) and Graham R. Dawbarn (1893–1976) who jointly won a British Empire-wide architectural competition. They planned the campus around enclosed quadrangles, drawing on a globally influential language of collegiate architecture first seen at the British colleges of Oxford and Cambridge.[34] The introverted neoclassical scheme had arched verandas lining the perimeter of, and looking into, the two quadrangles. It was organised based on an axial symmetry, with focal points and the hierarchical arrangement of architectural elements.[35] The closed form became problematic in the late 1960s with an expanding UoS student population, and existing site constraints made it impossible to accommodate new facilities.[36] The UoS engineering faculty even ended up sharing space with Singapore's first polytechnic, SP, at its campus at Prince Edward Road.

The space crunch faced by both institutes of higher education was exacerbated by Singapore's demand for skilled technicians and workers to support its growing economy. It led to plans for two new campuses. In 1969, the government announced it would build a new UoS campus in Kent Ridge and recalibrate the university's role. While SP had focused on providing technical training to support Singapore's industrialisation programme since its establishment, the UoS purportedly had an "imbalance of enrolment mix

in respect of national development needs", which was corrected by enlarging enrolments in engineering, applied sciences, economics and business.[37] The university would now aim to offer "broad enough training in the technological and applied sciences fields to deal directly with technology not only as practising engineers but also as managers, public administrators, and advisors". It would also equip those in "non-technological fields" with the ability "to understand and deal effectively with modern science and technology".[38] In short, UoS was to produce a new generation of workers who could function in a rapidly developing Singapore.

The university's new campus was constructed with a similar philosophy. Its design was carried out through "a systems concept of planning" based on technical and quantitative analysis of the site, student and faculty statistics, programme, land use, topography, open space, human and vehicular circulation, structure and services, and other data.[39] This was conceived by the Dutch urban planner and architect Samuel Josua van Embden (1904–2000) between 1969 and 1970, and implemented by his appointed chief designer and coordinator Meng Ta Cheang, a China-born architect and planner with the University of Singapore Development Unit (USDU). The masterplan was a grid system overlaid onto the topography of Kent Ridge to create a unified system of inter-connected, low-rise post-and-beam buildings that preserved the hills with minimum disturbance to the landform and vegetation.[40]

Instead of each university programme or department "having its space tailor-made to suit only itself", the campus' buildings were standardised in plan and design because its planners and architects felt that "conventional boundaries isolating fields of knowledge, have less meaning" in new universities.[41] The buildings were planned based on a three-bay by one-bay tartan grid, utilising a 26-feet wide bay. Each bay was in turn based on smaller modular constructional units. The tartan grid allowed the separation of services from the served spaces, thus affording the latter maximum malleability, while the constructional units facilitated interchangeability of smaller building components.[42] No wonder Meng proclaimed that the proposed grid solved "90 per cent of the problems" as it achieved not only structural unity, but also flexibility and expand-

ability in space, which were key in "the environment of uncertainty and change" in higher education.[43] UoS also took into account "the dynamic and rapid changes in the economy and society of the nation and the global scene" which it expected to lead to curricula revisions, changes in teaching mode and shifting conceptions of the university community "in short time-frames".[44]

Possibly the only non-generic aspect of the masterplan was how the tartan grid shifted in response to the landscape of Kent Ridge, creating a pattern that was initially described as "horseshoe",[45] and later "curve linear".[46] Reorienting the grid in different directions not only preserved the landscape and vegetation but also created a variety of open spaces as intended. Some allowed for future expansion and potential changes. Others were intended as landscaped spaces and piazzas where students could socialise.

Built between 1976 and 1982, the UoS turned out to be a linear campus of mostly look-alike buildings thinly spread across a 473-acre site. A series of meandering, up-down pedestrian walkways and bridges connected the various buildings in a manner that was disorientating to navigate and physically tiring to use.[47] Given the dispersed layout, the campus has no central spaces easily accessible by all students, and most of the open spaces feel like transitory in-between spaces for circulation, or landscaped areas not meant to be entered. The scattered arrangement differed from the original masterplan where the campus was better linked with its main circulation routes placed on the ridge.[48] This disconnect with van Embden's vision may have been in response to vice-chancellor Dr Toh Chin Chye's concerns about "student activism and its potentially disruptive possibilities on campus".[49] Toh was actively involved in the planning and design of the campus and had experienced the long history of student protests in Singapore as the founding chairman of the People's Action Party and as the country's deputy prime minister from 1959 to 1968. Moreover, the new campus was built in the aftermath of large-scale student demonstrations around many parts of the world in 1968. One even took place in Singapore in 1971 when SP students protested over some of their classes being moved to a temporary campus at the former Princess Mary military barracks. It was

an interim arrangement to relieve the space crunch at Prince Edward Road while SP built a new campus at Dover Road, but many felt it was the UoS students sharing the space who should move out first. Some 700 SP students boycotted classes and staged a sit-in at the "quadrangle" of SP's modernist building in Prince Edward Road, although it was really just a large open space.[50] The demonstrations ended after the administration assured the students they would provide reasonable facilities at the new campus.[51]

Against this backdrop, Toh probably did not want open spaces in the UoS campus where students could congregate, which explains the subsequent implementation of the masterplan.[52] In addition, the architectural quality of UoS' individual buildings are also generally low as they were formally and spatially uninteresting, poorly sited and badly detailed. This was unlike other university campuses in the Netherlands by van Embden's firm. Both the Eindhoven Polytechnic (today's Eindhoven University of Technology) and Twente Polytechnic (today's University of Twente) have good quality architecture informed by an industrial aesthetic, due to the input of talented designers in the firm, particularly Jacques Choisy and Arie Hagoort, who were absent on the UoS project.[53]

In contrast, the new SP campus completed by Wong and his firm in 1978 was much more successful in terms of planning and architecture. It too was planned with flexibility and expandability in mind and used a highly adaptable grid to create "a 'loose-fitting' indeterminate type of campus layout".[54] Being a smaller campus located on a less complex landform probably made it easier for the architects, but SP's

masterplan also had obvious focal points and a much more clearly articulated pedestrian circulation system that aided navigating the campus. The superior design skills of Wong and his team are also apparent in the much better proportioned, elegantly articulated and carefully detailed campus buildings.

Some three decades after UoS became the National University of Singapore (NUS), the Kent Ridge campus was extended with a new University Town (UTown) that was officially declared open in 2013. Located to the north of the original campus, which is separated by the Ayer Rajah Expressway, UTown was touted by then NUS President Tan Chorh Chuan as "the campus core that had previously been missing."[55] At its heart is an asymmetrical field called Town Green, which was envisioned as "the major open space for congregation, active play, supporting high levels of social interaction across campus".[56] Surrounded by distinctive buildings designed by various architects, Town Green can perhaps be read as a restitution of the quadrangle that was expunged from the original Kent Ridge masterplan. UTown subsequently became home to the first liberal arts college in Singapore, Yale-NUS College. Established with the American Ivy League university in 2011, the partnership ran for a decade before it was announced in 2021 that Yale-NUS College would be merged with the NUS University Scholars Programme by 2023, to form a new and larger liberal arts college. Some speculated that the episode was a reminder of the primary role of institutes of higher education in supporting Singapore's national development—as expressed in their technocratic planning and design.

Notes

33 "Singapore Polytechnic New Campus at Dover Road," *Journal of the Singapore Institute of Architects* 77 (1976): 4.

34 Jonathan Coulson, Paul Roberts, and Isabelle Taylor, *University Planning and Architecture: The Search for Perfection* (New York: Routledge, 2011), 5–8.

35 "Raffles College Plan Competition," *The Singapore Free Press and Mercantile Advertiser*, April 1924; "Raffles College Building to Commence This Year," *The Straits Times*, 4 September 1924; "Raffles College. Progress of Building Operations," *The Singapore Free Press and Mercantile Advertiser*, 5 July 1928.

36 Raffles College became the University of Malaya in 1949. It then became the University of Singapore in 1962. Numerous additions were made to the campus in the postwar period, including the 10-storey Science Tower designed by Ho Kok Hoe in the mid 1960s. See Kevin Y. L. Tan, Thian Guan Peck, and Fook Ngian Lee, "The Building of the National University of Singapore," in *Kent Ridge: An Untold Story*, ed. Kevin Y. L. Tan (Singapore: Ridge books, 2019), 245–47.

37 "University of Singapore Kent Ridge Campus," *Journal of the Singapore Institute of Architects* 66 (1974): 15.

38 Ibid.

39 Ibid., 19.

40 Tan, Peck, and Lee, "The Building Of", 266.

41 "University of Singapore Kent Ridge Campus," 19–21.

42 Ibid., 21–22.

43 Tan, Peck, and Lee, "The Building Of", 266.; "University of Singapore Kent Ridge Campus," 15.

44 Ibid., 16.

45 Ow Wei Mei, "'City of Learning' at Kent Ridge," *The Straits Times*, 24 July 1970.

46 "University of Singapore Kent Ridge Campus," 19.

47 One of the authors is also speaking from his experience of using the campus for over 25 years.

48 For van Embden's original masterplan, we refer to Joosje van Geest, *S. J. Van Embden* (Rotterdam: Uitgeverij 010, 1996), 152–54; Tan, Peck, and Lee, "The Building Of", 264–65.

49 Tan, Peck, and Lee, "The Building Of", 258.

50 Lee Su San, "'We Won't Budge' Demo by Poly Students," *The Straits Times*, 7 August 1971; "Protest Students to Boycott Classes at New Campus," *The Straits Times*, 8 August 1971; "700 Poly Students Boycott Classes at New Campus," *The Straits Times*, 11 August 1971.

51 "No More Demos as Long as Poly Keeps Its Word," *The Straits Times*, 22 August 1971.

52 Besides the demonstrations by the polytechnic students mentioned earlier in the essay, there were protests by Chinese middle school students, Nantah students and University of Singapore students. See Tan Jing Quee, Tan Kok Chiang, and Hong Lysa, eds., *The May 13 Generation* (Petaling Jaya: Strategic Information and Research Development Centre, 2011); Hong Lysa and Huang Jianli, *The Scripting of a National History: Singapore and Its Past* (Singapore: NUS Press, 2008), 109–35.

53 Hans Ibelings, *20th Century Architecture in the Netherlands* (Rotterdam: NAi Publishers, 1995), 112.

54 "Singapore Polytechnic New Campus at Dover Road," 4. Before Alfred Wong was commissioned to plan and design the campus, he was involved in a Singapore Institute of Architects' team that proposed a masterplan for SP campus at Dover Road in 1971. Besides Wong, the team comprised of Rex Koh Kim Chuan, Lee Weng Yan, Koichi Nagashima, Sim Hong Boon, Wee Chwee Heng and Tan Liang Seng. "Proposed Master Plan of Singapore Polytechnic New Campus at Ayer Rajah Road," *Journal of the Singapore Institute of Architects* 45 (1976).

55 Cited in Tan, Peck, and Lee, "The Building Of", 279.

56 The words of the landscape architect, STX Landscape Architects, in https://www.world-architects.com/en/stx-landscape-architects-singapore/project/nus-university-town-nus-utown, accessed 8 September 2019.

23.1 University of Malaya's first convocation procession of court and senate taking place in the quadrangle of its campus in Bukit Timah, 1950. The neoclassical design was thought to be ill-equipped for modern higher education in the 1970s.

23.2 Dr Toh Chin Chye (second from left) showing President Dr Benjamin Henry Sheares (far left) a model of the UoS campus at Kent Ridge in 1971. It displayed the original masterplan that consisted of a well-integrated system of inter-connected, low-rise buildings that preserved the hills and disturbed the vegetation minimally.

23.3 Original masterplan of the UoS campus at Kent Ridge by Samuel Josua van Embden, c. 1970. While it envisioned a campus linked with a main circulation route placed on the ridge, the built design was more dispersed and scattered.

23.1

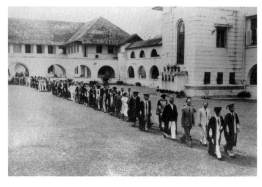

23.2

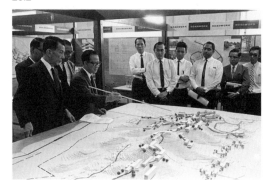

23.3

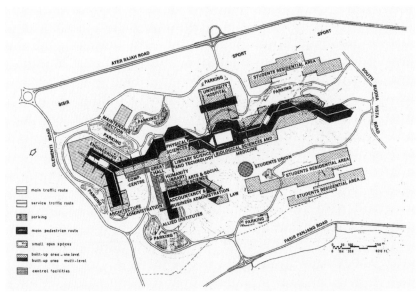

23.4 Study of the grid system for the UoS. It purportedly achieved structural unity and offered flexibility and expandability in space due to the uncertainty and change in higher education.

23.5 Aerial view of the SP, 1980. The planning and architecture by Alfred Wong Partnership also relied on a grid-like layout and standardised buildings, like those in the University of Singapore.

23.6 Perspective drawing of the SP with the administration building in the centre.

23.4

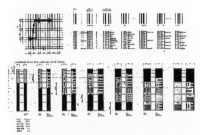

Fig. 10. SEARCH FOR INTERIOR MEASURES AND GRID-PATTERN

Fig. 11. CONSTRUCTION AND ZONING GRID

Fig. 12. BASIC SIZE OF GRID

23.5

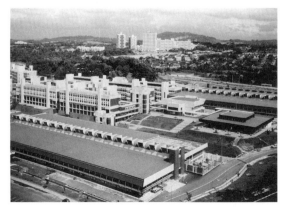

23.6

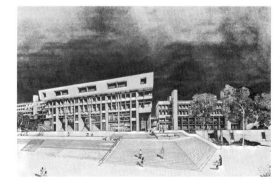

24 Institutional Buildings: A New Monumentality

Around the mid 1970s, two public institutions in Singapore moved from grand colonial edifices to newly built modern complexes. The Subordinate Courts brought together courthouses previously "scattered over different parts of the city"[57] in 19th century buildings such as the Mansard-roofed Police Courts (1885–1975) (also known as the Criminal District and Magistrates' Courts) and the neoclassical Civil District Courts (1867) (more commonly known as Empress Place) into a complex at Havelock Road. The Public Utilities Board (PUB), which oversaw the city-state's supply of electricity, water and gas, shifted out of a congested headquarters at the neoclassical City Hall into Somerset Road to "centralise the fragmented sections back in one building thus making for smoother administration and greater co-ordination".[58]

Beyond streamlining the respective public institutions' operations, the two new buildings were also designed to symbolise what modern governance looked like in a newly independent Singapore. Both came in the then emerging architectural language of brutalism. The Subordinate Courts expressed this in a "powerful form that would befit the image of the Courts".[59] Its plan consists primarily of 26 courtrooms with

their auxiliary facilities radiating from an octagonal-shaped atrium. Externally, the courtrooms are articulated as volumes with layered horizontal bands. They are also differentiated vertically as the top floors are recessed from the lower floors, creating a terraced form. At the highest floor was the judges' conference room, which was rotated at an angle from the lower floors and capped the entire complex. Although the Subordinate Courts' external form was "the direct expression"[60] of its internal spaces, the design also demonstrated a sophisticated handling of architectural massing. The sculptural complex contrasts against the lightness and the loftiness of the sky-lit octagonal-shaped atrium in its centre. From this public concourse, one can see—but not use—the separate circulation systems of the independent service cores and corridors for the building's three groups of users: the public, the accused, and the judges and magistrates.[61]

Like the Subordinate Courts, the PUB Building has a carefully articulated, sculptural exterior too. Made up of sloping walls, exposed columns, and vertical sun-breakers (brise soleil), these elements surround two slab blocks which are

arranged side by side and connected by a common service core. The building's massing steps outward such that the floor plates become bigger as its height increases. It also has an impressive public concourse that is generously proportioned and "made ingenious use of levels and [the] emphasis on colonnade effects".[62] When it was completed in 1977, the *Building Materials and Equipment* magazine even hailed the PUB Building as a structure "of abounding grace and eloquence" and "a symbol of well-mannered elegance" that represented a breakthrough in the design of institutional buildings in Singapore.[63]

Both buildings were part of a string of brutalist institutional buildings that were built during the 1970s in Singapore. In the up-and-coming Jurong industrial estate, arose the likes of Jurong Town Hall (1974) and Singapore Science Centre (1977).[(see *Jurong Town Hall*)] However, while these buildings in Jurong took on futuristic connotations partly due to their associations with a national industrialisation programme, the Subordinate Courts and the PUB Building were probably translated and received by the public in a different register because of their highly visible locations in central Singapore. Their heavy massing and sculptural forms might be read as representing a "new monumentality", a term first proposed in the West during the 1940s by architect Josep Lluís Sert, artist Fernand Léger and architecture historian Sigfried Giedion. What the trio advocated for was not the monumentality of authoritarian states or Fascist regimes, but a civic architecture that goes beyond the functionalist preoccupations of pre-war modernism to engage with the social, cultural and spiritual needs of a society.[64] Although they were seeking a change within the architectural expressions of modernism, it may have indirectly influenced how architects in Singapore sought to express a new form of monumentality using the brutalist vocabulary. Such ideas most likely routed through North America, where brutalism became the expression for civic monumentality with the completion of the Boston City Hall in 1968 by Kallmann McKinnell & Knowles. The PUB bears an undeniable resemblance formally, although there are obvious differences in programme, nature of site and finishing.

The monumental institutional buildings in Singapore were also distinguishable from other emerging public buildings, which were then largely designed by architects working in government agencies such as the Housing & Development Board (HDB) and the Public Works Department (PWD). In an analysis of the latter, specifically the National Development Building (today known as the Ministry of National Development [MND] Complex) and various HDB Area Offices, sociologist Chua Beng Huat observed the absence of obvious monumentality as compared to those by the colonial government that encoded its "self-conscious and forceful expression of power and domination" in the neoclassical architecture of buildings like City Hall.[65] He read it as a reflection of the shift in relationship between the elected People's Action Party (PAP) government and its people. The PAP had to "assume the authority of leadership yet must be embraced by the public on the ground of being 'similar'." Thus, public buildings it erected "encode this 'reluctance' of power" and conveyed what Chua called a "doubled relationship with the public". He argued that the buildings have "a sense of authority and yet exude a civility, a friendliness to receive the citizens rather than intimidating them into submission and resentment". In addition to designs that were approachable rather than dominating, Chua attributed the lack of differentiation with the general built environment to the pragmatism of the ruling government.[66]

The Subordinate Courts and PUB Building, however, were designed by architects in private practice. The former was by Kumpulan Akitek, a partnership then led in its Singapore office by Victor Chew, Wee Chwee Heng and Chan Sau Yan. Known for their geometrically rigorous and functionally well-resolved designs—such as Ming Court Hotel (1970), Highpoint Apartments (1974), and Townhouse Apartments (1976) [(see *Futura*)]—they were specially engaged to collaborate with the PWD. On the other hand, the PUB Building was the result of a two-stage competition launched in 1971 "to tap the best local talent".[67] It attracted 23 entries, and among the four finalists selected for the second stage were Singapore's then best-known local architectural firms: BEP Akitek, Architects Team 3, Alfred Wong Partnership and the eventual winners, Group 2 Architects.[68]

Both buildings became part of a small but significant list of institutional developments by private architects in the 1960s and 1970s,

including the National Theatre (1963–1986), the Singapore Conference Hall and Trade Union House (1965), Jurong Town Hall (1974) and the Singapore Science Centre (1977). These often came in progressive designs that contrasted with the more pragmatic forms adopted by the government architects. For instance, although the Subordinate Courts and the PUB Building were both located in Singapore's central area, they steered away from the podium tower typology then favoured by the state. Just across the Subordinate Courts were HDB public housing blocks and private shopping centres in this form. (see *People's Park*) The podium tower also defined two institutional buildings in the neighbouring central business district, the National Development Building and the former CPF Building. The state even mandated the typology on new private developments in the nearby Shenton Way. (see *Shenton Way*)

In contrast, there seemed little dispute amongst private architects in the 1970s that institutional buildings should come in the brutalist vocabulary instead. Three of the four finalists for the PUB Building competition were also clearly influenced by brutalism's emphasis on heavy, volumetric and sculptural massing.[69] Such a language eventually appeared in work by government architects too. Some examples include the HDB area office at Ang Mo Kio Avenue 1 (today the office of the Ang Mo Kio Town Council) (1977), the public housing estate at Crawford Lane (1982) and the Geylang East Public Library (1987).

While brutalism's monumental forms may have once decreed the significance of a building, this has since been called into question globally. In Singapore, the Subordinate Courts building (renamed the State Courts in 2014) has been conserved and is undergoing renovations to serve as the Family Justice Courts. A new high-rise court tower has been built next door, and it adopts an open frame design in contrast. Similarly, the PUB Building has undergone two extensive renovations to turn it into an office-cum-retail complex after it was sold to private real estate funds in 2008.[70] Although its external

form has remained largely the same, its distinctive rough mosaic tiles were re-cladded twice—first in shiny silver metallic panels; and more recently, in silver and gold. Both updates have arguably been attempts to soften their monumentality, keeping the buildings palatable in the era of the market state.

Notes

57 "Courtrooms Cascade from Different Levels and Directions in This Eight-Sided Complex." *Building Materials & Equipment* 61 (1975): 63.

58 "The Public Utilities Board Building," *Journal of Singapore Institute of Architects* 52 (1972): 5.

59 See an illustration and discussion of the high-rise solution in Hoong Bee Lok, "Victor Chew: An Architect" (B.Arch. Elective Study, National University of Singapore, 1981), 92–93.

60 Calvin Low, "Law and Order: The Subordinate Courts Complex's Geometric Scheme Unites Its Disparate Functions," *The Straits Times*, 5 July 2008.

61 "Courtrooms Cascade from Different Levels and Directions in This Eight-Sided Complex," *Building Materials & Equipment*, 63.no. December (1975

62 "The Big Switch-On: The S$62 Million PUB Building," *Building Materials & Equipment*, August (1977): 11.

63 Ibid., 7.

64 Nicholas Bullock, *Building the Post-War World: Modern Architecture and Reconstruction in Britain* (New York: Routledge, 2002), 39–60; Sigfried Giedion, "The Need for a New Monumentality," *The Harvard Architectural Review* IV (1984[1944]); Josep Lluís Sert, Fernand Léger, and Sigfried Giedion, "Nine Points on Monumentality," *The Harvard Architectural* Review IV. (1984[1943]).

65 Chua Beng Huat, "Decoding the Political in Civic Spaces: An Interpretative Essay," in *Public Space: Design, Use and Management*, ed. Chua Beng Huat and Norman Edwards (Singapore: Singapore University Press, 2011), 59.

66 For a discussion of pragmatism as a key ideology of Singapore government, see Beng-Huat Chua, *Communitarian Ideology and Democracy in Singapore* (London: Routledge, 1995).

67 "The Public Utilities Board Building."

68 "PUB Building Competition: Assessor's Report," *Journal of the Singapore Institute of Architects* 52 (1972): 6–8.

69 The only exception was a scheme by Architects Team 3.

70 Kalpana Rashiwala,"Tripleone Somerset Sold for $970m," *The Business Times*, 23 December 2013.

24.1 The monumental PUB Building along Somerset Road was an example of how brutalist design came to symbolise what modern governance looked like in independent Singapore during the 1970s.

24.2 The PUB Building design emerged from a two-stage public competition held in 1971 that attracted 23 entries. It was won by Group 2 Architects; the second place went to BEP Akitek, as featured in this rendering.

24.1

24.2

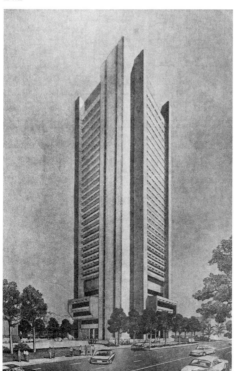

24.3 The third place scheme for
 the PUB Building design
 competition by Architects
 Team 3.

24.4 Alfred Wong Partnership's
 scheme for the PUB Building
 design competition won an
 honourable mention.

24.3

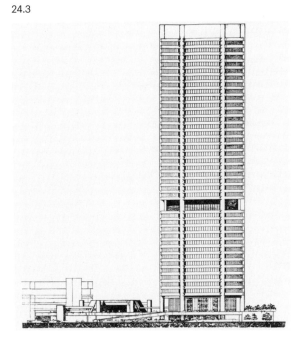

24.4

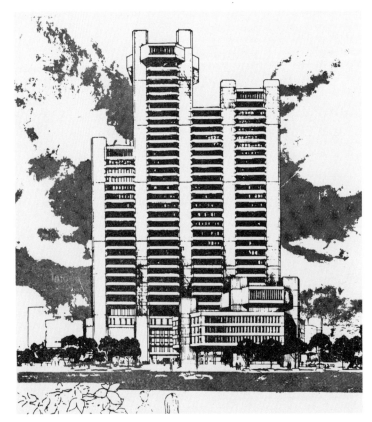

24.5 The brutalist vocabulary of
 volumetric massing was also
 adopted government architects as
 seen in this HDB area office at Ang
 Mo Kio Avenue 1 on the cover of
 Our Home magazine.

24.6 Elevation and section of the
 Subordinate Courts building.
 The top floor was the judges'
 conference room, and there was a
 sky-lit octagonal-shaped atrium in
 its centre.

24.5

24.6

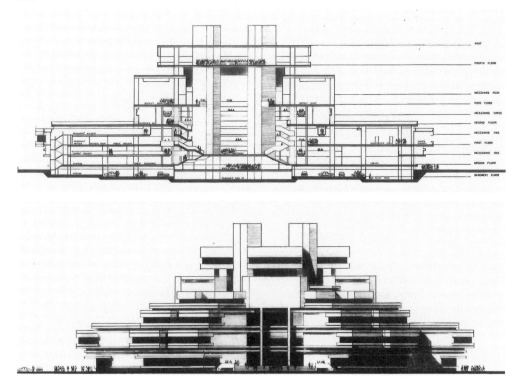

25 Public Libraries: "Palaces for the People"

When the old National Library Building at Stamford Road was threatened with demolition in the early 2000s, it ignited a wave of support for its preservation.[71] The decision became a hotly debated topic in Parliament too. Although local architect Tay Kheng Soon even put forth a proposal to keep the building while tackling the transportation and land issues that purportedly necessitated its removal, the library was eventually assessed as not having "enough" merit for conserving by the then Preservation of Monuments Board, a statutory body responsible for safeguarding historical landmarks in Singapore.[72] The decision to tear down the library in 2005 has since been called a "grievous loss of heritage", and continues to be a sore point in the city-state's conservation history.[73]

Such a controversial ending echoes the library's similarly divisive beginning in 1960. When the brick-faced building, designed by British architect Lionel Bintley of the colonial Public Works Department (PWD), was first completed, the official journal of the Society of Malayan Architects, *Rumah*, was unsparing in its criticism:

The building has been considered massive, clumsy and heavy. It lacks grace and elegance. It suggests a last minute and unsolved attempt to tackle the problem of the tropical sun. The articulation and circulation are indefinite, and the design concept has not been given sufficient emphasis for a major and complex building of this nature. There are no consistent structural principle and little spatial relationship between the different sections of the building.[74]

Despite such professional misgivings about its architecture, the library became a success with the public and membership rose rapidly with its opening. Beyond being just a repository for books and a place for promoting literacy, it also regularly hosted art and photographic exhibitions, film shows and talks.[75] Its first post-independence director, Hedwig Anuar, observed that many Singaporeans "make use of the library as a club", a place where they came regularly to read, meet friends and attend activities.[76] In this way, the National Library, and the subsequently built branch libraries across the city-state, became the "educational, social and cultural centres" of Singapore.[77] In short, they approximated what sociologist Eric Klinenberg has called in the American context "palaces for the people," places where divisions in ethnicity

and socio-economic classes were bridged and social capital was built.[78]

The National Library only came into existence as an institution in 1959, when Singapore was granted full internal self-government by the British. It was taken out of the Raffles Library and Museum, which dated back to 1874 and had a subscription library that served only a privileged minority. Influenced by both nationalist sentiments and UNESCO's initiative of promoting public libraries in Asia, the institution was converted into a public library that was freely accessible to all.[79] The shift was rendered more visible when the library moved out of the 19th-century neoclassical colonial edifice it shared with the museum along Stamford Road and into its new building next door.[80]

Besides granting public access, the library began catering to Singapore's multi-ethnic and multilingual makeup in order to create what then Minister of Culture S. Rajaratnam called a "truly National Library".[81] The original collection of books—which was made up almost entirely of English-language titles even though only around 10 per cent of the population was literate in the language—was diversified to include those in the vernacular, and by then official, languages of Chinese, Malay and Tamil.[82] It undoubtedly contributed to the National Library's popularity, such that just six year after it opened, its building was said to be "becoming totally inadequate to meet the growing demands for the Library's services".[83] The overcrowding accelerated a decentralisation programme that the library had undertaken since the 1950s. It established part-time branch libraries that opened three days a week in Siglap (1954–1981), Joo Chiat (1955–1974) and Yio Chu Kang (1956–1960), and also launched a mobile library programme in 1960 with the assistance of a US$2,500 donation from UNESCO.[84] Vans carrying books visited Singapore's outlying rural districts where they typically stopped at community centres for one to five hours. These mobile libraries were so popular that there was a "mad rush" for them whenever they approached one of their service points.[85]

With the establishment of new towns by the Housing & Development Board in the 1960s, the National Library was able to develop "'sizeable' branches" to further its decentralisation efforts.[86] The first full-time branch library was built in Queenstown, Singapore's first satellite town.

Officially opened in 1970 by Prime Minister Lee Kuan Yew, Queenstown Branch Library served the surrounding population of some 160,000 residents.[87] The library located along Margaret Drive sat next to a polyclinic, and across the town centre where there was a hawker centre, a market, a bowling centre, an emporium and a few cinemas.[88] The library became easily accessible to one of its main target user groups, children and teenagers, as there were up to 13 primary and secondary schools concentrated around Margaret Drive in the 1970s.

While the Queenstown library was also designed by PWD, its light, transparent and open design was a stark contrast from the National Library's heaviness, opacity and compartmentalised spaces. This was made possible by a simple two-storey post-and-beam structure infilled with louvred glass windows (replaced with fixed glass panels when it was air-conditioned in 1978) and ventilation bricks. Such architecture—particularly its open plan and light-infused interior—was in line with the modernist "libraries of light" that were built in Britain in the 1960s.[89] The Queenstown library also had a distinctive exterior with externalised columns and extruded ends of concrete beams on the top of the second storey. The edge beams curved towards the centre to create what has been described as "bow-tie" motifs lining the main roof and the entrance-porch roof. In 2014, it became the first public library gazetted for conservation and is one of the very few buildings that has remained standing in a neighbourhood that is currently being redeveloped.[90]

Singapore's second branch library was built in its second satellite new town, Toa Payoh. Officially opened in 1974, it too was located in the town centre, but had a significantly greater architectural presence. Instead of facing a road like the Queenstown library, the three-storey rectilinear building in Toa Payoh was fronted by a public plaza with a huge round water fountain in the middle. The large foreground accentuated the monumental expression of the building, punctuated by regularly spaced tall rectangular windows. From the mid 1970s to the late 1980s, six more free-standing branch libraries were opened in town centres across Singapore— Marine Parade (1978), Bukit Merah (1982–2018), Ang Mo Kio (1985), Bedok (1985–2017), Geylang East (1987) and Jurong East (1988)—in similarly

boxy designs. However, none matched the Toa Payoh library's siting and frontage.

The growth in full-time branch libraries led to the gradual phasing out of part-time branch libraries and mobile libraries. The last two part-time branch libraries were closed in 1988 and all mobile libraries ceased operation in 1991.[91] After the National Library became a statutory board in 1995, it was renamed the National Library Board. Branch libraries became known as community libraries and the board sought to bring its services even closer to the people by locating them in the increasingly popular shopping centres. (see Shopping Centres) The Jurong West Community Library was the first to open in 1996 inside Jurong Point. Today, over half of Singapore's public libraries are in shopping malls, where the consumption of books and information coexists with that of other commodities and services. There are also others that have become integrated with community centres such as in Marine Parade and revamped branches in Bedok and Tampines.

The demolition of the old National Library also saw it move into a new 16-storey complex along Victoria Street, which is part of Singapore's latest arts and heritage district. The design by the architecture firm T. R. Hamzah & Yeang includes corporate offices, seven floors dedicated to reference books, a drama centre, a large public square and a viewing gallery offering panoramic views of the Singapore skyline. Unlike the previous building, the new one has won many architecture accolades for its environmentally friendly design. However, it remains to be seen if "good" architecture is enough to win the hearts of its users—many of whom still reminisce about the old National Library. It is a reminder that these "palaces for the people" are incomplete without the latter no matter how modern their designs may be.

Notes

71 Maria Almenoar, "Hundreds Bid Final Farewell to Library," *The Straits Times*, 1 April 2004.

72 Lydia Lim, "National Library to Go," *The Straits Times*, 7 March 2000.

73 The words of *Straits Times* editor Warren Fernandez, "Balancing Past, Present and Future: URA Plans Make Plain That S'pore Remains a Work in Progress," *The Sunday Times*, 24 November 2014. For laments, see "Love for Library That Held More Than Just Books," *The Straits Times*, 8 August 2009; Natasha Ann Zachariah, "The Past Revisited: Three Conservation Advocates Have Put out a Book to Highlight Singapore's Early Architectural Gems," *The Straits Times*, 30 May 2015.

74 "The National Library," *Rumah, Journal of Society of Malayan Architects* 3 (1960). One of the committee's members, William Lim, also had his criticism reported in the newspaper. See Ian Mok-Ai, "They Gasp with Horror at This 'Monstrous Monument'," *The Singapore Free Press*, 9 July 1960.

75 Among the early exhibitions held were "Housing in Singapore" organised by the Housing & Development Board in 1963 and an exhibition on African and Asian countries held to coincide with the 1965 Afro-Asian Congress hosted by Singapore that year. See *Annual Report of the National Library 1963*, (Singapore: National Library, 1966), 9; *Annual Report of the National Library 1965*, (Singapore: National Library, 1967), 15.

76 Ismail Kassim, "Making Libraries Social and Cultural Centres," *New Nation*, 21 May 1974.

77 Ibid.

78 Eric Klinenberg, *Palaces for the People: How Social Infrastructure Can Help Fight Inequality, Polarization, and the Decline of Civic Life* (New York: Crown, 2018).

79 Lim Peng Han , "The History of an Emerging Multilingual Public Library System and the Role of Mobile Libraries in Post Colonial Singapore, 1956–1991," *Malaysian Journal of Library & Information Science* 15, no. 2 (2010). UNESCO organised a seminar in Delhi in 1955, in which 46 librarians and educators from around Asia, including Malaya, participated. See UNESCO, *Public Libraries in Asia: The Delhi Seminar* (Paris: UNESCO, 1956).

80 Lim, "The History of an Emerging Multilingual Public Library System."

81 "Library Should Serve All Groups—Minister," *The Straits Times*, 18 June 1960.

82 Lim, "The History of an Emerging Multilingual Public Library System," 90.

83 *Annual Report of the National Library 1966*, (Singapore: National Library, 1968), 1.

84 *Annual Report of the National Library 1963*, 8.

85 Lee Geok Boi, "Mad Rush When the Library Van Comes," *The Straits Times*, 14 July 1979.

86 "400,000 Readers Is Library Target," *The Straits Times*, 23 January 1964.

87 "Library of Their Own for 160,000 People," *The Straits Times*, 26 November 1968; "N-Library: The First Branch at Queenstown," *The Straits Times*, 21 December 1966; "$1,000,000 Library at Queenstown to Be Full-Time," *The Straits Times*, 24 December 1966.

88 Joanna Seow, "44-Year-Old Queenstown Library First of 26 Libraries under NLB to Be Preserved," *The Straits Times*, 25 July 2014.

89 Alistair Black, *Libraries of Light: British Public Library Design in the Long 1960s* (New York: Routledge, 2016).

90 Seow, "44-Year-Old Queenstown Library".

91 Lim, "The History of an Emerging Multilingual Public Library System,"97.

25.1 In 1960, the National Library started a
 mobile library service to decentralise it
 services. This later evolved to the
 development of permanent branch
 libraries in public housing towns.

25.2 The National Library was initially
 criticised by architects as "massive,
 clumsy and heavy" in design. But it
 grew to be loved by the public.

25.3 The National Library offered facilities for
 reading such as a reference room, but it
 was also where the public came to
 attend exhibitions, film shows and talks.

25.1

25.2

25.3

25.4 The Queenstown library at Margaret Drive was the first full-time branch library and was officially opened by Prime Minister Lee Kuan Yew in 1970.

25.5 A 1973 photo of Singapore's second branch library being constructed in the town centre of Toa Payoh New Town. The three-storey rectilinear building officially opened in 1974.

25.6 The branch library in Toa Payoh was fronted with a round water fountain and public plaza at its entrance, which accentuated the monumental expression of its architecture.

25.4

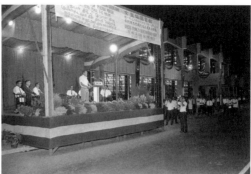

25.5

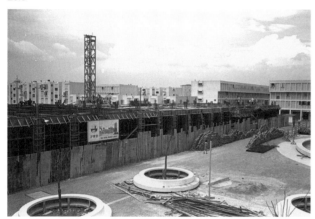

25.6

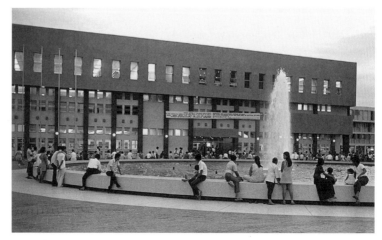

26 **Community Centres:** **Modernising the "Central Nervous System" of Singapore**

If we visualise the buildings, roads and playing fields as the bone structure or skeletal framework, and the people who live in them as the flesh, then what we must achieve is a wide network of nerves all inter-related and inter-linked in one central nervous system.... With a wide spread of coordinated nerve network, flesh will become muscle to take care of the body. The CC [Community Centres] network is part of this important nerve system of the body politic of Singapore.
—Lee Kuan Yew[92]

In the early 1980s, Singapore witnessed tremendous physical transformation through its urban renewal efforts. But for its Prime Minister Lee Kuan Yew, this was "not as profound a change" as the redistribution of its diverse mix of citizens. Groups of Cantonese, Hokkien, Teochew, Hainanese, Malay, Bugis, Arab, Tamil, Punjabi, Bengali or Ceylonese were no longer part of ethnic enclaves but living side by side in modern new towns in public housing flats. In these estates, the communities were connected to one another and the state by a network of community centres, or what Lee characterised in a 1979 speech as a "central [and centralising]

nervous system" that helped to politically organise and take the pulse of the population.[93]

Although community centres were first built by the colonial government, it was Lee and his People's Action Party (PAP) who greatly expanded the network after coming into power in 1959. They set up the People's Association (PA) in 1960 to oversee such centres that set out to run leisure and cultural activities for residents, act as a communication channel between the state and its people, and to promote good citizenship.[94] At the opening of the first community centre built by the PAP government at Minto Road in 1960, Lee declared it would open a new one every month to offer a recreational "escape valve" for residents. Between 1960 and 1963, such centres almost quadrupled from 28 to 103.

In the months leading to the 1963 referendum on Singapore's merger with Malaysia, the government built a community centre in any rural area where there were more than 200 families.[95] The community centres were vital for implementing government policies in a nascent nation, such as the introduction of compulsory military service for all male citizens and permanent residents in 1967, and of course moulding new Singapore citizens. As early as

1952, the Hill Report on local government recognised that "community centres should be the nursery of citizenship".[96] Under the PAP government, they became central to its efforts of social engineering Singaporeans into an "integrated and rugged society" through the organisation of leisure and cultural activities that shaped the population for a rapidly industrialising economy.[97]

Early community centres came in two designs: a "standard type" built of bricks for urban or semi-urban areas that cost between $20,000 to $30,000; and a wood structure "rural type" that cost $10,000 each.[98] However, such rudimentary designs were deemed to be inadequate by the late 1970s.[99] Deputy chairman of the PA, Lee Khoon Choy, noted the need for new and modern community centres "because the rural or standard types of old-fashioned community centres with minimum facilities could no longer attract young people".[100] In 1979, the PA unveiled a five-year masterplan to build 73 new community centres. Supported by a government subsidy of $40 million, government architects from the Housing & Development Board (HDB) and those in private practice were commissioned to create a new generation of designs. They had to be "delightful to look at and fun to visit" and offer "facilities commonly found only in private clubs", including squash and tennis courts, sound-proof music rooms and billiard rooms.[101]

Of the 40 "new look" community centres developed by HDB in the 1980s, the earliest to be completed were for Mountbatten, Brickworks, Kim Seng, Bukit Ho Swee and Punggol.[102] These came in two- to three-storey buildings to house their expanded facilities. According to guidelines issued by the People's Association, the basic facilities included offices and rooms for games, reading, homecraft, conference and multi-purpose functions.[103] There was also to be space for stores as well as a hall and stage. Finally, there was to be an outdoor basketball or volleyball court and a children's play area. Additional facilities included a lounge, billiard room, music room, dark room, squash courts, netball-cum-sepak takraw court, tennis court, amongst others.

By and large, the centres designed by HDB came in bulky concrete buildings not unlike the rectilinear blocks of public housing estates they were usually built next to. (see *Public Housing*) Some efforts to soften the centres included arranging the buildings in Kim Seng Community Centre (1980) around a courtyard. The heavy forms perhaps suggested their significance as institutions connecting residents to the state. There were exceptions such as Kallang Community Centre (1984), which had a pitched-roof structure, verandas and balconies to "create an informal and rural atmosphere".[104] Another was Alexandra Community Centre's (today Queenstown Community Centre) (1982) distinctive cylindrical auditorium that responds to its corner site and echoes the similar form of the Mujahidin Mosque just down the road.[105]

The community centres designed by private architects looked more playful in comparison. Prior to the drive for new community centres, Raymond Woo & Associates came up with designs in Havelock Road (1977) and Toa Payoh Central (1975) whose sloping roofs, porthole windows and bold forms distinguished them from their surroundings.[106] Another private firm involved was Regional Development Consortium Architects who built Chai Chee Community Centre (1981–2017) and Thomson Community Centre (1984–2019). At Chai Chee, the two-storey centre was designed with a compact U-shaped plan to overcome the tight site. Its ancillary facilities encircled a main hall with a circulation corridor so one could watch games being played in it. The architectural expression was also informal and light, and had playful elements such as exposed steel trusses painted in bright colour, simple modular window elements and colourful spaces. The goal was to "not adopt too formal a language in order to break social barriers between the bureaucracy and the masses".[107] The architects took a similar approach with Thomson Community Centre so as to "foster community cohesiveness and identity" through architecture.[108] It consisted of two interlocking blocks, each with its own pitched roof, and they were planned to accommodate on its southern corner a basketball court that also served as a forecourt and plaza to the community centre. The gable ends of the two blocks were given "design reliefs and punctuation to complement the forms".[109]

The addition of such playful touches to community centre was a precursor to several distinctly postmodern designs that emerged in

the late 1980s. One of the most notable was the Tampines North Community Centre by architect William Lim and his co-designer Mok Wei Wei. Completed in 1989, the design was influenced by American architect Frank Gehry's architecture in Southern California that they had experienced during their visit a year earlier.[110] The duo fragmented the building into four main volumes and two smaller ones, and these were unified by a colonnade that wrapped around the development and housed corridors linking the volumes. Built in reinforced concrete with glass blocks as infill, the centre was described as "tak[ing] on a glittering look when lighted up at night". Complemented with cheerful splashes of red, yellow, green and blue [that] liven[ed] up its wall", it had a carnivalesque atmosphere.[111] Such a postmodern aesthetic was further developed by William Lim Associates when they completed the Marine Parade Community Club in 2000 that, at the time of writing, is threatened with redevelopment.

The 1980s marked a significant transformation of community centres as the number of "modern" designs increased from 16 to 75, while 158 old ones—mainly those housed in rudimentary structures or rented HDB units— were closed or replaced.[112] The need to improve continued well into the 1990s when such centres sought to become more "upmarket" with "near private club status" facilities to serve an increasingly affluent population. Several community centres were even renamed as community clubs from 1990.[113] As a result, many of the "modern" community centres of the 1980s were demolished or substantially renovated.[114] In addition, community centres began co-locating with other compatible amenities to maximise the use of land.[115] These range from a public library (see *Public Libraries*) and performing arts group in Marine Parade Community Club to the National Council of Social Services sharing premises with Ulu Pandan Community Club. The latest example is the housing of Marymount Community Club in part of the newly built Eunoia Junior College (2019).

The twin efforts to make community centres more club-like while using land efficiently had led to the birth of mega developments, as seen in Our Tampines Hub (2017), Heartbeat@Bedok (2017) and Wisma Geylang Serai (2018). They house the Tampines Central Community Club, Kampong Chai Chee Community Club and Geylang Serai Community Club respectively, while also offering other public facilities and services that were traditionally stand-alone entities. These include recreational facilities, such as swimming pools and libraries as well as family services and health centres. While the range of offerings rival that of private clubs, the scale and colourful exteriors of these developments are reminiscent of shopping centres— popular gathering places for Singaporeans. (see *Shopping Centres*) As the "central nervous system" of Singapore, community centres and their changing designs over the decades can perhaps be read as a public mirror of how the social needs and desire of Singaporeans have evolved with the modern city.

Notes

92 Lee Kuan Yew, "Opening Address: Building the Central Nervous System and the Nerve Net-Work in the New Physiology of Singapore," in *The Role of Community Centres in the 1980s: Third Conference of Community Centre Management Committees*, ed. People's Association (Singapore: People's Association, 1979), 18.

93 Ibid.

94 People's Association, ed. *The Role of Community Centres in the 1980s: Third Conference of Community Centre Management Committees* (Singapore: People's Association, 1979).

95 Ibid., 32.

96 C. M. Turnbull, *A History of Modern Singapore, 1819-2005* (Singapore: NUS Press, 2009), 284.

97 Seah Chee Meow, *Community Centres in Singapore: Their Political Involvement* (Singapore: Singapore University Press, 1973), 37.

98 Ibid., 18.

99 Lee, "Opening Address", 17.

100 "73 Community Centres: All Futurist in Design," *Building Materials & Equipment*, April (1979).no. April (1979

101 "Models for the Future: Fresh Look of Community Centres to Come," *New Nation*, 4 April 1979.

102 "Community Living: HDB to Build 40 Community Centres," *Our Home*, April 1979.

103 "People's Association's Guideline for the Design of Community Centres," *Journal of the Singapore Institute of Architects*, 114 (1982), 3-6.

104 "Kallang Community Centre," *Journal of the Singapore Institute of Architects*, 114 (1982), 34-36.

105 "Alexandra Community Centre," *Journal of the Singapore Institute of Architects*, 114 (1982), 25-27.

106 "Havelock Road Community Centre," *Journal of the Singapore Institute of Architects*, 114 (1982), 50-51; "Toa Payoh Community Centre," *Journal of the Singapore Institute of Architects*, 114 (1982), 55.

107 "Chai Chee Community Centre," *Journal of the Singapore Institute of Architects*, 114 (1982), 41-43.

108 "Thomson Community Centre," *Journal of the Singapore Institute of Architects*, 114 (1982), 54.

109 Ibid.

110 Authors' correspondence with Mok Wei Wei, 6 July 2018 and 12 December 2018.

111 Rohaniah Saini, "Computerised Card for Tampines North CC Courses," *The Straits Times*, 28 March 1989.

112 Lee Yock Suan, "Opening Adress," in *The People's Association Conference: The Role of Community Centres in the 1990s, 12 November 1989*, ed. People's Association (Singapore: PA, 1989).

113 Kuan Kwee Jee, "The Role of the Community Centres in the 1990s," in *The People's Association Conference: The Role of Community Centres in the 1990s, 12 November 1989*, ed. People's Association (Singapore: PA, 1989), 38.

114 Among 16 community centres featured in a 1982 issue of the *Journal of the Singapore Institute of Architects*: Brickworks, Queenstown, Chai Chee and Havelock Road Community Centres are no longer around. Alexandra, Buona Vista, Cairnhill, Kallang, Kim Seng, Kim Keat, Potong Pasir, Tanjong Pagar, Thomson, Toa Payoh, Community Centres are at the same site but with either new or extensively renovated buildings. Serangoon Gardens and Bukit Ho Swee Community Centres are still at their original sites but they have been shut down and are not in use.

115 "Community Centres Get More Communal," *The Straits Times*, 1 June 1998.

26.1 Tuas Community Centre at 18th
 milestone, Jurong Road. The
 facility completed in 1960 was
 an example of a "rural type"
 design made out of wooden
 structures.

26.2 In 1979, the PA worked with
 government and private
 architects to create a new
 generation of community
 centres that were "delightful to
 look at and fun to visit".

26.3 Thomson Community Centre
 designed by Regional
 Development Consortium
 Architects in 1984 sought to
 foster community cohesiveness
 and identity through its unique
 architecture.

26.1

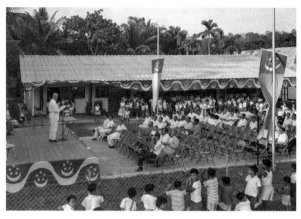

26.2

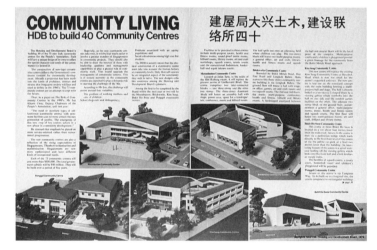

26.3

26.4 Minister of State for National
 Development and Home Affairs
 Dr Lee Boon Yang flagging off the
 courtesy walk and jog outside the
 Jalan Besar Community Centre, 1987.

26.5 Tampines North Community Centre
 designed by William Lim Associates
 in 1990. It is an early example of how
 the push for distinctive community
 centres led to the adoption of
 playful, postmodern designs.

26.4

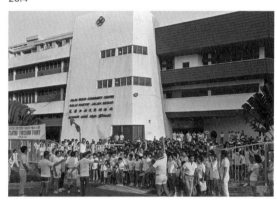

26.5

27 Hawker Centres:

Regulating Itinerant Individuals into a Social Institution

The "hawker centre" has taken on mythical status in Singapore. Despite its name, no one in these spaces selling food actually travels to hawk their wares. Instead, they operate out of fixed stalls within these government-built facilities that they are officially known as "food centres". But the misnomer has remained popular with many Singaporeans who are nostalgic of a time when hawkers once lined the city's streets. Such sentiments have been reinforced with Singapore's successful nomination of "hawker culture" to UNESCO's Representative List of Intangible Cultural Heritage of Humanity in December 2020. It has also cemented the agency's view of hawker centres as "community dining rooms" that "promote social cohesion, moderate the cost of living and foster a common national identity based on shared experiences, values, and norms".[116]

Such an expansive definition is unlike the hawker centre's origins after World War II as an architectural solution to regulate and rehabilitate hawkers on the streets. Far from celebrating a cultural hero, official narratives then characterised the hawker who sold cooked food, fresh produce and other wares on the streets of Singapore as a threat to the modern city. Such

was the case in the 1970s when then Minister for Health, Chua Sian Chin, outlined why the government was embarking on a programme of rehousing street hawkers. He said their poor hygiene standards polluted the environment and threatened public health by spreading infectious diseases such as cholera and typhoid through contaminated food.[117] They also obstructed the movement of people and the efficient flow of traffic along five-foot ways and the streets by gathering at popular areas. Some early efforts to contain them began at the turn of the 20th century when the British colonial administration began licensing hawkers to control their movement and numbers. In 1913, more by-laws were introduced to counter the "evils of hawking".[118] They included stipulating where a hawker could place their "stove, tubs stools, benches and other apparatus appurtenant to his [sic] calling"; the proper disposal of solid refuse and waste liquids; as well as when hawkers were permitted to operate based on the "Day Hawker" or "Night Hawker" licence they held.[119] The colonial government also began building shelters in strategic locations to house hawkers and get them off the surrounding streets. In the 1920s, they included Finlayson Green, People's Park,

Balestier Road, Carnie Road, Queen Street and within the grounds of Telok Ayer Market.[120] One question that arose out of such shelters was who it actually served as the "real two basket hawker" was being pushed out by the "fixed stall hawker" who operated more like a shopkeeper in a market or a stallholder in a privately run coffee shop.[121]

After the Second World War tighter controls were placed over hawkers by allowing them to operate only in fixed pitches, hawkers' shelters or on specific roads.[122] An interesting example of a hawker shelter also emerged in the form of the "Singapore Esplanade Restaurant", which was developed in 1952 by the City Council. It replaced what had become a popular gathering spot for hawkers selling all sorts of wares in front of the Padang, which some deemed to be an "Esplanade Eyesore" and even a "disgrace" to the city.[123] The "restaurant" erected at the end of Elizabeth Walk was a single-storey structure consisting of 21 stalls with open-air eating areas for up to 500 patrons.[124] Each stall housed two or three hawkers who were selected by the City Council from over 2,000 applicants to ensure it served food that suit the tastes of Chinese, Indians, Europeans and Malays.[125] The overall design of the restaurant drew a connection with its location along the Esplanade waterfront using a streamline moderne style, including a characteristic U-shaped plan and a projecting roof canopy. Each stall had a protruding rounded concrete frame that strongly resembled a ship's bow, and wave-shaped surfaces that were cast in concrete.[126]

Beyond offering hawkers a permanent roof over their heads, the Singapore Esplanade Restaurant introduced various features that have come to define "hawker centres". Only cooked food hawkers were allowed and those selected were subjected to strict medical examinations so the restaurant was "a model of cleanliness".[127] The restaurant's planned seating area created a visual continuity between cooking and consumption, and established the practice of having stalls facing the eating area. Patrons could sit on any of the portable 125 tables and 500 chairs provided, and such free-seating dining subsequently found its way to other hawker pitches started in the 1960s, including at Glutton's Square, Sennett Estate and Mackenzie Road beside Rex Cinema.[128] Such an arrangement meant patrons no longer had to buy only from the hawker stalls that provided them stools and tables, but could

instead sample dishes from a variety of stalls.

Despite colonial efforts, it was only after Singapore's independence that hawker centres as we know today emerged. The government launched an ambitious five-year plan in 1970 to resettle some 25,000 street hawkers as part of efforts to provide a "better and healthier living environment for the people to live in".[129] Hawker centres helped to clear hawkers off the street and the purpose-built developments were typically sited in the many emerging public housing estates and near work spaces, in recognition of their important role in offering the population affordable meals and even freeing mothers from cooking so they could join the workforce.[130] Compared to the "unaesthetic" hawker stalls on the streets that were a "hindrance to Singapore's efforts of creating a clean and beautiful environment", hawker centres were designed to emphasise function and order.[131] They typically had standardised indoor stalls arranged in rows and were provided with potable water supply, piped gas and sewage systems. While early centres had portable tables and chairs, these were subsequently replaced by fixed tables and stools. Hygiene was of utmost importance and the centres had ancillary facilities such as bin centres and washing facilities.

As hawkers were built by different government agencies often as part of larger development plans, they also took on other characteristics depending on their agenda. Those developed by the Housing & Development Board (HDB) were part of its new towns and functioned to feed the population being rehoused into public housing estates. Thus, they often came in the form of a double-volume, single-storey building that combined both a hawker centre selling cooked food, and a wet market or pasar in Malay, selling fresh produce. To minimise the risk of food contamination in its hawker centres, HDB even engaged labourers to maintain the cleanliness of the premises, collect used cutlery and remove food waste.[132]

Hawker centres were also built in the city centre, often by the Urban Redevelopment Department (URD) (it became the Urban Redevelopment Authority in 1974), to resettle existing hawkers and ensure there were affordable meals for workers. One early example was the single-storey Empress Place Food Centre (1973) along the Singapore River. Others include the conver-

sion of markets into hawker centres such as in Telok Ayer and Maxwell, as the residential population was resettled. Such standalone designs were rare, however, given the need to use land more efficiently in the city centre. Instead, hawker centres were often integrated into other developments. These include car parks (Amoy Street Food Centre [1983] and Golden Shoe Car Park [1984–2017]), public housing (People's Park [1968]) and even commercial centres (Funan Centre [1985–2016]). The hawker centre in Funan was the first such air-conditioned facility, a feature that is now found in privately run food courts.

A third kind of hawker centre was built by the Public Works Department (PWD), usually in the private suburbs or as part of public recreational facilities such as parks and gardens. As these typically served recreational crowds instead of residents and workers, their designs often took on distinct identities that spoke to their surroundings. For instance, PWD developed Newton Food Centre in 1970 as the first of its "hawker stalls in a garden setting".[133] It accommodated 56 resettled hawkers in seven gable-roof sheds that each housed eight stalls. According to a newspaper report, the stalls were surrounded by fixed tables and stools placed around the landscaped courtyard with "large shady trees", a "tall screening hedge", "scattered shrubs as background" and offered an al-fresco dining atmosphere.[134] The shed also had retractable canopies that could be extended to

provide shelter during frequent tropical showers. Colourful canopies hung over removable timber supports added to "the open-air characteristic typical of hawker stalls", while the landscaped surroundings enhanced the garden atmosphere. Other PWD hawker centres designed in a similar open-air style, include one in East Coast Park (1978) and The Satay Club (1971) at the Esplanade before it was demolished in 1995.

By 1986, the government declared that it had finally rehoused Singapore's last street hawkers— over a decade later than originally planned.[135] With over 175,000 hawkers now off the streets and operating in hawker centres built across the island, the government would stop building such facilities.[136] However, the government revised this policy some 26 years later in 2011 when it turned out that the appeal of hawker centres had grown beyond just a utilitarian solution to clean up the city and streets. Their modest and functional designs belie the important social structure they had grown to become.

"It's a part of local life, it's a place that people want to get to, it's a place where jobs, good jobs, are created for Singaporeans," explained then Minister for Environment and Water Resources Dr Vivian Balakrishnan as he announced that the government was building 10 new hawker centres in the years to come.[137]

"And there's that sense of belonging. I think that's the most precious and unique aspect about the hawker centres in a Singapore style."

This essay was co-authored with Ian Tan.

Notes

116 National Heritage Board, "Hawker Culture in Singapore," Our SG Heritage, 2017, https://www.oursgheritage.sg/hawker-culture-in-singapore/.

117 *10 Years That Shaped a Nation, 1965–1975* (Singapore: National Archives of Singapore, 2008), 117–21. Speech by Mr. Chua Sian Chin, Minister for Health, at the Opening of the Yung Sheng Road Hawker Centre, Jurong, on Saturday, 8 July 1972 at 1700 Hours." Accessed 30 May 2022, https://www.nas.gov.sg/archivesonline/speeches/record-details/7b22f254-115d-11e3-83d5-0050568939ad.

118 W. Bartley et al., "Report of the Committee Appointed to Investigate the Hawker Question in Singapore" (Singapore, 4 November 1931), 2.

119 "Hawkers In Singapore. Control Effected by Municipal Commissioners," *The Straits Times*, 12 April 1919.

120 Brenda S.A. Yeoh, "The Control of 'public' Space: Conflicts over the Definition and Use of the Verandah," in *Contesting Space in Colonial Singapre: Power Relations and the Urban Built Environment* (Singapore: NUS Press, 2003), 243–80.

121 "Singapore Hawkers," *The Straits Times*, 21 May 1926.

122 "New Hawker Policy," *The Straits Times*, 24 January 1952.

123 "Esplanade Eyesore," *The Straits Times*, 12 October 1951; "'Disgrace' to City Says McNeice," *The Straits Times*, 1 November 1951.

124 "500 Can Eat at Esplanade," *The Straits Times*, 1 October 1952.

125 "Rush for Esplanade Stalls," *The Singapore Free Press*, 5 September 1952.

126 "Opening of New Hawker Shed at Esplanade. National Archives of Singapore," National Archives of Singapore, n.d., https://www.nas.gov.sg/archivesonline/photographs/record-details/b21578de-1161-11e3-83d5-0050568939ad.

127 "Medical Test for Hawkers," *Singapore Standard*, 13 November 1952.

128 Lily Kong, *Singapore Hawker Centres: People, Places, Food* (Singapore: National Environment Agency, 2007), 27–31.

129 "Hawkers off the Streets by 1975," *The Straits Times*, 5 August 1970.

130 Sheere Ng, "Recipes for the Ideal Singaporean Female," BiblioAsia, Jan-Mar 2018, http://www.nlb.gov.sg/biblioasia/2018/01/08/recipes-for-the-ideal-singaporean-female/; "Gathering More Women into the Labour Force," *Business Times*, 20 November 1979.

131 Yong Shen Swee, "Top Priority for New Markets, Hawker Centres," *The Straits Times*, 10 July 1972.

132 *HDB Annual Report 1972* (Singapore: Housing & Development Board, 1973), 63–64.

133 "Hawker Stalls with Garden Setting Soon," *The Straits Times*, 11 December 1970.

134 Ibid.

135 "The Last Hawkers to Be Resited," *The Straits Times*, 29 April 1986.

136 "Enough Homes for Street Hawkers," *Singapore Monitor*, 29 April 1983.

137 Ng Lian Cheong and Hoe Yeen Nie, "10 New Hawker Centres to Be Built after 26 Years," *Channel NewsAsia*, 8 October 2011.

27.1 The Singapore Esplanade Restaurant along Queen Elizabeth Walk was developed in 1952 to shelter hawkers gathering in front of the Padang. The open-air eatery had a U-shaped building that housed different stalls.

27.2 Each of the Singapore Esplanade Restaurant stalls had a protruding rounded concrete frame resembling a ship's bow, inspired by its waterfront location.

27.3 Boat Quay Food Centre was built along the Singapore River to resettle hawkers and ensure affordable meals for workers in the city centre.

27.1

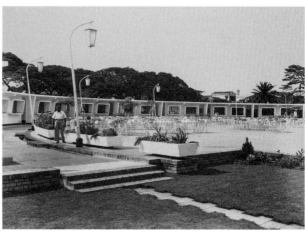

27.2

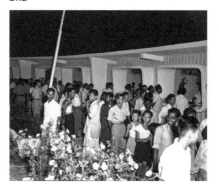

27.3

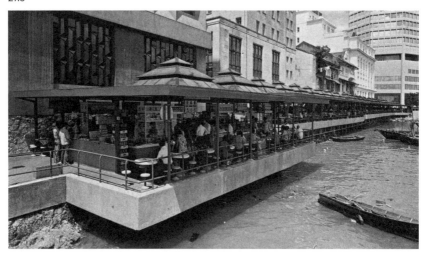

27.4 The design of the Newton Food Centre stood out for offering al-fresco dining within a green setting.

27.5 A 1980s booklet illustrating how a clean food stall was key to attracting customers. It was part of a public hygiene campaign aimed at hawkers.

27.6 The portable tables and chairs provided by hawkers in early hawker centres were later replaced by fixed furniture provided by the state. This allowed customers to order from different stalls regardless of where they sat.

27.4

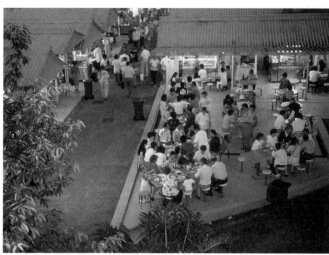

27.5

27.6

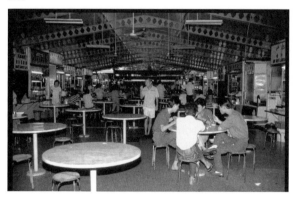

28 Lucky Plaza:

A Mall for the Migrants Who Modernised Singapore

It was envisioned as Singapore's very own "Ginza", the famous upmarket shopping district in Tokyo. But instead of Japan, Lucky Plaza is better associated with the Philippines today. Inside this mixed-use development along Orchard Road are restaurants, mini-marts and beauty salons that cater to the taste of Filipinos. There are also remittance agencies touting the best rates for sending money to the Philippines. It is no wonder the estimated 200,000-strong Filipino migrant population that lives and works in Singapore flocks here on their off days, turning Lucky Plaza into "Little Manila".[138]

It is not the only modern shopping complex in Singapore to have been associated with migrant community from Southeast Asia. Today, Golden Mile Complex is better known as "Little Thailand", Peninsula Plaza is popular with Burmese migrants, and City Plaza is where Indonesians are known to hang out. All four buildings coincidentally share a podium tower typology and exhibit characteristics of modernism, from their concrete construction to their geometric and rectilinear forms. However, their similar fates have little to do with their choice of architecture. The complexes have been transformed because of their ownership structure, respective locations

and the fact that they emerged during the 1970s and early 1980s when Singapore opened up to flows of migrants from the region.

When the construction of Lucky Plaza was first announced in 1972, developer Far East Organization touted it to become "the main focal point for tourists, shoppers and commerce" in the city-state. The complex was located in the "best possible business location in Singapore", literally at the heart of its main shopping boulevard, Orchard Road, where it was flanked by C.K. Tang and Fitzpatrick's Supermarket.[139] Betting on the government's push to promote tourism in the 1970s and the rising incomes of Singaporeans, Far East reportedly paid $20 million—believed to be one of the biggest land deals in Singapore at the time—for the three-acre site that was occupied by two car showrooms. The showrooms were replaced by a $100-million (costs eventually doubled) "Super Shopping Complex" that would provide shopping, tourist and entertainment facilities of "international standards".[140] These were housed in a six-storey podium designed for over 700 shops, and the complex was later topped with an tower of apartments from the 9th to the 30th storey. The architects, BEP Akitek, based the shopping

podium on an open vertical bazaar concept by creating centrally located open voids on every level that were served by 24 two-way escalators. The mall also had Singapore's first two sets of "bubble" lifts, which had glass walls, allowing shoppers to see through them as they travelled up and down Lucky Plaza. While the one in the interior showcased the mall's open plaza, the other on its exterior offered views of Orchard Road. Such lifts were subsequently adopted by other shopping malls such as Parklane Mall and Bukit Timah Plaza and also gained popularity with hotels like Meridien and Pavilion International. It even caught on in private residences, including Cairnhill Condominium and Elizabeth Heights.[141]

Lucky Plaza was also pioneering for its early support for the government's plans to pedestrianise Orchard Road. The complex had a car park for over 1,000 cars, but it was also designed with multiple access points for pedestrians. On the ground floor, the mall took advantage of an adjacent 7.6-metre-wide pedestrian mall by lining its 122-metre-long frontage with glass panels and offering four entrances to stores. The mezzanine floor had an elevated walkway meant to connect to future buildings next to it so that shoppers could "move freely without traffic interference"—although this vision of a pedestrian network by the state planning authority never materialised.[142] Lucky Plaza was in many ways typical of the scores of shopping centres built in Singapore during this period (see *Shopping Centres*). The new and highly lucrative type of property bred a "build first, think later" mentality amongst developers who were keen to simply reap the initial profit returns, rather than to regard their projects as "long-term income-generating machine[s]".[143] Thus, Far East sold the units in Lucky Plaza to individual owners, and advertised the complex as a "Big Money Spinner" simply because of its location.[144] Such behaviour was undesirable for both business and society, warned the development manager of Ocean and Capital Properties, Walter Davies, who was then promoting his carefully curated tenant mix and professional management of Bukit Timah Plaza.[145] He added, "Any lesser commitment than this will inevitably lead to a blight on the landscape of Singapore in the future, a blight which will survive for many years."

Davies' remarks seemed off the mark at first. Lucky Plaza's shopping podium opened in 1978 and quickly became a destination for fashion, housing a Metro department store and high fashion outlets including Singapore's pioneering multi-brand luxury fashion store, Glamourette, and the boutique of home-grown couturier Tan Yoong, TZE. Even though rents were raised between 100 to 400 per cent in 1981, there remained a healthy demand for its spaces.[146] But signs of trouble came in 1982 when Lucky Plaza's dirty toilets made the news. The mall's cleaning contractor blamed the lack of support from management.[147] Two years later, the management's lack of collective will was again an issue as retail plummeted with the dip in tourist numbers to Singapore. Unlike concerted efforts by tenants to collectively ask for rent reduction in malls such as Centrepoint and Parkway Parade, those in Lucky Plaza found it challenging because the mall's units were owned by individual landlords.[148]

The problem was compounded by a glut in retail space in the first half of the 1980s. A string of new shopping malls opened along Orchard Road, including Orchard Plaza, Far East Plaza, Centrepoint, Orchard Point, Scotts Shopping Centre, Meriden and Delfi Orchard. Lucky Plaza's immediate neighbours also redeveloped: the adjacent C.K. Tang made way for the 33-storey hotel-cum-shopping complex Tang Plaza in 1982; and across the road, Wisma Indonesia became Wisma Atria, an office-cum-shopping mall that opened in 1986. The succession of new developments outshined Lucky Plaza, although observers also noted that the mall had aged earlier than expected because of poor maintenance. One even called it a "slum".[149]

While Singaporeans and tourists left Lucky Plaza, the Filipino community hung around. One of the earliest newspaper records of Filipinos in Lucky Plaza dates back to 1984, when the mall, along with People's Park and Katong Shopping Centre, were said to become "mini-Manila" on weekends.[150] The influx of Filipino immigrants was due to the liberalisation of Singapore's foreign labour laws in the late 1970s. To ease the shortage of workers needed to build a modern city, the government introduced several new work permit schemes that allowed employers to recruit workers beyond Malaysia, specifically from India, Bangladesh, Burma, Sri Lanka, the Philippines, Thailand and Indonesia. The 1984 news article estimated there to be about 11,000

Filipino workers in Singapore. Many Filipino women came to work as domestic workers, freeing up Singaporean women to join the labour force, while Filipino men became construction workers to serve the country's growing development needs.

As Singaporeans were increasingly being resettled out of the city centre and into new public housing towns built in the suburbs, the incoming migrant populations flocked in. The Indians, Bangladeshis and Sri Lankans began congregating at Serangoon Road, which has historically attracted migrants from South Asia who have built up shops and services catering to the community over time. As there was no such equivalent for the Burmese, Filipinos, Thais and Indonesians, they turned to the modern malls of the 1970s and 1980s, essentially newly developed commercial sites freed of any historical and social baggage. This was especially so for malls lacking a master developer or strong management, as was the case with Lucky Plaza, Peninsula Plaza (1978), Golden Mile Complex (1972-3) and City Plaza (1980). These developments' units are owned by individual landlords, making them strata malls, and allowed any tenant to set up shop as long as it made commercial sense.

In the case of Lucky Plaza, a community of shops offering goods and services for the Filipino community emerged organically over time, which in turn attracted more of the same. By the late 1980s, the mall reportedly had cafeterias such as Filipino Corner (known as Paris Cafeteria on weekdays), a disco known as the Dahil Sa Iyo Recreation Centre (named after a popular Filipino love song; known as Belle Vue Deluxe Nightclub on weekdays) and three remittance services, one of which was called SIN-PHIL.[151] In 1986, a group of Filipinos even gathered at the steps of Lucky

Plaza to hold an anti-Marcos rally.[152] When the Ministry of Environment launched a Clean Public Toilets campaign in 1988, it tacitly acknowledged Lucky Plaza and People's Park as hubs of the Filipino community by having Tagalog versions of its posters in these malls.[153]

Similar transformations happened in Golden Mile Complex, Peninsula Plaza and City Plaza but these were enacted by Thais, Burmese and Indonesians respectively. It is unclear why Filipinos first settled in Lucky Plaza specifically, but there are usually very practical considerations. In the case of Golden Mile Complex, for instance, it was once a terminal for buses plying the Singapore-Hat Yai route and the travel agencies soon opened related businesses selling Thai food and wares. The initial establishment of functions for a community was followed by a subsequent "social construction" by the state, media and public which cemented these malls' identities as foreign enclaves.[154]

This process of "othering" set the malls apart from the rest of Singapore. The need for collective consensus to approve any major transformation in these strata properties has also made it challenging for the ageing malls to keep up with their surroundings, and led to them unfairly acquiring a reputation of being "eyesores" in the eyes of some Singaporeans.[155] Yet, Golden Mile Complex, Peninsula Plaza, City Plaza and Lucky Plaza continue to serve as important social hubs for their respective communities, who are often excluded from the rest of the city that does not cater to their needs. They also stand as concrete reminders of the flows of foreign labourers that Singapore continues to rely on to build and maintain a modern city-state.

Notes

138 "Overview of Philippines-Singapore Relations", The Embassy of the Philippines in Singapore, accessed 17 July 2022. https://www.philippine-embassy.org.sg/about-us-2/overview-of-philippines-singapore-relations/

139 "Far East Organization to Build $100 Million Lucky Plaza at Orchard Road's Golden Site Adjacent to C.K. Tang," *New Nation*, 10 February 1972.

140 Leslie Fong, "$20mil Orchard Road Land Deal," *The Straits Times*, 3 February 1972.; "Far East Organization to Build $100 Million Lucky Plaza."

141 Nancy Koh, "It's Great Fun in a Glass Lift," *New Nation*, 9 June 1981.

142 "Far East Organization to Build $100 Million Lucky Plaza."

143 Teo Teck Weng, "Planners' Paradise or Nightmare?," *Business Times*, 1 August 1978.

144 "Move Where the Luck Is...," *New Nation*, 26 December 1976.

145 Teo, "Planners' Paradise or Nightmare?"

146 "30 Move Out, 20 Move In," *New Nation*, 3 April 1981.

147 Sit Si Si, "Lucky Plaza Toilets 'a Disgrace'," *Singapore Monitor*, 20 December 1982.

148 Vincent Fong, "Lucky Plaza Shops to Join Drive for Reduced Rents," *Singapore Monitor*, 11 March 1984.

149 "Our Shopping Centres Are Unexciting, Says Expert," *The Straits Times*, 8 April 1984; Annie Chia, "Property Trusts Help in Upkeep of Buildings, Says Consultant," *The Straits Times*, 6 July 1987.

150 "Filipinas' Snapshots," *The Sunday Monitor*, 20 May 1984.

151 Anne Low, "Business at Its Sunday Best," *The Straits Times*, 25 April 1988.

152 Lito Gutierrez, "Filipinos in S'pore Losing Much Sleep," *The Straits Times*, 24 February 1986.

153 "Message in Tagalog, Singhalese and Thai," *The Straits Times*, 12 January 1988.

154 Ying-kit Chan, "The Golden Mile Complex: The Idea of Little Thailand in Singapore," *Austrian Journal of South-East Asian Studies* 13, no. 1 (2020): 103–21.

155 "Old Building a Real Eyesore," *The Straits Times*, 26 July 2009.

28.1 A 1973 advertisement for Lucky Plaza
 touting it as a "super shopping
 complex" built on a "superb
 location". The design by BEP Akitek
 included a six-storey retail podium
 for over 500 shops and an
 apartment tower of 88 residences.

28.2 Lucky Plaza in construction (centre)
 in 1976. It was one of the first
 shopping malls to be completed
 along Orchard Road, replacing what
 was previously two car showrooms.

28.1

28.2

28.3 Lucky Plaza had Singapore's first two "bubble" lifts, one of which was on its exterior that offered views of Orchard Road. Such lifts with views were subsequently adopted by other malls and even apartment towers.

28.4 Since the 1980s, Lucky Plaza has organically grown into a popular hangout for Filipinos as seen in this 2010 photo. They visit during their off days to remit money home, eat Filipino cuisine and meet friends.

28.5 The shortage of skilled local labourers to help build up Singapore led the government to hold the Construction Careers exhibition in 1983. It was part of an effort to achieve an all-Singaporean workforce in the industry by 1992, which failed to materialise.

28.3

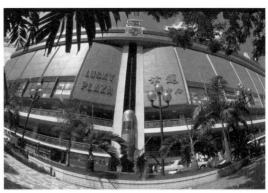

28.4

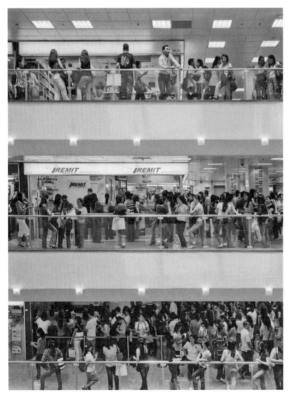

28.5

Pray

29-32

Churches:

Bringing God Closer to the Suburbs and the People

In the mid 20th century, many new and modern church buildings—particularly Catholic ones—were built in Singapore. The growth was driven by various factors, including the modernisation of the church, the emergence of a pioneering generation of local architects and the city-state's rapid urban development. Prior to this increase, few churches were located outside the central area of Singapore. This began to change as the population started moving out of the congested city centre and the post-independence govern-ment built new towns to redistribute the popula-tion. The Roman Catholic Archdiocese in Singa-pore, then under Archbishop Michel Olçomendy, began constructing churches to serve the new parishes that emerged, particularly those living in the private housing estates in the suburbs.

Among the first of these new churches were the Church of the Immaculate Heart of Mary in Paya Lebar, the Church of Our Lady Star of the Sea in Sembawang and the Church of our Lady of Queen of Peace in Tanjong Katong.[1] The three buildings dedicated between 1953 and 1954 were essentially simple linear buildings that housed a nave, a central aisle—and sometimes side aisles—without transepts projecting from it. This spatial configuration was typical of many churches in Singapore, dating back to even pre-war neoclassical designs. One example is the Seventh-Day Adventist Church completed in 1938 (and dedicated on the first day of 1939) at Balestier Road, which was originally commissioned by Reverend Cecil Jackson to house the Cantonese- and English-speaking congregations of the Assemblies of God.[2] It was designed by C. Y. Kong, a structural engineer who designed numerous art deco buildings in the 1930s.[3] The Seventh-Day Adventist Church was an early church in such a modern style that emphasised the exuberance of technical progress. Specifically, the design combines features from both the geometric forms of zigzag moderne and the aerodynamic-inspired streamline moderne. The façade facing Balestier Road has a series of vertical bands that are arranged symmetrically, and gradually step up towards a central band that terminates in a semi-circular arch. The arch hints at the vaulted ceiling of the church's interior, which is lit by clerestory windows on the two sides.[4]

Another wave of new church designs emerged from the 1950s as seen in the works of Alfred Wong. The Australian-trained architect completed one of his earliest works in 1959 with

the Church of St. Francis Xavier at Serangoon Garden Estate. Although it had a similar spatial plan to those of earlier suburban churches, its architectural language and structure were more gracefully modern.[5] The nave is covered by slender portal frames that taper elegantly at the base and the crest, reflecting the structural forces at work. The tall portal frames are flanked by elongated clerestory windows that create a brightly lit interior, distinguishing the nave from the dimmer and lower side aisles, which are lined with walls of ventilation blocks.

For the Church of St. Ignatius (1961–c. 1999) at King's Road, Wong adopted an innovative square plan to "bring the congregation closer to the high altar".[6] The building was also distinguished by an unusual multi-tiered roof, or what Wong described as "hip roofs on three levels" because the "whole concept of the building [was] based on the simplest means of roofing a square shape".[7] The structure of the roof was made out of steel lattice beams supported on reinforced concrete buttresses at the perimeter of the building. The beams were joined to a Vierendeel ring beam, which in turn supported a system of steel joists that held up the upper hip roof of the clerestory to let light into the interior space over the holiest place of worship, the sanctuary. At the apex of the upper hip roof raised a pyramidal steeple. Such use of exposed steel members became a recurring motif in the churches that Wong designed.

Today the best-known church that Wong has designed is probably the Church of St. Bernadette at Zion Road as it is largely intact and was gazetted for conservation in the late 2000s. Completed in 1959, the Church of St. Bernadette too had an unusual plan: a compressed hexagon that looks like a diamond. This shortened the distance between the entry and the altar and created an unusual seating plan. While the seats in the middle section are parallel to the entry walls, those on the sides are perpendicular and give the effect of "perspectival foreshortening", according to architectural historian Raymond Quek.[8] Such a geometry created a sense of greater lay participation in the church's liturgy, which was a strategy that modern Catholic churches around the world were adopting and eventually formalised in the recommendations of the Second Vatican Council.[9] Besides its atypical plan, the Church of St. Bernadette is also

supported by steel beams and the roof at the sanctuary is increased by a projecting volume above the main pitched roof. A skeletal steeple on top of the volume creates a vertical accentuation on the exterior.

Another common feature among the churches designed by Wong was their attention to climate appropriate design. He sought to provide as much passive cooling as possible for the congregation by having proper sun-shading and facilitating cross-ventilation through the use of breeze blocks (also known as ventilation bricks) as infills between the columns and the deployment of louvres over larger openings.[10] Similar design features were found in two other mid 20th-century modern churches: the former St. Matthew's Church (1963) by Booty, Edwards and Partners (the firm became known as BEP Akitek after 1969) and the Blessed Sacrament Church (1965) by Gordon Dowsett of Iversen Van Sitteren & Partners.[11] Such features have since been covered up or altered after the churches were subsequently air-conditioned.

Both the St. Matthew's Church and Blessed Sacrament Church also have distinctive roofs. The former, originally an Anglican church established for a Cantonese congregation, has a thin shell concrete roof structure that was commonly used in the 1950s and 1960s for buildings with a large span. There were also several well-known modern churches with thin shell concrete roofs in Asia around that time, including the Luce Memorial Chapel, Taichung (1963), designed by Ieoh Ming Pei, Chen Chi-Kwan and Chang Chao-Kang, and the St. Mary Cathedral, Tokyo (1964), designed by Kenzo Tange. Blessed Sacrament Church's distinctive folded pitched roof is said to resemble a tent, with its biblical symbolism. Although the roof was not informed by the structural logic of folding— and thus is unlike the former St. Matthew's Church—its sculptural form also evokes the large roofs of the region's vernacular architecture. (see Mosques) The multivalence of the roof can be attributed to its skilful architect who also designed other sculptural buildings, such as the MacPherson Road Market (1955-1990) and Globe Cinema (1959-1978). Both have unfortunately been demolished.[12]

Through adopting modern forms and ideas and adapting them for the tropics, churches built from the mid 20th century in Singapore redefined

the Christian community's place in a rapidly changing city-state. The architecture that arose out of these efforts not only helped the community update its faith within a modern city-state, but also reflected the transformation of the religion in the modern world.

Notes

1 Eugene Wijeysingha and René Nicolas, *Going Forth: The Catholic Church in Singapore 1819–2004* (Singapore: Titular Roman Catholic Archbishop of Singapore, 2006), 158–61.
2 Frederick George Abeysekera and Rita Abeysekera, *The History of the Assemblies of God of Singapore* (Singapore: Assemblies of God of Singapore, 1992), 103–7.
3 We are grateful to Julian Davison for providing this background information on C. Y. Kong. Authors' email correspondence with Julian Davison, 19 & 20 September 2019.
4 Alyssa Woo, "A Message of Simplicity," *The Straits Times*, 1 October 2016.
5 "New Church of St. Francis Xavier, Serangoon Garden Estate," *Rumah, Journal of Society of Malayan Architects*, 2 (1959).
6 "Church of St. Ignatius," *Rumah, Journal Singapore Institute of Architects,* 4 (1961): 17.
7 Ibid., 18.
8 Raymond Quek, "The Modernisation of the Catholic Church: 4 Churches by Alfred Wong 1958–1961," *Singapore Architect* 200 (1998).
9 Robert Proctor, *Building the Modern Church: Roman Catholic Church Architecture in Britain, 1955–1975* (Burlington, VT: Ashgate, 2014), 4–5, 54–55.
10 Alfred Hong Kwok Wong, *Recollections of Life in an Accidental Nation* (Singapore: Select Books, 2016), 101–2.
11 "St. Matthew Church," *Rumah, Journal Singapore Institute of Architects* 7 (1964).
12 "New Market will Serve Thousands," *The Straits Times*, 13 May 1955; "$1 m. Cinema Opens with Charity Premiere," *The Straits Times*, 15 January 1959; Eu-jin Seow, "Architectural Development in Singapore" (unpublished PhD thesis, University of Melbourne, 1973), 367–69.

29.2

29.1

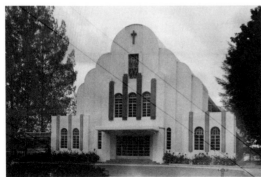

29.1 Completed in 1938, the Seventh-Day Adventist Church at Balestier was an early example of a modern style church. The design combined the geometric forms of zigzag moderne and the aerodynamic-inspired streamline moderne.

29.2 Church of St. Francis Xavier was one of several new Catholic churches built in the suburbs as Singapore's population moved out of the city centre. The church at Chartwell Drive was consecrated on 11 January 1959.

29.3 The interior of the Church of St. Francis Xavier had a more gracefully modern structure compared to its predecessors, including slender portal frames.

29.4 The Church of St. Ignatius at King's Road was distinguished by its square plan and unusual multi-tiered roof. It was consecrated in 1961.

29.5 The roof of the Church of St. Ignatius was made from steel lattice beams supported on reinforced concrete buttresses. The roof let light into the interior and over the holiest place of worship, the sanctuary.

29.6 The modern design of St. Matthew' Church along Eng Hoon Street by Booty, Edwards and Partners kept the congregation cool through passive cooling features such as breeze blocks, as seen in this photo, that facilitate cross-ventilation.

29.4

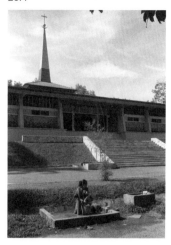

29.5

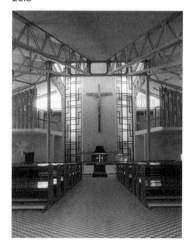

29.3

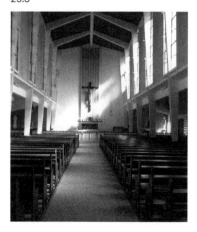

29.6

30 Cinema-Churches: From a "House of Pictures"
 to a "House of Prayers"

The 1980s seemed set to be a golden era for the Singapore cinema industry. In 1978, a United Nations survey noted that Singaporeans were the "greatest movie-goers in the world".[14] They averaged 19 visits to the cinema annually, as attendance in Singapore's 74 cinemas that year reached over 44 million.[15] In 1980, the industry had even added six new cinemas. Such bullish expectations, however, turned out to be a bubble. That year, Singapore registered its first drop in cinema attendance since 1976, as attendance fell by about 12 per cent from 46 million to 40.5 million.[16] Seven cinemas closed in 1981, beginning with open-air theatres such as one at Joo Chiat and rural ones like Nee Soon Cinema.[17] The continued decline in attendance led to the folding of larger cinemas in the following years. Between 1980 and 1986, the number of establishments almost halved, falling from a peak of 80 to 45.[18]

One reason for the stunning collapse was the fierce competition amongst the cinemas. Another was to the introduction of video tapes, said the director of cinema operator Eng Wah, James Goh, when he had to close King's Theatre in 1982. "People can get up-to-date films from Hong Kong and Taiwan months before the films are shown in the cinema," he said. "This is made worse because there are no copyright laws here. Anybody can buy the latest video tape of a film in Hong [K]ong, import it, get it cleared by the censors, duplicate it and distribute it."[19] As movie-going grew less popular, cinema owners began repurposing their buildings for alternative uses instead. For instance, Republic Theatre in Marine Parade and Rex in MacKenzie Road were turned into "live" theatres, Ocean Theatre in Upper East Coast Road was renovated into a seafood restaurant and Ang Mo Kio Cinema became a sports and recreation centre. While such recreational uses seemed logical, many cinema buildings were ultimately saved from demolition by a seemingly unlikely saviour—the Christian community.

One of the earliest examples saved from demolition were Shaw Organisation's former Grand Theatre and Pacific Theatre in New World amusement park. In September 1983, both were leased out to the Calvary Charismatic Centre. They were soon followed by another Shaw cinema, Ciros in Telok Blangah, which was leased out to the Christian Community Chapel. The conversions were relatively straightforward as the existing halls with seats suited usage for church services. While the Grand was converted into a 1,000-seat church, the Pacific became an

11-classroom Sunday school.[20] Both these churches kickstarted the 1980s trend of converting "house[s] of pictures" into "house[s] of prayer" to serve Singapore's growing Christian community.[21] They included the Hoover (His Sanctuary Services), New City (Bethel Assembly of God Church), Liberty (Faith Community Baptist Church), Venus (Church of Our Saviour) and Golden City (Fisherman of Christ Fellowship).

Many of these conversions saw churches move out of rented function rooms in places such as the World Trade Centre Auditorium and hotels. The seemingly makeshift situation for Christians in Singapore was a result of how religion is regarded as just another function in the modern city-state. Planners in Singapore typically allocate sites for different religions based on rational standards such as number of dwelling units in the area, not unlike recreational amenities such as shopping centres and cinemas, and are acquired by private tenders for land.[22] As the number of Christian denominations in Singapore grew larger than the public land available for new purpose-built churches, the community turned first to renting commercial properties built on private land, before subsequently purchasing them to convert to religious use. Unlike the Catholic community who built churches in Singapore's suburbs in the 1950s and 1960s (see Churches), many of the new church groups in the 1980s were Protestants. For them, the church building is not of absolute importance and can come in any form. It made the often functionalist architecture of cinemas suitable, and it did not matter even if the building had a flamboyant look leftover from its previous entertainment role.(see Cinemas)

Architect Mok Wei Wei who helped convert Venus cinema in Queenstown for the Church of Our Saviour in 1988 recalls being asked to repurpose it into "nothing like an orthodox Church".[23] He took inspiration from the original colourful 1960s cinema to create a striking Memphis-influenced design with geometrically diverse forms sticking out from the existing box and retaining its original coloured mosaic tiles. Or as one reviewer of the conversion said: "You may miss the church but you cannot miss the building!"[24]

Failing cinemas were attractive properties for church groups, which were doing very well financially in spite of Singapore undergoing a recession in the mid 1980s.[25] For instance, fierce competition from other churches for The Metropole cinema in Tanjong Pagar led Fairfield Methodist Church "to take all necessary action to secure" the 1,200-seat facility in 1985.[26] It splashed out S$2.75 million for the cinema in Tanjong Pagar, and spent an additional S$100,000 to renovate its interior, including replacing the cinema screen with an altar, and adding rooms in what was one of Singapore's earliest air-conditioned cinema halls. The conversion, however, was hardly visible from the exterior of this modern-style cinema that opened in 1958, replacing what was previously one of Chinatown's first cinemas, the Empire Theatre (renamed Chungking Theatre after the Second Word War and New Chungking Theatre in 1955).[27] The church kept architect Wong Foo Nam's original glazed and curved glass façade, with the only changes being the replacement the building's name and the addition of a cross. It was unlike Wong's other 1955 work, the King's Theatre at Kim Tian Road, which was demolished and replaced with a condominium after it closed.[28] The conversion of the Metropole into a Methodist church also has an unlikely parallel story: the owner of the Empire Theatre was Kung Tian Song who eventually sold his business to the Shaw family and spent his final days as an evangelist and lay preacher at Geylang Methodist Church![29]

As church groups continue to grow in Singapore, some have gone beyond simply repurposing private buildings to overcome the scarce space for religion. The Star Vista is an integrated development opened in 2012 by New Creation Church's business arm, Rock Productions and CapitaLand. The megachurch purchased the commercial site to create a three-level shopping mall that is topped with a 5,000-seat theatre that can serve its congregation and be rented as a venue for hire. With its sharp edges and sweeping curves, the building designed by Andrew Bromberg of Aedas looks more like a spaceship than a church, a nod to its location in the high-tech innovation district of one-north.(see Factories) Other instances of churches crossing over into the realm of commercial entertainment include the Gateway Theatre completed in 2016. Faith Community Baptist Church, which also occupies the former Liberty Theatre in Marine Parade, tore down the former Dalit Theatre in Bukit Merah to create a nine-storey performing arts venue designed by Ong & Ong. More recently, the Christian community has even entered the cinema business.

Salt Media @ Capital Tower and EagleWings Cinematics are housed within an office tower and a residential mall respectively, and they seek to present "positive-values content" and "uplifting faith-based films" besides the usual blockbusters.[30]

From the renting of commercial properties to the conversion of cinemas, and the building of multi-purpose developments today, the Christian community in Singapore is perhaps an example of how religion has had to adapt in a city-state planned on the modernist principles of function and needs to survive and thrive in the competition for space.

Notes

13 "Singaporeans among World's Top Movie-Goers," *The Straits Times*, 7 December 1978.
14 Ng Eng Hock, "A Record Year for Films in Spite of Competition," *The Straits Times*, 5 November 1979.
15 "More Cinemas but Fewer Patrons," *New Nation*, 7 September 1981.
16 "Seven Cinemas out of Business This Year," *The Straits Times*, 14 November 1981.
17 Philip Cheah, "More New Roles for Cinemas," *The Straits Times*, 13 January 1986.
18 "King's Cinema Falls Victim to Competition," *The Straits Times*, 13 December 1982.
19 Leong Weng Kam, "From the Silver Screen to Worship Centre," *The Straits Times*, 25 November 1983.
20 "Our History & Heritage," *Bethel Assembly of God*, Accessed 18 February 2021, https://www.bethel.org.sg/about-us/our-history-heritage.
21 Lily Kong, "Ideological Hegemony and the Political Symbolism of Religious Buildings in Singapore," *Environment and Planning D: Society and Space* 11, no. 1 (1993): 23–45.
22 Mok Wei Wei, "Church of Our Saviour, Singapore," *Mimar: Architecture in Development*, 1988.
23 Chua Beng Huat, "A Born Again Building," *Mimar: Architecture in Development*, 1988.
24 Stu Glauberman, "Churches Are Doing Very Well, Thank You," *The Straits Times*, 9 June 1985.
25 Lito Gutierrez, "Sermons Instead of Films at Metropole," *The Straits Times*, 2 June 1985.
26 王振春, "金华戏院变教堂," in 石叻战前老戏院 (新加坡: 新加坡青年书局, 2011), 55–58.
27 "Another Cinema Bites the Dust," *Singapore Monitor*, 5 February 1984.
28 Linda Lim, "Tracing Confucius' Bloodline in Singapore," *The Straits Times*, 8 February 2014.
29 "Two New Cinemas Screening 'Values-Based' Content Open in Singapore," *Salt & Light*, 21 December 2018, https://saltandlight.sg/news/eagle-wings-cinematics-salt-media-cinema-movies-christian-singapore/.

30.1

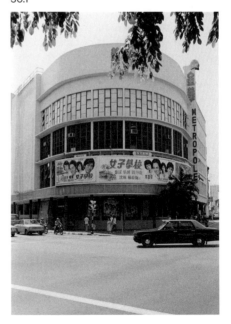

30.1 Metropole Cinema, also known as Jinghwa Theatre, opened in 1958 in Chinatown. In 1985, it was converted into Fairfield Methodist Church with little changes to its exterior.

30.2 King's Theatre at Kim Tian Road was completed in 1955. It was demolished in the 1980s and replaced with a condominium.

30.3 After screening kungfu films for over two decades, Hoover cinema along Balestier Road was converted into a live theatre in 1982. In 1989, His Sanctuary Services leased it for three years to serve as a church.

30.4 In the mid-1980s, the former Venus cinema in Queenstown was converted into the Church of Our Saviour. Its colourful Memphis-influenced design reflected the Charismatic church's emphasis on celebration.

30.5 The repurposing of Venus cinema retained many of its original 1960s design. A series of aluminium spheres complete with encircling orbits in the theatre that previously symbolised its namesake was reinterpreted as expressing the theme of creation.

30.2

30.3

30.5

30.4

Darul Aman Mosque:

A Modern Revival of the Traditional

Amongst the many mosques in Singapore, the architecture of the Darul Aman is one of the most celebrated. It won a Singapore Institute of Architects Design Award in 1987 and was shortlisted two years later for the prestigious Aga Khan Award for Architecture, an international prize for buildings that serve societies in which Muslims have a significant presence. Officially opened on 3 August 1986, the Darul Aman was the first in Singapore to revive the Nusantara model of mosque.[30] Its three-tiered *tajug* (pyramidal hip) roof recalls the early mosques of the region, such as the 18th-century Kampung Laut Mosque in Kelantan and the 15th-century Agung Demak Mosque in Central Java. The design also evokes the two major three-tiered *tajug* roof mosques that used to exist in Singapore—the original Sultan Mosque (1824–1926) at Kampong Glam and the Maarof Mosque (1870–1996) at Jeddah Street.[31]

Although based on a traditional design, the Darul Aman is what local architectural historian Imran bin Tajudeen considers to be "the only sophisticated modern re-interpretation of the *tajug* mosque in Singapore".[32] The design by Bangladesh-born Mohammad Asaduz Zaman was clearly modern in its use of materials, construction techniques and structural systems. It was built primarily from reinforced concrete and steel instead of traditional timber, which is only used sparingly such as in the carvings at the mihrab.[33] A rhombus motif was also derived from the geometry of the steel roof truss and used throughout the building—in the screens, balustrades and fences. Such a careful combination of traditional forms and modern techniques in the mosque made it "a design breakthrough" for Mohammed Asaduz Zaman, then an architect at the Housing & Development Board (HDB).[34] It was also representative of a new generation of mosques that he and his team at HDB were designing. "We want to copy the traditional form but incorporate the use of modern construction technology and more high-tech materials as well," he said.[35]

Darul Aman was one in a line of mosques that the HDB designed and built as part of a mosque-building scheme kickstarted in Singapore during the 1970s. Just as much of the population was resettled into HDB new towns, so were many mosques and *surau* (Islamic assembly buildings), alongside Chinese temples, Hindu temples and churches.[36] The Majlis Ugama Islam Singapura (MUIS), a statutory board established in 1968 to

administer Islamic affairs—such as the administration of mosques, the collection of *zakat* (tithe), the management of *wakaf* land, and the coordinating Haj activities—began working with the HDB to build mosques in new towns to serve Muslims in Singapore.[37] As the community struggled to raise the necessary funds to build these mosques at first, Prime Minister Lee Kuan Yew suggested establishing the Mosque Building Fund (MBF) in 1975.[38] Muslims would contribute a small portion of their Central Provident Fund (a social security fund) to build and maintain mosques in Singapore, and the government would help by setting aside space for the building of mosques and subsidising the cost of land.[39] While other religions in Singapore needed to tender for spaces in new towns that were set aside for religious buildings, the government exempted the mosque-building committee from the tender process. Instead it allocated sites to MUIS for mosques.[40]

Between 1975 and 1981, MUIS embarked on its first mosque building scheme by commissioning the HDB to build six new mosques in public housing estates. They included the Muhajirin Mosque in Toa Payoh (1977), the Mujahidin Mosque in Queenstown (1977), the Assyakirin Mosque in Jurong (1978), the An-Nur Mosque in Woodlands (1980), the Al-Muttaqin Mosque in Ang Mo Kio (1980) and the Al-Ansar Mosque in Bedok (1981).[41] Each was typically three to four storeys in height with a single tall minaret. They were bigger than the older kampong mosques because of larger budgets, and not only had prayer halls but also community facilities, such as multi-purpose halls, libraries, conference rooms and study rooms.[42] Although the mosques were all built out of modern materials, mainly reinforced concrete structures and sometimes with brick-faced or glass-mosaic-clad exteriors, they were designed in the architectural language of domes and arches, including being topped with an onion-shaped dome. Their scale, colour and distinctive architectural language stood out amongst the surrounding functionalist public housing blocks.(see *Public Housing*)

While such an Arabesque image was regarded as the image of mosque architecture in Singapore, it is actually a relatively recent development. It was first introduced in the city-state through the prominent case of the new Sultan Mosque that Denis Santry of Swan &

Maclaren completed in 1932. Built in reinforced concrete, it featured two gold-coloured, onion-shaped domes, four *chattri* (free-standing canopied turrets derived from Mughal architecture), and a slender minaret at each of the four corners.[43] Such Indo-Saracenic architecture was actually a British invention that combined architectural elements associated with the Mughal Empire and an eclectic array of various medieval Muslim dynasties, with the organisational structure and spatial configuration of European neoclassical architecture. The style was originally introduced by the British in colonial India during the late 19th century, and historian Thomas Metcalf has argued in his magisterial study *An Imperial Vision* that the Indo-Saracenic architecture represented the British appropriation of India's past in order to legitimise its colonial rule.[44] Interestingly, the British did not apply this style to the design of mosques in India as it had a non-interference policy in religious matters there. Instead, they built monumental mosques in this style in Malaya. Prior to rebuilding the Sultan Mosque in Singapore, the British built the Jamek Mosque in Kuala Lumpur (officially opened in 1909) and the Ubudiah Mosque in Kuala Kangsar (1913-17) both in the same style and designed by the same architect, Arthur Benison Hubback.[45] These early 20th-century mosques "dramatically altered the accepted conventions of Malay religious architecture",[46] which traditionally had come in the form of the three-tier *tajug* roof.

The emergence of a different kind of mosque architecture in the mid 1980s with the Darul Aman, reflected architectural modernism's global descent into crisis. While some architects turned to postmodernism, many in Asia chose architectural regionalism as a way to represent socio-cultural identity through architecture. It was a reaction to how architectural modernism, particularly the international style variant, had purportedly neglected indigenous traditions and local cultures through its uniform architectural language. Such a view was supported by the establishment of the Aga Khan Award for Architecture in 1977, which sponsored many publications and conferences to promote the renewal of traditions in Islamic architecture around the world.[47]

Besides the Darul Aman, two other mosques developed by HDB during this period also

exhibited regional tendencies, including Al-Amin (1991) with its Sumatran Minang roofs and Kampung Siglap (1992) with its design inspired by the Malay kampong house. It was not just mosques that adopted such designs. Near the Darul Aman, the Eunos MRT station and bus interchange were completed around the same period with Minangkabau-style roofs to "blend in nicely with the environment".[48] (see *Interchanges*) But the Darul Aman was more than just a modern interpretation of what looked traditional, its design functioned well in Singapore's hot and humid climate too. This aspect was key to figuring out "whether it has genuinely moved away from the anonymity of modernism into a regional form",[49] wrote the Indian architect Romi Khosla, who served as the technical reviewer for the Aga Khan Award for Architecture. He was duly impressed with how the Darul Aman's main prayer hall was open, very well ventilated and comfortable under different local weather conditions.

The modern reinterpretation of traditional architecture in Darul Aman not only won accolades from the architecture fraternity but may have impacted the region too. When Indonesian president Suharto paid an official visit to Singapore in 1987, he prayed at the Darul Aman and subsequently promoted the building of mosques based on a similar architecture in Indonesia under his New Order regime.[50] In Singapore, however, the Darul Aman did not ignite such a transformation in subsequent mosques developed under the MBF (now known as the Mosque Building and Mendaki Fund), which number 26 in 2021. While some bear designs that borrow from regional heritage, many have continued to use Arabesque motifs of arches and domes—a modern invention of tradition.[51]

Notes

30 A. Ghani Hamid, "Minaret Adds Beauty to the Mosque," *The Straits Times*, 16 April 1987.

31 Imran bin Tajudeen, "Singapore Mosques: Modern Heritage," *The Singapore Architect* 14 (2019).

32 Ibid., 132.

33 A. Ghani Hamid, "Carvings That Enhance Serenity in the Mosque," *The Straits Times*, 23 April 1987; "First Hari Raya Haji at New Eunos Mosque," *The Straits Times*, 16 August 1986.

34 Tony Keng Joo Tan, "Architect's Record for Darul Aman Mosque Submitted to Aga Khan Award for Architecture," (archnet.org, accessed 2 October 2019, 1989). Tony Tan was the chief architect of HDB. The project architect was Mohammad Asaduz Zaman.

35 Quoted in Lim Kwan Kwan, "'Inspired' Designs for New Mosques," *The Straits Times*, 19 September 1988.

36 Between 1974 and 1987, 23 mosques, 76 *surau*, 700 Chinese temples, 27 Hindu temples and 19 churches in Singapore were affected by urban development and were demolished. Lily Kong, "Ideological Hegemony and the Political Symbolism of Religious Buildings in Singapore," *Environment and Planning D: Space and Society* 11 (1993): 31.

37 Suzaina Kadir, "Islam, State and Society in Singapore," *Inter-Asia Cultural Studies* 5, no. 3 (2004).

38 The Mosque Building Fund (MBF) was later extended to support the educational advancement of the Malay/Muslim community and became known as the Mosque Building and Mendaki Fund (MBMF) from 1984. Dr Yaacob Ibrahim, "Muis at 50: A Personal Reflection," in *Fulfilling the Trust: 50 Years of Shaping Muslim Religious Life in Singapore*, ed. Norshahril Saat (Singapore: World Scientific, 2018), xxxv.

39 Ibid.

40 Mohamad Helmy Mohd Isa, "Mosques in Singapore: Managing Expectations and the Future Ahead," in *Fulfilling the Trust: 50 Years of Shaping Muslim Religious Life in Singapore*, ed. Norshahril Saat (Singapore: World Scientific, 2018), 133. It was estimated in the 1990s that the typical land price for a mosque was three to four times lower than the market rate. See Kong, 28.

41 Masagos Zulkifli Masogos Mohammad, "50 Years On: Singapore's Malay/Muslim Identity," in *Majulah!: 50 Years of Malay/Muslim Community in Singapore*, ed. Zainul Abidin Rasheed and Norshhirl Saat (Singapore: World Scientific, 2016).

42 "Mosques Built by HDB," *Journal of the Singapore Institute of Architects* 110 (1982).

43 "New Sultan Mosque," *The Singapore Free Press and Mercantile Advertiser*, 1 January 1930.

44 Thomas R. Metcalf, *An Imperial Vision: Indian Architecture and Britain's Raj* (New Delhi: Oxford University Press, 2002 [1989]).

45 Arthur Benison Hubback was an English expatriate architect with the Public Works Department.

46 Thomas R. Metcalf, *Imperial Connections: India in the Indian Ocean Arena, 1860–1920* (Berkeley: University of California Press, 2007), 62.

47 Robert Powell, ed. *Architecture and Identity: Proceedings of the Regional Seminar in the Series Exploring Architecture in Islamic Cultures* (Singapore: Aga Khan Award for Architecture, Concept Media, 1983); Robert Powell, ed. *Regionalism in Architecture: Proceedings of the Regional Seminar in the Series Exploring Architecture in Islamic Cultures* (Singapore: Concept Media, 1985). The emergence of architectural regionalism through the activities of the Aga Khan Award for Architecture was also linked to writings on critical regionalism by Kenneth Frampton, William Curtis and others. See Jiat-Hwee Chang, "'Natural' Traditions: Constructing Tropical Architecture in Transnational Malaysia and Singapore," *Explorations* 7, no. 1 (2007).

48 "Ethnic Touch for Eunos MRT Station," *The Straits Times*, 20 June 1986.

49 Romi Khosla, "Technical Review Summary of Darul Aman Mosque for Aga Khan Award for Architecture," (archnet.org, accessed 2 October 2019, 1989), u.p.

50 "An Hour Spent in Prayer," *The Straits Times*, 7 February 1987; Abidin Kusno, *Behind the Postcolonial: Architecture, Urban Space and Political Cultures in Indonesia* (New York: Routledge, 2000), 2–4.

51 See for example, Assyafaah Mosque (2004) by Forum Architects and Al-Islah Mosque (2015) by Formwerkz Architects.

31.1 From 1975, mosques were developed in public housing estates as part of a state mosque building programme. One example was the Assyakirin Mosque in Jurong as seen in this photo of officials and residents examining its model in 1977.

31.2 The Assyakirin Mosque designed by the HDB was completed in 1978. It was one of six mosques commissioned by MUIS as part of the First Mosque Building Scheme.

31.3 Another mosque built as part of the scheme was the Al-Ansar Mosque completed in 1981. It was built at Chai Chee Street, next to public housing estates along Bedok North Avenue 1. Like other mosques designed then, it used the language of domes and arches.

31.1

31.2

31.3

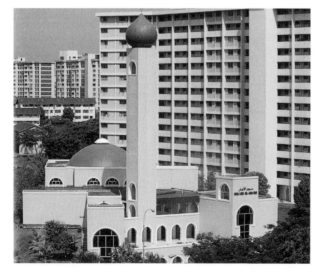

31.4 Worshippers sitting outside the in-between spaces between the main prayer hall and the surrounding pavilions of the Darul Aman Mosque, 1987. Like traditional architecture of the region, mosque spaces were designed to extend to the outside with large openings and overhanging roofs.

31.5 Worshippers inside the main prayer hall of the Darul Ghufran Mosque, completed by the HDB in Tampines in 1990.

31.6 Besides the Darul Aman, another mosque design that looked to the region for inspiration was the Al-Amin in Telok Blangah. The 1991 design by HDB had Sumatran Minang roofs.

31.4

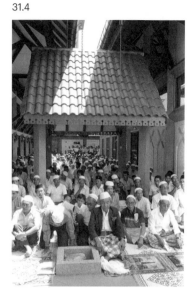

31.5

31.6

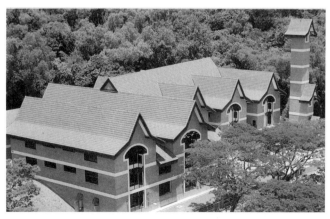

32 # Columbaria:

Raising Up the Dead for the Living

When there is a limited supply, there will be a scramble. When the commodity is land, the scramble is between the dead and the living. In this land rush there can be only one winner. That is why the dead are moving on—and moving up.[52]

Around 80 per cent of the dead in Singapore—or almost all except those whose religions require burial—are cremated today. This is double the percentage in the mid 1970s, and the growth is visible in the rise of columbaria in the city-state and the displacement of old cemeteries for housing and other developments.[53] As the above epigraph suggests, the history of spaces for the dead in Singapore is very much intertwined with the living. Or in the more recent words of another journalist:

In Singapore, death is forever but you cannot say the same for the dead resting in one place as the living claim space for condos and air bases, [among other uses]. Exhumations done en masse are common here as they are a part of policy that requires those who have been buried for 15 years to make way for new interments.[54]

Since the colonial era, cemeteries in Singapore have been regarded as planning and sanitary problems. From the mid 19th century, municipal commissioners regarded cemeteries as insanitary and sought to regulate the threat to public health with little success.[55] Town planners in the early 20th century attributed the overcrowding in the city to it being "hemmed in by public reserves, graveyards and agricultural allotments" along its perimeter.[56] It was only after Singapore gained independence that the People's Action Party government developed a masterplan to regulate land use, and (re)classified cemeteries as land for urban development.[57] In the words of the Ministry of the Environment, "[w]ith land in short supply in Singapore, we cannot afford to put aside large tracts of ground for burial purposes in the future".[58]

Numerous large burial grounds owned and managed by various Chinese clan associations were compulsorily acquired by the state from the 1960s. They were often cleared to build public housing estates, including in Queenstown, Tiong Bahru, Redhill, Nee Soon and Bishan. The associations obtained certain concessions from the government in return. For example, the Hakka clan association Ying Fo Fui Kun kept a small 4.5-acre portion of its burial ground in Holland

Close for the reburial of the affected graves, creating what is known today as the Shuang Long Shan Cemetery.[59] However, no new burial was to be allowed at the ground that had a 99-year lease. The conditions were consistent with a broader government policy in the 1960s to stop issuing new licenses for burial grounds. In 1972, legislative changes were introduced to give the state even greater power to "close cemeteries without having to assign reasons for doing so".[60] By then, the state-owned Bidadari Cemetery, which opened in 1908, had reached full capacity. Thus, Singapore's only burial ground with vacant plots was Choa Chu Kang Cemetery, which was opened in 1947 at the north-western edge of the city-state.[61]

While the state restricted the burial of the dead, it encouraged cremation by building the first state-owned crematorium at Mount Vernon in 1962.[62] The facility located next to Bidadari Cemetery quickly reached full capacity as there were only two other privately owned crematoriums at that time.[63] Both were owned by Buddhist institutions, including the Tse Tho Aum Temple, then located at Upper Changi, and the Kong Meng San Phor Kark See Monastery at Sin Ming. In the mid 1970s, the government expanded the crematorium at Mount Vernon and also began building a columbarium to make it an attractive and convenient place for Singaporeans to store their dead after cremation.[64] The concept of a columbarium was such a novel one that a newspaper article had to explain that it is "a building where the ashes of the dead can be stored".[65] The Mount Vernon columbarium consisted of 15 blocks that housed a total of 3,000 niches. Each block was essentially a simple concrete wall with five rows of 20 niches on each side. Five of these slab blocks were arranged in a circular pattern amidst pathways in a garden landscape.

Following the expansion of Mount Vernon, the Housing & Development Board (HDB) built two larger columbaria at Nee Soon and Mandai that marked an "unprecedented move to cope with the large-scale exhumation of graves on cemetery lands required for development".[66] Their construction coincided with the clearance of one of Singapore's largest cemeteries, the 32-hectare Kwang Teck Suah Cemetery at Sembawang Road. Some 25,000 graves and 27,000 urns were exhumed to make way for what became the Nee Soon new town.[67] The exhumed graves at Kwang

Teck Suah Cemetery were relocated to the columbaria at Nee Soon and Mandai. The first phase of Nee Soon Columbarium (today known as Yishun Columbarium) was completed in 1978 with a capacity of 2,980 niches.[68] It was planned in such a way to allow an additional 14,484 niches to be added in a later stage.[69] Mandai's first phase was completed in 1981 and included a state-of-the-art crematorium housing 12 cremators and computer-assisted, energy-saving and pollution-preventing cremation technologies.[70] With a projected total of 200,000 niches, the Mandai facility was also the largest columbarium planned at that time. Its first phase of construction entailed the completion of two blocks of "new-style, high-rise columbarium" designed by HDB with a total capacity of 62,320 niches.[71] Besides housing remains exhumed from Kwang Teck Suah Cemetery, the columbarium at Mandai also took in those from the Tong Gik and Peck San Theng cemeteries.

By 1981, 59 per cent of Singaporeans who died were cremated.[72] The government announced it was expanding the Mount Vernon Columbarium, as 2,250 of its 3,000 niches were full. While the original plan was to add another 5,000 niches, an additional 13,230 niches were built by the late 1980s.[73] These came in the form of a two-storey church-style building and what became an iconic nine-storey tower in a traditional Chinese architectural style, similar to the pavilions with (rather bulky) flying eaves built at the columbaria of Nee Soon and Mandai. It perhaps reflected how the three columbaria primarily served the Chinese community whose ancestor's graves were being exhumed, and were being encouraged to take up cremation. Unlike Singapore's other major communities—Malays are mainly Muslims who are required by their religion to bury their dead, and Indians are predominantly Hindus that tend to scatter the ashes of their dead in the sea—the Chinese community is made up of those with religious beliefs that accept or do not reject cremation. Furthermore, Chinese temples have similar architectural expressions. The earliest columbarium in Singapore, completed in 1947 at Kong Meng San Phor Kark See Monastery, was also built in the style of the traditional Chinese temple and may have served as the architectural precedent for the government when it began building columbaria.

One aesthetic exception was the Kwong Wai Siew Peck San Theng. Completed in 1991, the design by Akitek Tenggara houses up to 90,000 urns in a stepped section that allowed densely arranged walls of niches to be illuminated by daylight and are also naturally ventilated. Such a modern outlook was even christened by a journalist as a "'condo' for the dead."[74] The private columbaria was erected when the 324-hectare Peck San Theng Cemetery, first established in 1870 by a federation of sixteen Cantonese and Hakka clan associations, was acquired by the HDB in 1979 to build Bishan New Town.[75] The association successfully negotiated with the government to preserve its temple and obtained a 3.3-hectare plot next to it for a columbarium and memorial hall.[76] Peck San Theng was subsequently followed by similarly contemporary designs of three columbaria that opened next to Choa Chu Kang Cemetery in the 2000s. One was a government-run facility designed by the newly corporatised Public Works Department housed some 147,000 niches in various three to four-storey blocks topped with steel roofs, and arranged in a radial formation surrounded by landscaping. While this could be "mistaken for a modern polytechnic or university", the two other privately run columbaria had even more stylish features.[78] The Garden of Remembrance featured gentle curves and granite walls akin to "an

upmarket Holland Road mansion", while the Ji Le Memorial Park (today known as Nirvana Memorial Garden) even offered air-conditioning for the dead.

As Singapore has continued its urban redevelopment to meet the changing needs of the living, the relocation of its dead is today no longer restricted to those who are buried. In 2018, Mount Vernon Columbarium was closed to make way for the new Bidadari public housing estate, and its niches were relocated to Mandai Columbarium.[78] Prior to this, Singapore's first public crematorium in Mount Vernon had ceased operations in 2004.[79] The government is also exploring even more space-saving alternatives such as scattering cremated remains at sea or on land. While plans to build a sea burial facility for scattering remains along the shoreline in Tanah Merah were eventually shelved, ashes can still be scattered off the mainland at a site in Pulau Semakau.[80] In 2021, the first of two inland ash-scattering gardens was opened in Choa Chu Kang Cemetery Complex with another to follow in Mandai.[81] Both methods of "housing" the dead are touted as more ecological and economical than storing ashes in a columbaria. They are also perhaps the only way one can truly have a final resting place in Singapore.

Notes

52 David Kraal, "The Dead Move on—and Up," *The Straits Times*, 9 August 1984.

53 向阳君，, "捨棄土葬，改用火化," 《南洋商报》, 8 April 1976.

54 Denise Chong, "Feed My Remains to Trees, Stop Moving Me around When I'm Dead," *The Straits Times*, 6 August 2017. Chong's remarks were made partly in response to a number of Muslim graves in Choa Chu Kang that the government ordered to be cleared to make way for the expansion of Tengah Air Base that year.

55 Brenda S. A. Yeoh, *Contesting Space: Power Relations and the Urban Built Environment in Colonial Singapore* (Kuala Lumpur: Oxford University Press, 1996), 281–311.

56 "Town Planning and Improvement in Singapore: The Problem," *Journal of the Singapore Society of Architects Incorporated* 1, no. 4 (1929): 18.

57 Tan Boon Hui and Brenda S. A. Yeoh, "The 'Remains of the Dead': Spatial Politics of Nation-Building in Post-War Singapore," *Human Ecology Review* 9, no. 1 (2002).

58 "Ministry's Plan to Discourage Burials," *New Nation*, 25 July 1974.

59 Melody Zaccheus, "Hakka Tombstone May Have to Go," *The Straits Times*, 8 June 2014.

60 Cited in Tan and Yeoh, 4.

61 Judith Holmberg, "More Crematoriums Will Be Set up by the Govt," *New Nation*, 21 May 1974.

62 A public crematorium was proposed by the colonial government as early as 1941. See "Public Crematorium: Views Are Invited," *Morning Tribune*, 28 March 1941.

63 Holmberg, "More Crematoriums Will Be Set up by the Govt"; 向阳君, "捨棄土葬，改用火化"; "That Temple on a Hill Is to Come Down Soon," *New Nation*, 14 September 1976.

64 "S'poreans Urged to Cremate the Dead," *The Straits Times*, 27 July 1974.

65 Holmberg, "More Crematoriums."

66 *HDB Annual Report 1977/78* (Singapore: Housing & Development Board, 1978), 51.

67 "Graves to Make Way for Town," *New Nation*, 26 July 1977.

68 "HDB Columbaria for Nee Soon," *The Straits Times*, 1 May 1978.

69 *HDB Annual Report 1978/79* (Singapore: Housing & Development Board, 1979), 24.

70 *HDB Annual Report 1980/81* (Singapore: Housing & Development Board, 1981), 25.

71 "Dead to Get New Resting Place," *New Nation*, 3 June 1980.

72 Koh Yan Poh, "59 Pc of S'poreans Who Died Last Year Were Cremated," *The Straits Times*, 31 July 1981.

73 *Singapore 1988* (Singapore: Ministry of Culture, 1989), 206.

74 Leong Weng Kam, "'Condo' for the Dead," *The Straits Times*, 29 April 1985.

75 Paul Wee, "Govt Acquires Site for Housing Scheme to link Toa Payoh, Ang Mo Kio estates," *The Straits Times*, 30 April 1979.

76 李国樑, "碧山亭的起源与重建," 《扬》 35 (2017).

77 Laurel Teo, "300,000 More Niches for Ashes of the Dead," *The Straits Times*, 21 December 2000, sec. Home.

78 Rachel Au-Yong, "New Funeral Parlour Complex to Replace Mount Vernon to Be Smaller with More Wake Halls," *The Straits Times*, 9 January 2018.

79 Wong Pei Ting, "The Rise and Demise of Mount Vernon Columbarium," *Today*, 8 September 2018.

80 Shabana Begum, "First Coastal Facility for Post-Death Rites to Be Built at Changi Beach but No Sea Burial Site at Tanah Merah: NEA," *The Straits Times*, 30 December 2020.

81 Deepa Sundar, "Singapore to Open First Inland Ash-Scattering Garden in Choa Chu Kang on May 17," *The Straits Times*, 12 May 2021.

32.1 The need for space to house the living led the Singapore government to phase out cemeteries where the dead were traditionally buried. Here a family pays respect to their deceased ancestors at a cemetery next to a public housing estate, 1993.

32.2 Singapore's first state-owned columbarium was built in Mount Vernon in the mid-1970s. The simple concrete slab blocks were joined by a high-rise columbarium pagoda tower (background) in the late 1980s to house the growing population.

32.3 A 1986 photo showing how one pays respect to the deceased at a columbarium in Singapore during the Qing Ming Festival.

32.1

32.2

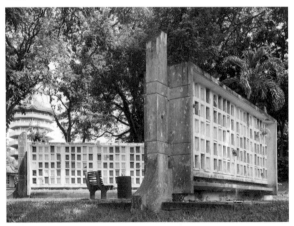

32.3

32.4 Columbarium at the Church of St
 Teresa, 1989. Located in
 Kampong Bahru, it was built in
 1983 and the first Catholic
 Church in Singapore to have one.

32.5 The Kwong Wai Siew Peck San
 Theng Memorial Hall (foreground)
 and Columbarium, were
 completed in 1991 by Akitek
 Tenggara. Its modern design led
 the media to dub it as a "'condo'
 for the dead".

32.6 Kwong Wai Siew Peck San Theng
 Columbarium (left) replaced a
 cemetery that was acquired by
 the government to build Bishan
 New Town, as seen in the
 background.

32.4

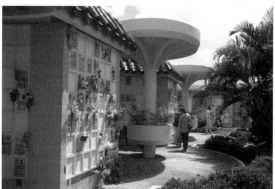

32.5

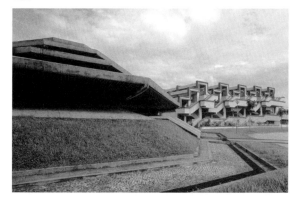

32.6

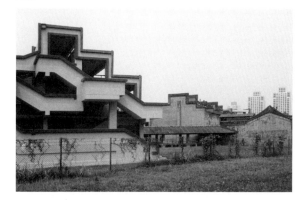

A

B

Q

R

S

Y

Z

Image Credits

Everyday Modernism:
The Singapore Vernacular

0.01 Otto Koenigsberger's collection. Courtesy of Renate Koenigsberger.
0.02 Otto Koenigsberger's collection. Courtesy of Renate Koenigsberger.
0.03 Otto Koenigsberger's collection. Courtesy of Renate Koenigsberger.
0.04 Singapore Improvement Trust, *Final Report of the New Towns Working Party on the Plan for Queenstown*, 1958.
0.05 *Journal of the Singapore Institute of Architects* no. 62, 1974. Courtesy of Singapore Institute of Architects.
0.06 *HDB Annual Report 1972*. Courtesy of Housing & Development Board.
0.07 *JTC Annual Report 1968/9*. Courtesy of JTC.
0.08 *JTC Annual Report 1977/78*. Courtesy of JTC.
0.09 *What's On in PWD*, July 1975. Courtesy of Ministry of National Development.
0.10 *HDB Annual Report 1976/77*. Courtesy of Housing & Development Board.
0.11 *HDB Annual Report 1983/84*. Courtesy of Housing & Development Board.
0.12 *HDB Annual Report 1984/85*. Courtesy of Housing & Development Board.
0.13 *Our Home* vol. 123, 1986. Courtesy of Housing & Development Board.

Public Housing:
The Many Shapes of Home

1.1 Courtesy of the National Museum of Singapore, National Heritage Board.
1.2 Ministry of Information and the Arts Collection, courtesy of National Archives of Singapore.
1.3 *HDB Annual Report 1969*. Courtesy of Housing & Development Board.
1.4 Housing & Development Board Collection, courtesy of National Archives of Singapore.
1.5 *Our Home*, 1979. Courtesy of Housing & Development Board.

People's Park:
Pioneering Integrating Living in a Denser City

2.1 *First Decade in Public Housing 1960–1969*. Courtesy of Housing & Development Board.
2.2 *First Decade in Public Housing 1960–1969*. Courtesy of Housing & Development Board.
2.3 *First Decade in Public Housing 1960–1969*. Courtesy of Housing & Development Board.
2.4 *HDB Annual Report 1976–77*. Courtesy of Housing & Development Board.
2.5 *HDB Annual Report 1975–76*. Courtesy of Housing & Development Board.

Futura:
The Past and Future of Luxury High-rise Apartments

3.1 *Building Materials & Equipment*, March/April 1975.
3.2 *Far East Builder*, November, 1970.
3.3 *The Architecture of Timothy Seow + Partners*, 1982.
3.4 *The Architecture of Timothy Seow + Partners*, 1982.
3.5 Promotional brochure published by Kumpulan Akitek, c. 1970s. Courtesy of Wee Chwee Heng.
3.6 Promotional brochure published by Kumpulan Akitek, c. 1970s. Courtesy of Wee Chwee Heng.

Pandan Valley:
The Domestication of "Rural" Singapore

4.1 Courtesy of Archurban Architects Planners.
4.2 Courtesy of Archurban Architects Planners.
4.3 Courtesy of Archurban Architects Planners.
4.4 Advertisement in *New Nation*, 30 March 1978. Courtesy of DBS.
4.5 *Building Materials & Equipment*, November 1977.
4.6 *Building Materials & Equipment*, November 1977.

Pearl Bank Apartments:
How Can We Maintain the High Life?

5.1 *Building Materials & Equipment*, April 1976.
5.2 Courtesy of Archurban Architects Planners.
5.3 Courtesy of Marisse Caine.
5.4 Courtesy of Archurban Architects Planners.
5.5 Courtesy of Docomomo Singapore.

Cinemas:
The Architecture of Advertisement

6.1 *The Straits Times Annual 1939*.
6.2 RAFSA Collection, courtesy of National Archives of Singapore.
6.3 Lim Kay Tong, *Cathay: 55 Years of Cinema*, 1991.
6.4 Lee Kip Lin Collection, courtesy of National Library Board.
6.5 Courtesy of National Archives of Singapore.
6.6 *Journal of the Singapore Institute of Architects* no. 174. Courtesy of Singapore Institute of Architects.

Shopping Centres:
Moving Retail from the Streets to the Interior

7.1 Courtesy of the National Archives of Singapore.
7.2 Ministry of Information and the Arts Collection, courtesy of the National Archives of Singapore.
7.3 Ministry of Information and the Arts Collection, courtesy of the National Archives of Singapore.
7.4 Ministry of Information and the Arts Collection, courtesy of the National Archives of Singapore.
7.5 Ministry of Information and the Arts Collection, courtesy of the National Archives of Singapore.
7.6 Courtesy of the National Archives of Singapore.

Hotels:
Singapore as a Tropical Asian Paradise

8.1 *Hotel Malaysia Limited Annual Report*, 1971.
8.2 *Hotel Malaysia Limited Annual Report*, 1969.
8.3 *Journal of the Singapore Institute of Architects* 26–27, 1968. Courtesy of Singapore Institute of Architects.
8.4 Kouo Shang-Wei Collection, courtesy of National Library Board.
8.5 Private collection.
8.6 Courtesy of the National Museum of Singapore, National Heritage Board.

Lookout Towers:
Views of Singapore's Modern Development

9.1 Ministry of Information and the Arts Collection, courtesy of National Archives of Singapore.
9.2 Ministry of Information and the Arts Collection, courtesy of National Archives of Singapore.
9.3 Courtesy of Keola Ho.
9.4 Ministry of Information and the Arts Collection, courtesy of National Archives of Singapore.
9.5 Courtesy of Yeo Hong Eng.
9.6 Ministry of Information and the Arts Collection, courtesy of National Archives of Singapore.

East Coast Park:
"The Singapore Way" to Recreation

10.1 Federal Publications (S) Pte Ltd.
10.2 Ministry of Information and the Arts Collection, courtesy of National Archives of Singapore.
10.3 *URA Annual Report 1977*, © Urban Redevelopment Authority. All rights reserved.
10.4 Ministry of Information and the Arts Collection, courtesy of National Archives of Singapore.
10.5 Marine Parade Community Centre Collection, courtesy of National Archives of Singapore.

HDB Playgrounds:
Sandboxes for Moulding Model Citizens

11.1 Courtesy of Khor Ean Ghee.
11.2 Courtesy of Khor Ean Ghee.
11.3 Courtesy of Khor Ean Ghee.

City Council Pools:
Swimming for Health, Leisure and Survival

12.1 Edward William Newell Collection, courtesy of National Archives of Singapore.
12.2 Private collection.
12.3 Private collection.
12.4 Courtesy of the National Museum of Singapore, National Heritage Board.
12.5 Ministry of Information and the Arts Collection, courtesy of National Archives of Singapore.
12.6 Ministry of Information and the Arts Collection, courtesy of National Archives of Singapore.

Former Singapore Badminton Hall:
Financial Gymnastics and Sporting Venues

13.1 Ministry of Information and the Arts Collection, courtesy of National Archives of Singapore.
13.2 Ministry of Information and the Arts Collection, courtesy of National Archives of Singapore.
13.3 Ministry of Information and the Arts Collection, courtesy of National Archives of Singapore.
13.4 *URA Annual Report 1976–77*, © Urban Redevelopment Authority. All rights reserved.
13.5 Courtesy of Yeo Hong Eng.

Shenton Way:
Singapore's Commercial Centre Grows Up!

14.1 *Planning Department's Annual Report*, 1964, © Urban Redevelopment Authority. All rights reserved.
14.2 Courtesy of Lim Chong Keat.
14.3 Ministry of Information and the Arts Collection, courtesy of National Archives of Singapore.
14.4 Courtesy of Lim Chong Keat.
14.5 *URA Annual Report, 1977–78*, © Urban Redevelopment Authority. All rights reserved.
14.6 Courtesy of Lim Chong Keat.

Industrial Spaces:
Housing Industrialisation, then a Tech Revolution

15.1 *JTC Annual Report 1970*. Courtesy of JTC.
15.2 *JTC Annual Report 1970*. Courtesy of JTC.
15.3 *JTC Annual Report 1970*. Courtesy of JTC.
15.4 *JTC Annual Report 1979*. Courtesy of JTC.
15.5 Ministry of Information and the Arts Collection, courtesy of National Archives of Singapore.
15.6 *JTC Annual Report 1980–81*. Courtesy of JTC.
15.7 *JTC Annual Report 1980–81*. Courtesy of JTC.

Jurong Town Hall Road:
The Industrial Future as Brutalist

16.1 *JTC Annual Report 1972*. Courtesy of JTC.
16.2 *Journal of the Singapore Institute of Architects* no. 39, 1970. Courtesy of Singapore Institute of Architects.
16.3 *Journal of the Singapore Institute of Architects* no. 49, 1971. Courtesy of Singapore Institute of Architects.
16.4 Courtesy of Horst Kiechle.
16.5 *Singapore Science Centre Annual Report 1978/79*. Courtesy of Science Centre Singapore.
16.6 Courtesy of JTC.

Tan Boon Liat Building:
A Modern Godown for the Creative Economy

17.1 Lee Kip Lin Collection, courtesy of National Library Board.
17.2 Lee Kip Lin Collection, courtesy of National Library Board.

17.3 Majorie Doggett, *Characters of Light*, courtesy of National Archives of Singapore.
17.4 Courtesy of Koh Nguang How. Reproduced with permission.
17.5 Singapore Tourist Promotion Board Collection, courtesy of National Archives of Singapore.

Market Street Car Park:
Up, Up ... and Who Pays?

18.1 *The Highway*, December 1964, courtesy of Automobile Association of Singapore.
18.2 *The Highway*, 2nd Quarter, 1965, courtesy of Automobile Association of Singapore.
18.3 Courtesy of the National Museum of Singapore, National Heritage Board.
18.4 Courtesy of Yeo Hong Eng.
18.5 *First Decade in Public Housing, 1960–69*, courtesy of Housing & Development Board.
18.6 *The Highway*, February 1966, courtesy of Automobile Association of Singapore.

Pan-Island Expressway:
Speeding Up and Spreading Out Modern Life

19.1 *Planning Department Annual Report 1970*, © Urban Redevelopment Authority. All rights reserved.
19.2 *PWD Annual Report 1971*. Courtesy of Ministry of National Development.
19.3 Ministry of Information and the Arts Collection, courtesy of National Archives of Singapore.
19.4 *The Straits Times Annual 1970*.
19.5 G P Reichelt Collection, courtesy of National Archives of Singapore.
19.6 Singapore Tourist Promotion Board Collection, courtesy of National Archives of Singapore.

Pedestrian Overhead Bridges:
Staying Safe Amidst Accelerated Development

20.1 Ministry of Information and the Arts Collection, courtesy of National Archives of Singapore.
20.2 Ministry of Information and the Arts Collection, courtesy of National Archives of Singapore.
20.3 *National Safety First Council Bulletin* (Vol. 1 No. 3). Courtesy of the National Safety Council of Singapore.
20.4 Ministry of Information and the Arts Collection, courtesy of National Archives of Singapore.
20.5 Ministry of Information and the Arts Collection, courtesy of National Archives of Singapore.

Interchanges:
The "Nerve Centre" of an Efficient
Public Transport

21.1 *SBS Annual Report 1978*. Courtesy of SBS Transit.
21.2 *SBS Annual Report 1983*. Courtesy of SBS Transit.
21.3 *HDB Annual Report 1978/81*, courtesy of Housing & Development Board.

21.4 *SBS Annual Report 1982*. Courtesy of SBS Transit.
21.5 Ministry of Information and the Arts Collection, courtesy of National Archives of Singapore.

Public Schools:
In Search of a Flexible and Identifiable
"Instructional Equipment"

22.1 Ministry of Information and the Arts Collection, courtesy of National Archives of Singapore.
22.2 Ministry of Information and the Arts Collection, courtesy of National Archives of Singapore.
22.3 *The Design of Secondary Schools in Singapore*, 1981.
22.4 Ministry of Information and the Arts Collection, courtesy of National Archives of Singapore.
22.5 *Building Materials & Equipment*, December 1984.
22.6 *Building Materials & Equipment*, December 1984.

Institutes of Higher Education:
Systems Planning to Support a
Technocratic State

23.1 Raffles College Collection, courtesy of National Archives of Singapore.
23.2 Ministry of Information and the Arts Collection, courtesy of National Archives of Singapore.
23.3 Joosje van Geest, *S. J. van Embden* (Rotterdam: Uitgeverij 010, 1996).
23.4 *Journal of the Singapore Institute of Architects* 1974, no. 66. Courtesy of the Singapore Institute of Architects.
23.5 Courtesy of National Archives of Singapore.
23.6 *Journal of the Singapore Institute of Architects* 1976, no. 77. Courtesy of the Singapore Institute of Architects.

Institutional Buildings:
A New Monumentality

24.1 *Building Materials & Equipment*, August 1977.
24.2 *Journal of the Singapore Institute of Architects* 52, 1972. Courtesy of the Singapore Institute of Architects.
24.3 *Journal of the Singapore Institute of Architects* 52, 1972. Courtesy of the Singapore Institute of Architects.
24.4 *Journal of the Singapore Institute of Architects* 52, 1972. Courtesy of the Singapore Institute of Architects.
24.5 *Our Home*, December 1979. Courtesy of Housing & Development Board.
24.6 Promotional brochure published by Kumpulan Akitek, c. 1970s. Courtesy of Wee Chwee Heng.

Public Libraries:
"Palaces for the People"

25.1 Ministry of Information and the Arts Collection, courtesy of National Archives of Singapore.
25.2 Ministry of Information and the Arts Collection, courtesy of National Archives of Singapore.

25.3 Ministry of Information and the Arts Collection, courtesy of National Archives of Singapore.
25.4 Ministry of Information and the Arts Collection, courtesy of National Archives of Singapore.
25.5 Ministry of Information and the Arts Collection, courtesy of National Archives of Singapore.
25.6 Ministry of Information and the Arts Collection, courtesy of National Archives of Singapore.

Community Centres:
Modernising the "Central Nervous System" of Singapore

26.1 Ministry of Information and the Arts Collection, courtesy of National Archives of Singapore.
26.2 *Our Home*, April 1979. Courtesy of the Housing & Development Board.
26.3 Singapore Federation of Chinese Clan Associations Collection, courtesy of National Archives of Singapore.
26.4 Ministry of Information and the Arts Collection, courtesy of National Archives of Singapore.
26.5 People's Association Collection, courtesy of National Archives of Singapore.

Hawker Centres:
Regulating Itinerant Individuals into a Social Institution

27.1 Ministry of Information and the Arts Collection, courtesy of National Archives of Singapore.
27.2 Ministry of Information and the Arts Collection, courtesy of National Archives of Singapore.
27.3 *URA Annual Report 1974–75*, © Urban Redevelopment Authority. All rights reserved.
27.4 Singapore Tourist Promotion Board Collection, courtesy of National Archives of Singapore.
27.5 Courtesy of the National Museum of Singapore, National Heritage Board.
27.6 Ministry of Information and the Arts Collection, courtesy of National Archives of Singapore.

Lucky Plaza:
A Mall for the Migrants Who Modernised Singapore

28.1 *The Straits Times Annual 1973*. Courtesy of Far East Organization.
28.2 Ministry of Information and the Arts Collection, courtesy of National Archives of Singapore.
28.3 Singapore Tourist Promotion Board Collection, courtesy of National Archives of Singapore.
28.4 Courtesy of Sam Kang Li.
28.5 Ministry of National Development Collection, courtesy of National Archives of Singapore.

Churches:
Bringing God Closer to the Suburbs and the People

29.1 Wong Kwan Collection, courtesy of National Archives of Singapore.
29.2 Ministry of Information and the Arts Collection, courtesy of National Archives of Singapore.
29.3 Ministry of Information and the Arts Collection, courtesy of National Archives of Singapore.
29.4 Courtesy of National Archives of Singapore.
29.5 Courtesy of National Archives of Singapore.
29.6 Courtesy of St. Matthew's Church.

Cinema-Churches:
From a "House of Pictures" to a "House of Prayers"

30.1 Lee Kip Lin Collection, courtesy of National Library Board.
30.2 Wong Kwang Collection, courtesy of National Archives of Singapore.
30.3 Lee Kip Lin Collection, courtesy of National Library Board.
30.4 Courtesy of W Architects, photography by Albert Lim.
30.5 Courtesy of W Architects, photography by Albert Lim.

Darul Aman Mosque:
A Modern Revival of the Traditional

31.1 Ministry of Information and the Arts Collection, courtesy of National Archives of Singapore.
31.2 MUIS, *New Generation Mosques and their Activities: Bringing Back the Golden Generation of Islam in Singapore*, 1991. Courtesy of MUIS.
31.3 MUIS, *New Generation Mosques and their Activities: Bringing Back the Golden Generation of Islam in Singapore*, 1991. Courtesy of MUIS.
31.4 Ministry of Information and the Arts Collection, courtesy of National Archives of Singapore.
31.5 Ministry of Information and the Arts Collection, courtesy of National Archives of Singapore.
31.6 MUIS, *New Generation Mosques and their Activities: Bringing Back the Golden Generation of Islam in Singapore*, 1991. Courtesy of MUIS.

Columbaria:
Raising Up the Dead for the Living

32.1 Lee Kip Lin Collection, courtesy of National Library Board.
32.2 Courtesy of Don Wong.
32.3 Ministry of Information and the Arts Collection, courtesy of National Archives of Singapore.
32.4 Courtesy of National Archives of Singapore.
32.5 Akitek Tenggara Collection, courtesy of National Archives of Singapore.
32.6 Akitek Tenggara Collection, courtesy of National Archives of Singapore.

Biographies

Jiat-Hwee Chang is Associate Professor at the Asia Research Institute and the Department of Architecture, National University of Singapore. He is an interdisciplinary researcher working at the intersections of architecture, environment and STS (science, technology and society). He is the author of *A Genealogy of Tropical Architecture: Colonial Networks, Nature and Technoscience* (2016), which was awarded an International Planning History Society Book Prize 2018 and shortlisted for the European Association for Southeast Asian Studies Humanities Book Prize 2017.

Jiat-Hwee is also the co-editor of a few books and special journal issues. His research has been supported by institutions in North America, Britain, Germany, Australia, Cyprus, Qatar and Singapore. He was recently a Carson Fellow at the Rachel Carson Center for Environment and Society in Spring 2020, a Manton Fellow at the Clark Art Institute in Fall 2019, and a Canadian Centre for Architecture – Mellon Foundation Researcher, 2017-19.

Justin Zhuang is an observer of the designed world and its impact on everyday life. Since 2009, the journalism graduate has covered architecture and design for magazines in Singapore and around the world. He has also authored several books and websites on local design including *Mosaic Memories: Remembering Singapore's Old Playgrounds* (2013), *INDEPENDENCE: The history of graphic design in Singapore since the 1960s* (2012) and *Reclaim Land: The Fight for Space in Singapore* (2009).

Zhuang is also the founder of the Singapore Graphic Archives which aids research on local design and visual culture. In 2013, he was awarded the DesignSingapore Scholarship to study in the School of Visual Arts' MFA in Design Criticism program in New York. He is now back in Singapore running In Plain Words, a writing studio and imprint with his partner, Sheere Ng, that specialises in food and design.

Darren Soh is a sociologist by training. He originally intended to become an academic, but after he began working as a photographer in 2001, he started using photography as a way to understand the world. Soh's personal works are an extension of his curiosity about how we live and the spaces we create as well as leave behind. His works have been exhibited internationally and are collected by public institutions such as the National Museum of Singapore, as well as numerous private collectors. He is also one of the cofounders of PLATFORM, which originated and drove the TwentyFifteen.sg initiative and has published several monographs on the architecture and landscape of Singapore. For work, Soh mostly photographs new pieces of architecture, but he leads a double life documenting places and spaces that are in danger of disappearing. He has a particular obsession with modernist and vernacular architecture that are deemed too banal or insignificant to be noticed.

Acknowledgements

The genesis of this project occurred in 2015, just as Jiat-Hwee finished the manuscript for his first book, *A Genealogy of Tropical Architecture*. As the book focused primarily on colonial architecture history in Singapore and its British actors, the architectural historian felt his next project should concentrate on local builders in the nation's post-independence period. Singapore was also celebrating its 50th anniversary of independence at that time, and there was a surge in interest in documenting such histories. One example was an informal oral history project led by the eminent local architect Tay Kheng Soon, for which pioneer architects of modern Singapore were interviewed. Jiat-Hwee became involved in the project, and it was one reason that he began researching more deeply about this generation of practitioners and their works. He successfully applied for a Ministry of Education Tier 1 research grant from the National University of Singapore for "Agents of Modernity: Pioneer Builders, Architecture and Independence in Singapore, 1890s–1970s" (WBS No. R-295-000-127-112) in 2016.

Over the next two years, Jiat-Hwee interviewed a number of pioneer architects and delved into their archives, including those of Datuk Seri Lim Chong Keat. A lack of archival materials, however, led to the realisation that the project had to look beyond just the iconic modernist buildings of Singapore and its architects. The approach also failed to capture the uniqueness of Singapore's modernism, including its variety, ubiquity and popularity. The project scope was thus widened to cover quotidian building types and landscapes as well as their social histories. Two collaborators, Justin Zhuang and Darren Soh, were roped in to help realise the expanded vision. *Everyday Modernism* is the result of a productive four-year collaboration between an architectural historian, a design writer and a photographer/visual archivist.

Along the way, we have also benefited from the generous suggestions, assistance, and guidance of many people. Those include, in alphabetical order, Cheah Kok Ming, Mark Crinson, Fong Hoo Cheong, Miles Glendinning, Ho Puay Peng, Ho Weng Hin, Lim Chong Keat, Ronald Lim, Mok Wei Wei, Jon Poh, Timothy Pwee, Hannah le Roux, Tan Kar Lin, Karen Tan, Tay Kheng Soon, Ana Tostões, Wee Chwee Heng, Jean Wee and Winnifred Wong. We also received significant help from our hardworking research associates and assistants—Ian Tan, Han Yun Chou, Tan Bao Yu, Teh Jing Ying, Jason Ng, Toh Wei Wei, and See Kum Wai Victoria. Ian Tan, in particular, wrote the first drafts of three of the essays in this book. At NUS Press, Peter Schoppert supported the book project enthusiastically from its inception and Lindsay Davis carefully copy edited our text. We would also like to thank the National Heritage Board for awarding us a Minor Project Grant that supported the production of this beautifully illustrated book that Hanson Ho of H55 designed.

Jiat-Hwee Chang, Justin Zhuang and Darren Soh **5 August 2022**

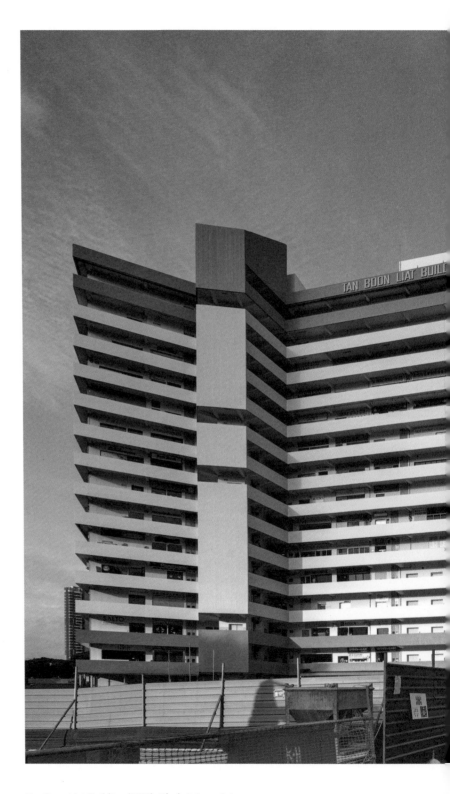

Tan Boon Liat Building (1976), Chok & Associates.

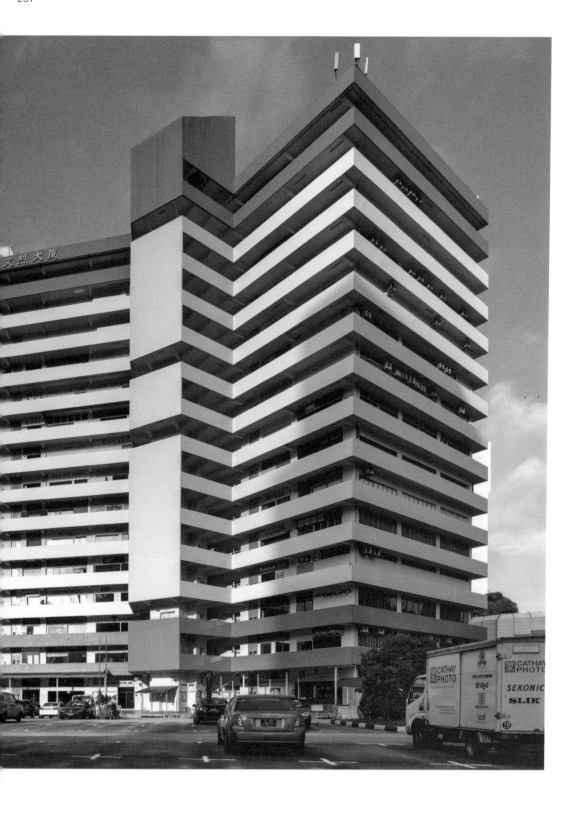

Former Wee Bin & Co. godown (1895), converted into The Warehouse Hotel (2016).

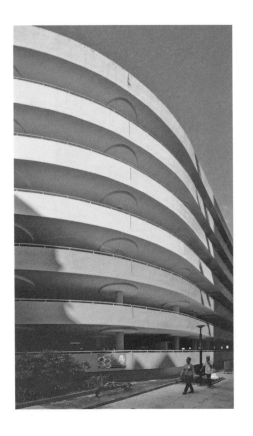

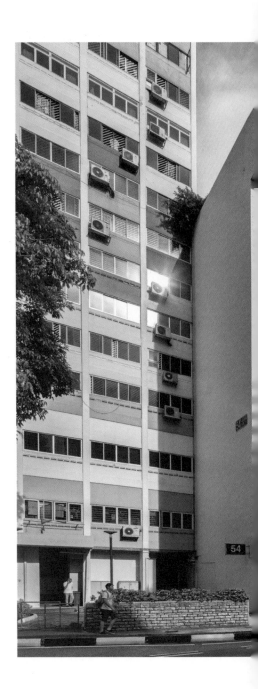

33 Park Crescent (c. 1968), Housing & Development Board.

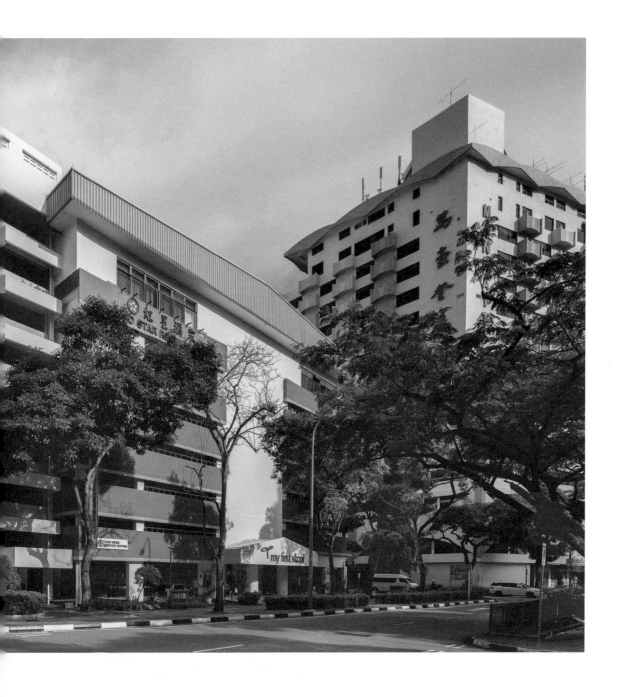

Red Star Restaurant-cum-multi-storey car park at 54 Chin Swee Road (1973), Housing & Development Board.

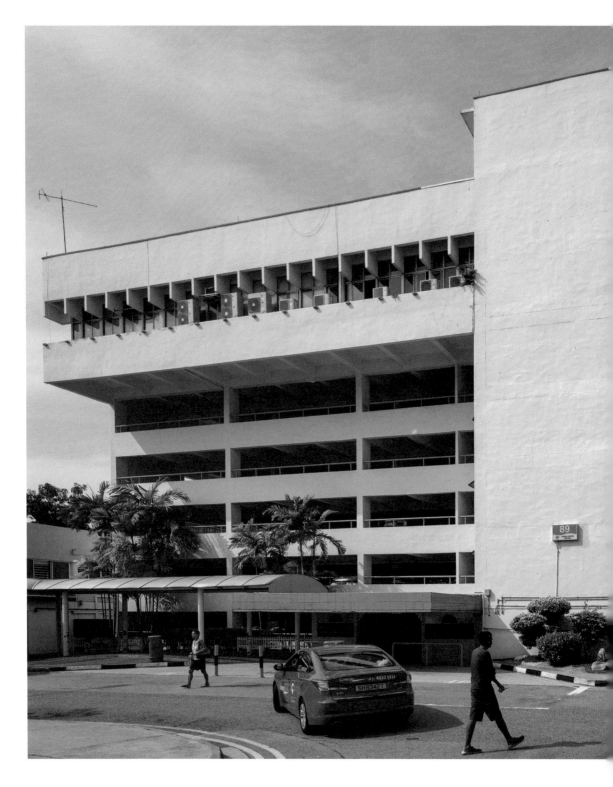

Roland Restaurant (former Sin Leong)-cum-multi-storey car park at 89 Marine Parade Central (1978), Housing & Development Board

Pan-Island Expressway Phase I between Thomson Road and Jalan Eunos, near Jalan Toa Payoh, Public Works Department.

Corrugated metal bridge along Ang Mo Kio Ave 1, near Lorong Chuan (1975), Mak Ng & Associates.

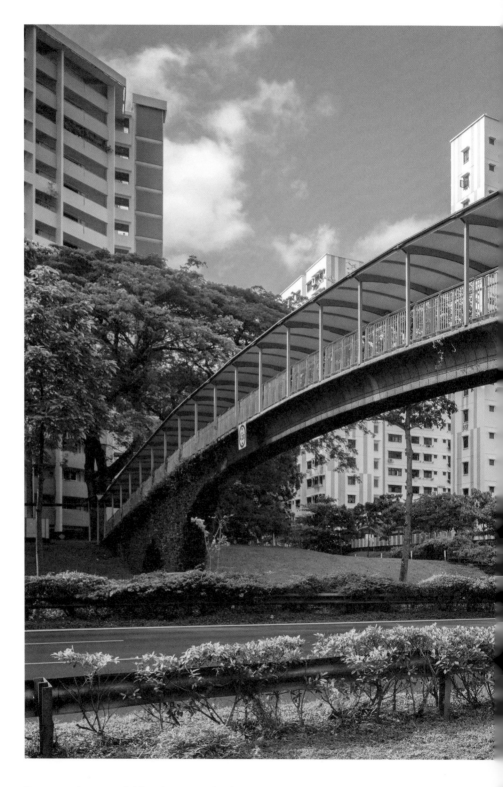

Pre-stressed concrete bridge along Pan-Island Expressway connecting Bedok Town with Bedok North (1

ic Works Department.

Bukit Merah Bus Interchange (1981), Housing & Development Board.

Choa Chu Kang Bus Interchange (1990–2018), Housing & Development Board.

Bishan Bus Interchange (1987), Housing & Development Board.

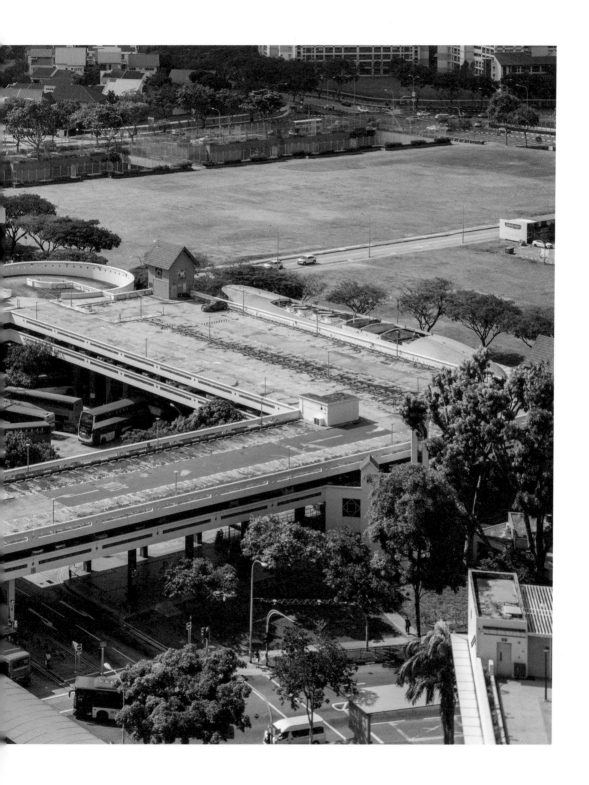

1960-type design, former Changkat Changi Primary School (1965), Public Works Department.

1965-type design, former Mei Chin Secondary School (1976), Public Works Department.

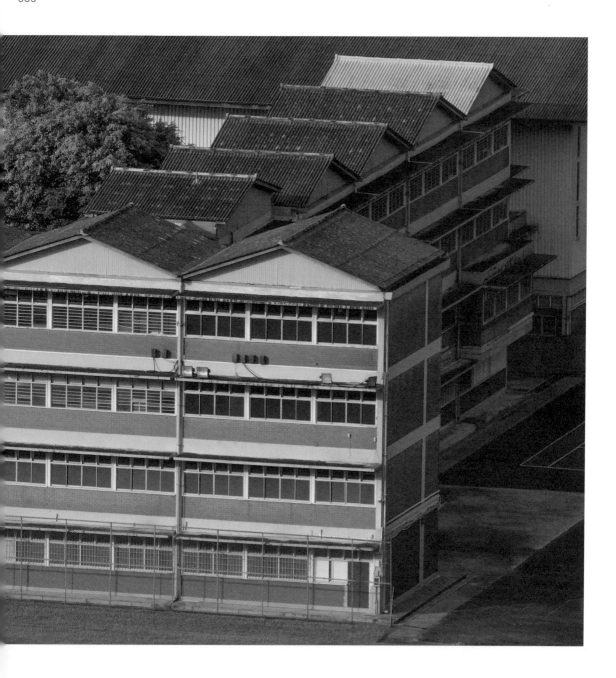

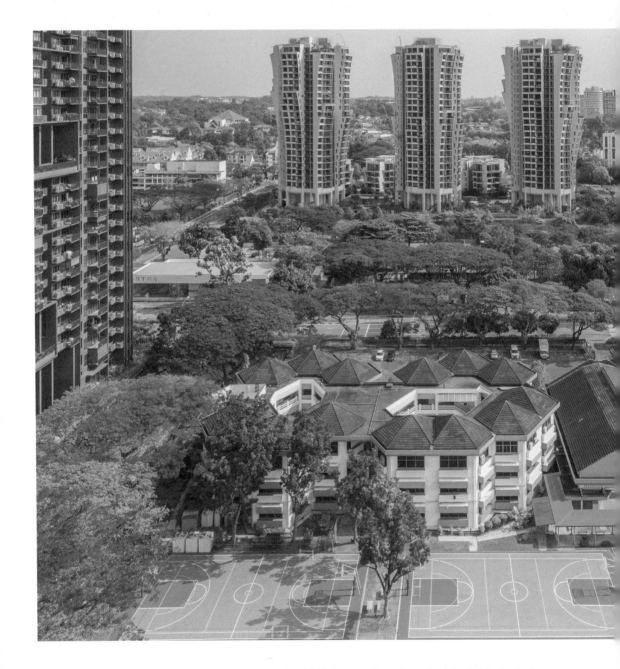

Hexagon-shaped school, former Keng Seng Primary School (1980), Puangthong Intarajit of the Public Works Department.

Former Braddell-Westlake Secondary School (1977–2017), Public Works Department, featuring Ho Cheok Tin's mural "The History of Development in Singapore" (1979).

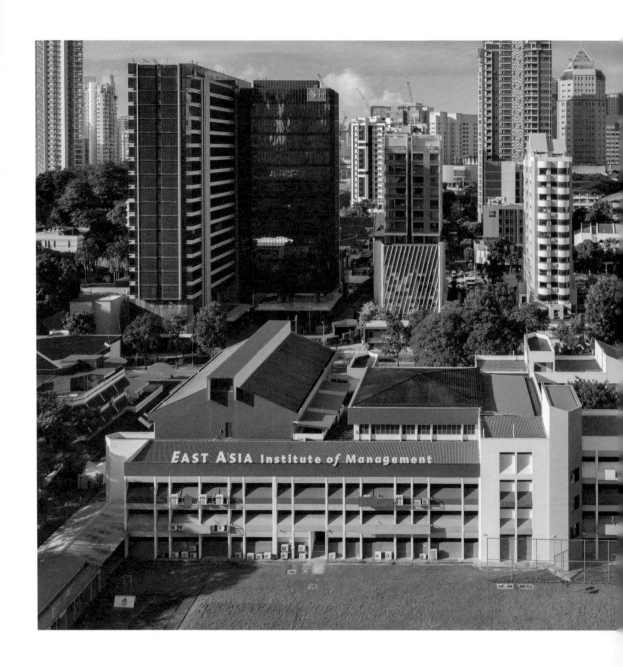

S100-type school, former Lee Kuo Chuan Primary School (1987), Alfred Wong Partnership.

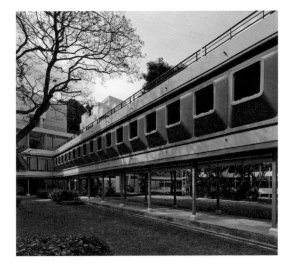

Singapore Polytechnic (1978), Alfred Wong Partnership.

Former Singapore Polytechnic (1958), Swan & Maclaren.

Former Administration Building, National University of Singapore (c. 1978–2013), University of Singapore Development Unit.

Former Subordinate Courts (1975), Kumpulan Akitek.

Former PUB Building (1977), Group 2 Architects.

Blk 342 Ang Mo Kio Ave 1 (1977), Housing & Development Board.

Demolition of the National Library at Stamford Road (1960–2005), Lionel Bintley of the colonial Public Works Department.

Queenstown Public Library (1970), Public Works Department.

Geylang East Public Library (1987), Public Works Department.

Thomson Community Centre (1984–2019), Regional Development Consortium Architects.

Marine Parade Community Club (2000), William Lim Associates, featuring Surachai Yeamsiri's mural, the "Texturefulness of Life".

Former Bukit Ho Swee Community Centre (1980s), Housing & Development Board.

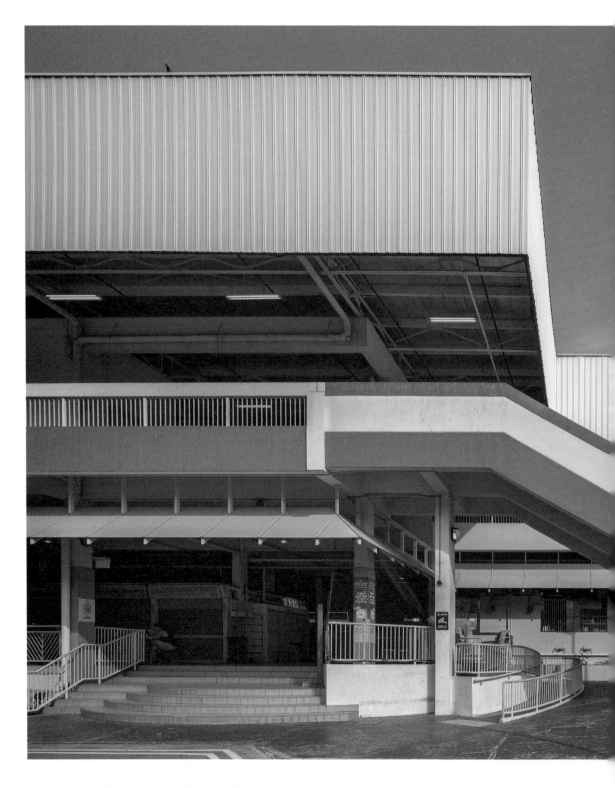

Old Airport Road Food Centre and Market (1973), Housing & Development Board.

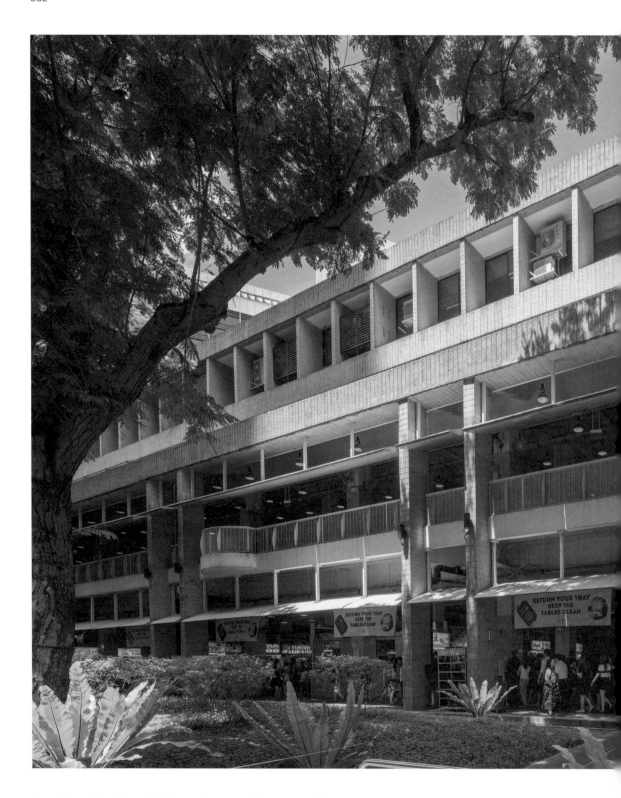

Amoy Street Food Centre (1983), Housing & Development Board.

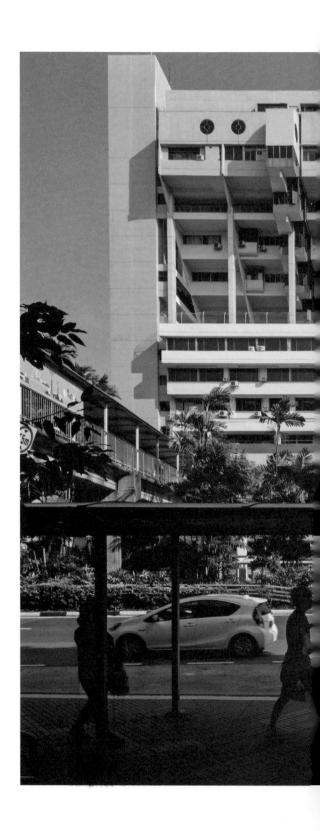

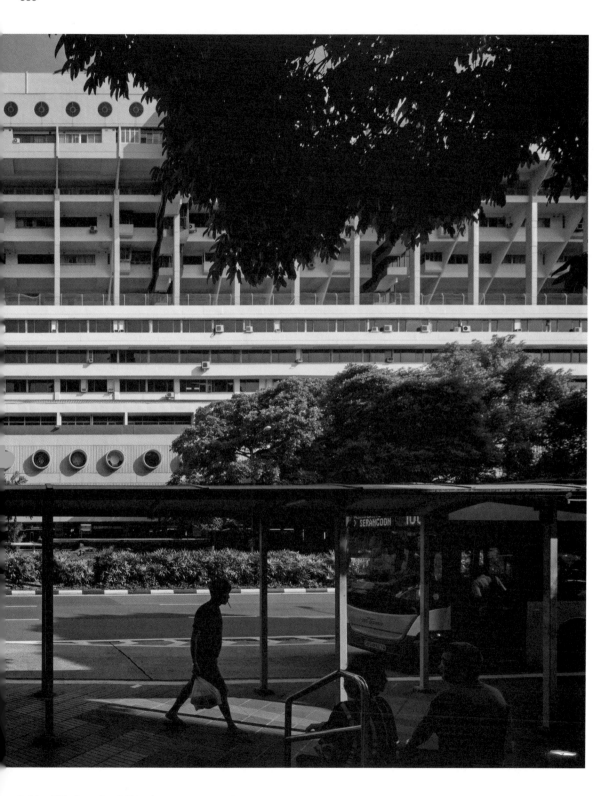

Golden Mile Complex (1972–3), Design Partnership.

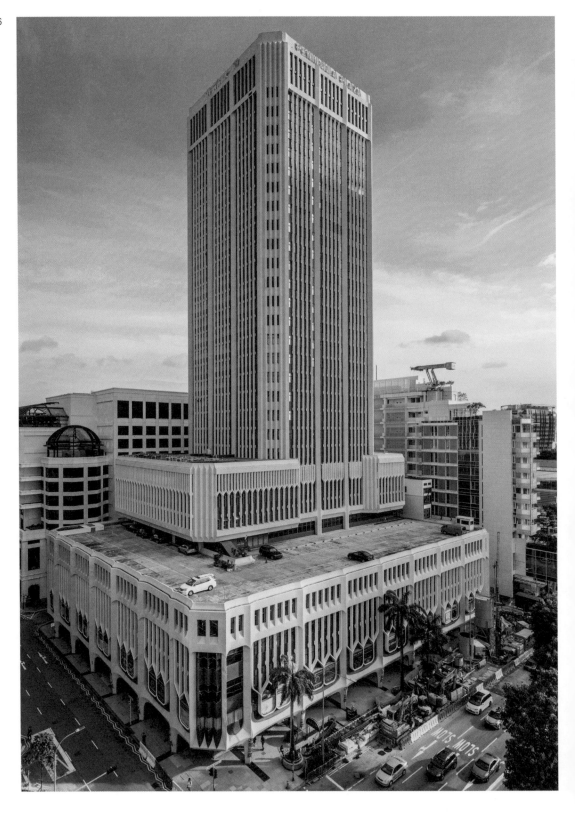

Peninsula Plaza (1979), Alfred Wong Partnership.

City Plaza (1980), Ong & Ong Architects.

Church of St. Bernadette (1961), Alfred Wong Partnership.

Blessed Sacrament Church (1965), Gordon Dowsett of Iversen Van Sitteren and Partners.

Interior of Blessed Sacrament Church.

Former Metropole cinema (1958), Wong Foo Nam converted into Fairfield Methodist Church (1985).

Former Liberty Theatre (1978) converted into Faith Community Baptist Church.

Darul Aman Mosque (1986), Mohammad Asaduz Zaman of Housing & Development Board.

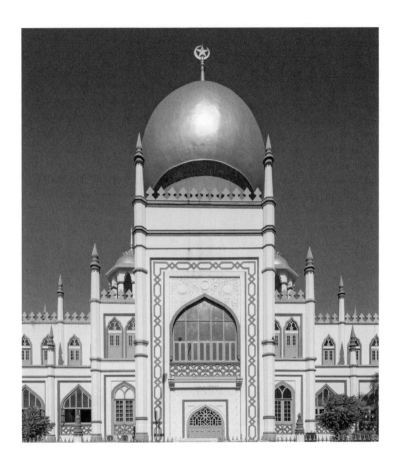

Sultan Mosque (1932), Denis Santry of Swan & Maclaren.

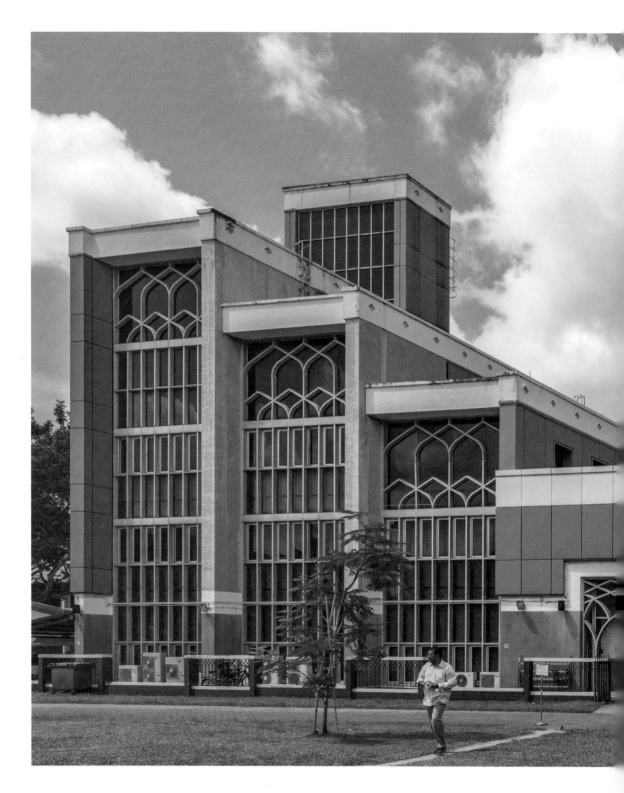

Darul Ghufran Mosque (1990), Housing & Development Board.

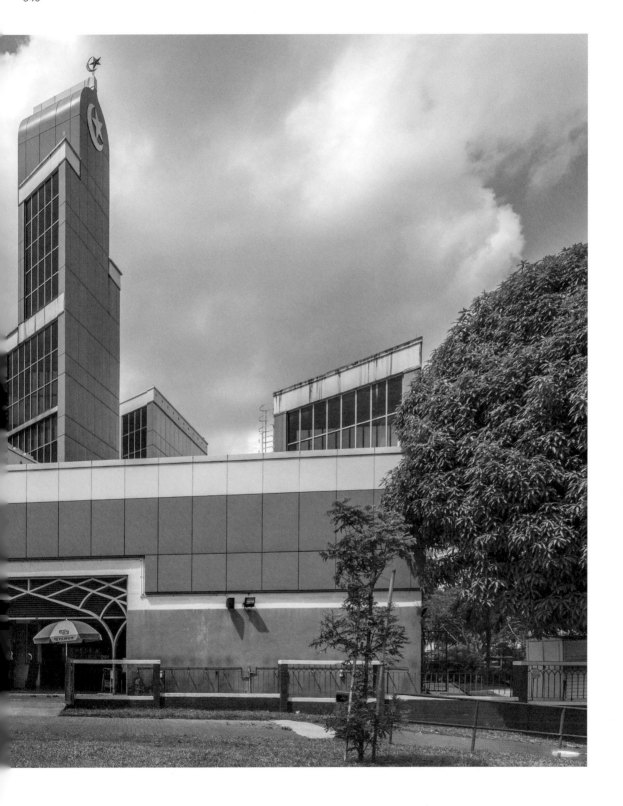

Mandai Columbarium (1981), Public Works Department.

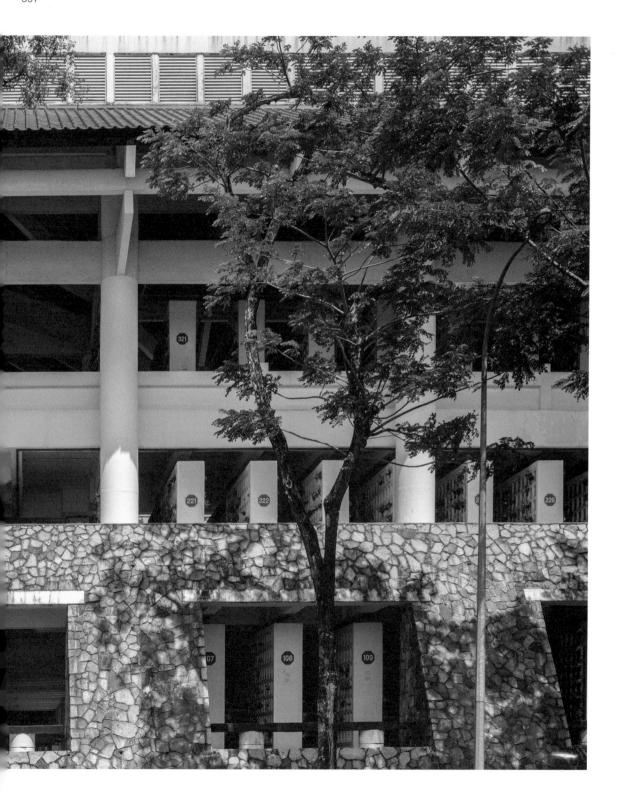

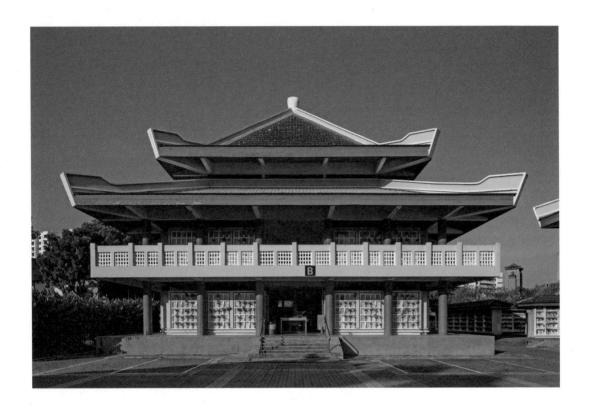

Yishun Columbarium (1978), Housing & Development Board.